# READING RUSSELL

# READING RUSSELL

## ESSAYS 1941-1988
## ON IDEAS, LITERATURE, ART, THEATER, MUSIC, PLACES, AND PERSONS

## BY JOHN RUSSELL

Harry N. Abrams, Inc., Publishers, New York

To

LAVINIA

One fair daughter, and no more,
The which he loved passing well.

*Hamlet,* Act II, scene 2.

Editor: Ruth A. Peltason
Designer: Samuel Antupit

The publisher and author gratefully acknowledge the following magazines, newspapers, and publishers for permission to reprint the essays mentioned, some of which originally appeared in slightly different form:
"Clive Bell" in *Encounter*, December 1964, pp. 47–49. "Gilbert & George" and "Anthony and Violet Powell" copyright 1985, 1988 John Russell, in *House & Garden*. The Foreword in *John Pope-Hennessy: A Bibliography* copyright © 1986 by The Metropolitan Museum of Art. "Henry James Comes Down From the Ivory Tower," "An Odd Couple: Flaubert and Turgeniev," "Gibbon in Lausanne," and "Sainte-Beuve, The Weekly Achiever" copyright 1943, 1947, 1948, 1950 John Russell, in *The New Statesman and Nation*. "The Malraux Show," "Luminism: The Healing Art," "Nijinski and Nijinska," and "Meyerhold Redux" reprinted with permission from *The New York Review of Books* copyright 1976, 1980, 1981, 1982 NYRev., Inc. Some of this material first appeared in *The New York Times*. Copyright 1976, 1977, 1978, 1979, 1980, 1981, 1982, 1983, 1985, 1986, 1987, 1988 The New York Times Company. "Pleasure in Reading" copyright John Russell, in *The Times*, London and "Farewell to London" copyright John Russell, in *The Sunday Times*, London. "From Aksakov to Chaliapin," "Voltaire in Geneva," and "Eugene Ionesco: A School of Vigilance" reprinted courtesy of *The Times Literary Supplement*.

Photograph Credits: 8, 13, 14, 24, 34, 38, 85, 96, 123, 144, 157, 228, 233, 235, 239, 240, 249, Philip Pocock.

Library of Congress Cataloging-in-Publication Data
Russell, John, 1919–
Reading Russell.
Includes index.
1. Arts. I. Title.
NX65.R87    1989          700          88–34966
ISBN 0–8109–1550–2

# CONTENTS

# ACKNOWLEDGMENTS

Going on three years ago, I was taken to lunch by Paul Gottlieb, the president and publisher of Harry N. Abrams, Inc. After some amiable preliminaries he said that he would like to publish an anthology of what I had written, here and there, over the previous forty and some years.

Knowing as I do that most publishers dread the very mention of such a book, I wondered if this could be a monumental tease. But "No, not at all," he said. The idea had originated with Ruth Peltason, an Abrams editor whom at that time I had never met. She had broached it to Robert Morton, Abrams' director of special projects. He liked it. Paul Gottlieb liked it. Wouldn't I say "Yes"?

Of course I would. And I did, forthwith.

There followed a blissful period in which Paul Gottlieb and Bob Morton were around as beaming presences and Ruth Peltason went to work. The complete professional, she doubled from my point of view as cormorant and precisionist, high flyer and safety net. Looking back, and remembering the care, the good judgment, the sense of fun, and the very long hours that she brought to the book, I count my blessings.

Also at Abrams, Sam Antupit, art director, proved himself not only a champion problem-solver but a connoisseur of out-of-the-way ornamentation. At The New York Public Library, Robert Rainwater, assistant director for Art, Prints and Photographs, and curator of the Spencer Collection, acted as a proven master in his field and went out of his way to help us.

Since 1956, when I first had an editor/author relationship with Rosamond Bernier, she has been the reader whose judgment I value most. It was always her wish that this book, or one like it, should appear. Now that it is at last in her lap, I realize how much it owes not only to her ardent and generous spirit but to her specialized awareness.

J.R.

# INTRODUCTION

In the last months of World War II, I dreamed of writing a book that would fly into the stores as if from nowhere and give pleasure to everyone who opened it. "Peacetime at last!", they would say as they lingered over page after page and read this or that passage aloud. And in no time at all I should find myself rich, and famous, and loved.

Fat chance! Even in those easygoing days, not a publisher in London would touch my project. It was not as if they didn't know me, either. There were publishers' houses at which I dined once a week, and others at which I took on a cocktail or two, every other Tuesday, the way Anna Karenina's train took on water at Klin. But, after a while, even they would cross the street to avoid further discussion of my idea. "Just come up with something else," they would say. "*Anything* else!"

There were visiting American publishers, too—men and women world-known for their experience, their acumen, and their readiness to take a chance. All heard me out. Without exception, they returned a forthright "No." (One of them was so aghast that he dropped a heavy cut-glass tumbler in the grate and broke it.)

But I thought then, and I think now, that my project had potential. What I put forward, as the Allied forces brought the war to an end in one country after another, was what could be called "An Alphabet of Admirations." It was to be about people whose names had added something of enduring value to the English language. What I had to say about them would be powered by wonder and awe, admiration and affection.

And why not? Where would we be, in everyday conversation, without "Homeric," "Platonic," "Shakespearean," "Mozartian," "Jeffersonian," "Emersonian," "Proustian," "Freudian," "Kafkaesque," and (as then seemed mandatory) "Churchillian"? We'd get along, beyond a doubt, but how much less nimbly! Would it not be a public service to take twenty-six such names, from A to Z, and root around in them like a mouse in a wheel of Brie? Like the alphabet itself, such a book would help us to think better, faster, more clearly, and with a riper understanding.

I planned twenty-six short portraits in prose of a kind that I had always loved to read and was eager to write. I dreamed of all manner of unexpected inclusions—Gibbon, a great historian, Nijinsky, a great dancer, Franz Schubert, a great composer, Karl-Friedrich Schinkel, a great architect now almost too popular, Charles-Augustin Sainte-Beuve, a French nineteenth-century critic who left us what has been aptly called "a great ocean of reading," and Ludwig Wittgenstein, a philosopher then known only to professionals in the field but now the prey—through no fault of his—of high fashion.

"A bit too idiosyncratic for us, old man," said the Americans. "Might be all right if you were Max Beerbohm" was the nearest that I could get to encouragement from the British side. And so—in the boiler-plated phrase familiar to every obituarist—"for a variety of reasons the project was laid aside."

Or was it? When my friends and colleagues at Abrams invited me to undertake that well-known act of professional suicide, the reprinting of selected essays from the past, it eventually became clear to me that in a roundabout and half-conscious way I had got my "Alphabet of Admirations" into print, here and there, in one guise or another, over a period of time that ranged from 1941 to 1988.

Much was different, of course. The world had changed. My cast of characters had changed. I myself had changed. So had my way of writing and, no less so, the audience for whom I wrote.

All this notwithstanding, in the book that has heaved itself over the hill, as if by its own legless energy, elements of "An Alphabet of Admirations" still survive. They come disguised, admittedly. The alphabet is all banged up, and left by the side of the road. Many a heavyweight figure from the past has been dropped. Sometimes, like Schinkel and Wittgenstein, they had been too often pawed over by others. Sometimes I had never had a chance to write about them. I have opinions about Sophocles and Walt Whitman, Racine and Kafka, but the reader of this book will be spared them.

Fundamentally, this is a book of portraits, even if it addresses a number of large general subjects along the way and ends with an evocation of a whole people in sociable tumult. As for the unity of time, place, theme, or discipline that is often sought for in books of this kind, it was never a part of my designs.

This is, in other words, a peculiar mixture. Some of the people to whom I owe most are not mentioned at all. But this is either because I have said my say about them elsewhere or because I intend to write about them in quite another format.

Furthermore, likings are omnipresent in this book, and dislikings omitted almost without exception, though I rather regret not having included a dismissive review of T. S. Eliot's *The Cocktail Party* that came out more than forty years ago, along with one or two outbursts of more recent date—about Rodin's *Gates of Hell*, in particular.

But, unlike some other critics, I do not see my role as primarily punitive. There are artists whose work I dread to see yet again, dance-dramas that in my view have set back the American psyche several hundred years, composers whose names drive me from the concert hall, authors whose books I shall never willingly reopen. But it has never seemed to me much of an ambition to go through life snarling and spewing. This is a matter in which I share the point of view of John Updike—"Better to praise and share than blame and ban."

Besides, I wrote these portraits of individual human beings to amuse myself. Not a line in this book came to me as a chore. If I was lucky enough to find editors who would print them, it was in part because most of these pieces had a predestined deadline—an exhibition, an anniversary, a new edition, a translation, a controversy, a recent death. Looking through the list, I remember that Berthe Morisot had a centenary in 1941, Henry James a centenary in 1943, and Aksakov a centenary in 1959.

It would be a pity to have been around in those years and not got in early with *Waiting for Godot* by Samuel Beckett, the intermittent opening-up of the Soviet Union, the output in art history almost from his schooldays onward of

John Pope-Hennessy, the occasional writings of Lincoln Kirstein, and the emergence of David Hockney as a stage designer.

It was good to be alive at a time when Meyer Schapiro set the standards of academic discourse, when Joseph Beuys and Anselm Kiefer rewrote the map of Germany, in imaginative terms, and when John Wilmerding compared American Luminist painting to the Gettysburg Address and carried at any rate one reader with him.

This book does not, of course, cover more than a tiny part of what has been most rewarding in arts and letters over the last fifty years. It has no such pretention. Its object is to tell how it felt to wake up in the morning, say to oneself of some topic or other that "I simply have to write about that," and persuade someone to print it.

I count myself very lucky that every piece in this book was accepted as written and without demur. Editors come in many kinds and sizes, but there again I have been lucky beyond my desserts. Not every editor, to be sure, has the nonchalance of Peter Quennell, who set a record of some kind in his light-handed management of *The Cornhill Magazine* in London just after World War II. (Once, when I had submitted a long piece to him, I asked if he had had time to read it. "Oh no," he said. "I always think it's more amusing to wait till it comes out in the magazine.") Others were more watchful, and I treasure the memory of the American editors who have run me to earth in hotels all over Europe to ask if it would really be all right to substitute a colon for a semi-colon, or vice versa.

Rereading these pieces (and hundreds of others) I realize to what extent I have kept in mind an attitude that I attributed in 1946 to Lytton Strachey in an essay too long to be used here. I said that Strachey saw history as "a series of tête-à-têtes with chosen persons—something not so much written as talked over; and from what came of those talks we can picture the outside and the inside, the hide and the heart, of the subject." Lytton Strachey's reputation at that time was about as low as it could be, but it still seems to me what he called his "portraits in miniature" will bear unlimited rereading.

It was not until the early 1970s that I got to write three little profiles (for Louis Kronenberger's "Atlantic Brief Lives") that were the epitome of what I had in mind for "An Alphabet of Admirations." They were about Franz Schubert, Piero della Francesca, and Camille Corot. (If a more lopsided trio could hardly be found, that is because everyone else that I fancied had already been spoken for.) As I see it, they sat there like a wreath of welcome on a front door that was waiting to be pushed open.

After I moved to the United States in 1974, my professional life took on a new tempo. Gone was the relative languor with which I produced bite-sized prose pieces for the London *Sunday Times*. My step was necessarily brisk, my overview vastly more wide, and the level of encouragement and support a hundred times higher. Working for *The New York Times,* I found myself writing about art, as had already been agreed. But I also found myself writing about the centenary of Dr. Albert Schweitzer, the bicentenary of the battle of Lexington, the special properties of the color green, and the fact that "wisteria" rhymes with "hysteria."

I went to see Russell Page, a great gardener, Willem De Kooning, a major

painter, and Madeleine Renaud and Jean-Louis Barrault, the doyenne and doyen of the Parisian stage. I wrote about luggage, and about the Merritt Parkway, and about the emotional role of railroad schedules the world over.

Though a novice in such matters, I was sent to cover both the Republican and the Democratic conventions in 1984. A universal hospitality was extended to me at the *Times,* and whereas in London my activity had been measured out with coffee spoons, the *Times* set no limit to it. "Big boss, he say give us all you can" were almost the first words I heard in the *Times* office in the years when copy was still carried by hand from writer to editor, and I have yet to hear them contradicted.

The personal portraits that found their way into exhibition review, book review, obituary, and controversy alternated from time to time with pieces that were, in effect, a portrait of the times rather than of individual contributors to them. Those pieces were a by-product of the right to know. Were the 1970s a bust? Has contemporary art gone down the drain? Is cleaning pictures another word for destroying them? Is there such a thing as postmodernism? Has European art still got something to say? Is the auction market a true guide to enduring stature? Did this or that spectacular purchase turn out to be a fake? Questions of this sort are always being asked, and it is the duty of the critic to answer them.

These last years have been in every respect the most rewarding of my professional career. Writing fast and often has been said to be a recipe for disaster, but I have not found it so. I feel myself to be more inquisitive, more alert, and vastly more energetic than in the 1950s, when visitors to my apartment in London would sometimes remark that the same three sentences on the same sheet of paper had been in my typewriter for six weeks on end.

"Fa presto!" was the nickname of the Neapolitan painter Luca Giordano in the years when he tackled one enormous commission after another in Naples and Madrid and completed every one of them in record time. I know what people meant when they coined that name, but I also know how Luca Giordano felt—that as long as someone wanted him to paint he was damn well going to do it.

So that's the way it is. Work begets work. May it ever be so!

J. R.
New York, 1989

# I.

# ENDURING PRESENCES

The first batch of essays is about people who have nothing in common except the fact that without them I should have found the world a poorer place and myself a drearier person.

# Alexander Pushkin

## Unpublished, c. 1971

*Among persons ever present to me, Alexander Pushkin has few rivals. A great language, a great literature, a glorious freedom from littleness or self-impor-tance—all were his mark. What follows here owes much to Vladimir Nabokov's edition of* Eugene Onegin, *and something to Edmund Wilson, the reader whom I would most have wished to please. Though accepted by two very good American magazines, it never ran, and therefore appears here for the first time.*

There is a great man whose ghost haunts Odessa as it haunts Leningrad, and Moscow, and half a dozen estates between Pskov and Simbirsk: Alexander Pushkin. Pushkin is at our side in Odessa when we amble after dinner along the esplanade above the Black Sea, watching the pleasure launches on their way back from well-named Arkadia, the beach resort a few miles to the east; he is with us when we go to the opera house, or when we pick out the Frenchmen, the Spaniards, the Armenians, the Egyptians, and the Greeks among the perambulating crowd, or when we note that the local young ladies are as sensitive as ever to the fascination of the strong young man from the sea. Pushkin saw all this before us; he put it down in his travel notes, touched on it in some wonderfully racy letters, and quintessentialized it in his verse novel *Eugene Onegin*. He is right there at our side, in Odessa, and we know he is there; but between him and us the glass is frosted over. Pushkin in translation is just not Pushkin at all.

In point of fact Pushkin had a horrible time in Odessa. He was sent there in July, 1823, when he was just twenty-four years old, as a minor official on the staff of Count Woronzow, Governor General of the area. During the year that he managed to stick it out, he was continually short of money; he had to dress shabbily in a city that had European pretensions to elegance; he got on very badly with the anglophile Woronzow, whom he regarded as a Vandal, a boor, a paltry egoist, and "a man who knew as much about Russian literature as the Duke of Wellington"; and the most interesting of his assignments was proba-bly the last, when he was despatched to investigate a plague of grasshoppers in

the neighborhood of Chersonesus. None of this emerged when he put Odessa into the fragmentary travel notes that form an appendix to *Eugene Onegin;* for that particular distillation of experience he remembered only the new consignment of oysters in the exemplary restaurant run by a Frenchman, César Automne, and the performances of Rossini's *Turco in Italia,* which gladdened his last days in the city, and the look of the merchants, children "of Calculation and of Venture," as they trained their telescopes out to sea in the hope of sighting the ships that would double their fortunes. We know that Pushkin described all this supremely well, and yet to a large extent we must take that on trust: without Russian, we shall not get far.

Still, it would be difficult, anywhere in the world, to beat up much dissent to the proposition that Pushkin was one of the greatest writers who ever lived. Even if we know of his achievement only by hearsay, we know that Pushkin reinvented the Russian written language as an instrument of the deepest, subtlest, most arrowy forms of expression. All great writers reinvent the language they write in, but Pushkin did more than that: he promoted Russian literature, single-handedly, to the front rank of world literatures. As Maurice Baring said in 1914, "Pushkin is Russia's national poet, the Peter the Great of poetry, who out of foreign material created something new, and Russian." He reinvented the forms of Russian literature—lyric verse, narrative verse, blank-verse drama, the short story or novella, the novel-in-verse—and, like Shakespeare and Molière and Melville, he put on the page individual characters in whom every one of his countrymen can recognize a part of himself. Dostoevsky was not exaggerating when he said in 1880 that Pushkin was the first man to detect and place on record the pathological phenomenon of the alienated Russian: the Russian who was brought into being when Peter the Great opened the windows on to the West. But Dostoevsky also said in that same speech that Pushkin was the first to put forward an ideal of steadfast, uncorrupted femininity that is peculiarly Russian; Pushkin has kept his freshness intact, so that even after almost a hundred and fifty years he is the author to whom Solzhenitzyn's characters turn for comfort when they are most in jeopardy.

That much is available to us. We may know it only from that depleted and misleading pabulum that we call Pushkin-in-translation, but at least we can get hold of it. We have also a number of auxiliary resources. We can read what has been written about him in English: by Maurice Baring in his *Landmarks in Russian Literature,* first published in 1910 but still of great value; by Vladimir Nabokov in the introduction and notes to his 1964 edition of *Eugene Onegin;* by John Bayley in his *Pushkin: A Comparative Commentary* (1971); and by David Magarshack in his excellent biography of 1967.

We can also go to the opera. No fewer than five of the masterpieces of Russian opera derive directly from Pushkin. Mussorgsky's *Boris Godunov* comes from a historical verse-drama by Pushkin which we are never likely to see on the legitimate stage. Tchaikovsky's *The Queen of Spades* is taken from the most taut and concise of Pushkin's short stories in prose. *Eugene Onegin* (Tchaikovsky again) is a much-simplified but heartfelt elaboration of certain episodes in the great novel-in-verse. Glinka's *Ruslan and Ludmilla* is based on an epic poem by Pushkin that was written in octosyllabic verse of a conversa-

tional kind: Mr. Bayley cites Voltaire as Pushkin's most likely model in this instance. As for Rimsky-Korsakov's bedizened *Coq d'Or,* it is a derivative of Pushkin's "Tale of the Golden Cockerel," which in its turn was a derivative of one of the pseudo-Oriental tales in Washington Irving's *The Alhambra.*

It is in these diverse and roundabout ways that the genius of Pushkin makes itself felt at second hand. They are not wholly misleading, either. Listening to the unsupported wind chords with which Mussorgsky opens the prologue to *Boris Godunov,* or noting the awe with which he evokes the act of writing when Pimen the chronicler takes up his pen, we catch something of the intensity with which Pushkin guided his audience toward a new level of identity with the history of Russia. Tchaikovsky's two Pushkinian operas have little of the bitter, spare, factual, unforgiving quality of their originals. But in the character of the nurse in *Onegin,* and in the extroverted carousing in the final scene of *The Queen of Spades,* we glimpse two elements in Pushkin's own life—the truth and simplicity of spoken Russian as he heard it from country people, and the ferocious high spirits of the hussars with whom he consorted in his last year at school.

Despite the intermittent magic of these derivatives, it is in later Russian literature that the genius of Pushkin finds its most faithful reflection. In *Eugene Onegin,* in the narrative poem "The Bronze Horseman," in the short story called "The Negro of Peter the Great," in many of the shorter poems, in the frantic vitality of the letters and the interminable tribulations of the life, the essentials of Russian literary experience are present in acorn form: with time, the oaks came.

Anyone who doubts this should look at the minor characters in *Eugene Onegin. Onegin* is, apart from so much else, a prototypical comedy of manners, in which every word spoken, every intonation of voice, and every detail of dress and deportment is made to tell. Overpowering emotions sweep through it from time to time, but Pushkin never lapses into vague general statement: the particular is his domain. A crucial episode in the novel is, for instance, the duel in which Onegin kills his neighbor and close friend, the poet Lensky. There need never have been any such duel. But from the moment that an unmotivated mischief prompted Onegin to flirt with Lensky's fiancée the incident was bound to end badly. The forms of life took over: Lensky had to challenge Onegin, Onegin could not refuse the challenge. They could have made it up? Of course they could; but in those days, as Pushkin remarks, "false shame played a terrible part in the quarrels of fashionable people." Lensky had no heart for the duel and would never have killed Onegin; but Onegin was form's prisoner, and he shot his friend dead while Lensky was still screwing up his left eye and preparing to take aim. Pushkin tells us all this with a brisk factual accuracy that extends even to the faceting of the pistol barrels and the precise color of the powder in the pan. He was accurate in human detail, also: that we can tell from the portrait of Zaretsky, who acted as Lensky's second in the duel. His brief appearance could be that of a cardboard man, a convenient cipher not to be brought forth from the shadows. But Tolstoy himself could not have been tauter: in just a line or two, Pushkin shows Zaretsky as a former rakehell, a crack shot who could hit an ace at twelve yards, an ex-prisoner of the French, and a veteran of brawls beyond number now living in sage retirement among

cabbages, ducks, and geese. Gogol, again, is the supreme master of the Russian provincial grotesque; and we should think of him when we read Pushkin's list of the guests at the Larins' little ball, even if Vladimir Nabokov were not on hand to describe them as "grotesque personages waiting for Gogol to transfer them from a rather obvious comedy of hoggish manners and Hogarthian noses into his own fantastic and poetical world."

"The Negro of Peter the Great" is not one of Pushkin's more successful stories. An unwonted idealization has crept into the portrait of his maternal great-grandfather, Abram Gannibal, who was brought to Russia from Abyssinia by way of Constantinople at the beginning of the eighteenth century and became a favorite of Peter the Great. Pushkin's description of Paris under the Regency of Philippe d'Orléans is open, likewise, to the charge of fantasy. Pushkin often dreamed of going to Paris, but he never got permission to do so; and he did rather go overboard when he allied a wished-for Paris to the dream of his great-grandfather as a voluptuous black giant whom no Frenchwoman could resist. But when the story moves to the St. Petersburg of Peter the Great, Pushkin shifts to quite another level of authenticity. He gives, in fact, new dignity to the historical novel, a genre in general so burdened with kitsch as to put us quite out of patience; and when he describes the scene at the czar's assembly in the Winter Palace, where the wives and daughters of the Dutch sea captains "in dimity skirts and red bodices sat knitting their stockings and laughing and gossiping among themselves as though they were back at home," we seem to get a first glimpse, a brief unfinished sample, of the great set pieces of historical reconstruction in *War and Peace*.

Pushkin never lingered. Like the practiced duelist that he was, he took aim, fired, and moved on. He was fast, dry, and succinct at all times; but, for all that, we get a pre-echo of Turgeniev and Aksakov when Pushkin describes the Larins' unhurrying way of life in the country, and a pre-echo of *The Three Sisters* when the garrison commander makes his appearance, like Chekhov's Vershinin, at the Larins' ball. Country life and Pushkin were not always made for each other. "When I think," he wrote in 1826, "of London, railroads, steamships, of the English reviews, the theatres and bordelloes of Paris, then my Mikhailovskoe backwoods make me ill with boredom." But even in so short a poem as the one that begins "It is winter. What shall we do in the country?" we can find the origins of Turgeniev's "A Sportsman's Sketches," of scene after scene in Chekhov, and of the great panoramas of country life in Aksakov. In just forty-seven lines the poet moves from early morning to midnight. Initially irresolute ("Shall I get out of bed and into the saddle, or would it be better to leaf through my neighbour's old magazines till dinner-time?") he is persuaded by the look of the powdered snow on the ground to go out hunting. He has a great deal of fun, even if he does miss two hares. Later, back at home, he tries to write and cannot. Bored, he goes into the drawing room, only to hear "a conversation about the impending elections, and another one about the sugar-factory." Toward evening two beautiful sisters arrive unexpectedly, and the evening takes on a new and beguiling aspect, with waltzing and whispering and lingering meetings on the narrow staircase and at last a kiss at twilight on the snow-driven porch. "How hotly burns a kiss in freezing weather! How fresh is a Russian girl among powdered snow!"

Above all, Pushkin knew Russian society through and through, from top to bottom. He lived at a critical time for Russia, and for the Russian language. (*"Are* there any Russian novels?" says the old Countess in *The Queen of Spades.*) And he knew how to choose themes that had a resonance far beyond that of mere private entanglements. For a long time people thought that *Onegin* was a quasi-Byronic novel-in-verse about a rich, idle, foppish young man who brought nothing but unhappiness to himself and to those who came near to him. But Edmund Wilson pointed out the mistake of this reading at the time of the Pushkin centenary in 1937. "The chief disaster of *Eugene Onegin,*" he wrote, "is not Eugene's chagrin or Lensky's death; it is that Tatiana should have been caught up irrevocably by that empty and tyrannical social world from which Eugene had tried to escape and from which she had felt and still feels so alien....In opposing the natural humanity of Tatiana to the social values of Eugene, Pushkin set a theme which was to be developed throughout the whole of Russian art and thought, and to give it its peculiar power. Lenin, like Tolstoy, could only have been possible in a world where this contrast was acutely felt."

These were the high stakes for which Pushkin was playing: the reinvention of the Russian language, the achievement among Russians of a new level of national self-awareness, and the unequivocal statement in metaphorical form of the dilemmas which had to be faced before a new Russia could come into being. Pushkin aspired to take Russia bodily, upon his own two shoulders, and carry it into the future. It was the right kind of ambition for a great writer, and he fulfilled it.

Knowing all this, we might flatter ourselves that we have a sound general idea of Pushkin and his achievement. But our situation at such moments of complacency is that of the inattentive sentry who leaves himself wide open to the sniper's bullet. No sooner have we attempted to relate Pushkin's travels in the Caucasus to those of Lermontov's Pechorin than Vladimir Nabokov is there to remind us that without detailed, thoroughgoing, firsthand knowledge of the original text such general ideas "must necessarily remain but worn passports allowing their bearers short cuts from one area of ignorance to another."

I cannot think of a more redoubtable snub. There is undeniably something shoddy about enthusiasms that have to be lived out at second hand. And Mr. Nabokov is tart—very tart indeed, in fact—about English translations of Pushkin. By the time we put down his magisterial four-volume edition of *Onegin,* we are persuaded once and for all that Pushkin in any language but his own is like a pre-electric recording run at the wrong speed on a defective phonograph. So what to do? Well, we can learn more about Pushkin himself, to begin with.

Alexander Sergeevich Pushkin was born in Moscow on May 26, 1799. He was of noble Russian stock on his father's side—he was able, for instance, to put one of his ancestors on stage in *Boris Godunov*—and he set considerable store by a descent that made him, in his opinion, the social equal of anyone around. "You simply must realize," he wrote to a friend in 1825, "that the spirit of Russian literature depends in part on the status of our writers. We cannot offer our work to noble lords in humble dedication, for we believe ourselves to be their equals in birth. Russian writers must not be judged like foreigners."

Pushkin had been one of the first pupils at a small experimental school at Tsarskoe-Selo, which had been established under the direct patronage of the Czar Alexander I with the object of forming the elite of the coming generation; and he never, in all his life, knew a moment of social discomfiture. On his mother's side he was descended, as I said earlier, from Abram Gannibal, "the negro of Peter the Great." A lot of people have made heavy weather of this; not least, Pushkin himself, much given to deprecatory jokes about his dark skin, his thick rubbery lips, his close-curling hair, and his supposedly African temperament. When as a young man he conducted himself with young ladies like Priapus personified his friends took it as an expressly African trait; and one of his biographers refers to his "solid white cannibal teeth." Cannibal may rhyme with Gannibal; but if Pushkin was one-eighth African he was also one-eighth German-Swiss (through his maternal great-grandmother), and I don't know that it is really the best idea to press either the one or the other too hard. Nor was the Abyssinian in question much to boast about, even if he did end life as a major-general much in demand for his prowess as a director of firework displays. Pushkin in "The Negro of Peter the Great" made him a welcome guest at table with Voltaire and Montesquieu; but in reality, as Mr. Nabokov observes, Gannibal was "a sour, groveling, crotchety, timid, ambitious and cruel person." (Balked and betrayed by his Russian wife, he rigged up a torture chamber in which he would string her up to the wall in the hope of extracting a confession.)

Pushkin from the first had evident gifts as a writer, and a background which could be said to favor them. He had an uncle who wrote poetry of a facile, undemanding sort. He had the run of his father's excellent library. He had French tutors who could tell him what had been going on in western Europe. The school that he attended from 1811 onward was designed to give the best possible education to pupils for whom a great future was in store. He himself was never in doubt as to what he wanted to do, and when he read his own verses aloud on prize day, no one in the audience could fail to notice that if the matter of the poems was somewhat conventional they were delivered with an energy and a conviction that were quite out of the way.

Even so, much was against him. He had rackety, pretentious, unreliable parents. He was one of Nature's nonconformists. He was always short of ready money. He was not at all discreet. He drank, and gambled, and ran after women, and talked freely about matters as to which it was better to remain silent. When he was just eighteen and had taken over an unexacting post in the Foreign Office in St. Petersburg, he was already writing poems that were interpreted as a call to revolution. His friends loved him, and before long there was hardly an intelligent young officer in a fashionable regiment who did not know something of Pushkin's by heart; but as what they knew by heart was likely to be a personal attack on the Czar Alexander I, or on one of his favorites, it was inevitable that he should be in trouble with Authority at a time, and in a country, where Authority held all four aces and had a fifth one up its sleeve. In May, 1820, the month of his twenty-first birthday, he was banished from St. Petersburg. It was not the kind of banishment that would have befallen a person of no account—Pushkin spent four years in southern Russia in circumstances that could not be called penal—but it was banishment none the less.

In point of fact, he was rather lucky to have been sent away from St. Petersburg during the years in which the Decembrist rising of 1825 was being fomented. Had he been in the capital at that time it is possible that he would have been incriminated, if only by association, in an adventure that ended with the death or exile of its leaders. As it was, he heard of such things only from a great distance and at third or fourth hand, and he spent the year 1825 under police surveillance on the family estate at Mikhailovskoye. When the revolt had been put down and a new Czar, Nicholas I, was on the throne, there began a new phase in Pushkin's relations with Authority. Initially, it looked to be a more favorable one, in that Nicholas I received him in Moscow, assured him that the past was forgotten, and went on to say that as far as his writings were concerned, he could in future submit them directly to the Czar himself for censorship.

In all this, as much as in any of his writings, Pushkin was prototypical. Authority in Russia has not changed. It is as suspicious of the artist as ever it was, and its methods have altered hardly at all. We can all think of great Russian writers who have lived their lives with Authority just a pace or two behind them: not quite in jail, but not quite in freedom, either. In no other country is there so consistent and so intimate a dialogue between the writer and Authority. Rare is the head of state in the West who would harry a writer directly, and as man to man, in the way that the rulers of Russia harry writers who are "agin the government"; and if we sometimes flatter ourselves on the superiority of our system we should also wonder whether its advantages are not owed rather to indifference than to any superior wisdom.

Pushkin was hardly ever allowed to publish what he liked and as he liked, and the promised surveillance by the Czar himself turned out to be nothing better than supervision by the chief of the secret police. This was galling in practical ways. "Bother fame!" he had written in 1824, when part of *Onegin* was ready. "*Money* is what I need. Don't haggle over the price—cut the verses if you have to, tear them, put them through the mincer, but get me some money, for God's sake, some *money*!" But it was even more galling to a man who prided himself on his ancient Russian lineage and knew that he had something to give to his country.

Once again, the habits of our own century were prefigured as Pushkin was slapped down, time and again, by people who are now remembered only for their ignoble part in his affairs. He was dismissed from the civil service for entertaining the possibility of atheism in a private letter; he was informed upon in his own house by his own father; he was never allowed to publish many of his most important works; he never saw *Boris Godunov* on the stage; he was never allowed to go to western Europe, even when his doctors confirmed that he needed specialized treatment for varicositis of his right leg. (In this last instance, the Czar suggested that a doctor in Pskov would do just as well. "I have checked about the surgeons in Pskov," Pushkin wrote to a friend, "and a certain Vsevolodov was recommended to me—an accomplished veterinarian, well known for his treatise on the healing of horses.")

All this was very painful to Pushkin, though he put a good face on it in letters to his friends. He always hoped for an emperor who would encourage him as Molière was encouraged by Louis XIV, or Voltaire by Frederick the

Great. What he got was, at the best, the Czar Nicholas I, who said of *Boris Godunov* that "with certain necessary expurgations it could well be turned into a historical novel on the lines of Sir Walter Scott's." At the worst, he endured the iniquity of knowing toward the end of his life that even his letters to his wife were being opened and passed back to Authority. "One can live without political liberty," he wrote to her in June, 1834, "but if family life is to be continually violated, life becomes impossible. Penal servitude would be better." Pushkin's crime, in all this, was the crime of the free-minded individual who dares to say "Down with tyranny, down with slavery, down with censorship!"

There was nothing rhetorical about Pushkin's statement of his beliefs: plain words were enough. "You are a Czar: live alone" was his advice to other writers in "To The Poet" (1830). Nor was he ever "satirical." "My embankment would crumble if I were to touch satire," he once wrote, doubtless having in mind the great granite walls that hold the Neva in place as it moves through Leningrad, and perhaps implying also that certain matters were too serious for satire.

He was not at all sentimental. He loved the best of Byron as much as anyone, and he gladly paid for a mass to be said for Byron on the anniversary of his death, but he refused to see that death as a calamity. "I am very glad of it," he wrote, "as·a sublime theme for poetry, but Byron's genius ended with his youth." He was equally realistic about public events as to which a generous but mindless nature would have lost all sense of proportion. He was moved, in 1821, by the outbreak of the Greek War of Independence, and he passed on an account of how the Greeks in Odessa had sold up their property, spent the proceeds on sabers, rifles, and pistols, and gone off talking of Leonidas and Themistocles. But by June of that same year he was writing to another friend that "one must really keep one's head about the fate of the Greeks. Naturally I wish that they could be freed, just as my brother Negroes should be freed, from an intolerable bondage. But it is childish, and unforgivably so, for the enlightened peoples of Europe to imagine that a rabble of bandits and shop-keepers are the legitimate descendants of Themistocles and Pericles."

Pushkin was the more sensitive to outsize claims of this sort in that he had the loftiest possible ideas about Russia's own place in history. He put these on paper in October, 1836, just over three months before his death, in a letter to his lifelong friend Peter Chaadaev. Chaadaev had just published a "Philosophical Letter" in which he had argued that since the Great Schism of 1054, in which Russia had taken the side of the Orthodox Church, she had been an outcast among the nations: a country without history, without culture, without tradition. (The censor who passed this for publication was immediately dismissed from his post, and Chaadaev himself was officially declared insane.)

Pushkin replied in a letter which he was for once prudent enough not to send. His view was that in so far as Russia had been isolated, her isolation was a glorious martyrdom voluntarily undergone in the object of saving western Europe from Mongolian domination. "And as for our history being of no account," he went on, "I must absolutely disagree with you.... Not for anything in the world would I consent to change my fatherland, or to wish for it any other history than that of our ancestors."

In a sane society Pushkin would have been held in honor for a patriotism that was as profound as it was intelligent, just as his friend Chaadaev would have been acclaimed for the integrity and the deep personal conviction with which he put forward quite another view of Russian history. As it was, Pushkin was regarded to the day of his death as a menace to the state. ("Good riddance!" said the Grand Duke Michael when he heard that Pushkin had died.)

Pushkin in his thirties was a changed man, in physical terms. His hair was going gray, he was lame, he thought of himself as old and ugly, and when in St. Petersburg in fine weather he pottered about the Summer Garden in dressing gown and slippers and not seldom took a nap on a bench; little remained of the sinewy debauchee who could out-swim, out-fence, out-talk, and out-drink the strongest of his contemporaries. Only on his wife's name-day did he allow himself a bottle of champagne, a bottle of Château Lafite, and a glass of hot pineapple punch in the company of old friends. He was writing a lot, and as well as ever: mostly in bed, with the paper propped up on his knee, from nine in the morning until three in the afternoon. He had been married since February, 1831, and had proved himself an exemplary husband and an adoring father. His many letters to his wife are as uxorious as any in the annals of matrimony. "They say," he wrote to a friend in 1834, "that unhappiness is a good school. So it may be. But happiness is the best university."

It was not, however, a university from which Pushkin would ever graduate. Nathalie Pushkin, born Goncharov, passed as a great beauty at the time, though to ourselves she looks overblown and overdressed. She was twelve years Pushkin's junior, and there is no indication that she was ever aware of his true quality. She made use of her good looks and his position to flirt with everyone who fancied her; and a great many men did fancy her, from the Czar Nicholas I downwards.

Pushkin warned her about this, as early as October, 1833, in terms that even she should have understood. "Where there's a trough," he wrote, "there'll be swine." But she didn't understand; and as Pushkin in such matters was governed by a particularly touchy and delicate sense of honor it could only be a matter of time before he had to issue a challenge. He did so in January, 1837, and on the 27th of that month he was mortally wounded in a duel with a young French royalist émigré, Baron d'Anthes, who had gone far beyond what any husband could permit at that time. What Edmund Wilson calls "that empty and tyrannical social world" had claimed its greatest victim.

But Pushkin survives? Yes: and one of the great rewards of Russian travel is to come upon places that he once visited and people with whom he would have been in sympathy. There are many such people in Russia, though it would be in no one's interest to give their names. There are many such places, too: not least the Summer Garden in what is now Leningrad, on a fine afternoon in spring when huge plaques of lately-loosened ice go racing past on the Neva and one might almost hope to see, against all reason, a little gray-haired young-old man in his middle thirties nodding off on one of the benches.

# Eugène Delacroix

### The Cornhill Magazine, 1944

*During World War II and for many years afterward, I identified with the great
French romantic painter Eugène Delacroix to the point of wincing at what seemed
to me his unspoken "Where's the big book?" whenever I looked at his self-portrait
in the Louvre.*

    *And what came of it? One or two distillations, of which the shortest and
earliest is reprinted here, and a lengthy introduction, long ago pulped or shredded,
to his selected letters.*

Delacroix preferred in general to deal with things rather than with people.
"Men are so boring," he once remarked, "with their tics and so forth." He himself
had no tics to speak of, and nobody found him boring. His physical envelope
was startlingly fine, and he was exceptionally well able to please in society;
nothing less, after all, could be expected of a son of Talleyrand. Yet even as a
very young man he had been solitary, and in later life he turned from western
life, as if in disappointment, and read eagerly all that was then known of more
primitive types. Tartars and Iroquois, Sandwich Islanders and Iowa Indians—
each was more curious than the last. He loved to scavenge among travelers'
tales and read of the Patagonians, for instance, that they were covered with a
thick layer of filth and "consummately perfidious." It is, in fact, a paradox that
anyone so skeptical of human progress should be usually associated with such
pious and ideal conceptions as the *Liberty Leading the People* of 1830. A more
representative subject, and one to which he returned again and again, is that of
Tasso in prison, tormented by idiots and criminals.

    Four spectral lines of Baudelaire are often taken to contain the whole of
Delacroix:

> Delacroix, lac de sang hanté des mauvais anges,
> Ombragé par un bois de sapins toujours vert,
> Où, sous un ciel chagrin, des fanfares étranges
> Passent comme un soupir étouffé de Weber.

Taken point by point, these lines are tolerably exact. There is decidedly a lot of
dirty weather in his work; as a young man he confessed that in his heart there
were black depths that called out for satisfaction; at least one memorable event
happened to him during the overture to *Freischütz ;* and the mortality among
his figures is so abnormally high that the words "molochist" and "cannibal"
have been coupled with his name. These things did, in fact, go very deep; one
cannot read his description of Arab horses fighting and not sense that it had

for him a compulsive and symbolic interest. "They go at one another with their beautiful teeth like tigers. Nothing can separate them. Their breath comes hot and hoarse from their scarlet nostrils, and their manes awry or clotted with blood..."; this is clearly obsessional, and it is in character that when he was walking on the beach at Tangier the marks left on the sand by the retreating tide seemed to him like those which he had seen on the back of a tiger. He went to great pains to trace a Persian painting in which there was *un crocodile colossal;* so fond was he of adjuncts to disaster that any form of statistic about unnatural death would always find a place in his diary. Twelve persons, he noted, were hanged every day in Constantinople; British merchant marine losses, for the first seven months of 1858, totalled over 960; even the eating of mussels had been known, said the *Courrier du Havre,* to have fatal results. A florilegium of this kind could be continued, but at the expense of proportion. Delacroix insisted always that an artist should be sufficiently of his time to use means which were known to it; he was in his example a romantic artist, with all the sensationalism of lust, extravagance, and death which this phrase calls to mind. It is thus the more remarkable that in precept, and in his letters and journal, he should have honored the great classical tradition of France; and that while other romantic leaders died violently or fell into some dismal routine of abandon, Delacroix remained by his own fireside and read aloud from *Athalie* to his old servant.

Frenchmen are naturally of a deductive and aphoristic turn, and love to reduce all knowledge to a set of maxims. Delacroix had his full share of this trait. "Whether it be a virtue or a shortcoming of the French nation," he said, "we cannot help bringing our intelligence into play." His intellectual history is of the first interest to all who care for that classical tradition which remains, as Gide once said, "a school of design for Europe and the world entire." It is a history of progress from particular to universal tenets. All young writers and artists feel that they and their friends, by their very existence, are filled with a kind of innocent power; this is typified for instance in the lines of Charles Cros:

> Paul Fort, Vildrac, Ponchon, Derême,
> Quel joli bruit font ces noms-là!

Delacroix as a young man had feelings of this kind. He enjoyed his friends and liked to dazzle them by wearing suits of English cut; all things, from eating ices to bawling out an ensemble from *Figaro,* were best enjoyed in company. As a good romantic, he made almost a fetish of impulse; "reasonable painting is not for me," he would cry. Yet even at twenty Horace was one of his favorite poets, and it is in the steady recession of the romantic ideal that the fascination of his journal lies. It is as if he believed himself to be, as Racine had been, a romantic for his own time, but for all others the very image of the classical idea.

He began, for instance, as a rabid anglophile. Bonington and Copley Fielding were his friends, and from Constable he learned that first principle of color which underlies the dazzling assurance of his tonality. He read a great deal, and had probably a wider and more vivid appreciation of writing than any other great painter. His first self-portrait was in the character of a hero from Scott; he was among the first French enthusiasts for *Vanity Fair;* he translated passages from Addison; above all he revered Shakespeare. He had

seen Kean in London; and the visit ᵢ ₁1828 of an English company to Paris was for him an apotheosis of pleasure. "Othello is readying his killer's knife," he wrote to Victor Hugo, "and the stage policeman is not yet born who can stop him." Though later he felt bound to say that Shakespeare's was not a good example for other writers, he was held to the last by the audacity, the astounding nonchalance, of his execution. There at least was something beyond analysis. England itself was disappointing. He never liked traveling north of Paris; in Brussels even the trees sat awkwardly; in the Rhineland there was too much Gothic and people spoke an expressionless jargon. In England there were admitted compensations. The shops of London were wonderfully fine; church parade was memorable for its *éclat;* and Delacroix, as a true kinsman of Riesener and Oeben, could not but admire the skiff in which he rowed down to Richmond—it was like "a connoisseur's violin." Outside the world of rank and fashion, however, surly and hippophagous goddams glowered at every corner, and among the lower classes there was "something brutish and ferocious that is horrible to see." Even a certain lady, with whom he was much taken, had atrocious rheumatism and could hardly move her arms or legs. He preferred in short to know the race at one remove—to read about Fox rather than to endure at table or in a railway carriage "the uniquely uninvigorating company of these people who do nothing but make money." Corruption alone kept the British constitution going, and as for our literature—he declared in middle life that "the English and the Germans, like all anti-Latin peoples, can have no literature, simply because they have no idea of taste or proportion. The most promising subjects become wearisome in their hands." One had always to count on "the bad taste common to all foreigners." Even Courbet's lurking torsoes, which Delacroix regarded as antipodean to art, had not this capital fault.

It is typical of Delacroix that although he might himself be called an atrocity-painter, he deplored in others the tendency to regard terror as an end in itself. Poe, he thought, went on too long; Monk Lewis had only a feeble talent and did not know how to conserve it. In this, of course, he flouted a grand Romantic canon; but as he grew older he allowed one after another of the great sources of romantic fever silently to run dry. Politically, for instance, he recognized the values of the great world and did not care to see them overthrown; 1830 had been an inspiration, but 1848 was a year "of barricades and false patriotism." Early in 1849 he was shocked to see the Palais-Royal and the Tuileries in use as common playgrounds and "stinking of barrack-room and cheap tobacco." By 1857 he had come even to detest the invention of railways, on the score that they encouraged restlessness among artisans. In society he maintained an inviolable reserve; "he sits wrapped around himself," one observer said, "like the pythons in the zoo." Over the natural vehemence of his character he had achieved an absolute dominion; other romantics would, in fact, have welcomed an occasional outburst on their behalf, but Delacroix did not care to impose his views upon stray acquaintances; only oafs, or persons from Quimper, behaved so. He never tired of recalling the perfection of *tenue* with which Talleyrand had overcome his enemies, and in public he gained in opacity from year to year. In private, however, his judgments became increasingly harsh. Hugo, for instance, had been his friend and associate; yet he

came to regard his work as "the first drafts of a man of talent; he says whatever comes into his head." It is a true symptom of his change of heart that he came to feel more in sympathy with Stendhal than with Victor Hugo; Stendhal at least understood what for Delacroix had become a first principle of the artist's life—the necessity of not saying everything that came into one's head. "How to leave things unsaid is a great art, and one unknown to novices. They have to put in everything." Even Balzac, by this standard, was indicted as a novice. "Genius is nothing more than the gift of what to choose and when to generalize," said Delacroix at the climax of his evolution. In this way, running always before one strong set wind of the heart, an artist might hope to improve to the very end of his life. Titian's *largeur de faire* at the end of his career often seemed to Delacroix the perfection of painting, and he took many notes of those who seemed to him admirable in this way. Turenne, for instance, each of whose campaigns was more audacious than the last; Rachel who, with age, grew ever more ardent, more fiery and more violent; and Gluck, the painters' composer, who broke new ground in his seventh decade.

Delacroix did not think that any very wide general education was necessary to an artist. There were exceptions to this, but in general three attributes of a great painter were in themselves sufficient occupation for a lifetime—"the exactitude of his eye, the sureness of his hand, and the ability to carry a painting through from sketch to completion." He himself had none of these in the highest degree. His eye was rarely quite true; his hand had never the final assurance of the greatest masters; and although he could admirably enumerate the stages by which a picture was brought to perfection, his example fell always far short of his precept. In the National Gallery last year a sketch for his *Sardanapalus* held its own among many great French pictures of the nineteenth century; the finished picture could not have done the same. In his sketches he caught something of Rubens' sense of grand design; even to read his notes upon Rubens would set his mind on fire for work. "I love him for being so emphatic," he once cried, "I love his way of pushing beyond the limit, in his forms, and then suddenly letting them go." Even the hippopotamus ("a shapeless brute that cannot be made bearable in paint") could in Rubens' hands become the center of a heroic composition. The quality of finish in technique interested him so much that even Meissonier seemed to him admirable in this sense. He thought endlessly about it; he noted that in his favorite Rossini "the Italian in him gets the upper hand—ornament gets the better of expression, in other words;" and his great love of the theater suggested at one time that the practice of Talma or the Malibran might offer some fruitful analogy. It was the element of improvisation which finally defeated him; he could recognize it in others (the unbelievable nonchalance of Shakespeare was always in his mind), but in the grand scenes which he set himself to attempt he could never catch anything approaching it. His notebooks are full of sketches in a most delightfully easy, almost vernacular style; cats, flowers, Algerian landscapes, and creatures of myth—he never paused, and one can readily believe that on his rare excursions into the world he would spend the evening happily drawing. Yet in his huge public pieces he had not that sense of inevitable design which is the mark of the great decorative artist; nothing, one senses, was ever quite as he intended. From 1835 until his death in 1863 he was largely occupied with

enormous decorative schemes; the Chambre des Députés, the Luxembourg, the Galerie d'Apollon at the Louvre, and finally Saint-Sulpice. Delacroix was a fastidious man, and had kept his studio always at equatorial heat; his habits of work when young were spasmodic. It is thus the more remarkable that in middle age, when he was already seriously ill, he should have got up every morning at half-past five, traveled to Paris by the first of the antiquated puffers which plied between there and Champrosay, and worked through the hours of daylight at Saint-Sulpice. An observer remarks that his inspiration seemed never to flag; and if he felt the need of diversion, he would take up a guitar and play a few tunes—some of those, perhaps, which he had heard in Andalusia; he had always liked the jota and the seguidilla better than the "insipid polka." The conditions were far from ideal; he was ill paid, no adequate provision was made for the eventual display of the work, and in some cases the fabric of the building was so unsuited to decoration that cracks and fissures appeared even while he was working upon it. Yet even upon the *jour de l'an* he refused to take an hour's holiday: two years before his death he wrote to George Sand that "nothing gives me so much pleasure as painting—and, besides, it makes me feel as strong and as well as a man half my age." This passion for decoration sprang in part from his essentially literary turn; in the ceiling of the Palais Bourbon, for instance, he could perpetuate that Stoical view of life which he believed to be just; Pliny is shown engulfed by Vesuvius, Seneca kills himself at the will of a tyrant, St. John the Baptist is beheaded, and the fair land of Italy is overrun by Attila. But one may suspect from a note made in 1847 that Delacroix turned to decoration in the hope of overcoming inhibitions which would always thwart him as an easel-painter. "Unlike Titian, for instance," he wrote, "Veronese does not come on as if his every painting had to be a masterpiece. The knack of not *doing too much,* every place, and that apparent disregard for detail that makes the work look so simple and straightforward— all that comes from having done so many *decorations.*"

Delacroix was by two years a man of the eighteenth century, and he came of solid agnostic and revolutionary stock. It was therefore natural that he should always have been tormented by the desire to formulate some binding moral law. Even the memory of his childhood was colored by this; "I can well remember," he said to Baudelaire, "that as a child, I was a *monster.* A sense of duty is not easily acquired; it is only by suffering, punishment and the progressive exercise of reason that man can slowly diminish his natural tendency to wickedness." The first pages of his journal, written at the age of twenty-four, are full of such reflections as this: "all bodily passions are vile, but those of the soul are veritable cancers." At this period he longed to believe; the idea of chance as the prime governor of human affairs was repulsive to him. Delacroix loved the stretch and rebound of intense mental activity, and was in many ways in advance of his time. (He anticipated Sickert, for instance, in his habit of sketching from photographs.) But just as in painting he had launched himself backwards in order to take over the heroic and ornamental mode of Rubens, so in morality he sought to graft on to the orderly tradition of France the severe and discouraging decrees of Seneca and Marcus Aurelius. The "baroque idea of progress" appeared to him delusory. "No matter what people say," he wrote in 1850, "it's chance that rules in our affairs." Submission to

natural law was the final lesson of all experience. For all this he was delighted by any organized attempt to raise the quality of human life; the sight of nuns in an omnibus, for instance, would put him in good spirits for the rest of the day. Age, too, brought many consolations. He was over fifty before he saw swans in flight; a magnolia tree in flower, or a maytime concert of birds seemed to him in his fifty-third year the greatest of human pleasures. He took to staying at Dieppe, where he could hear arias from *Orfeo*, pick mussels at low tide, or watch a regiment of soliders parading on the waterfront; Touraine in November never disappointed him—"the countryside, all striped with rubies, emeralds, and topaz, is at its most sumptuous now that the year is bidding us good-bye." He never married; when he was young, a wife of his own caliber seemed to him the greatest of blessings, but he does not seem on the whole to have been well equipped to find one. In middle life a brief and calamitous fugue to the Low Countries disabused him forever of any passionate attachment. He often quoted some passages from *La Chartreuse de Parme,* when speaking of the influence of women, but it is rather in *Armance* that the clue to his own experience may be found.

Delacroix was never entirely well, and he took extravagant precautions to maintain himself in health. One summer at Augerville a curious fellow-guest was startled to find in Delacroix's room innumerable sets of waistcoats, caps, and scarves, each numbered and corresponding to possible changes of temperature. He never knew how to reconcile his passion for cigars with their appalling effect upon the system; this problem so occupied him that he would discuss it with strangers in trains and pursue it, trusting to Balzac's mania for instruction, into the darkest corners of *Les Paysans.* At one stage green-tea cigarettes were specially ordered from St. Petersburg. Wellington and Turenne, he noted, had lived to a great age in spite of their invalidism when young; for himself he prescribed a diet as strict as that of Voltaire. Even the nervous effort of talking to a deaf woman would set him off on a bronchial cold. All this does not seem to add up to a happy way of life; yet Delacroix accepted gladly the final loneliness of the not wholly successful artist, and the last entries in his journal are those of a man enjoying the full resources of an exceptionally active and noble mind. In public, moreover, the extreme beauty and distinction of his presence served to impress upon many young men and women the possibilities of human dignity. In reading, for instance, the account of Odilon Redon one is reminded of the impression left upon Macaulay by a meeting at Holland House with Talleyrand. At an official ball in 1859, Redon saw Delacroix; "he was as beautiful as a tiger—the same pride, the same finesse, the same strength. Fine-boned and aristocratic, he stood straight upright and alone, in front of a group of women who were sitting in the ballroom." As the young men approached, Delacroix turned upon them with "that look through half-closed eyes that was his alone, and more alight and alive than any chandelier." He left early; they followed at a discreet distance, and were surprised to find that for hours he walked alone in the streets of Paris. He who had always detested "the Schuberts, the dreamers, the Chateaubriand" could always enjoy in his own thoughts what he had never been quite able to sustain in his work—the inexhaustible beauties of the great classical tradition of France.

# From Aksakov to Chaliapin

### The Times Literary Supplement, 1959

*The country house called Abramtsevo, on the road from Moscow to the churches of Zagorsk, is not often visited by foreigners. Yet it has a twofold magic—as the former home both of Konstantin Sergeyevich Aksakov, one of the greatest of European autobiographers, and later of Savva Mamontov, the patron who brought Russian opera, Russian painting, and the Russian decorative arts to a new level of sensitivity. "No Mamontov, no Chaliapin" is not an empty phrase.*

"In Aksakov," D. S. Mirsky wrote in 1924, "Russian literature has gained a new and decisive victory over the English reader." This victory has not been consolidated. Alphabetically speaking, Aksakov has still the primacy which Dobrolyubov ascribed to him after the publication, in 1856, of the complete *Family Chronicle;* but in terms of range, and influence, and enduring stature most people would put him well below the big men whose work, thanks to the Maudes, Mrs. Garnett, and Mr. Magarshack, is now as much a part of English as of Russian literature.

And yet Aksakov has also his translator. The version published in 1915 by J. D. Duff has much of the translucency, the incomparable *naturel* which Russian scholars discern in the original. Page after page of *A Russian Gentleman* (Duff's title for Part 1 of *A Family Chronicle*) calls to mind Maurice Baring's judgment that

> no more perfect piece of prose writing exists.... One is spellbound by the charm, the dignity, the good nature, the gentle, easy accent of the speaker, in whom one feels convinced not only that there was nothing common nor mean, but to whom nothing was common or mean, who was a gentleman by character as well as by lineage, one of God's as well as one of Russia's nobility.

If not everyone has descried in Aksakov one of the major delights of a literary lifetime, it is partly because his books are not easily come by. As to this, the centenary year—his dates are 1791–1859—would have seemed the moment to set matters to rights; but there are other difficulties. His subject matter, for instance: Aksakov is taken by those who have not read him to be a kind of rustic memorialist—the father-founder, what is more, of those "sensitive evocations of childhood" which bulk so deplorably large in recent English literature. The notion has got about, in short, that Aksakov's *oeuvre* consists of an endless Mahlerian *adagio*, a parade of country sights and sounds such as has been mounted as well and more briefly by many an English writer.

These are illusions. Adult passions run as high, in *A Russian Gentleman*, as in any of the great Russian novels of the 1860s and 1870s. The attempted abduction of Natasha in *War and Peace* has few equals in fiction for narrative power and intensity of feeling; but one of them is Aksakov's account of the

marriage of Mihail Maximovitch Kurolyessov. Turgeniev is our touchstone, where delicacy of feeling is concerned; but nothing in Turgeniev is superior, in this respect, to the wooing of Sofya Nikolaevna in *A Russian Gentleman*. And if it is the privilege of literature to set before us recurrent human types to whom we should not otherwise be able to set a name—why, then, Stepan Mihailovitch Bagrov must rank with Penelope, and Electra, and Falstaff, and Alceste in *Le Misanthrope,* and Natasha herself as one of the definitive creations of European literature.

Creative, in the strict sense, he was not, of course: Aksakov is an autobiographer, not a novelist, and "old Bagrov" was the name that he gave to his own grandfather. But *A Russian Gentleman* ends with Stepan Mihailovitch leaping out of bed in the late afternoon to add to the family tree the name of a newborn child, his grandson Serghei. That same Serghei began his memoirs as a man of forty-nine; there must, therefore, in his account, have been an element, if not of invention, at any rate of imaginative arrangement.

Much in Aksakov is on an epic scale, in respect alike of the events described—the migrations, the patriarchal social structures, the creation from its first beginnings of a complete new society—and of their Eden-like environment. Aksakov wrote of what is now the Bashkirian Republic, and a month or two ago a statue of him was unveiled in Pushkin Square, Ufa; but in the period he describes Bashkiria was unsubdued and its people, nourished by the redoubtable *koumiss* (mare's milk fermented in bags of horsehide), inhabited "an earthly paradise, then still called the Province of Ufa." Aksakov's account of this countryside should be read entire, for no extract can give any idea of its cumulative effect. The particularity of his style lies, indeed, in the perfect regularity of its tread. Yet it is not a regularity which courts monotony; on the contrary: such is the crystalline character of the narrative that we are borne forward without effort, as if in a dream. Almost never does Aksakov employ a metaphor or an unexpected turn of speech: all is transparency. The simplest of words, and the most exact: such are his instruments, and he works in intimacy with his subject, never obtruding himself, rarely proffering a comment.

To Maurice Baring, writing in 1914, it seemed that "the story of Aksakov's grandfather might be the story of any country gentleman, in any country, at any epoch." But we ourselves prize it for quite a different reason. We find in it a kind of Russian life which, if not quite extinct, is inaccessible to western visitors; and, almost more precious, a kind of Russian character which, in international negotiations at any rate, is not now much to the fore. Human characteristics so deeply rooted, so elemental in their range and force, cannot be driven underground forever: that is one of the things in Aksakov from which we may draw comfort. And the day may come when the river marges of Bashkiria will be open to those who remember how Aksakov describes them:

> The river was so transparent that, if you threw in a copper coin, you could see it resting on the bottom even in pools fifteen feet deep. In some places there was a thick border of trees and bushes—birches, poplars, service-trees, guelder roses, and bird-cherries, where the hopbines trailed their green festoons and hung their straw-coloured clusters from tree to tree. In other places the grass grew tall and strong, with an infinite profusion of flowers,

including tall meadowsweet, lords' pride [the scarlet lychnis], kings' curls [the martagon lily], and cat-grass or valerian.

Aksakov excelled in the poetic recreation of country sports—fishing for perch with crayfish-tails, setting a hawk to catch a quail, or watching Philip, the old falconer, bring down a mallard. And he brings to all this a golden equanimity (Mirsky called it "a beautiful Russian purity and an air of distinction and unaffected grace") which makes us loath to take leave of the Bashkiria of a hundred and fifty years ago. Intourist may yet put that province on its list; but he would be a fortunate visitor who was entertained to a meal such as Aksakov describes:

> Cold dishes came first—smoked hams seasoned with garlic; next came green cabbage soup and crayfish soup, with forcemeat balls and rolls of different kinds; then fish-salad on ice, sturgeon kippered and sturgeon dried, and a dish heaped mountain-high with crayfish-tails. Of entrées there were only two: salted quails *aux choux,* and stuffed ducks with a red sauce containing raisins, plums, peaches, and apricots. These were a concession to modern fashion: Stepan Mihailovitch did not like them and called them "kickshaws." They were followed by a turkey of enormous size and fatness, and a hind-quarter of veal; the accessories were preserved melons and gourds, apple chips, and pickled mushrooms. The dinner ended with round jam-tarts and raised apple-pies served with thick cream. All this was washed down with home-made liquors, home-brewed March beer, iced *kvass,* and foaming mead.

It was in 1840, and at Gogol's suggestion, that Aksakov began to write his memoirs. Natural as it would be to imagine him pacing in middle life the scenes of his first youth, and drawing forth from those whose memories went back to the eighteenth century the substance of his seamless narrative, the truth is quite otherwise. All his books were written in or near Moscow—either at the town-house, 30, Sivtsev Vrazhek, where a memorial plaque was unveiled in May of this year, or at the manor house of Abramtsevo, several rooms of which have been preserved as an Aksakov Museum. It was, therefore, at a distance of 700 miles and forty or fifty years that he re-created with such hallucinatory clarity the life and the landscape of Aksakovo and Nadezhino; all the evidence points to his not having returned to Bashkiria during the nineteen years that he devoted, off and on, to his memoirs.

Nor is this the only surprising aspect of his literary career. Aksakov was, by any standards, a late starter. He was forty-eight when his first book appeared; and *Notes on Angling* gave no indication of the gifts which were to make him famous. Nor can Turgeniev, favorably as he wrote of its successor, *Notes on Shooting in the Orenburg Country,* have detected in Aksakov, his senior by almost thirty years, a storyteller of his own caliber. Yet Aksakov did not live in an unlettered society, but rather in one over-saturated with writing and talk of writing. He himself had, moreover, that form of hyperexcitability which is, if anything, a hindrance to creative work, so completely does it absorb its possessor's energies. As a very small boy, he tells us, when Rhine wine and Buchan's "Domestic Medicine" had between them revived him after a serious illness, he would lie all day in a receptive swoon on bedding laid out for him "in the high grass of a forest ride, under the shade of the trees"; as a student, he reacted to tenth-rate plays and operas like *The Sausage-Makers* much as more

fortunate young people react to *Phèdre* or *Don Giovanni;* and even in middle age he had a way of expressing admiration so immoderate that the objects of it shrank back in embarrassment.

The more remarkable, therefore, is the perfected equilibrium which is one of Aksakov's master qualities as a writer. Aksakov in middle life, the father of fourteen children and the husband of a woman of commanding intelligence, had still a youth's responses to the people he admired; he never demurred, for instance, when Gogol flicked bread pellets at table. But once he was in his green-papered study, with its gold-framed family portraits, its bust of Gogol, and its long low green-upholstered sofa, quite other traits predominated; and when he turned to write (or, in the last years, to dictate to his daughter) no further *écarts* were permitted, in himself or in others. Everything, from the pettiest moves in a provincial intrigue to rages more dreadful than Lear's, was under absolute control.

The visitor who today turns off the main road from Moscow to Zagorsk at a point some forty miles northeast of the capital will, as it were, "pick up" Aksakov from the moment he drives into the prettily landscaped estate. This is miniature country, with streams, spinneys, plunging rides, and bird-loud islets all measured exactly to the taste of an ailing landowner who delighted in country pursuits. Small wonder that landscape painters may be seen squatting in echelon before the approved motifs, or that visitors to Abramtsevo number more than 70,000 a year. The house, likewise, has a rusticated dignity, an amplitude of veranda, a smell of beeswax and clean linen, and, as one light and elegant room opens into another, an intimacy of scale which explains why Chekhov, when Stanislavsky was planning the first production of *The Cherry Orchard,* should have said "Make it something like Abramtsevo." On a fine Sunday in summer a hallooing of young voices, a distant strain of concertina-music and, almost, the famous sound of "a breaking string" are quintessentially Chekhovian.

Not everything at Abramtsevo relates to Aksakov. Already on arrival certain features of the estate betoken a later stage in Russian self-awareness; for, although Aksakov was a confirmed Slavophile and believed passionately in the regenerative power of all that was truly old Russian, it would not have occurred to him to purchase the North Russian idol, a standing figure as mysterious as anything on Easter Island, which now lurks at the entrance to one forest walk. Nor, perhaps, would he have erected the "Baba Yaga's hut" which does duty as a summer-house, or the private chapel, so clearly the fruit of a sophisticated revivalism, which gleams white and gold in the middle distance. All these date from the time, some thirty years after Aksakov's death, when Abramtsevo was the property of Mamontov, the railway millionaire to whom Russia owes, in large degree, the existence of Russian opera and Russian art as they were later revealed to western Europe. It is, indeed, one of the most curious accidents of Russian history that the unpretentious estate where Gogol read from the second part of *Dead Souls,* and Aksakov planned his memoirs as he stood, rod in hand, by the amiable stream, should also have resounded to the galvanic enthusiasm of Mamontov. When the visitor tires of prospecting for the exact spot in the garden where Gogol was stung on the nose by a bee, he will find that the look of the house in Mamontov's time has been

preserved in every detail.

Delightful as it is to pore over the autographed tablecloths, the stove with majolica tiles designed by Vrubel, the photographs of Chaliapin, Rachmaninov, Mussorgsky, Rimsky-Korsakov, and Dargomijsky, and the rapid affectionate studies of Abramtsevo by Vasnetsov, Repin, Polenov, and Serov, there is no denying that we miss the memorialist who, above all others, could have taken Abramtsevo in the 1880s and 90s and preserved it as exactly as he preserved the Bashkiria of a hundred years earlier. And to Aksakov, likewise, the life of the house would have seemed an apotheosis beyond all imagination. For when we seek out in the Bakrushin Theatre Museum the actors and playwrights and singers and composers with whom Aksakov twittered away his twenties in Moscow we cannot find one who has commended himself to posterity. Whereas in Mamontov's day—but here let Stanislavsky speak:

> But for Mamontov we should never have heard Chaliapin. Without Mamontov and Chaliapin, we should never have known Mussorgsky; nor should we have known the best works of Rimsky-Korsakov, for *Snow Maiden, Sadko, Tsar Saltan* and *Coq d'Or* were written for Mamontov. We should never have seen the canvases of Vasnetsov, Polenov, Serov and Korovin who, like Repin, Antakolsky and all the other great artists of the day may be said to have grown up in Mamontov's house....

In Mamontov himself, with his massive, disgarnished brow and capacity for doing a dozen things to perfection at one and the same time, Aksakov would have found a subject as rewarding as his own Stepan Mihailovitch. Already in his *History of My Acquaintance with Gogol* we glimpse the masterpiece that might, with some assistance from the time machine, have been forthcoming. When we remember the effect on Aksakov, in early Ufa days, of some of the most arrant rubbish ever mounted on the boards, we can picture his excitement at the creation, within his own four walls, of a whole series of enduring works of theatrical art. As we stand by the two pencil-thin birches that guard the family graves in the forest, we dream of a *Selected Aksakov* in English, with the Gogol essay, and a choice of pieces from the *Literary and Theatrical Reminiscences,* to complete the work that J. D. Duff so ably began.

# Henry James Comes Down From the Ivory Tower

**The New Statesman and Nation, 1943**

Some of the unpublished letters of Henry James to Edward Warren illumine that last period of his life in which, physical torment notwithstanding, he plunged entirely into work for the Allies. There is a special fitness in this, for Edward Warren was James's architect as well as his old and intimate friend; he had stood sponsor to James's love for England, and for fifteen years of mounting contentment James had lived at Rye in a house which, though built two centuries before, was now ordered from cellar to eaves by Warren.

The war years were not the crown of Henry James's career, though certainly there is something fine in the last energies of the old man who formed a *point de rallye* for both England and France. The occasional piece called "France" for instance, has never been bettered in its affirmation that "what happens to France happens to all that part of ourselves which we are most proud and most finely advised to enlarge and cultivate and consecrate." Yet war is apt to give a spurious sense of identity with one's fellows, and it was on balance a loss that so scrupulous and watchful a mind should have ceased to ring with enquiry, becoming instead

<div style="text-align:center">

a civitas of sound
Where nothing but assent was found.

</div>

James lived most of his wartime life in a block of flats in Cheyne Walk; though a tall and uncomely pile, not readily distinguishable from an orphanage or house of correction, this appeared to suit him very well. He had been ill, and found the "large area and conversational resources of London...a precious, in fact quite a remedial, resource; and though I have but a couple of ample rooms straight on the river, which I pay for by a much dimmer rearward residuum, such a fine scrap of front...very decently suffices and makes me more than content." This was in 1913; he could "ventilate and circulate" each afternoon, with the assurance of finding "here and there a blest old friend at home about 5.30"; but he remained an invalid, "regularly subject to such aggravations of pain toward the real close of day as to have to tear off my clothes for very anguish and tumble into bed by 8 o'clock."

At the outbreak of war he found himself entirely in line with the public. This was a new and intoxicating situation for him. He had not drawn directly upon political life or international affairs for some thirty years—not, in fact, since the revolutionaries and class warfare of *The Princess Casamassima;* but he had been a close friend of Paul Bourget, who in 1885 had defined the mandate of the nineteenth-century mammoth—"the process of art is simply a sign of the history of moral life. The book is the great initiator." This leadership

had always been denied to James, although there are few human problems which do not sit whole among his pages; but now he longed to share the general sense of what was at stake in the struggle. His fine appraisal of the way of life which was imperiled made him, as public orator, the nonpareil. It was as if some old fire-ship, long silted up in the Cinque Port of his beloved Rye, were now suddenly set alight, to burn to the waterline as it sailed against the enemy.

On September 18th, 1914, he wrote to Warren, "Your kindest of letters has come to me, breaking the silence with which we have had all to be stricken dumb since the great Nightmare began. Its effect has been infinitely to hush *me* at least from mere vain words." He could not remain inactive, and soon came up to London: "I find I can't stand, amid this awful tension, and not less this horrible 'immeasurable interest,' the too solitudinous and 'out of it' life of the country any longer. I must be where I can hear and ask and have informational contacts; I eat my heart out alone... You have all my sympathy in your loss of young relations (one lives with a wrung heart) and your vision of the genial recruits etc. of your countryside. I find the vision of them—with whatever black shadows on it—unspeakably uplifting and thrilling. All through this shining heartless summer here I looked out at Rye across the transparent air and exquisite blue Channel at the very edge of the horizon on just the other curve of which the Belgian infamies and abominations were going on; and the helpless ache and rage of the scale of them were at times more than I could bear." This letter is written on dead-white paper, which James rarely used, and with his habitual black ink; the effect of the thick and tufted vertical strokes in his handwriting is like that of funeral plumage.

He was always inhibited by what he called his "failure of consanguinity"; and in his progress toward naturalization he may well have remembered the example of Zola who had given himself, as was his right, as a sacrifice to the Republic. He had admired Zola's work, and said of its cyclic conception that "no finer act of courage and confidence" had been recorded in the history of letters. Re-meeting him in 1893, he had felt in him a man "with arrears of personal history to make up"; and although Zola was by temperament a retiring, even a timid, man, he had exalted the position of the writer in society. No lover of France could but be agitated by her condition in 1898: "I can't even *spell* Dreyfus now," James wrote to Warren. He had had high hopes of the Republic: "Parliamentary government is really being put to the test, and bearing it well," he wrote to Grace Norton in 1877; but that a writer should come forward at the crisis was a surprise. He had known the great Frenchmen, Flaubert, Daudet, France, Zola himself, and the little ones, Meilhac, Sarcey, Coppée; and in 1889 he told William James that they were "finished, besotted mandarins, and their Paris is their celestial empire." Yet now a writer had outsoared the soldiers and the statesmen and the priests; James wrote to Warren in February, 1898, "Heavens, yes, the whole Paris business sickens and appals me—and I worked off a part of my feeling yesterday by writing to Zola. He won't, I think, however, go to prison. He will appeal, and there will be delays, and things will happen—elections and revulsions and *con*vulsions, and other things. As it was, I think, I fully believe, his sentence on Wednesday saved his life. If he had got less, or acquittal, or attenuation, he would have been *torn limb from limb* by the howling mob in the street."

In 1899 he returned to France; he loved the vernacular life of this country, and his *Little Tour in France* can always be reread. But on this visit the Virgilian beauties of the country round Hyères seemed to him to contrast sharply with the condition of Paris; and even in the south of France he found something to criticize in the tokens of contemporary life. "Wondrous are the resources of this people," he wrote, "but (let us bear up!) hideous—apparently, mainly—their villas *as* villas. On many questions of taste—!" In a letter from the capital he recorded a more serious shock; "the extraordinary Paris, with its new—I mean more and more multiplied—manifestations of luxurious and extravagant extension and general chronic *expositionism* is a spectacle it would be interesting to assist at with you in some detail; awfully curious in its way. It strikes me as a monstrous massive flower of national decadence, the biggest temple ever built to material joys and the lust of the eyes, and drawing to it thereby all the forces of the nation as to a substitute for other—I mean other than Parisian—achievement. It's a strange great phenomenon, with a deal of beauty still in its great expensive symmetries and perspectives—and *such* a beauty of light."

This decadence in what had seemed to him the finest style of life could have been the moral subject of his last years of work; and in the serious comedy of *The Ivory Tower* there are signs that he was working toward it; but with the outbreak of war he turned to a short-run siege-morality. This was a human choice; and while one may regret the loss of an incomparable guide, one must agree with Virginia Woolf that "perhaps no other elderly man existed in August, 1914, so well qualified to feel imaginatively all that the outbreak of war meant."

He was passionately proud of England, and prostrated by "the destruction of her magnificent young manhood. Nothing abates that; it's a black dead loss and woe—it makes me howl and almost collapse." Yet he remained a moral barometer of rare precision, and felt deeply any falling-off from this high example; and when in March 1915, he accompanied the Warrens to the theater he found it "an ordeal of painful sharpness. The mere inside of a theater at present represents a terribly false note to me, haunted as one is with horrors, and with the one ideal of concentration; and the sight of the so large contingent of the portentously *bête* public cost me the keenest anguish. I feel, moreover, that this country (*with* which I so unutterably feel!) is now, or awfully ought to be, *in all ways* on her good behaviour before the world; and the ineptitude and wretchedness of its kind of that exhibition made me ask myself terrible questions. *Any* complacent display of hopeless amateurishness becomes in these conditions, to my imagination, a *general* dreadful portent." This note of foreboding does not recur; and on August 18th, 1915, he wrote of his naturalization: "It *was* strange that at the end of all the fond years here I should still have been aware of anything further to attest; but my old attachment was chronic and the acuteness of the public situation made me somehow want to do something also in the key of acuteness. In short it had become anguish to hold off any longer from translating my participation and adhesion into the only terms that really would mean something; and now that it is done the sense of a false position corrected passes expression." Yet it is possible to see this personal easement as a public misfortune; for until then he had accepted the

lonely station of the artist and had persisted, as few writers can, in breaking new ground after his seventieth year; and while we must rejoice in the acquisition of so great a champion of our cause, there is also room for agreement with Edmund Wilson when he says that Henry James "in writing *The Ivory Tower* had been much closer to contemporary realities than in becoming an English citizen."

# Meyerhold Redux

Meyerhold the Director, *by Konstantin Rudnitsky, translated by George Petrov, edited by Sydney Schultze. Ardis.* Meyerhold at Work, *edited by Paul Schmidt, Ilya Levin, and Vern McGee. University of Texas Press*

### The New York Review of Books, 1982

*For the first thirty years of this century Vsevolod Meyerhold had his great beaked nose into just about everything that mattered in the Russian theater. He was the first Konstantian in Chekhov's* The Sea Gull. *He directed Lermontov's* Masquerade *in a form that held the stage from 1917 till 1941. After the revolution he was hugely courted, and no less hugely attacked, and much that now passes as modern was invented by him.*

To those who, like myself, were in and out of many Soviet theaters in the late 1950s and early 1960s, nothing could have seemed less likely than that as early as 1969 there would appear a monumental book on Vsevolod Meyerhold, drawn entirely from Soviet sources and written by a distinguished Soviet historian of the theater. It was taken for granted at that time that Meyerhold was a martyr, as he had once been the hero, of Soviet theater, and that his name had been struck from the record forever.

Yet here in English translation is a book that weighs four and a half pounds, measures in all some 200 cubic inches, has 200 illustrations (most of

them unfamiliar), and discusses even productions that Meyerhold himself thought too ephemeral to bear recording. Konstantin Rudnitsky was only nineteen when Meyerhold was shot in a Moscow prison in 1940 after a trial in which he was accused among other things of spying for Japan. He cannot write, therefore, as a participant, but what he has to say carries conviction from start to finish. He has filled well over five hundred crowded pages with a vast amount of firsthand contemporary material. Productions that hardly anyone now living ever saw are brought to life. Authors, actors, actresses, stage designers, composers are fully characterized. So are the officials—whether pre- or post-revolutionary—with whom Meyerhold had to deal. His forty-year professional career is spelled out for us in close detail. If little is said of his private life, and nothing whatever either of his violent death or of the hideous and never-explained murder of his wife—well, doubtless there are limits to what can be expected of an authorized Soviet publication. Besides, the title of Konstantin Rudnitsky's book is not *Meyerhold: A Biography.* It is *Meyerhold the Director.*

As such, it could not be more topical. We now have a new generation of playgoers who might well not remember that the theater once belonged to actors and actresses. They were the consecrated monsters whose names drew a full house, no matter how flimsy the play or how paltry the production. Not to have seen David Garrick, Edmund Kean, Sarah Siddons, Frédéric Lemaître, Henry Irving, Sarah Bernhardt, or Eleonora Duse was to have missed great artistic work, and to be that much less of a human being.

Ours is by contrast the day of the director. It was for Walter Felsenstein, and not for any of his singers, that people from West Berlin filed through Checkpoint Charlie to the Komische Oper in the 1950s. It was for Grotowski, and not for any individual performer, that Polish theater got a great name in the 1960s. People scouring the French provinces today for what is strongest and most original in French theater seek out Roger Planchon, and not any member of his troupe. It is for Peter Brook, and at his sole whim, that people beat one another over the head with umbrellas in order to get into the dreariest and most uncomfortable theater in Paris. As much as anyone else, André Serban, for all his vagaries, gave new life to the theater in New York in the 1970s. For better or worse, Bayreuth for several recent seasons belonged almost as much to a young French director, Patrice Chéreau, as it did to Wagner. Ariane Mnouchkine in Paris, Sarah Caldwell in Boston, and Susan Sontag in the hinterlands of Italy caused hardly less of a stir.

This development has a complicated and a multinational family tree, but no matter where we part the branches of that tree we shall come upon the lanky, angular, huge-nosed, and disjointed figure of Vsevolod Emilievich Meyerhold.

Meyerhold was born in a sad little town some way to the southeast of Moscow in January 1874. (His parents on both sides were German, by the way. He had no Russian blood, wholeheartedly as he came to identify himself with Russia.) As a law student in Moscow he made no mark, but when he turned into a drama student, an actor, and a director there was never any doubt of his supreme abilities. From the moment that he entered the Moscow Art Theater in 1898 until the day of his death in 1940 he was the most inventive, the most provocative, and the most controversial figure in the Russian theater.

He had of course a great senior in Konstantin Stanislavsky. Stanislavsky made him welcome in the Moscow Art Theater, directed him in the premieres of *The Sea Gull* and *Three Sisters,* invited him to take part in his experimental theater-studio in 1904–1905. When Meyerhold felt it necessary to strike out on his own, Stanislavsky took it well. When Meyerhold felt it necessary to attack Stanislavsky's theater in public, he still spoke of Stanislavsky himself as "our beloved master" and as "a *maître des grands spectacles,* with the theatrical range of a Michelangelo." And when Meyerhold was in deep trouble in 1938, with his theater shut down by the police and every door closed against him, Stanislavsky saved him for the time being by offering him a job as his assistant.

We could say of Stanislavsky and Meyerhold that each saw in the other the necessary alternative without which the art that they both served would have lost its equilibrium. What Poussin was to Rubens, what Ingres was to Delacroix, what Brahms was to Wagner, and what Turgeniev was to Dostoevsky, Stanislavsky was to Meyerhold. For forty years the supposed polarization between them was fundamental to the development of the Russian theater.

But in their posthumous reputations there was until lately no parity whatever. The theater that Stanislavsky and Nemirovich-Danchenko founded in 1898 still continues, with much of its repertory intact and its tradition by no means obliterated. Stanislavsky never fell out of favor with the Soviet authorities, and there have long been directors the world over who feel—with however scant a justification—that they are doing what he would have done.

After Meyerhold's death, on the other hand, it was as if he had never been. It was not enough that he was done to death in a Soviet prison, and that his wife was foully murdered—most probably, as it now seems, by agents of the police. All trace of his long activity was obliterated. The new theater that was being built for him was remodeled and turned into a concert hall. In these acts of extermination, no detail was too tiny to escape notice. In his *Moscow Rehearsals,* first published in 1936, Norris Houghton gave us an authoritative account of Meyerhold's methods in the last years of his life. But when Mr. Houghton revisited Moscow some twenty-five years later and asked to see the copy of his book in the Lenin Library he found that every reference to Meyerhold had been cut out with very sharp scissors.

For this reason there was for many years an evident disparity between our knowledge of Stanislavsky and our knowledge of Meyerhold. The unity of tone, the perfection of nuance, the self-evident rightness and naturalness that were the mark of the Moscow Art Theater at its best were easy to enjoy, even if they were anything but easy to duplicate. In Stanislavsky's work there was a consistency that would have made it relatively accessible even if he himself had not been at such pains to explain it. Meyerhold was quite another matter.

Meyerhold was the complete professional, and he was never the same, year by year, month by month, or week by week. There was virtually nothing that he could not do in the theater. He knew exactly what he wanted, and exactly how to get it. He had an extraordinary and distinctive speaking voice. He was a prodigious mime. He knew how to set the stage, how to light it, how to make silence seem louder than speech, how to enroll the best painters of the day as equal partners, and how to make color work for him as it had never worked in

the theater before. He re-invented himself, throughout his life, in such a way that there is no one production by which he can be judged.

He could adapt, moreover. When it was necessary for him to produce twenty-seven different plays in a short time, as he did in the season of 1904–1905 in Tbilisi (then called Tiflis), he went ahead without complaint. If he had unlimited time, as he did at the Alexandrinsky Theater in St. Petersburg before the revolution, he was happy to spend five or six years, on and off, on a single production. Where he himself was concerned, he would risk anything. What other director could have appeared as Pierrot in Michel Fokine's ballet *Carnaval*, under Fokine's own direction, and got away with it? ("He was a man from a different world at the first two rehearsals," Fokine wrote later, "but by the third rehearsal our new mime had matured, and in the performance gave a marvelous image of the melancholy dreamer Pierrot.")

He could deal with difficult actors, too. When he produced Molière's *Dom Juan* at the Alexandrinsky Theater in 1910, he taught the whole company to walk in a new way, with a casual dance rhythm, a melodic walk, and an ease and a lightness that were to permeate the whole production. Not until a late stage in rehearsal did he find that the vital role of Dom Juan's servant, Sgnarelle, was to be played by a popular favorite who was too old to learn his lines and too frail to walk more than a step or two. Undeterred, Meyerhold devised two pretty screens, one on either side of the stage, behind which prompters could tell the great veteran what to say. He rearranged the production in such a way that Sgnarelle's immobility seemed a master-stroke of sly cunning. As for the old man's rare and carefully harbored moments on his feet, Meyerhold directed them in such a way as to cause "such animation in the house"—to quote one observer—"that it seemed like the advent of a holiday."

This was the man who had been a prized friend of Anton Chekhov, had called on Tolstoy, was venerated by Sergei Eisenstein, thought that Pushkin the dramatist was better than Shakespeare, had no praise too high for the art of Buster Keaton, and decided toward the end of his career that what he really believed in was "a simple laconic stage idiom which evokes complex associations." He nurtured his productions with everything from bio-mechanics and Russian Constructivism to the frescoes that Sir Arthur Evans had just uncovered in the Palace of Minos at Knossos. Yet he said in the 1930s that "the idea of a director's theater is absolute nonsense and must not be believed in. There is no director—that is, no *good* director—who would rank his art above the interests of the actor as the chief person in the theater." Decidedly, no one formula will do, where Meyerhold is concerned.

For this reason, studies of Meyerhold were in very poor shape in the 1940s and 1950s. Even when he was drawn into the climate of adulation that marked the Westerner's rediscovery of the Russian avant-garde during the 1960s there was little to go on beyond a handful of prehistoric black and white photographs that grew ever fainter with continual re-use. What was Meyerhold without color, without movement, without speech, without the direct physical contact between actors and audience, and without the astonishment, the outrage, the night-long discussion that had always followed his new productions?

Surviving eyewitnesses were fewer and fewer, memories were ever less reliable, and in Meyerhold's own country the conspiracy of suppression had

done its work all too thoroughly. No copy is known to exist, for instance, of the filmed version of *The Portrait of Dorian Gray*, for which Meyerhold wrote the script in 1915, and in which he played the part of Sir Henry Wotton, while the part of Dorian Gray was played by an actress, Varvara Yanova. Yet there were those who thought it as daring, and as original, as *The Cabinet of Dr. Caligari*, which dates from four years later.

But the name of Meyerhold did not die altogether. It was difficult to write on Mayakovsky and not say how closely he and Meyerhold had collaborated on the production of his plays. Sergei Eisenstein was known to have preserved some of Meyerhold's papers at great risk to himself. In the West there were people who remembered—however faintly—that Abel Gance, the creator of *Napoleon*, had been directed in Paris by Meyerhold in the year 1913 in a particularly appalling play by Gabriele D'Annunzio. Others recalled the evening at the Théâtre de Montparnasse in 1930 when Meyerhold and his company were acclaimed by an audience that included Picasso, Louis Jouvet, Paul Eluard, Charles Dullin, Jean Cocteau, and André Derain. There were even one or two people who knew that if his wife had not been against it Meyerhold would have tried to work in New York as of November 1930, and might conceivably have stayed there.

But fundamentally these were the preoccupations of a dwindling minority. Few people knew, or cared, that what passed for modernity in our Western theaters was an anthology of Meyerholdiana, from the arena stage to the exposed rear wall of the theater, and from the intrusion of the actors into the auditorium to the use of absolutely any enclosed space as a theater. Meyerhold had been everywhere before us, and when Peter Brook put his actors through a course of specially devised physical exercises some remembered the bio-mechanics with which Meyerhold in 1922 had aimed to raise his actors to a new level of physical readiness and adaptability.

In *Novy Mir* in 1961 Alexander Gladkov published his "Meyerhold Speaks," a long series of notes on what Meyerhold had said to him in friendly conversation between 1934 and 1939. One or two of these may indicate the vivacity, the concision, and the freedom from *parti pris* that made people hang on his words:

> An actor's creativity—or for that matter anyone else's—is the act of a clear, happy mind and a healthy unclouded will.

> Observation! Curiosity! Attention! Yesterday I asked several of our young actors what sort of street lamps there were in front of the theater, and none of them gave the right answer. This is awful! When you read the classics you should start by reading those which can teach you to be observant. Gogol in *Dead Souls* is wonderfully observant.

> Read Ibsen's plays carefully, and you will see that there is as much action in them as in an American Western.

> I forget who said that "art is to reality as wine is to grapes," but it's a brilliant remark.

> A light touch adds an electrifying quality to tragedy, to comedy, to kitchen-sink drama, to everything. That is why vaudeville is such great training—a splendid school for comedy, and even for tragedy.

In Pushkin's day the art of the director did not exist, but he brilliantly foresaw it. That is why Pushkin's dramas are the theater of the future.

A director has to specialize more widely than anyone on earth.

Have no respect for the margins of books. A book that I have written in is ten times more valuable to me than a new one.

I think it was Scriabin who said that rhythm was "time bewitched." What a brilliant remark!

It would be difficult to read those remarks and not feel oneself in the presence of a free and independent spirit. The more remarkable, therefore, was the rehabilitation of Meyerhold that got under way in the Soviet Union during the 1960s and culminated in the publication of a two-volume set of his collected writings in 1968 and of Rudnitsky's extensive survey in the following year. In the English language, Edward Braun's *Meyerhold on Theater* appeared in 1969 and is still the best short guide to the subject. With Rudnitsky now translated, and with the recent *Meyerhold at Work*, edited by Paul Schmidt, the English-speaking reader can consider himself in luxury.

After reading what is now available to us in English, we may well decide that on the long roster of creative people who were beaten down by the Soviet regime Vsevolod Meyerhold is the one who most consistently held his own. Where others fell silent, turned to hack work, or were forced into exile, Meyerhold did nothing that he did not want to do. He remade the theater as he thought best, and not as someone else dictated. He made artistic mistakes now and then throughout his long career, but they were the mistakes of a headlong, uncalculating spirit. For forty of the most difficult years in human history he was true to himself alone. As he lived, so he died. "I am sixty-six years old," he said to the court that presumed to "try" him, "and I want my daughter and friends to know some day that I remained an honest communist to the end."

It is legitimate to speculate on what aspects of his career may have passed through his mind when he lay in prison, a carefully chosen victim of the purges, after the obliteration of his theater. He knew about prison, both at first-hand—as a captive of the Whites in southern Russia just after the revolution—and in his imagination. As early as 1905, when he directed Maeterlinck's *Death of Tintagiles* in Tiflis, he said that the queen's castle in the play "represents our prisons, and Tintagiles the youth of mankind.... And someone ruthlessly puts these young people to death....On our island thousands of Tintagiles suffer in prisons...."

Meyerhold never liked to be pinned down. When he had a great official theater at his disposal, he told people that the real life of the theater lay with jugglers and tumblers and the improvisations of the fairground booth. Himself a performer like no other, he was ready to forego all his natural advantages and impose upon his actors (as in Strindberg's *Crime and Crime* in 1912) "an overall metallic coloration and an external frigidity created by an image of concealed emotion coupled with energetic sound." There was no refinement of luxury and subtlety and artificiality that he would not permit himself when the production required it; but he was just as happy with the unisex blue denim overalls and anti-naturalistic scenery that he apotheosized in the 1920s.

Himself the most gifted and influential man of the theater that our

century has produced, he never saw the theater as a closed world sufficient unto itself. He took from music—his production of Tchaikovsky's *Queen of Spades* was dedicated to the pianist V. V. Sofronitsky—and from painting. Not only did he rely on painters—on Golovin, above all—for his sets, but he took from painters in a more general way. "Böcklin landscape and Botticelli poses" was how he summed up one of his productions, and as early as 1911 he seems to have based one of his most hallucinatory stage-pictures on Vincent van Gogh's *The Night Café*.

His career never followed a straight line. Whether or not he agreed with his fellow director Tairov that "propaganda theater after a revolution is like mustard after dinner," he directed the accepted Soviet playwrights as rarely as he could. In his later years he preferred the great classics that can always be re-interpreted. Next to them, he chose plays like Olesha's *A List of Assets* (1931), where he could make the meaning jump every which way and an interpolated scene from *Hamlet* could suggest to the audience a whole treasury of implications. (Even in time of great tribulation, Meyerhold held fast to Shakespeare. When Alexander Gladkov asked him about the show trials of 1937–1938, all he said was "Read and re-read *Macbeth*.")

Meyerhold was under attack all his life. He had more ideas than he could ever put into practice. His work could not come into being at all without the cooperation and the loyalty of other people. It would have been a miracle if he had never boiled over, never changed his mind or heart, and never thought that friend had turned into foe. Konstantin Rudnitsky somewhat plays down this aspect of Meyerhold, and it is one of the virtues of Paul Schmidt's anthology that he quotes at length both from Meyerhold's students (among them Sergei Eisenstein) and from actors like Igor Ilyinsky whose names are linked with some of Meyerhold's greatest triumphs.

Almost without exception they suggest that—as Eisenstein puts it— "there was something both of Lucifer and the Wandering Jew in the crumpled face of my teacher." Leonid Varpakhovsky, Meyerhold's assistant in the 1930s, said that "Meyerhold's friendship turned eventually and quite regularly into its diametrical opposite, and the rejected friend had to suffer in succession his indifference, coldness, dislike, hostility and hatred."

And yet they one and all remembered how Meyerhold had turned their lives around, just as he turned the art of the theater around and changed it forever. How did Eisenstein begin his notes on Meyerhold? By saying, "It is time for me to confess that I have never loved, never worshiped, never adored anyone as much as I have my teacher." And how did he sum him up later? As "a creative genius and a perfidious man."

For this aspect of Meyerhold, and for many an unguarded reminiscence, Paul Schmidt's *Meyerhold at Work* is an indispensable appendix to Rudnitsky. Reading them side by side—with pencil in hand, as Meyerhold would have wished—we count ourselves lucky to be living in 1982, when so much of the truth can be said, and not in 1942, when the very name of Meyerhold had been suppressed.

# The Malraux Show

André Malraux, *by Jean Lacouture, translated by Alan Sheridan. Pantheon, 1976.*
Malraux's Heroes and History, *by James W. Greenlee. Northern University Press.*
*1976*. Hôtes de Passage. *Gallimard*. Lazare. *Gallimard*. La Tête d'obsidienne,
*Gallimard*

## The New York Review of Books, 1976

*The Malraux discussed here is neither the novelist nor the legendary adventurer,*
*but the confidant of Charles de Gaulle, the prodigious conversationalist, and the*
*high officer of state who gave a new momentum to French cultural policy in the*
*1960s.*

It was difficult to be very young in the European summer of 1938 and not feel
about André Malraux as Henry James felt about James Russell Lowell: that he
was "the poet of pluck and purpose and action" who "commemorated all manly
pieties and affections." Malraux at that time radiated a high-souled mas-
culinity. Where others talked, he acted. Where others thought of writing, he
wrote. He was the nonpareil of the decade, the admired of all admirers; it was
difficult to carry a new-minted copy of his *L'Espoir* from one end of a Parisian
street to the other without making a friend on the way. That book moved a
generation as perhaps no novel has moved one since; and those who were
nineteen and in Paris at the time still find it hard to think ill of André
Malraux.

But all that was a long time ago, and there is no denying that when the
seventy-fifth birthday of André Malraux comes around on November 3 of this
year the taste will have soured. Just about everyone now has it in for Malraux,
for one reason or another. Malraux may feel with his friend Charles de Gaulle
that "whenever I was right, I had everyone against me"; but the fact remains
that he is contested as a novelist, contested as an explorer and a man of
adventure, contested as an aesthetician, contested as a hero of the Spanish
Civil War and the French resistance, contested as a master of language, and
contested as a cabinet minister who refused to present himself to the electo-
rate. Some there are who still see him as François Mauriac saw him in 1969: as
the greatest living writer in the French language. But there is a counter-
opinion: that he is at best an eccentric with no sense of reality and at worst a
magniloquent fraud who is one step short of the madhouse.

On the one hand we have the sumptuous pictorial biography with which
the French publishing industry hopes to put him in the Pantheon forever. On
the other, we have the opinion of Richard Cobb, who knows France better than
most of us know our own front door. Reviewing Jean Lacouture's biography of
Malraux for the London *Sunday Times*, Professor Cobb spoke of "inescapable
evidence of repeated and deliberate distortion, mythmaking and posturing."
As for the Great Thoughts with which Malraux likes to stun his interlocutors,
this straightforward Anglo-Saxon will have none of them. "If, in the original,
they seem merely obscure," he says, "in English they look like plain rot."

Well, yes. Malraux throughout his life has mixed truth with untruth the way painters mix oil colors with turpentine. And when dealing with ideas of an exalted, all-circumscribing sort, he may well often remind us of an automobile which has sixteen cylinders and no steering wheel.

But then again, no. "I do tell lies," Malraux said to Clara Goldschmidt not long after their marriage in 1921, "but my lies turn into truths." What we are dealing with in this peculiar case is the lie as a source of vital energy: as an indispensable part, in other words, of the persona that drives a writer to write. There are precedents in French literature for Malraux's persistence in suggesting (to quote two instances only) that in Saigon in 1923 he was in prison with Ho Chi Minh and that in 1927 he spent six months in Canton. Chateaubriand in his *Mémoires d'outretombe* describes a meeting with George Washington which could not have taken place. Stendhal let it be known that he had been present at the battle of Wagram when in fact he had spent that particular day on a sofa in Vienna.

Malraux is not in the class of Stendhal as a novelist, and we may doubt that he was in the class of Chateaubriand when it came to diplomatic realities; but the claims which he makes for himself are in many cases so dotty as hardly to call for rebuttal. Pending a final judgment on the career which they seem to have helped to make possible, we can most profitably regard them as a kind of pneumatic make-believe with which Malraux has felt the need to support himself. (It would also, by the way, be a mistake to assume that because some of his claims are untrue all of his claims are untrue. No man who gets the Croix de Guerre four times over, between 1944 and 1946, can be altogether a fraud.)

The matter of Malraux's Great Thoughts is likewise one on which judgment can be passed too hastily. One problem is that Malraux is a lifelong allusionist. In private conversation his allusionism confers upon the listener a sense of privileged euphoria. It is as if we were plugged into a central telephone exchange and were eavesdropping, without regard for place, period, or plausibility, on two hundred conversations at the same time. The builder of the Great Pyramid is on the line to Cézanne, Socrates has a long-distance hookup with Robespierre, Nehru swaps epigrams with Montezuma. Two hours later we reel out of the house with cerebral cramp and cannot remember a word.

In print, we miss the often described but inimitable snorting delivery, just as we miss the seignorial good manners with which our own halting contributions are received. We may even suspect that the allusionism is a device for never staying long enough in any one place to be able to tell sense from nonsense. It may or may not be true, as Malraux said already in 1922, that "we shall understand more about the Greek genius by comparing a Greek statue with an Egyptian or an Asiatic statue than by getting to know any number of other Greek statues." What is true beyond a doubt is that this belief absolves us from the discipline that is required if we want to discuss one Greek statue in relation to another Greek statue. This nonchalant aerial purview has got Malraux in trouble with art historians. "There is no evidence," E. H. Gombrich wrote in 1954, "that Malraux has done a day's consecutive reading in a library or that he has even tried to hunt up a new fact."

But when that has been said it remains true that along with much that is gaseous and impenetrable in Malraux's writings on art, as on everything else,

there are surprising observations that come not from "a day's consecutive reading in a library" but from the firsthand experience of one of the oddest men of this century. Malraux writes like a man who wants to write what he once called "the first complete history of mankind" and believes from time to time that he almost has it within his grasp. Whence the giddy, all-risking character of the adventure which he proposes to us, and the difficulty—and, in some cases, the resentment and the exasperation—with which we debrief ourselves at the end of it.

There is some reason to suppose that he himself may have been startled from time to time by his own legend. Was it not strange, he said to Charles de Gaulle in December 1969, that some characters in history achieve the status of legend, whereas others, no less remarkable, do not? Julius Caesar, for instance. He won battles, but they were not the battles that really counted. He ran a first-rate administration, but then so did other Roman emperors. Yet it was Julius Caesar who was singled out first by Plutarch and later by Shakespeare.

De Gaulle may also have had himself in mind. "Caesar hooked them," de Gaulle said. "Pompey didn't. Even Augustus didn't. But Caesar did." Warming to his theme, the *miles Christianus* who had never fought a major battle, let alone won one, went on to say that "victories are not as important as people think. Maurice de Saxe won every battle he fought, but no one would mention him in the same breath as Napoleon, who ended his career as a beaten man. Victories which are only victories don't get anyone very far. Other considerations come into play—the future of the nation (think of Joan of Arc), the future of the world, the confused and symbolical status of those who make History—well, you know what I mean...."

Malraux did know what de Gaulle meant. He himself has not yet found his Shakespeare, and maybe he never will, but his Plutarchs stretch all around the block. He has had a "confused and symbolical status" ever since the summer of 1924, when almost every writer of consequence in France signed a protest against the sentence of three years' imprisonment which had been passed upon Malraux by the French colonial authorities in Saigon after he had been caught filching statues from a deserted temple. To deconfuse his status is the first task of his biographers, and it is not an easy one.

The aspiring Plutarch has to master Malraux's already voluminous and still rapidly growing *oeuvre*. He has to distinguish in this work truth from untruth, insight from platitude, successful action from evasion and near catastrophe; and he must be able to deal with Trotsky, Valéry, Eisenstein, Oppenheimer, Genet, and de Gaulle. He must make the reader understand, too, what it was like to be in the cabinet room at the Elysée, and in a French prison with the Gestapo nearby, and in an officers' mess in Djibouti in 1934, and in the presidential residence in Dakar during the week in which Léopold Senghor took over the destiny of his country. He needs to know a great deal about old and new art, about French symbolist literature, as well as about those whose ideas were opposed to Malraux's: e.g., the one hundred and twenty-one writers, artists, and moviemakers (among them Malraux's own daughter) who in September 1960 banded against the government of which Malraux was a member. He must also penetrate the lifelong discretion (somewhat breached of late) with which Malraux has surrounded his origins, his private life, and his

personal thoughts and feelings.

Meanwhile the legend of Malraux—if that is what it is—is remarkably tenacious. Biographies abound. Articles, even more so. And, just to thicken the plot, he himself is in full eruption. After ten years (1957–1967) in which he was too busy to publish anything, a slew of new titles has come into being. This is thanks in part to skillful merchandising by the Editions Gallimard, who clearly do not want to issue the rest of the autobiography in one fat book when there is material in it for quite a few thinner ones; but it is fair to say that those shorter books have added substantially to our knowledge of him and have clarified certain concepts—among them that of *la fraternité virile,* which his Plutarchs need to get straight once and for all. Malraux has also published a further monumental volume, *L'Irréel,* in his series on art.

All this might be bad luck for Jean Lacouture, whose biography was first published in French in 1973 and has recently appeared in an abridged form in English. But in fact this lean, pungent, and fair-minded book is still valid in its approach to those aspects of Malraux in which M. Lacouture feels most at home. Like his predecessors Robert Payne and Pierre Galante, M. Lacouture has a professional inclination toward political history and the newspaper library. The biographer of Ho Chi Minh, Nasser, and de Gaulle, M. Lacouture is good on power, and on war, and on the ups and downs of faraway peoples. He knows Indochina at first hand.

Lacouture is also very good on certain aspects of Malraux's career which came to nothing but are none the less fundamental to his ardent, wholehearted, and flamboyantly unrealistic nature. An instance of this is the expedition which Malraux planned with great care in the year 1929 but did not get to carry out. Its object was to rescue Trotsky, who at that time was sequestered in Alma-Ata. It could not possibly have succeeded, any more than in 1971 Malraux could possibly have taken an active part in the liberation of Bangladesh. But Malraux thinks nothing of improbability, and it is one of M. Lacouture's good points that he does not fall into an easy derision when confronted with this trait. To be afraid of being ridiculous is the mark of a small nature, and M. Lacouture knows this, even if he is also quite free with the evidence of Malraux's oddities and inconsistencies in his ministerial years. On the private life of his subject he is less intrusive than M. Galante, who had the advantage of knowing Louise de Vilmorin, with whom Malraux lived during the last years of her life. But if there is a certain personal blankness at the center of his portrait, that is the way Malraux has always wanted it.

It is very curious, that blankness. Malraux is quite specific about it in *Hôtes de Passage,* a book which is made up primarily of a long and fascinating exchange between himself and Léopold Senghor, the poet-president of Senegal. "I am more interested in other people's secrets than in my own," he writes. "Gide was always amazed at this. 'But surely,' he would say, 'you must sometimes feel that you are not like everyone else?' But I don't, really. To be a Chinaman would be different. To be a woman would be different. But to be an individual? No. That's not how I see myself. But then I've never liked to pass judgment on others, either, and I daresay that the two things go together."

Now it is true that the European exaltation of the individual is something that Malraux has been decrying ever since he published *La Tentation de*

*l'Occident* in 1926. Whence, perhaps, the expansionism—the compulsion to race backward and forward in time and space—which is fundamental to his ideas on the evolution of art. It has always seemed to him a letdown that art, which for so long concerned itself with the gods, should be thrown back on the individual European. But there is something more to his revulsion than the power of an idea. Malraux can't bear to be shut up in his own culture, his own century, or his own skin.

Relevant, here, are the intensity, the pent-up narrowness of his own origins: "Our family," his father once said, "has lived between Calais and Dunkerque since the eighteenth century, and every one of us has been a proletarian." To get out of that situation decisively, it was not enough for Malraux to be a rare and curious person; he had to develop an intimacy with other times, other places, and other civilizations which would distract us from the identity of A.M., its transmitter. (Malraux once told me that when he first saw a whirling dervish it seemed to him that here was a new level of intensity in human communication, and one in which individual identity was abolished in the interests of the purity and directness of the message to be conveyed.)

The image of the dervish turns, as do so many of Malraux's images, on the insufficiency of Europe. European individualism in its modern form has always seemed to him divisive, impotent, disoxygenated. It was this (among other things) that got him in bad odor with virtually every intellectual in France during his years as minister of culture. On official visits to India, China, the United States, and Africa he fared better, because his ideas could soar aloft without the chance that he would be called upon to carry them out.

Exactly what came of those meetings with heads of state is as murky as much else in Malraux's past. But, contrary to rumor, he is a very good listener when there is something to listen to; and in Senghor he found the ideal interlocutor, someone who believes, as Malraux does or once did, that the world can still take a turning for the better. "For thirty years now," Senghor said, "I have been singing the praises of intermarrying civilizations. We should work together to create a great new intermarrying culture, such as the Egyptians had, and the Indians, and the Greeks. The universal civilization toward which we are tending will not deserve the name until it draws upon the dormant energies of Africa, and even of Asia. An Afro-Latin civilization will bring about a union of complementaries. The Occident mutilated humanity...."

Malraux in these matters has a divided loyalty: or, to be more exact, a twofold aspiration. On the one hand he is, as he has often said, someone who "married France" or "had a contract with France." On the other, he knows that the world is growing up—not without all the difficulties which that phrase implies—and he takes a long view of the incidental adjustments which have to be made. Talking with Senghor, he remarked that although the Romans cut off the hands of 40,000 Frenchmen at Uxellodunum, France went on to be the greatest of the Roman provinces, and the proudest. There is nothing narrow about his allegiances, and in the end it may well be the notion of "one world, one civilization" which is closest to him. But he is also a shrewd observer of the world as it actually is. "For all your talk of negritude," he said to Senghor, "it is for Senegal that you live. The notion of nationhood was born here, now, and today. Nietzsche has got the better of Marx."

Malraux did nothing for the theater when he was minister of culture, but in his own writings he is a great stage director. *Hôtes de Passage* includes one of his finest short historical romances: the story of how he looked into the suggestion that a piece of textile which had been offered to the Louvre was stained with the blood of Alexander the Great. The narrative skill, the heightened sense of the past, the headlong commitment to what might have been—all these may make us regret that Malraux has for so much of the last thirty years been more a public figure than a writer.

This feeling will be enhanced if we turn to *Lazare,* a book prompted in the first place by a disagreeable few days in the Salpetrière hospital. Malraux was rushed there with symptoms which until quite recently would have proved fatal. But he survived, after adventures which he describes with a characteristic detachment, and in the first part of the book he re-presents a famous but now almost irrecoverable episode from *Les Noyers d'Altenburg,* the novel or part of a novel which he wrote during World War II and published in Switzerland in 1943.

This book, along with all of Malraux's other novels, is analyzed in depth in *Malraux's Heroes and History* by James W. Greenlee. Dr. Greenlee has done his research with an exemplary thoroughness, and by dint of turning page after page and sifting and resifting view after view he raises point after point which is fundamental to Malraux's evolution. But there is (as there is also in Malraux's own works) an absence of the first person singular. Nothing is quite pushed home in a personal way in Dr. Greenlee's book, any more than the taboo word "I" turns up more than very occasionally in Malraux, for all the rampant subjectivity of so much of what he has to say. Dr. Greenlee gives us the facts on which a decisive judgment can be based, but he doesn't make that judgment himself.

*Les Noyers d'Altenburg* is so important for Malraux that we should have welcomed a thorough discussion of (for example) the Germanic element in Malraux's evolution. It has to be significant that the most extended of Malraux's flights of the imagination should take place within the setting of the German army, and that the symposium which is so important to the book should have been transposed from the secularized Abbaye de Pontigny, where Malraux learned to distinguish between knowledge and wisdom, to an imaginary abbey in Germany. Readers of Clara Malraux's memoirs will not have forgotten that the very formula of Malraux's books on art was given to him more than fifty years ago by a curator from Cologne. This is the kind of thing which the definitive study of Malraux will have to deal with.

The episode rewritten for *Lazare* concerns an imaginary incident on the eastern front during World War I. The Germans have decided to use poison gas for the first time. The inventor of the gas is on hand, the German soldiers are forewarned and have their masks at the ready, the Russians know nothing of what is to befall them. The gas does all that can be asked of it; but so far from pushing home their advantage, the German soldiers set to work to rescue their Russian victims. Brotherhood has proved stronger than national policy.

This passage reminds us that Malraux was one of the first consequential writers to be influenced by the cinema. In *Lazare* there is an image of a runaway horse that is as vivid in its way as the image of the dead white horse

which slides down the bridge in *October*. Malraux uses the quick cut, the close-up, the long shot, the slow pan much as Pudovkin and Eisenstein used them in the films that he saw in his early twenties. But the long passage has also a moral power which can be called "Tolstoyan" without exaggeration; Malraux convinces us that this was the moment at which something went irreversibly wrong with mankind.

Not everything in the new books is of this quality. Reading *Hôtes de Passage*, we may for instance find something obnoxious in the insouciance with which in May 1968 Malraux goes on talking of old times in Spain with a fellow-survivor of the period while civil servants come in and out with bulletins of the fighting in the streets. "Four hundred and fifty wounded," one message reads. "Nobody killed yet. Rather interesting, isn't it?" and the two old gentlemen go on with their chat. It is as if Malraux for ten years had been so dazzled by the lights around his lectern that he never once looked at the actual French men and women who turned out to hear him. When Charles Bohlen arrived in Paris as United States ambassador he felt it no more than polite to congratulate him on the success of the referendum which had recently been held by the Gaullist administration. Malraux's reply took him somewhat aback. "If you take a bunch of zombies who might as well have dropped from the moon and ask them their opinion, they're so delighted to be asked that they'd say Yes to anything."

Yet that is the same Malraux who in *Lazare* discourses so tellingly on the lost ideal of fraternity. "People think they understand fraternity," he says, "because they confuse it with human warmth. But in point of fact it is something much deeper, and it was belatedly and almost apologetically that it was added to the blazon of the Republic, whose flag at first bore only the words Liberty and Equality.... The word Liberty has still the same ring to it, but Fraternity now stands only for a comical utopia in which nobody would ever have a bad character. Men believe that Fraternity was just tacked on, one Sunday, to feelings like Justice and Liberty. But it is not something that can be tacked on at will. It is something sacred, and it will elude us if we rob it of the irrational element that lies hidden within it. It is as mysterious as love; and, like love, it has nothing to do with duty, or with 'right thinking.' Like love, and unlike liberty, it is a provisional sentiment, a state of grace."

Whether this is what Richard Cobb calls "plain tripe," or whether it is a good stab at the definition of something which the world would be poorer without is a good question. For Malraux, certain beliefs are indispensable to a full human life. If those beliefs are not defined, they cannot be acted upon and will die. The difficulty with this particular belief is that it has been so often perverted. (One of Jean Lacouture's most telling references concerns the memoirs of one of Malraux's bodyguards, who saw fraternity as an excuse for brutalization.) But that is no reason to discard it. Fraternity of the kind that Malraux had in mind finds an unmatched beauty of expression in Verdi's operas, for instance. When tenor and baritone are united we sense immediately that something of incalculable importance is being set before us by a man whose basic instincts are entirely good. Fraternity as it has been systematized in our century is almost always a curse: so much so that we shrink from the word. But there are concepts which should be formulated against all

the odds, and this is one of them.

Malraux has never been odder, more eloquent, more completely himself, than in these late works. Anyone who has ever managed to get beyond the first pages of *The Psychology of Art* will treasure, for instance, the long passage in *Tête d'obsidienne* in which Malraux discusses the concept of the "museum without walls" with Picasso. Malraux had not yet gone into print on the subject, but Picasso knew that what he had in mind was "not a Museum of Preferences, but a museum in which the works of art choose us more than we choose them." No one could have been more sensitive to that idea than Picasso. "Why did Derain collect Scythian plaques, while I didn't?" he asked. "Those plaques have more to do with me than with him. And why did Matisse buy fetishes before we did? What did they have to do with him?" And Picasso went on to say that in his case the imaginary museum was not so much something to enjoy as something to paint against. It was a matter of hand-to-hand combat and not of detached aesthetic pleasure. "I don't choose to like the things I like. I am obliged to like them." Malraux did some good talking, and some good listening, that day; there is much to be learned from Picasso's laconic, elliptic, unstudied replies. And when he suddenly compares a kachina doll to the gigantic figures of the Managers which Picasso designed for *Parade* we remember that Malraux, who usually has to be caught midway between the west door of Chartres and the memory of Angkor, has also been familiar with twentieth-century art since he was first taken to see D.-H. Kahnweiler almost sixty years ago.

Yet, once again, we have to admit that this prehensile cross-referencer can blank out in relation to particular works of art just as decisively as he blanks out in relation to particular human beings. It amused him that he was able to send the Mona Lisa to Washington against the advice of every curator and conservationist in the French museum profession. And what did he remember about it all when he got back from seeing it on the wall in the United States? Mostly that a young man had tried to smuggle his dog into the gallery in order that it could be pointed out to his friends as "the only dog in the world that has seen the Mona Lisa."

There is about this story an irredeemable triviality, a terminal silliness which makes us wince for the man who told it. (It went down very well with the de Gaulles, by the way.) Can this really be the Malraux who was once thought of as the conscience of Europe? It is the distinction of Malraux that at the height of the colonial era he had post-colonial intimations; that he foresaw the shrinkage of European power and authority, and did his best to see it in terms that were other than defeatist; that at a time when orthodox aesthetic experience was still hierarchical and compartmented he opened it out to the unlimited photographic information that was about to become available; that he dreaded the arrival of a shiftless, fragmented, self-destructive, and beliefless society in which there would be "Frenchmen, but no France"; and that all his life he went out for the exalted and the universal as against the petty and the contingent.

Sometimes he talked like an over-wound encyclopedia. Sometimes, as Simone de Beauvoir once pointed out, he could not tell the difference between an idea and a formula. He had a great sense of the dignity of action as it was

upheld by others, but it cannot be said that his own actions were always such as would make the Grand Condé roll over in envy. But there are people who should be given the benefit of any reasonable doubt, and he is one of them.

# Godot Remembered

**The New York Times, 1978**

*Whether in the elegant, soft-grained production made by Peter Hall in London, or in the more percussive mode favored by the author,* Waiting for Godot *made an unforgettable impression upon its first audiences. Twenty-five years later, this essay looked back to the earliest days in London.*

Next Thursday's production of Samuel Beckett's *Waiting for Godot* at the Brooklyn Academy promises to commend itself even to those who remember Bert Lahr's famous contribution to the original Broadway production in 1956 and believe that it could not be bettered. The director—Walter Asmus, of the Schiller Theater in Berlin—is Beckett's own choice and the production as a whole is said to bear the author's stamp.

*Waiting for Godot* and its author have come a very long way since the play was first performed in Paris just twenty-five years ago. Those were difficult days. A lot of people hated the play. Houses were small. Among the few who paid for their tickets, there were some who sat through the short evening and sulked, some who stood up and insulted the actors, some who walked out, and one or two who traded blow for blow with anyone who was not of their opinion.

The malcontents gave a very bad account of the play. It was about two bums who did nothing but talk, they said. The two bums did a dance, but it didn't bring Nijinsky back from the dead. They sang a little song, but you could hear better in the café round the corner. There were two other characters who acted out a master-and-slave relationship that was both painful and repulsive. Meanwhile, and until the very end of the evening, the two bums hung around waiting for a Monsieur Godot who never came. There was no plot, no construction, no beginning and no end. The whole thing was a gyp.

There was another point of view, but it was not widely held. According to that other point of view, *Waiting for Godot* posed no problems at all. It was a play about human bondage. It was a dramatized encyclopedia of the ways in

which one human being can depend upon another. It was funny. It was poignant. It was unforgettably well expressed. It was the work of a master of language who, though Irish by birth, had written it in French in a very short time. It was a mix of all the known modes of theater, from vaudeville to the kind of tirade that had gone out with the death of Jean Racine in 1699. It might not have worked, but it did; and within a matter of days it was common ground among intelligent people in Paris that the date of its first performance— January 3, 1953—would be pricked out in gold in the annals of the stage.

This preeminence was taken for granted among the tiny public that had known of Samuel Beckett since he was talked about in the circle of James Joyce before World War II. But it was also taken for granted among hardened professionals of the French commercial theater.

Playwrights like Jean Anouilh and Armand Salacrou—then riding high —had no reason to come out in Beckett's defense. But they did, in no time at all. Anouilh said that *Godot* was like watching Pascal's Pensées acted out by the best clowns that ever were. Salacrou said that *Godot* proved that an author of genius did not have to play around with the fixed number of known dramatic situations; he could make do with "a story that has no beginning and no end but captivates us because it is our own story."

All this made a brisk little set-to in 1953. Then time did its work. *Waiting for Godot* has now the status of "a modern classic," with all that those words imply in the way of slovenly acceptance. It is in every college course in Modern Drama. In its Grove Press edition it has gone into heaven-knows-how-many printings. It has a vast and daunting bibliography, in which "Beckett, oder die Unzuanglichkeit der Sprache" sits next to "Beckett e l'iperdeterminazione letteraria." *Godot* is with us for keeps.

But it is not in the classroom that plays come alive. *Godot* has to be acted and seen, lived through and assimilated, as an experience without which anyone who has been around in the second half of our century is very much the poorer. Moreover, there is still room for discussion as to what *Godot* is about and how it should be acted. All the more reason, therefore, to welcome *Godot* to the Brooklyn Academy on Thursday. As with the German performances that had so hallucinatory an effect when they were given at BAM last year, we are promised the authorized version: the one which—in intention, at any rate— supersedes all others.

But certain other performances will take some superseding: not least, perhaps, the notional ones that formed themselves in privacy and silence among the people who read the play before ever it was put on the stage. They were a small but committed band, those early readers. They got the skimpy little book the moment it came out from Editions de Minuit in October, 1952. They read it and re-read it: singly, jointly, collectively. A stage-picture without precedent formed itself in their minds; and they imagined a stage-music—a reshaping of language and a reinventing of human exchange—for which there was likewise no parallel. They couldn't wait to see *Godot* on the stage, but meanwhile it was their personal property, and they loved it.

What came up off the printed page was a twofold study of human bondage. There was bondage between equals, in the case of the two tramps, Vladimir and Estragon. And there was bondage as tyranny, in the case of Pozzo the

master and Lucky his slave.

These parallel and simultaneous studies were worked out in a temporal and geographical limbo. The two main characters happened to be tramps, and they happened to be men. But with the excision of a line here or there what they had to say could have been said without incongruity by a well-to-do husband and wife whose marriage had gone stale after forty and more years.

Pozzo and Lucky were grotesques from an updated Punch and Judy show. But if they were to be played as the chief executive of a great conglomerate and his brutalized personal assistant the play would work just as well. Bondage has been bondage since the beginning of time and at every level of society.

*Godot* eventually got on to the stage by a roundabout route. Samuel Beckett wrote it in 1948. He then put it aside and made no attempt to canvass its chances (1948 was a fertile year for him, in that he had also completed two short novels, *Molloy* and *Malone Dies,* and a number of poems). Though ranked very highly by the five or six people who really count for something in Paris he was not at all the kind of author whose name brought the commercial managements running to his door. In fact he had no name at all, in that sense, and lived by translating an article here and an article there.

Then in 1949 he went to see a production of Strindberg's *Ghost Sonata* at a little theater in Montparnasse. There was almost no one there, but it seemed to him that Roger Blin's production of this famously difficult play was exactly right. As Blin was if anything even shyer than Beckett himself, there was no question of a direct approach; but Beckett sent Blin the typescript of *Godot,* and Mrs. Beckett tested the ground a little later, and finally the two tall tormented individuals met face to face.

The performance which resulted had a marked and specific character. (If it was so long delayed, the fault lay with the managements who saw no future in it). Blin got the cast together, he himself played Pozzo, and the sculptor Alberto Giacometti designed the tree that was Beckett's only concession to scenic illustration.

Doubtless there were many in that first audience who had no idea what was coming. But both *Molloy* and *Malone Dies* were in the neighborhood bookstores, and those who had read them recognized immediately both the non-landscape in which the action was set and the non-situation that was set up in the opening lines.

They knew the "road remarkably bare, I mean without hedges or ditches on any kind of edge" from *Molloy*. They knew the "boots, hobnailed, dust-whitened," from the same source. They knew, again from *Molloy*, of Beckett's preoccupation with hats ("I took off my hat and looked at it. It is fastened, it has always been fastened, to my buttonhole, always the same buttonhole, at all seasons, by a long lace. I am still alive then.") They were not surprised, therefore, when the only way to stop Lucky's endless and unbearable tirade was to latch on to his hat.

They were also at home with the idiom. *Godot* in its French version deals largely in the worn familiar coinage of everyday speech. But Beckett varies that coinage with doubloons new-minted and thalers unknown to the numismatist. His broken-down characters come up with remarks the like of which no one had ever heard before. That did not seem implausible to people who knew

that in Pascal, for example, passages of down-to-earth exposition alternate with phrases that extend the potential of language.

Nor did the French need Stephen Sondheim to say "Send in the Clowns." Clowns have been fundamental to French life since Antoine Watteau painted *Gilles* and Honoré Daumier drew the workaday veterans of street theater. Nobody in France is surprised if clowns stir some of the deepest of all human feelings.

Clowns have to hold fast to their audience, and Roger Blin moved the play along quickly and unsentimentally. French people come to the theater for the equivalent of championship tennis matches, rather than of beginner's badminton; and if the director implies that they are not as quickwitted as he is they will soon show their displeasure. Blin knew that he had a great text on his hands, and he saw it as his job to get it across at top speed and without additives. And "additives," in that sense, were the marks of expression that English-speaking readers read into the printed words.

*Waiting for Godot* got around without further delay. Already in 1954 it was a great success in German, and in August 1955 it was put on in London, at the Arts Theater Club, in the English translation that Beckett had made himself. The producer was Peter Hall (later director of Britain's National Theatre) and the actors were Paul Daneman, Timothy Bateson, Peter Bull, and Peter Woodthorpe.

The play as presented in London was quite unlike the play as presented in Paris. Peter Hall is a wonderful director, and he was working with first-rate actors. The play made a tremendous effect. But then it always makes a tremendous effect. What differs from production to production, country to country, and decade to decade is the nature of that effect. What we saw in London was a "Godot" that had been passed through an English sensibility and was thereby transmuted.

There was, for instance, a Tennysonian sweetness about many of the exchanges between the two bums. There were musical silences, moments of communion between cast and audience for which the text gave no warrant. The little boy who came in to say that Godot would not be coming that day had a Pre-Raphaelite beauty.

Pozzo was very good, but we had trouble believing that he could really have thought up one of the most terrible things ever said on the stage: "They give birth astride of a grave, the light gleams an instant, then it's night once more." Lucky was very good, too; but it was a beaten-down English schoolboy, rather than a grown man, who responded to his master's "Think, pig! Think!" with the first and not the least astonishing of the tirades with which Beckett has embellished the French theater.

We do not have in the English-speaking theater that same tradition of the tirade. Characters make long speeches from time to time, in Shakespeare and elsewhere, but our current convention is for them to make them in a slightly shamefaced or absentminded way, as if they were best got over with as little fuss as possible. "The barge she sat in..." says Enobarbus in *Antony and Cleopatra*; but just as we look forward to hearing about Cleopatra's lifestyle the dear fellow looks the other way and starts to mumble.

In France this is not so. Actors love a big speech, and audiences insist on

them. Even Anouilh writes in big speeches to keep everyone happy. And Beckett is enough of a French writer to know that there is nothing like a bit of heavy duty to get the audience on his side. Somewhere in back of him is the death-scene in *Phèdre* and the *songe d'Athalie*: two scenes in which Racine excelled himself. And, avant-garde or no avant-garde, the tirade is still one of the great means of human communication.

Beckett has since then done more and gone further in that same direction. *Happy Days* is in essentials one long tirade, and Madeleine Renaud for one got the measure of it. *Not I* is a monodrama of twenty minutes' duration in which ideally the protagonist should never draw breath. (Billie Whitelaw did it to perfection in London.)

But even in the well-modulated naturalism of Peter Hall's production the first arrowy impact of Lucky's monologue was prodigious. Where every word in the opening scenes of the play had been counted and given its full weight, here was a verbalized Chaos: an overspill of language that was just on the far side of comprehensibility.

On the part of Lucky, who had previously been shown merely as a beast of burden, it reminded us of the traditional function of the playhouse as a place where pity and terror are at home. What we witnessed was the rebirth of human speech: but a rebirth at which, as Pozzo was to say later in a larger context, a gravedigger wielded the forceps.

The play loses a little in English. In the French there are references to place-names, to activities peculiar to one part or another of France, and even to the color of the earth near Roussillon. These arouse a French audience to immediate recognition, but in the English text they have not been rethought to the point at which they mean anything to an English-speaking audience. There is also a loss of ferocity; the same man is pitching the ball, but in the English version we can see it coming.

Beckett reportedly did not care for the slower, gentler, sweeter tone of Peter Hall's production. Instead of the great clowns (the Fratellinis, to be exact) of whom Jean Anouilh had been reminded, we in London caught an echo of Flanagan and Allen, a favorite English comedy duo of the day. Looking not long ago at a book by Ludovic Janvier called *Beckett Par Lui-Même*, I came upon an even earlier pre-echo of Peter Hall's production. For there, the very image of respectable prosperity in his foursquare derby hat and his foursquare big black boots, was Beckett's own father, a successful Dublin quantity surveyor. And on the facing page was Beckett himself, at seventeen, in the impeccable striped cap and blazer of a schoolboy cricketer.

As Beckett is one of the great poets of memory, I do not think we can exclude the idea that in *Waiting for Godot* there was caught and turned inside out something of Beckett senior, the reliable agnostic man of business who gave young Samuel such a happy childhood. As for the little boy who tells the two tramps to try again tomorrow, because Monsieur Godot will certainly come then, there may be something in him of the exemplary youth who had posed for that group portrait way back in 1923.

But then there is something of everyone in this play, and something of everywhere, too. That is why what it has to offer is a landmark in life, as distinct from an accomplished evening in the theater.

# Fischer-Dieskau:
# A Golden Future

### The New York Times, 1976

*It was in the summer of 1951 that James Strachey, Freud's English translator, first told me of a German baritone, then twenty-five years old, to whose natural gifts no limits need be set. In no time at all, that was news no longer.*

By the end of the 1940s it was common knowledge among people who cared about such things that the much-battered city of Berlin had produced a young singer of limitless potential. "There's never been anything like it," said that great conductor Fritz Busch when he came back to England in 1951. "Such a voice, such an assured technique, such musicality, such a range of interests, such an imperious intelligence! And still in his twenties. It's phenomenal. And such a terror of performing, too! You practically need a snowplow to push him on to the stage."

People in other countries longed to hear this young singer, whose name took some getting used to. (When he first appeared in London, even the programme didn't get it right.) "Dietrich Fischer-Dieskau," we said to one another, chewing each syllable forty times. When he gave Schubert's *Schöne Müllerin* in London in January 1952, at the age of twenty-six, the posters carried an endorsement by an English critic not given to hyperbole: "The Greatest Living Lieder Singer," it said.

The hall sold out. The house was in a state of un-English ebullition. The lights dimmed. An unmistakable stamping tread was heard advancing from the wings, and there before us was the forthright young giant whose name has ever since sold out the great concert halls of the world.

Fischer-Dieskau had then, has now, and is likely to continue to have a most remarkable history. After four years in the German army (the last two of them spent as a prisoner of the Americans in Italy) he got back to Berlin in the summer of 1947 without a penny in his pocket. He was just twenty-two years old. Virtually nothing was left of his home. His widowed mother could barely make ends meet. He had not had a singing lesson since the spring of 1943. Berlin was a mess, the like of which we must hope never to see. Yet he stood by an entry in his wartime diary. It was dated from the eastern front in June 1944: "If only I can stay alive, I have a golden future."

There was nothing rhetorical about that "If only..." When the Americans overran the post which he had helped to man for month after miserable month in the foothills of the Apennines he was the only German survivor. But to be so confident of his "golden future" at the age of eighteen! And to achieve it so rapidly, so completely, and with never a mistaken step! That is the remarkable thing.

Talent helped, of course. Even when German soldiers in Italy were none too popular, Fischer-Dieskau had only to open his mouth and sing to himself in the streets of Lucca for a friendly crowd to gather. High officers would whisk him out of the front line to sing for them in their palaces in Bologna. ("I saluted. I stood to attention. I said 'Schubert: Erl King' or 'Schumann: Dichterliebe.' I sang. The general said: 'Dismissed.' I went back to the front line, where I spent a whole winter next to a man who scrubbed himself night and morning with rancid butter.") As a prisoner of war he was in demand as singer, pianist, poetry reader, stage director, chorus master, and conductor. ("It had its disadvantages. I was allowed to sleep late after a concert, but the others resented that and used to turn a hose on my face when it was time for them to get up.")

But Fischer-Dieskau never had it in mind to be just a champion vocalist. He loves opera, and he has had a great deal to contribute to it (most recently, and after many years of self-questioning, as Hans Sachs in *Die Meistersinger*). But he sees lieder-singing as one of the highest, subtlest, and most complex forms of human expression. The lieder-singer has to make us aware as never before of poems which we may have read or heard a hundred times over. He has to make us aware of a musical structure which, in the case of Schubert, Schumann, or Hugo Wolf, is likely to be as dense, and as concise, as anything in the entire repertory of western music.

The great lieder-composers can epitomize in two minutes what would take a novelist three hundred pages, and take a playwright a whole evening, to set before us. Each generation has to re-define this experience for itself. Fischer-Dieskau as a very young man knew instinctively, just as he knew it as a fact of history, that great singing has to change, just as great acting has to change, and that the great lieder-singers are landmarks in the history of human development.

It is because he knows this, and not because he collects the way other people collect stamps, that Fischer-Dieskau's house in Berlin has the look of a private museum in which everything relates to the history of his profession. Those who think of him as entirely serious may like to know that the guests' washroom is papered from floor to ceiling with the bad reviews which even he receives from time to time. No one who has an unmistakable personal style can be at the top of his profession for nearly thirty years and not make enemies.

It has been said of Fischer-Dieskau that sometimes he bullies, shouts, and hectors. It has been said that he cannot leave well alone but goes on refining and nuancing with material that is best sung quite straight. (One English critic even used the words "high camp" in that context.) It has been said that no one who records quite so much can manifest throughout that ideal intensity of commitment which marked some of the lieder-singers of an older generation. It has been said that the rough traffic of the operatic stage does not really suit

him. There is quite enough of that sort of thing to save on wallpaper in the smallest room in the house.

Fischer-Dieskau is not gregarious, but when people do come to the house it amuses him very much to show them around. "Let's see, now. This desk was Mendelssohn's. The death mask on the wall is of Liszt. That portrait is of Schiller, as you know. This is the announcement of Hugo Wolf's funeral. That drawing over there is of the original of Goethe's harpist in *Wilhelm Meister*. As for the framed photographs, I lost count of them as long ago as 1961. That is Eugen Gura, the baritone who rediscovered Loewe's ballads. That is Theodor Reichmann, the first Amfortas in *Parsifal*. That is Ludwig Hess, the baritone who was a friend of Max Reger. That cabinet? It's full of all sorts of things—a letter from Verdi inviting some friends to *Fidelio*, a cadenza written out for Turgeniev's great love, the soprano Pauline Viardot, a school report on the tenor Leo Slezak when he was a boy...."

He has never forgotten what his teacher Hermann Weissenborn once said to him: that in singing the entire human being is committed, and not just the voice. He inherited that same conviction from his father, who was a well-known headmaster in Berlin and eventually had a street named after him, and from his mother, whose limpid and unaccented English was a joy to listen to. "My father was a many-sided man. He wrote a novel, he designed a new form of desk which was taken up in schools all over Germany, he was the first headmaster to introduce a cinema projector into his school. He was always at odds with authority. At the time of the inflation, when everyone else got scared, he organized subscription concerts with first-rate artists. He never ran out of ideas.

"We were always Prussians. You must remember that Prussia didn't always have the kind of name it has now. My family were more military than musical. One of them invented a new trajectory for the artillery in the time of Frederick the Great. My grandmother was on nickname terms with Field-Marshal Moltke. After World War II, when I appeared in Alban Berg's *Wozzeck*, my own sympathies were more with the enlisted man. Dieskau, by the way, was the name of a little castle somewhere between Leipzig and Halle. We sold it in the 1870s or thereabouts, and now it's a school for the Volkspolizei, but I like to remember that J. S. Bach used to stay in it and wrote some of his cantatas there."

So Fischer-Dieskau's career has a double history. There is the history of the voice itself, which in the late 1940s appeared as a phenomenon of nature which has been coaxed by sustained effort and high intelligence into a phenomenon of art. With that voice, and with a following which grew more numerous every year, Fischer-Dieskau could have settled for what came to him most easily and for what his audiences most wanted to hear.

But he didn't, as we all know. Where earlier singers chose ten or eleven songs by Schubert and stayed with them, Fischer-Dieskau recorded 408. He will not be satisfied until he was recorded everything by everyone: all Schubert, all Schumann, all Beethoven, all Hugo Wolf, all Brahms, all Richard Strauss. "And don't think I've finished," he said a year or two ago. "Remember there's all Pfitzner, all Mendelssohn, all Meyerbeer, all Liszt, all Peter Cornelius, all Ives...." (He had Ives's songs in his workroom long before most

Americans so much as knew Ives by name.)

What drives him is a sense of music as something that is there to be reinterpreted. But so is the concert-formula. Even as a prisoner of war he despised the potpourri. A concert, for him, is a department of the history of ideas. In this, his great predecessor was his fellow-baritone Johannes Messchaert (1857–1922), who built each of his programmes around a specific idea. To stay with one composer for a whole evening is to make of the concert what the English novelist Henry Green called "a long intimacy between strangers"; continuity and concentration go together. In the case of a singer like himself, who could have excelled in the spoken theater, a great poet can equally well bind the evening together. When Goethe is in question, for instance, Fischer-Dieskau can take a melodious nothing by that most famous of blue-stockings, Bettina von Arnim, and make a huge audience hold its breath at the beauty of his declamation.

Concert managements dread new music. But Fischer-Dieskau has not forgotten how long it took Michael Vogl, the foremost singer of Schubert's day, to consent to look at Schubert's songs. He also identifies very strongly with Julius Stockhausen (1826–1906), the Alsatian baritone to whom Brahms dedicated the *Magelonenlieder*. "Brahms knew Stockhausen's voice through and through, and in those songs we can hear exactly how he sang, relying more on musicality and depth of feeling than on weight of voice."

To find a living composer who would write for him as inventively as Brahms wrote for Stockhausen is a dream that Fischer-Dieskau has pursued with a selfless and largely unrewarded generosity, as if it lay with him to save lieder-singing (and for that matter opera as well) from the status of an antiquarian activity. No matter how strenuous, thankless, or finally un-vocal the score may have turned out to be, he has never gone back on a promise. And the phonograph keeps most of these adventures on ice, even if there are few who care to defrost them.

Fischer-Dieskau was fifty last year: an occasion to which he gave a characteristically low profile. He has as many plans as ever. "To be precise, I have one plan fewer than last year, in that much as I love conducting I have decided to give it up. Two careers are one too many, to begin with, and also my twenty-two-year-old son Matthias wants to conduct. He has made a very good beginning, both with the orchestra which he started himself—they specialize in chamber opera—and as chief conductor of the new Youth Orchestra which UNESCO has founded in Berlin.

"I have just built a new house on the Starnbergersee, near Munich, and in a few years' time I hope to hold regular master classes there. In the fall of 1977 I shall make a short tour of the U.S.S.R. with Sviatoslav Richter, I look forward to doing *Bluebeard's Castle* with Julia Varady, I've just recorded Schumann's *Genoveva* in Leipzig, and in 1978 I shall appear as King Lear in a new opera by Aribert Reimann. Oh, and one last thing. I have a studio in my new house, and I enjoy painting more than ever, so I won't promise not to have a little exhibition one day."

And so it is that at an age when many a very good singer is being politely encouraged to step down, Dietrich Fischer-Dieskau still has before him what he foresaw for himself in 1943: "a golden future."

# Lincoln Kirstein:
# In the American Grain

### The New York Times Magazine, 1982

*Though best-known as the co-founder with George Balanchine of the New York City Ballet, Lincoln Kirstein has a second, almost clandestine reputation as a master of a specifically American kind of prose—a taut, tight, fat-free investigatory idiom that he has applied to painting, sculpture, photography, and not least, to the great American President whose name he bears. This is someone who cannot bear to see his country sold short.*

One of the most valuable of living Americans turned seventy-five several weeks ago. His name is Lincoln Kirstein. Among many other cultural accomplishments, he persuaded the Russian émigré George Balanchine in 1933 to come to this country. Not only did he get him here, but he beavered away until the dream of a specifically American ballet company of the highest order had come into being. Without Kirstein, there would be no New York City Ballet today. Nor would there be the School of American Ballet to keep alive the tradition of St. Petersburg's Imperial Ballet School in which Balanchine himself was raised.

It is not merely that Kirstein conceived the idea of these two institutions, but that he nurtured them day by day, and continues to do so. Nor is this his only contribution to American awareness of the dance. Without the collections of dance memorabilia that he formed and presented (for which he has not sought acknowledgment), the Dance Collection at Lincoln Center might never have got off the ground.

Thanks to his own many-sided writings, and to his founding editorship of *Dance Index Magazine* between 1942 and 1948, the literature of dance in this country took on a new dimension. Anyone who reads his 1970 book, *Movement and Metaphor*, has a grounding in the whole history of the subject, from the court ballets of the sixteenth century to the masterpieces of our own day.

As much teacher as impresario, Kirstein set out to form both a great ballet company and an educated public, and he succeeded. He can feed people facts as skillfully as anyone now writing, but his genius as an educator lies rather in his ability to sum up a subtle and complicated subject in a simple declarative sentence. "Balanchine's ambition has ever been," he once wrote, "to make audiences see sound and hear dancing." We can read whole books about Balanchine and not come away with a sharper image of what sets him apart.

Not only does Lincoln Kirstein have talent for defining art, but he has perhaps an even greater talent for fostering it. It is as a threefold impresario—of dance, literature, and the fine arts—that he has done as much as anyone now living to raise his fellow Americans' level of awareness in these domains.

"My whole life," Kirstein said lately, "has been about trying to learn how things are done. What I love about the ballet is not that it looks pretty. It's the method in it. Ballet is about how to behave."

Somewhere within that notion of perfected behavior there is an implied autocracy. The manners that Kirstein prefers are traditional European court manners. "Balanchine is just the same," he will say. "He's an Imperial Russian. I'm an Imperial American." Even in his twenties, Kirstein conceived of the ideal world as one in which he would tell talented people how to fulfill themselves. In May 1933, for instance, he wrote to the poet Allen Tate: "I am trying to jockey myself into a position where eventually I can act as I like in relation to the employment or cooperation of the artists of this country."

Presumptuous as it may have sounded then, it worked. The young Kirstein could be irresistibly persuasive. If he was after something or someone, he erased the word "no" from the dictionary. And if he was *against* something or someone—well, it was best to hide under the sofa. (It still is, by the way. Kirstein's periodic rages add a new dimension to invective. Vast, thunderous, and unforgettably well expressed, they cause even the most intrepid listener to run up the white flag.)

Those rages are much talked of among Kirstein's associates. But they should be considered as a reversed image of the untold amount of selfless trouble he will take to help anyone in whom he believes. There is no way to compute the extent of his services both to the City Ballet and to the School of American Ballet. As director of the one and president of the other, his activities could be largely honorific. But, in fact, he has an office in both places and is forever wondering how to make them even better than they are.

"I've never met anyone more helpful and supportive when I'm doing a new work," says the choreographer Jerome Robbins who since 1949 has worked primarily with the New York City Ballet. "If he asks me what I'm up to, and I tell him, I know that by the time I get home, there'll be a pile of books on the doorstep, not to mention photos and relevant essays and research material. He grasps what I am about very fast, and then he gives me almost more than I can digest.

"He's also very acute in his reaction to individual dancers. He sees exactly what each one of them can bring to a particular work, and what it can mean to the whole perspective of a dancer's career. There are times when he can be as bewildering as anyone I've ever known, but he feels for dance in the deepest possible way, and what he has to say about it is wonderfully provocative, stimulating, and profound."

"He was just as scary then as he is now," the architect Philip Johnson said the other day on the basis of a fifty-year friendship. "But he had a power of concentration the like of which I've never seen. I can't tell you how he gets things done. He never seems to keep office hours. He spends half the day in bookstores. But backstage at the City Ballet, you find a perfection, an ease and a freedom from bickering that I've never found anywhere else. The City Ballet's in the black, too. Somehow or other, those two totally mad people, Kirstein and Balanchine, have been able to attract practical, day-to-day people who run the whole thing perfectly."

"It's not just a great ballet company," says the critic Susan Sontag. "It's an ideal community, with excellence as its only standard. It's a kind of Bayreuth, but without any of Bayreuth's—and Wagner's—pretensions. There's an ideal of pleasure in the New York City Ballet, but there's also an ideal of intellectual integrity."

Even at Harvard, so his classmate Edward M. M. Warburg remembers, "Lincoln maintained that the art form that could bring the most artists together in a single production was the ballet. For this, one could have composers, designers, choreographers, and dancers." But although he became closely acquainted with Diaghilev's Ballets Russes in London in the summer of 1922, when he was only fifteen, Kirstein did not commit himself fully to the ballet until 1933.

In literature and the visual arts, on the other hand, he was precocity personified. It was in 1927 that he founded the literary quarterly *Hound and Horn*, and as its editor until 1934 he produced what is still an exemplary "little magazine," whose contributors included T. S. Eliot, Ezra Pound, Edmund Wilson, and e. e. cummings.

Just after his twenty-first birthday in 1928, he joined forces with his classmates John Walker (later director of the National Gallery of Art in Washington) and Edward Warburg, soon to become a patron of the arts and philanthropist. Out of this came the Harvard Society for Contemporary Art. "With Eddie's money, Johnnie Walker's social contacts, and my brains there was just no stopping us," Kirstein said in an incautious moment some years later.

The society was meant to haul Harvard into the twentieth century in areas where it was woefully far behind. Modest in scale—it consisted of two rooms above the Harvard campus store, and the founders often had to double as both curators and guards—the society set up echoes that went way beyond Harvard. It was an astonishment to people all over the country that Picasso and Matisse were taken seriously at a great university. It was an even greater astonishment that Alexander Calder could arrive at the train station with three rolls of wire over his shoulder and produce in an evening a complete exhibition of wire sculptures. Could this, people asked, be art? And could it be

art when R. Buckminster Fuller showed prototypes of industrial design?

This was on every count a new kind of exhibiting society, and it turned out that there was an audience for programs of precisely the kind that were to be mounted a year or two later by the infant Museum of Modern Art in New York. "Make no mistake," Monroe Wheeler, a trustee of the museum, said recently, "the Museum of Modern Art began in Harvard."

No one—least of all, Kirstein himself—could say that Kirstein today is on the side of modern art. ("You must know that I loathe modern art," is one of his milder opening gambits.) For not one of the accepted masters of the twentieth century—from Matisse to the present day—does he now have a kind word. "Oblivion waits!" he will say when apprised of a record price for one of them at an auction. His unstinted admiration goes rather to painters who, like his lifelong friend and brother-in-law, Paul Cadmus, carry on the ancient tradition of working directly from the human figure.

When he writes about Elie Nadelman and Gaston Lachaise—sculptors he knew and admired for their mastery of the human figure, both male and female—he does it in a way that will never be bettered for originality of insight and beauty of utterance. In his writings on photography, moreover, he did the work of a pioneer. Faced with the then unknown Walker Evans, with Henri Cartier-Bresson, and with W. Eugene Smith, among others, he produced a long series of landmark definitions in articles and books.

In literature, he has had a complex career, and one that is by no means ended. Those of Kirstein's friends who looked into the mammoth autobiography on which he was engaged predicted that it would be to our time what *The Education of Henry Adams* and John Ruskin's *Praeterita* were to earlier generations. They also saw in it something of Walt Whitman's "attempt to put a Person, a human being, freely, fully and truly on record." (*Memoirs of a Sly Fellow* was Kirstein's working title for the book.)

It was as a poet that Kirstein first appeared in *Hound and Horn,* and it was as a poet that he produced an idiosyncratic contribution to the literature of World War II. Never was there a less pretentious poet than the author of *Rhymes of a Pfc,* a revised edition of which was published last year. He wrote in rhymed, diary form of a career in the United States Army that took him to England, to France at the outset of the Allied invasion, and deep into a Germany that was still well able to defend itself. (He also served for a time as Gen. George S. Patton's driver.) They look casual, those poems, but nobody ever picked a quarrel with W. H. Auden for saying that "as a picture of World War II, *Rhymes of a Pfc* is by far the most convincing, moving and impressive book I have come across."

But to most readers, Kirstein is best known for the strong and original utterance of his opinions on poetry, movies, theater, architecture, and—by no means least—what it means to be an American citizen. At a time when patriotic feeling is often dispersed and fragmented, he has consistently upheld a Homeric view of his nation's history.

Above all, the great President whose name he bears is his touchstone of civic duty. If, as the New York City Ballet's representative on the Lincoln Center council, he has watched the fortunes of the arts center with a ferocious and implacable attention, it is because he cannot bear the name of Abraham

Lincoln to be associated with anything that is misconceived, aborted, or second-rate. (His friends have noticed, however, that he feels an even closer identification with the center. After listening for some time to Kirstein on the follies and iniquities with which Lincoln Center had been afflicted, Igor Stravinsky once ventured to console him: "After all, my dear, it's still Lincoln's Center, isn't it?")

Kirstein in his seventy-sixth year is a mystery to most people, and has long been happy to remain so. "People have trouble figuring out who I am," he said the other day. "They can't make out if I'm a P. R. man for the City Ballet, or if it was all some kind of accident, or if I'm just a rich boy who tagged along. The fact of the matter is that I always knew what I wanted to do and I was very well prepared for it. I had a very good education—an amateur professional education of exactly the sort that I needed."

Kirstein was born in Rochester on May 4, 1907. He was the son of Louis Edward Kirstein, later to be a partner in Filene's, the Boston department store, and Rose Stein Kirstein. When he was five, the family moved to Boston, and he was reared to be "a proper Bostonian," drawing inspiration from three major sources. First was Charles Eliot Norton, who had taught the history of art at Harvard University from 1875 to 1898. Second was John Ruskin, the English moralist and esthetician who had proved that art could engage the highest faculties of mankind. Third was Mrs. Jack Gardner—Isabella Stewart Gardner—whose famous house in Boston's Fenway Court boasted as much great art to the square inch as many a major museum.

"My mother made a house that she thought was like Mrs. Gardner's," Kirstein recalls. "It was a big house, at 506 Commonwealth Avenue. It had a French room and a Chinese room, and it also showed a passion for neo-classical art—the kind that Napoleon loved. The walls were hung with green silk. There were Napoleonic bronzes everywhere, and designs by Percier and Fontaine, the architects whom Napoleon fostered, and pieces by Pierre Philippe Thomire all the way up the stairs.

"It was perfectly beautiful. Upstairs, my mother decided that she'd like a Chinese bedroom, done up in red satin slipper silk, and she got that made by a firm of decorators in Boston called Casson & Davenport."

Kirstein goes on: "Some people might have thought that the house was terribly nouveau riche, but I loved it. You have to remember that whereas my mother was born to money, my father was a poor boy. It was he who gave me my education and set me free. I owe everything to him. He went bankrupt three times before he was thirty, but he ended on top. My father sold eyeglasses on the road, and he did very well. Later, he went to work for Filene's in Boston, and in 1913 or 1914 they made him a partner."

The things that Lincoln Kirstein has been interested in came his way, every one of them, when he was a boy. He was ten when he first bought a picture, twelve when he first saw Pavlova dance, fourteen when his first play got into print (it was set in Tibet). And he was fifteen when he went to London, met John Maynard Keynes, E. M. Forster, Lytton Strachey, and the Sitwells and went every night to Diaghilev's Ballets Russes:

"They were all very sweet to me. Keynes was a collector, as well as the great economist of the day, and he took me to a lot of exhibitions. I'll never forget how

he pointed to some paintings by Gauguin and told me that although they were works of art, they were also negotiable securities. That was quite a new idea to me.

"And, of course, Keynes had learned a lot about dancing from being in love with Lydia Lopokova"—Keynes's wife, one of the great dancers of the Ballets Russes—"so I got to know the ballet at first hand. In everything that I have ever done, I have been able to talk to the people concerned on a professional basis, not as an outsider. That's the only way to get anything done. You have to know about art, but you have to know about craft, too.

"London was everything I liked best. My father encouraged me in that, as he did in everything. Ever since he went to Berlin and was pushed off the pavement and knocked down by Prussian officers because he was a Jew, he transferred all his feelings for Europe to London. The only time he ever told me not to do something was when I wanted to go to Germany in 1932. 'You just can't,' he said, and that was that.

"He was crazy about England, and about English ways. My father raised me on King Arthur, Robin Hood, David Balfour, David Copperfield, and Rudyard Kipling's Kim. Later, when he went to Europe for Filene's, he used me as a kind of model or pet. I was dressed by Anderson & Sheppard, the best tailor in London.

"My father taught me to present myself in a certain way, and I did. It was a wonderful education. Thanks to my father, I have never known what it is to be guilty about either money or sex. When I got out of college in 1930, he said, 'Look here, I'm going to leave you a lot of money. Do you want it now or when I die?' I said, 'I want it *now*,' just like that, and he gave it to me. That was the only way I could do what I have done. He gave me utter freedom, and I used it."

For many years now, Kirstein has lived with his wife, Fidelma, in a Manhattan town house that looks much like many others from the outside, though it is well known to the mailman for the huge parcels of new books from Heywood Hill, the London bookseller he prefers to any other.

A light sleeper since boyhood, he is generally padding around the house by 6:30 in the morning. He was always enormous, several inches over six feet tall and massively built. A bronze sculpture of him as a young man by Elie Nadelman makes us see how he could at one time have aspired to be heavyweight champion of the world. Advancing age has not shrunk him. Rare is the corridor in his house, and rarer still the staircase, that does not seem too narrow for his colossal frame.

"There's continuity in everything," he will say if asked about the superabundance of books, paintings, drawings, sculptures, objects of art, dimestore Japanese toys, and memorabilia of every sort in his house. "Everything in this house is didactic and serves a purpose." The furniture is spare but palatial, veering heavily toward the style of the First Empire in France. The harpsichord, by William Dowd of Boston, is dated 1963. The translucent lyre on the wall is by the sculptor Isamu Noguchi, and was carried by Orpheus in the Stravinsky-Balanchine-Noguchi ballet of that name. Something of theater permeates the ground-floor room that is lit by chandeliers and hung with swags of stage velvet the color of peach juice.

Oddities abound. Many are owed to the obsession with cats that has

prompted Kirstein to form what he calls "one of the world's largest collections of cattery." (On one occasion, he startled the board members of the New York City Ballet by proposing that it should be renamed the New York Kitty Ballet.) Live cats are present in undefined numbers, but they are upstaged by the multiform images of cats in two and three dimensions that fill a large part of the house. They even turn up on the music stand, where the score now most in favor is a Victorian duet for two high voices called "Two Little Kittens Lost Their Mittens."

Next in terms of numbers are the evocations of the dance. They range from a calling card that bears the name of "Serge de Diaghilev" to a Renaissance bronze of an acrobat, and from a Nadelman group of the dancers Vernon and Irene Castle to an Etruscan tripod with finely modeled legs and feet.

The theme of excellence is never far away. Kirstein could have grown up to be a moneyed fop who had nothing better to do with his life than to hang around antique shops and stroll down to the theater on fine summer evenings. But now, as in first youth, he is driven by the idea of excellence as a form of service to others. Like his friend, the English poet Stephen Spender, he can say with truth, "I think continually of those who were truly great." Whence the portrait of Voltaire by Houdon (the presentation model, as it happens, that Houdon made for Catherine the Great), the bust of the composer Gluck, the bust of Napoleon, and the photographs of W. H. Auden, E. M. Forster, Hart Crane, T. E. Lawrence, and others. Whence, likewise, the portrait-plaque of Robert Louis Stevenson by Augustus Saint-Gaudens.

For breakfast, he makes himself a cup of coffee, unless, exceptionally, he hurries along the street to a nearby burger shop for which he has a mysterious liking. After working for two or three hours on his memoirs, he dresses for the street in a costume that never varies: black suit, black socks, black tie, black shoes, white shirt. No one could guess from his appearance today that he is one of the few living men who have donated their vests to the collections of the Metropolitan Museum. "I long ago worked out," he once said, "that I would save a great deal of valuable time if I forewent that particular choice."

Then he takes a taxi to the School of American Ballet, which is housed in the Juilliard School of Music. Unlike most dance academies, this one is run on lines unchanged since George Balanchine studied at the Imperial Ballet School in St. Petersburg. (The bathrooms are better, though.) Much Russian is heard. And there are the great senior ballet mistresses who teach their classes with an unfailing old-style politeness and may well be dressed as if for luncheon at the imperial summer residence of Tsarskoye Selo.

On the way in from the elevator, the visitor can admire a wallful of colored engravings of St. Petersburg. Next comes a suite of rare prints of the great French early nineteenth-century mime Deburau. Finally, above the reception desk, there are some images from the heyday of nineteenth-century operatic stage design. There is a noticeable lack of fuss, racket, and bickering.

"We teach the kids good manners," Kirstein says of the school's approximately four hundred students, ranging in age from eight to about twenty. "This isn't the Imperial Ballet School, where they wore the same uniforms as the army and navy cadets and the czar gave every one of them a gold watch on graduation that insured them immunity from arrest. But we teach them court

manners. A ballet school is the most undemocratic thing there is, and there are three things they have to learn about this one. One is that there's no justice. The second is that they must never complain. The third is that they must shut up.

"This isn't the Royal Ballet School in England, where they all come away knowing how to play the piano and paint watercolors. Our kids are taught to have their brains in their feet. There may be one or two who've opened a book, but I've yet to meet them. Six hours a day on their feet—that's what they're here for."

Once past these rather daunting preliminaries, the visitor will find that Kirstein, when face to face with his students, radiates an uninhibited pride and affection. "What pretty feet!" he will say. "What a great tragic actress in the making!" "What an astounding boy! Really astounding! This is something we get once in every fifteen years!"

"People say that the City Ballet will fall apart when Balanchine dies," Kirstein says. "Like bloody hell it will! Peter Martins could run this company for the next fifty years and make it better than it's ever been before." (Martins, now ballet master and a principal dancer with the company, is widely regarded as Balanchine's most likely successor.)

At some point in the morning, Kirstein will have made a rendezvous for lunch at a restaurant not far from the Juilliard School. For the newcomer, this may prove a formidable occasion. Not long ago, one of his oldest friends was lunching with him. Halfway through the meal, Kirstein put down his knife and fork, got up from the table without a word, left the restaurant and high-tailed it up the street. Fearing that Kirstein was not well, his friend ran after him. "What's the matter?" he said. "Why did you get up and go so suddenly?" "Because you bore me," said Kirstein without stopping or turning around.

Limitless by contrast is the generosity with which he will treat anyone in whom he sees a gleam of talent. "It's simply overwhelming," said Robert A. Gottlieb, president and editor-in-chief of Alfred A. Knopf, the publishing company, who gives much of his spare time to the affairs of the New York City Ballet, of which he is a board member. "He has the true aristocratic approach to talent. He does exactly what has to be done, without question. He doesn't want a payoff. There's nothing in it for him, and he doesn't want anything. Nor does he feel resentful or belittled if nothing comes of it. He doesn't invest—he gives."

Nor is it just money that he gives to the City Ballet and its school, or to the many gifted young people in the arts whom he has helped individually through the years. It's opportunity. Writing about the photographer Walker Evans in 1974, Lloyd Fonvieille noted, "Kirstein, whose ubiquitous midwifery is traceable through so much that is fine and indispensable in twentieth-century American culture, was an undergraduate at Harvard when Evans met him. In the winter of 1931, Kirstein, then twenty-four years old, proposed a plan to record the surviving Victorian architecture of Boston, and in the spring of 1932 he assisted Evans in carrying the project out. Kirstein's practical aid was of less importance to Evans than the example of his disci-plined intellect, his capacity for excitement over the lessons of tradition, and his conception of the past as a dynamic incitement to new, living art."

What Walker Evans said about their partnership was more revealing: "What happened was that this undergraduate was teaching me something

about what I was doing. It was a typical Kirstein switcheroo, all flash, dash and a kind of seeming high jinks that covered a really penetrating intelligence about, and articulation of, all esthetic matters and their contemporary applications. The man was essentially explaining to me what I was doing in my work. It was immensely helpful and hilariously audacious."

Later, and partly in collaboration with the writer James Agee (a class-mate of Kirstein's at Phillips Exeter Academy), Walker Evans did the work for which he is most often remembered—an unsparing but ever compassionate survey of American society during the Depression. It prompted Kirstein in 1938 to make as intelligent a pitch for the role of photography in our times as had yet been made in print. "After looking at these pictures," he wrote, "with all their clear, hideous and beautiful detail, their open insanity and pitiful grandeur, compare this vision of a continent as it is, not as it might be or as it was, with any other coherent vision that we have had since World War I. What poet has said as much? What painter has shown as much? Only newspapers, the writers of popular music, the technicians of advertising and radio, have in their blind energy accidentally, fortuitously, evoked for future historians such a powerful monument to our moment. And Evans's work has, in addition, logic, continuity, climax, sense and perfection."

In writings such as these, Kirstein operates as an insider who can talk with his subjects as peer with peer. But he is also the radiant outsider who brings the whole of human history to bear upon the photograph, the sculpture, the poem, the rare moment in the theater, the passage of prose. Everyone today admires the photographs of Henri Cartier-Bresson, for instance. But who else has written about him like this?

"It is inescapable," Kirstein wrote in 1947, "that Cartier-Bresson's attitude is French, for he is a Frenchman, and a certain sort of Frenchman. It has been said of him that he is 'a Protestant Jesuit.' And he does exude a flexible rectitude, a supple censure; coolness, a knowledge of how this world is run, and who runs it, and with that sense of irreducible morality that is normal to all lovers of Stendhal and Saint-Simon. The courts of Napoleon I and Louis XIV were magnificent academies of social realism. They established and main-tained the taste of the world in fashion and politics. These were, hereditarily, Cartier-Bresson's schools, too, and in them one hears the basic logic and wisdom of the West: how men say they behave, how they pretend to behave, and how they do behave; what 'stands to reason'; what is 'common sense'; what is, ultimately, true. For Cartier-Bresson is a moralist. He is not interested, ultimately, in the propriety of an ethic, but in *les moeurs*, the actual, essential behavior of men."

Looking at the voluminous diaries that Kirstein has kept for many years in a neat, clerkly hand, one soon realizes that he too is concerned with "the actual, essential behavior of men," whether in history or in the life of every day. Take his reverence for Abraham Lincoln. "The superiority of Abraham Lincoln over all other statesmen," he wrote not long ago, "lies in the limitless dimensions of a conscious self, its capacities and conditions of deployment." But he doesn't care to see Lincoln inflated into a divinity. For that reason he rates Augustus Saint-Gaudens's standing figure of Lincoln very high indeed.

"In it, we see the Lincolnian self, capable of delay, double talk, maneuver,

hesitancy, compromise, in order that the one prime aim of his own era be effected: preservation of Federal union. It was Saint-Gaudens's genius to present him not as a romanticized rail-splitter, a synthetic Honest Abe, War Lord, Liberator, but as politico-President, scientist of the possible, an executive of the human race, who with supranormal ability managed the chaotic affairs of other humans." Kirstein's greatest wish at the moment is that one of the existing casts of the sculpture should be erected somewhere in Lincoln Center. "Would you believe it?" he will say. "I've raised the money. The sculpture's ready to go. John Pope-Hennessy at the Met says it's the finest standing figure of the nineteenth century. We have nothing of Abraham Lincoln in Lincoln Center. Isn't it an outrage? Doesn't it make your blood boil for the stupidity of it?" (Casts of the sculpture can be seen in Lincoln Park in Chicago and at the former home of Saint-Gaudens in Cornish, N.H.)

As impresario, editor, organizer of exhibitions, and balancer of the City Ballet's books, Lincoln Kirstein has had every opportunity of "managing the chaotic affairs of other humans." The more remarkable the other human being, the better he is at it. In that respect his correspondence with Stravinsky is of great fascination. When Kirstein and Balanchine were feeling their way toward what later became the ballet *Agon*—one of the great achievements of Stravinsky's seventies, and one of the two dozen Stravinsky works presented in the company's just-concluded Stravinsky Centennial Celebration—he floated the idea for Stravinsky in the following terms:

> George would like a ballet which would seem to be the enormous finale of a ballet to end all the ballets the world has ever seen—mad dancing, variations, *pas d'action, pas de deux*, etc., with a final terrific and devastating curtain when everyone would be exhausted. He suggested a competition before the gods; the audience are statues; the gods are tired and old; the dancers reanimate them by a series of historic dances, the correct *tempi* of which you can quite ignore, but they are called *courante, bransle, passepied, rigaudon, menuet*, etc. It is as if time called the tune and the dances which began quite simply in the sixteenth century took fire in the twentieth century and exploded.

A smaller composer might have fussed over a commission that was at once so extravagant and so precise. But although *Agon* did not turn out quite as Kirstein had suggested, Stravinsky was delighted with the general approach. "Limits are precisely what I need," he wrote to Kirstein, "and are above all what I am looking for in everything that I compose. The limits generate the form."

As will by now be clear, Kirstein is a man who falls completely, recklessly and, as it seems, irrevocably in love with people, ideas, books, buildings, and projects of all kinds. But he also falls out of love from time to time, and with a vehemence that never ceases to startle. Sometimes, great institutions catch it. "Harvard taught me how to use a library," he will say. "The rest was zilch." Sometimes, it is primarily a matter of common sense—something that he learned a long time ago from Virgil Thomson, the composer and critic. "He undazzled me," is Kirstein's way of summing up Thomson's influence. "No one has understood the politics of the lyric theater, or painting, or musical institutions better than he."

But Kirstein's undazzlement—whether with people, ideas, institutions, or

works of art—proceeds from something stronger than either calculation or whim. There is in those terrifying rages something of horror at what he calls "the detestable nature of man," and something of outrage that a fellow human being should have fouled a great opportunity. To have the potential for life, liberty, and the pursuit of excellence and not be worthy of it! That may well be the nightmare that prompts those Lear-like outbursts. But if we look at what Lincoln Kirstein has done and is doing with his life, we know that this particular nightmare is one from which he will always awake.

# John Pope-Hennessy

*Foreword from* John Pope-Hennessy: *A Bibliography, compiled by Everett Fahy. Metropolitan Museum of Art/Ecco, 1986*

*As an art historian with a shelf of books to his credit, and as the onetime director of the Victoria & Albert Museum and the British Museum and consultative chairman of the Department of European Paintings at the Metropolitan Museum, John Pope-Hennessy has never been idle. What is less well known is the range of intellectual curiosity, the potential for lifelong friendship, and the gift for indiscretion (much muted here) that makes his company so much coveted.*

Bibliographies make dull reading, some people say, but I have never found them so. They remind us, they prompt us, and they correct us. They double and treble as history, as biography, and as a freshet of surprises. They reveal the public self, the private self, and the buried self of the person commemorated. How should we not enjoy them, and be grateful to the devoted student who has done the compiling?

A bibliography is the more welcome when its subject has led so active a public life, and published so many books that lasted so well, whereas his occasional writings have for the most part vanished from view (though not from memory). That is the case with John Pope-Hennessy, whose far-scattered articles and reviews may almost be said to constitute a clandestine autobiography. That they should be put in order, and listed, and eventually republished in one form or another, may be a project that he himself would do nothing to advance. But what Everett Fahy has begun with a four-years' labor should

have its sequel, for this is a case in which the buried self, the public self, and the private self need to walk side by side.

It was a happy day for New York when the Metropolitan Museum and the Institute of Fine Arts persuaded John Pope-Hennessy to come to their city with a double-headed appointment as consultative chairman of the Department of European Paintings at the Met and professor of art history at the Institute. That appointment took effect on January 1, 1977, and New York has been livelier ever since for the omnipresence of that elongated silhouette, those restless, energized movements, and that unmistakable swooping utterance.

J. P.-H. at that time had already had several careers in one. His first book, on Giovanni di Paolo, came out in 1937, when he was twenty-three. His second book, on Sassetta, came out two years later, when he was twenty-five. They ruffled some elderly feathers by their fearless maneuvering on terrain staked out many years earlier by Bernard Berenson, and J. P.-H. himself came to think that he was operating on "a dangerously narrow front." But the unfeigned aplomb, the apparent ease of statement, and the radical character of the investigations made it clear that this was a new person, in a new time, who would have new conclusions to offer on whatever subject he chose to address. This, if ever, was someone who would write what a character in the novels of Ivy Compton-Burnett describes as "Real books coming out of our heads! And not just printed unkindness to other people's."

Those books did indeed come out, and happily for us they are still coming out, close on fifty years later. If they are not listed in this foreword, it is because anyone who picks up this bibliography is likely to have their titles by heart. There are essential areas of Italian art in which not to have read John Pope-Hennessy is to be an ignoramus. So perhaps we can turn to J. P.-H., servant of the public. He could have had an agreeable and constructive life as an independent scholar. Accountable to no one and free to go where he liked and stay there as long as he wanted, he could have produced as much or as little as pleased him. But when he came down from Oxford, he spent six months at the National Gallery in London, traveled on his own for two years in Europe, and then opted to work in the Victoria and Albert Museum, where he dealt with English portrait miniatures, English watercolors, and the large holdings of John Constable. His career in the V. & A. was interrupted by World War II, and when he was persuaded to return there in 1945 he agreed to do so on condition that he was assigned to a department of which he knew nothing whatever.

In considering these choices, it is important to remember that, although J. P.-H. has an all-seeing eye for the current state of the world, he is the child, as are we all, of a particular moment in time. Lodged way back in his consciousness is the state, or non-state, of art history in England as it had existed not long before his birth. "In England in the first decade of this century," he once wrote, "art history was an unfamiliar, and almost exclusively academic discipline, its techniques appeared unscientific and its findings seemed provisional, and the temptation was to relapse into a *non possumus* approach to every problem as it arose."

It should also be remembered that in first youth J. P.-H. did not take to Bernard Berenson, as to whom he later revised his opinion. ("I found the whole atmosphere at I Tatti *mondain* and unprofessional," he said in 1982. "One

is a great prig at that age.") A national museum, by contrast, offered a middle ground between the solitude of the independent scholar and the give-and-take of teaching, in which the element of oral communication is so demanding as to put the act of writing out of mind. Conceivably, also, J. P.-H. was—as he himself said later—"influenced by the facilities I was myself accorded at the age of eighteen in the Kaiser Friedrich Museum in Berlin. They still seem to me to set a standard of which we today should not fall short." Even with Hitler already on the rampage, a great German museum could foster freedom of enquiry.

European museums were staffed, then as now, by professionals. As is well known, J. P.-H. never had any formal training in art history, felt his way into the subject, never thought of putting in for a Ph.D., and is, in fact, a self-taught scholar. It could have made for a rambling, amateurish turn of mind, and one that would have left him on the fringe of the world that interested him. But, as he once said, "I was born in the middle of the world I was meant to be born in. I was brought up with Italian paintings and a great many Chinese objects, among other things. My parents were friends of, for example, the director of the Victoria and Albert Museum, of collectors, and of many other people interested in art." It is also pertinent that his mother, Dame Una Pope-Hennessy, passed on to him the standards of accuracy and clarity of statement which distinguish her books on the French Revolution, early Chinese jades, and Charles Dickens. As the son of someone who detested slipshod work, J. P.-H. was never in any doubt as to the foundations on which worthwhile history should stand. "It is the inadequacy of the historical backgrounds of many scholars that limits their usefulness as art historians. I was never trained as an art historian, but I was trained as a historian (at Balliol College, Oxford) and a pretty rigorous training it was."

It is also important that the element of so-called chance always seems to have been in his favor, and that he acted upon it with his habitual pertinacity. He himself dates his preoccupation with art history to a moment in 1926 when he was walking along Connecticut Avenue in Washington, D.C., where his father was military attaché at the British Embassy. He stepped aside into a bookstore and came out with Crowe and Cavalcaselle on North Italian painting. At Downside, the Roman Catholic school that he went to in England, his interests were encouraged by the Abbot of Downside, Dom John Chapman, and he collected as prizes the six-volume *History of Painting in Italy* by Crowe and Cavalcaselle and Bernard Berenson's *Study and Criticism of Italian Art*.

In 1931, as a schoolboy, he was sent to see Kenneth Clark, who was twenty-eight at the time and became in 1933 the youngest-ever director of the National Gallery in London. Anyone who heard, or has read, J. P.-H.'s address at the memorial service to Lord Clark in London in October 1983 will know that this meeting was an inspired move on the part of Logan Pearsall Smith, the American expatriate writer who had engineered it. With hindsight, we could name three separate counts on which Clark had the best of influences on J. P.-H. There was Clark's ability—manifested in 1939 by his book on Leonardo da Vinci—to present some of the highest and most complex of human achievements in terms that were both lucid and authoritative. There were his exceptional capacities as a museum man. ("At his touch," J. P.-H. said in his memorial

address, "the then inert hulk of the National Gallery in London sprang to life.") With these, there were a highly developed sense of the human comedy and a disposition which was defined by J. P.-H. when he said that Kenneth Clark "quite legitimately preferred the company of people who were talented, in no matter what field, to the company of untalented professionals."

Unpredictable encounters of an impersonal sort also played their part in his early career. He well remembers, for instance, the Sunday in 1938 when—hard at work on his book on Sassetta—he drove down to lunch at Ashburnham Place in Kent. He arrived late. Lunch had already begun. He sat down in some embarrassment in his appointed place. He looked up, and what did he see on the wall but an unmistakable Sassetta—a predella panel that is now in the Detroit Institute of Arts. This is the kind of thing that makes us believe that he was indeed born into the middle of the world that he was meant to be in.

When J. P.-H.'s New York appointment was announced in 1976, I summed up his activity before World War II by saying that "he read, he traveled, he looked, he wrote. That's all there was to it." I was wrong, of course. There was much more to it than that. Not only did he read, travel, look, and write, but he listened. He had, beyond a doubt, his own way of setting about his activities. (Asked to account for the choice of a subject for his first book, he said "I looked at the literature of Sienese painters to find which of the artists I liked was in the greatest muddle. The answer was Giovanni di Paolo.") But in the foreword to his *Essays on Italian Sculpture* in 1968, he put his development in a broader and deeper perspective:

> Though art historians, like other people, cherish the illusion of free will, their course is set by forces external to themselves; they are controlled by guardians like those in Eliot's *Cocktail Party*. A concern with attributions was instilled in me by early visits with Evelyn Vavalà to the Accademia in Florence, where one learned to distinguish the chubby children of one artist from the chubby children of another. At Assisi I was admitted by Perkins to the sodality of students of Sienese painting. My books about Italian sculpture grew from seeds sown by Jenö Lanyi before the war, and my interest in small bronzes goes back to lunch-time conversations with Saxl about Riccio's works at Padua. One of my most vivid memories is of reading for the first time at Oxford *Italian Primitives at Yale University*. From the perspective of today it seems to me that I owe more to the constructive discouragement of Offner than to the encouragement of other scholars, with the exception of Berenson, to whom my debt is greater still.

Anyone who follows up the leads in this bibliography will be able to add other, later names to this list. J. P.-H. can be memorably dismissive of art historians and curators who fall short of his own standards, but he is both ardent and tender in defense of those who do not. Only a month or two ago he described how, shortly before World War II, he decided that "it was not only works of art that needed to be looked at in the original, but art historians too, since their results were a projection of their personalities. So for some years I made meeting art historians a secondary occupation."

> When I read *The Development of the Italian Schools of Painting,* I can still recall Van Marle's brainless bonhomie. When I read Max Friedländer, I see a frightened face peering out in 1938 from the grille of a door in the Keith-

strasse, and when I read Antal I still hear the sound of his gentle, dogmatic, unpersuasive voice. In the first half of the nineteen thirties art history in England was still synonymous with connoisseurship, but through German and Austrian emigration this situation changed, and the field was enriched by scholars of the calibre of Rudolf Wittkower and Edgar Wind and Johannes Wilde and Otto Paecht. With the advent of the Warburg Institute, the subject took an unprecedented depth, and its director Fritz Saxl was singlehandedly responsible for transforming dilettantish scholars of my generation into professionals. During the war I developed a Platonic relationship with aeroplanes (a useful training in accuracy if nothing else), and the occasions I recall with greatest pleasure are the weekly lunches I had with Saxl in Soho discussing the Renaissance portrait medal and the iconography of Riccio's Paschal candlestick.

As to that, the readers to whom this bibliography is primarily addressed may well be alert to every nuance. They will have his books on their shelves, and they will know that he has been director of both the Victoria and Albert Museum and the British Museum, and that at one time or another he has seemed to many good judges to be the predestined next director, first of the National Gallery in London and later of the Metropolitan Museum in New York. It would be difficult to name any other man whose name comes so often to mind in relation to four of the greatest museums in the English-speaking world. (I should add that the National Gallery of Art in Washington, D.C., is also believed to have made him what it regarded as a tempting offer.)

But this bibliography is concerned to a large extent with the buried Pope-Hennessy—with the author, that is to say, of articles and reviews which have been coming out in this journal or that for more than fifty years but have rarely been reprinted. There are hundreds of these articles. Not even their author has a complete set of them, and if it had not been for Everett Fahy we should never be able to track them down on demand—all the more so since many of the best among them were written for the *Times Literary Supplement* during the years when contributions to that bastion and epitome of English civilization were never signed.

People sometimes regard writings of that kind as ephemeral, by their very nature. They also see them as insubstantial, by reason of the rapidity of composition that is often called for and the lowering of the intellectual sights to which writing for periodicals is said to lead. The "learned article" is one thing, on this reading, and the ad hoc estimate quite another. It is not a reading that will survive the perusal *in extenso* of the articles listed in this book.

These prove, on the contrary, that the collected occasional writings of half a century and more can act as the light cavalry of ideas—darting this way and that, turning up where and when they are least expected, hoisting the flag of truth and beauty where we most need to see it, and not seldom taking an adversary by surprise and leaving him dead on the ground.

They also prove that J. P.-H. at the age of eighteen was already very much the person he is today. Reviewing Clive Bell's *An Account of French Painting* in *The Downside Review* in 1932, he noted the "high percentage of *marivaudage,* as Mr. Bell would doubtless prefer it termed" which the author had allowed himself. Reviewing Sacheverell Sitwell's short study of Mozart, he called it "strangely out of date" and regretted that the author should have

missed both the "extraordinary expansion of the rondo form in the D minor piano concerto" and the way in which the minuet in Mozart's G minor quintet is "at least half way along the road from Haydn to the great minuetto in Brahms's A minor quartet." These are not the attitudes of a beginner.

A day or two after his twentieth birthday he began to write for *The New Statesman and Nation,* which at that time was the leading intellectual weekly in England. I shall forbear to name the study of English painting in which J. P.-H., on December 30, 1933, found all too many "anecdotes selected with an unvarying eye for the irrelevant." (When one of the authors in question was rash enough to write a letter-to-the-editor in reply, J. P.-H. wrote from Balliol to remark that the author seemed to claim for himself "an automatic exemption from the obligation of accuracy and coherence on which a better-educated public might insist.")

One of the privileges of London life in the 1930s was the succession of major winter exhibitions at the Royal Academy. In April 1934, J. P.-H. wrote a review of the English art exhibition there in which he displayed for the first time a gift for concise, forceful, and unhedged summations that last very well. There were not many people in 1934 who would have said of George Stubbs that he was "not primarily a sporting painter," but someone "to whom we can give unstinted admiration." Already firm in his likes and dislikes, he said that "as a painter, Hogarth cannot be over-rated. He has speed and animation, accomplishment and wit." And if there were bad paintings in the show, as there certainly were, J. P.-H. responded to them in a way that shows him to have been already in 1934 what he was to be all his life—a student above all of the creative process. "Even the bad picture is a key to the past," he wrote. "The fault is ours if we refuse to use the lock into which it can be fitted."

Other judgments from the 1930s demand to be lifted from their context, so briskly do they show to what an extent J. P.-H. in first youth was on top of his tasks. In December 1936 he said of Berenson's *Lists* that in 1932 "as now, the book seemed to have achieved an astonishing equipoise between the dangers of over-rigid scholarship and inclusion for the sake of mere inclusiveness." Nor did he hesitate to make judgments that still strike us by their boldness—that Gainsborough's *Drinkstone Park* was "the nearest thing that I know to alchemy in painting," for instance, or that "in many respects, Raphael apart, Seurat is the most remarkable artistic phenomenon there has ever been."

If he did not write often on Italian old master painting, it was doubtless because the subject rarely came up in the context of the London exhibition schedule. (Nobody seems to have asked him to write on the old master exhibitions—some of the greatest things of their kind ever held—that were organized in Venice in the 1930s.) Like everyone else who saw it, he recognized the exhibition of seventeenth-century art at the Royal Academy in the winter of 1937–38 as one of the landmarks of a lifetime. "During the 17th century," he wrote, "the use of oil paint...attained a fluency, a subtlety and a strength, on which no advance has been or ever can be made.... The art of the 18th and 19th centuries under one aspect is nothing but a struggle to maintain a standard the 17th century had set."

Anyone who feels that I have overstressed the element of combative generalization in J. P.-H.'s occasional writings has only to turn to the series of

international surveys of "Recent Research" which he contributed to *The Burlington Magazine* over many years. This was an activity in which an Edwardian *non possumus* was out of the question. Whatever had been written, on no matter what subject, had to be read. Once read, it had to be assessed. The author might be English, American, French, German, Swiss, Italian, Belgian, Dutch, or Spanish. The subject might be close to J. P.-H.'s own particular interests, or it might not. Either way, he went ahead. The pressures of World War II found no reflection in these surveys. Even when he was working full-time in the British Air Ministry, J. P.-H. gave the same unhurried, even-handed treatment to subjects and authors from all over. We may also salute, at a more than forty years' distance, the steadiness of mind with which he wrote, for *Art in America* magazine early in 1943, a stringent and unsentimental account of certain minor works of art relating to Pisa and Siena which were in his possession. No one could possibly have inferred from this that Great Britain and Italy were at war on Italian soil and that the very survival of those two cities was in jeopardy.

By 1943, the state of Europe was such that the authors discussed in "Recent Research" were almost all American, and thereafter there was neces-sarily a silence until July 1946. When something akin to normal life was resumed, articles came flooding in once more. Up to twenty-eight at a time were summarized and assessed until well into the 1950s—by which time anyone less curious, less energetic, or less conscientious would have long ago turned over the job to someone else. The effect in dark times of these deft and multifarious estimates has not been forgotten.

In the many articles that J. P.-H. contributed to the *Burlington* in those gruesome years, he treated the life of the mind as an international continuum that should be interrupted as little as possible. With France waiting passively for the German invasion, he published an article in the *Gazette des Beaux-Arts* on Georges de la Tour. When England and Italy were at war, he discussed the marbles in the Boboli Gardens as if it were still possible to drop everything and go over to see them. Nor was he forced into inactivity by the starveling visual diet that was available in England between 1940 and the end of the war. He looked, he thought, and he wrote, no matter how thin the pretext might be.

It came as a surprise to many people that when Matisse and Picasso made their reappearance in liberated Paris at the Salon d'Automne in 1944, one of the first English visitors to comment upon it was J. P.-H. Where others were disoriented by the experience, he spoke in particular of a still-life by Matisse "whose rich harmonies and classical structure lend it much of the significance which a middle period Titian would have had for the mannerists of the later cinquecento." He also said that Matisse was "the painting of yesterday, while the vital, often repellent pictures of Picasso are the painting of today." This might have been an isolated response to an altogether exceptional occasion, but in point of fact J. P.-H. knows more about what is going on in the world of new art than almost anyone among his contemporaries.

He has also had, on occasion, an exemplary patience with writers whose approach to great art is unprofessional. "Non-professional" might be a better adjective for Adrian Stokes, the English aesthetician who published a book on Venice in 1945. There were those in the profession who dismissed it out of hand.

J. P.-H. was not among them. Admittedly, he wrote that "One would judge Mr. Stokes to be almost entirely deficient in the gifts required on the one hand for constructive aesthetic thinking and on the other for original professional study. He has neither a respect for logic nor a capacity for logical expression." "But," he went on, "he possesses intuitions in their way as important as any of these—intuitions which might, if left to themselves, make him the most vital, the most delightful and perhaps the most significant contemporary esthetic commentator. He can write, and he can feel." Sharper by far was his dismissal of an Italian colleague, around the same time, for having produced "a thrice-refined pabulum of transcendental moonshine."

As will by now be clear, J. P.-H. has at no time in his career been "a specialist" in the narrow, confining, almost fortified sense of the word. There was a time, for instance, when his chief academic interest was Dark Age and Carolingian history. "So strong was it," he wrote recently, "that when I first went to Milan in 1933, my prime objective was the treasury at Monza (with the baskets in which Theolinda thought the loaves and fishes had been distributed) not the Brera Gallery or Leonardo's *Last Supper*." This was the stage in his life at which the free-thinking readers of *The New Statesman and Nation* learned from J. P.-H. that "The ninth century was a period of transition. Its Alcuins, its Theodulfs, its Walafrids sound the death-rattle of a classicism garrotted by St. Gregory." "Was it a matter for regret?" he went on to ask, and we may wonder how many of his readers were competent to reply.

After World War II it was in conversation, more often than in print, that he manifested his gift for the concise plain statement that lands where we least expect it. Readers did however glimpse it from time to time—as when he wrote in 1945 of the period (during the heyday of Turner and Constable) when "the center of gravity of western painting was in London and not in Paris or Rome or Madrid." More provocative than many an hour-long seminar was his thirteen-word reference in 1950 to "Holbein as he was, earnest, fertile and humane, in all his mysterious complexity." In 1952 he suggested that "modern painting began in May 1432, when the *Adoration of the Lamb* was set up in Ghent—the first work in which the retinal reactions of the artist to perceived reality are recognisably our own." In 1953 we treasured especially a passage in his review of the exhibition of Lorenzo Lotto in Venice: "How strange...that the patrons of Titian and Palma Vecchio should not have welcomed with enthusiasm those glazed figures wrapped in printed paper, those angels with green hair, those saints with electric-blue boots advancing resolutely from their frames!"

Even so, people persisted in trying to pin him down, although he sometimes gave them the slip with an allusion that not every professional would recognize. (That Tintoretto around 1580 reminded him of "angle shots by a Cinquecento Carol Reed" was one such.) Meanwhile, international recognition came. When J. P.-H. was in his early thirties, Roberto Longhi had this to say about his studies of Sienese painting: "Il Pope-Hennessy nel suo recente libro sul maestro (Sassetta) ha finalmente avuto la decisione di rilevarne i molti e precoci fiorentinismi, togliendolo così da quell' atmosfera pseudobuddistica in cui lo avevano lasciato gli studi decadentisti precedenti."

But, even as that was being written, J. P.-H. was reminding his readers that "Were a poll to be taken of the six most beautiful paintings in the world, the

Vienna Vermeer would surely find a place on every list." And in 1975 he said of the *Three Ages of Man* by Titian, now on long loan to the National Gallery of Scotland, that "I would rather own this painting than any other picture in the world.... The pragmatism of the 'Georgics,' the mythology of the 'Metamorphoses,' the philosophy of the 'De Rerum Naturae'—these and much else lay below the surface of Titian's consciousness."

These divergences from specialization notwithstanding, J. P.-H. has always known when to concentrate, and he has also always known that concentration means having the original works of art near at hand. "You can't study sculpture from photographs," he told two visitors from Rutgers University in 1981. "The only way to study sculpture is to touch it, see how deep the cutting is, the exact nature of the modeling, and all that sort of thing. The precondition of everything that I have written about sculpture was to live, day in, day out, for twenty-two years with a collection of Italian sculpture and a very large cast collection."

Yet concentration and specialization are two different things. "I benefited very greatly," he said not long ago, "at the Victoria & Albert and at the British Museum from the obligation to get on terms with unfamiliar media and cultures and areas of study; one learned to take Victorian brass lecterns and filthy plastic bags containing the mummies of Peruvian children in one's stride."

Though now relieved of that particular obligation, J. P.-H. is as reluctant as ever to stick with what he already knows. The logbook of a recent two-week motor-journey in France gives some indication of this. Having traveled relatively little in France, J. P.-H. was determined to correct that lacuna. Day by day, the tally mounted. Goya in Agen and Castres, Romanesque architecture in Souillac and Conques and Moissac, the burial place of Saint Thomas Aquinas in Toulouse, Ingres in Montauban, the Musée Stendhal in Grenoble, Toulouse-Lautrec in Albi, Domenichino in Béziers, Courbet in Montpellier, the Maison Carrée in Nîmes, Laurana in Avignon and Marseilles, the *Coronation of the Virgin* in Villeneuve-lès-Avignon, a fake Donatello in the Lapidary Museum in Avignon, Rubens in the cathedral in Grasse, Uccello in Chambéry, and the basilica of Saint-Maximin-la-Sainte-Baume, where Mary Magdalen is buried—all these and much else were scrutinized. As a rare concession to "relaxation," J. P.-H. spent one afternoon in Arles in front of a television set, watching the finals of a lawn-tennis tournament.

As in much else that J. P.-H. does, there was something in all this of Bernard Berenson in his capacity as reader, sightseer, and cross-cultural mediator. The Berenson who had read everything, looked at everything, been everywhere, and talked to everyone is not a stranger to the subject of this bibliography, either as a human being or as an exemplar. Throughout his very long lifetime, Berenson was a controversial figure—adulated by some, detested by others. (J. P.-H. first heard of him when his mother took him to tea with Helen Clay Frick in the summer of 1927, and Miss Frick happened to say "Berenson. Never let me hear the man's name again.") Alike in conversation and in print, he heard the arguments for and against B. B. over and over again.

And then, from 1945 onwards, he and B. B. became friends. In his own words, "I owe more to this association than to any other professional relation-

ship....The most important thing I learned was that a stable system of value judgments was the tent pole of art history."

Many items in this bibliography bear witness to his feelings for B. B. Together, they constitute an elegy none the less poignant for the informality of its presentation and its dispersal among articles now not easy to come by. I think especially of the review, dated August 28th, 1953, of the new edition of Berenson's *Venetian Painters of the Renaissance*, first published fifty-nine years earlier. As in his own work, J. P.-H. takes the emphasis away from the historian and directs it toward the work of art. "The last word," he said, "rests with the work of art, and ultimately it is the work of art that passes a favorable verdict upon Mr. Berenson, and an unfavorable verdict upon writers whose esthetic judgment operates on a more superficial plane."

Unlike certain other people, on the other hand, J. P.-H. has taken care to differentiate himself from Berenson, much as he admires the intellectual energy that prompted B. B. to say, when he was eighty-eight, that he would be prepared to make a new edition of the Florentine lists on condition that he could take every decision about an attribution as if he had never taken it before. This is what J. P.-H. said in 1981:

> Berenson declared on more than one occasion that almost everything that he had published was written from the standpoint of the consumer, the person who looks at works of art. My own bias is the opposite; I try to look at works of art from the standpoint of the producer, to understand the way in which the work of art developed and why it took the form it did. With the study of Italian sculpture there is no second option. So long as it remains a matter of comparing one finished sculpture with another, all solutions are approximate. The valid comparison is not between two finished sculptures but between the processes by which they were produced.

As between J. P.-H. and Bernard Berenson, we are entitled to point to another difference. B. B. did his work in the field, on the hoof. When he came back, it was to his own library. He never taught. He never worked in a museum. He never organized, catalogued, or installed an exhibition. J. P.-H. has done all these things, and he has done them in such a way that his work in retrospect seems to have been all of a piece. In recent years, his books on Luca della Robbia and Benvenuto Cellini have spoken for him, but so has the reinstallation of the European Paintings galleries at the Metropolitan Museum, where every least label seems to bear his mark.

He has done the work of a connoisseur, a detective, a moralist, and a teacher. There have been occasional pieces, like the examination of Roger Fry's record at the Metropolitan Museum, in which he has set history to rights in ways that called for the narrative skills of novelist and biographer. And there was his account of the exact state of affairs in Florence not long after the catastrophic flood of 1966, in which an apparently impartial auditing had overtones of Daniel Defoe's *Journal of the Plague Year*. Yet how many of those who pick up this bibliography will know where to find the one, or in which issue of the London *Financial Times* to look for the other? At those times, and on many another occasion here recorded, J. P.-H. was the necessary human being who said what had to be said. And that is what makes this, in its turn, a necessary book.

# II.

# THEY SAY LIFE'S THE THING

This group of pieces about books and their writers is predicated on the remark of Logan Pearsall Smith that "They say life's the thing, but I prefer reading."

# Pleasure in Reading

### The Times, London, 1962

*This was part of a long-running series in* The Times *in which people of every kind discussed what they most liked to read. Like every such essay, at no matter what time, it by now has a period look. But I stick by it.*

The best writers are the best, all through. For every moment when a Tolstoy or a Wordsworth seems to have handed over to the automatic pilot, a dozen others jump to mind when these gigantic natures have so complete a mastery of their experience that whatever they do colors the whole of life. The "specialist," in particular, is then put out of countenance. One could read the dramatic critics for a lifetime and come upon nothing better than Dostoevsky's burlesque, in *The Possessed,* of the avant-garde theater. The practicing critic of art who reads Proust's essays on Chardin and Rembrandt may well throw down his pen in despair. His musical colleague will be the better able to take stock of next season's *Trovatore* if he has first sought out the relevant passages in Walt Whitman's opera-notes. The big writers—"Alas!" or "Hooray!", according to the nature of our involvement—can do anything.

This is what really matters to those who, like myself, read for revelation. Not for us today's selections, readers, digests, and anthologizings: only the Complete Edition will do. Without it, we should miss Shelley's version of the *Symposium,* Mallarmé's estimate of Robert Louis Stevenson (and Hofmannsthal's of the Pre-Raphaelites), Flaubert's notes on the Neapolitan museums, Gibbon's account of a day in Switzerland with Charles James Fox, Hazlitt's dissenting verdict on the frescoes in the Sistine Chapel, Baudelaire's ideas for a good name for a new monthly review *(Quand Même!* among them, and *Paucis,* and *Le Recueil de ces Messieurs),* and Mérimée's descriptions, in his letters to Stendhal, of what a Parisian party of pleasure was like in the 1830s. By these, much plodding is rewarded.

Revelation can work directly, also—as when, for instance, the big writers direct, concentrate, and intensify the sensations of travel. Fatigue and inattention are shamed away, even after many weeks on the move, when we remember

how Matthew Arnold, on his way to visit George Sand at Nohant, looked out of the window of his diligence and saw "a silent country of heathy and ferny *landes,* a region of granite boulders, holly and broom, of copsewood and great chestnut trees; a region of broad light, and fresh breezes, and wide horizons." Arriving on a fine afternoon at Mount Vernon, it is still possible today to see George Washington's estate as Henry James saw it—bathed in a luminous stillness which combines with the sublimity of the site and the beautiful ordinariness of the house itself to "become truly the great white decent page on which the whole sense of the place is written." And in those Russian country houses where Time has been arrested by government order, it is the novelists and memorialists of the past hundred and fifty years, Gogol and Aksakov and Turgeniev and Goncharov, who compellingly call the tune; even the Intourist menù dances to it when it offers us Narzan mineral water and we recollect how Lermontov called it a drink fit for Circassian heroes and had the narrator of *Princess Mary* call for it by the bathful.

What works with places works also with people. Reading is no substitute for direct human contact, but it can suggest modes of awareness remote from those with which circumstances have endowed us. Nor is it necessarily "the best writers" who can most easily achieve this, for the best writers take on eventually a universal and an ageless air. More effective, in this context, are writers who remain unperturbedly of their time. I doubt, for instance, if anyone would not be the wiser for reading the word-portraitists of the seventeenth century: in our country Clarendon, Aubrey, Shaftesbury, Halifax, and Roger North, and in France Tallemant des Réaux, Bussy-Rabutin, and Mademoiselle de Montpensier's collective *Galerie des Peintures, ou Recueil des portraits et éloges en vers et en prose* (1663). As to which country excelled the other, it would be hard to say: perhaps Clarendon, exiled at Montpellier and there composing his grand and lively Characters, could be ranked as honorary President of all those who, whether in French or English, aimed at a perfected candor and an undressed vivacity of utterance. One can spend years in their company and still come upon regions as secret, and as rich in unexpected rewards, as the disused chapel in Henry Hastings's house where, so Shaftesbury tells us, "the pulpit, as the safest place, was never wanting of a cold chine of beef, pasty of venison, gammon of bacon, or great apple-pie, with thick crust extremely baked."

In reading such passages we remember that this was an age in which painters, likewise, worked close to their subjects, often with a lamp or candle to heighten the illusion of physical palpability. Neither painting nor prose has ever since given quite so predominant a role to the act of plain physical observation; our memoir writers are too squeamish or too little observant, and our novelists aim rather to diffuse and fragment their effects. It is for their superabundance of now-historical detail that I have read with pleasure an exceptionally large number of French novels of a kind that academics place well below the salt: Daudet (*Sapho,* above all, and *Le Nabab*) is their respectable front man, and Abel Hermant, Claude Farrère, and Jean Lorrain fair specimens of those who follow behind.

I have never regretted the time thus spent. Hermant's vision of England, Farrère's of the Far East at the time of the Russo-Japanese war, and Lorrain's

of Paris at the turn of the century have a dazzle of high absurdity that will not be denied. In their attitude to character, however, these three novelists are nearer to Martial or Suetonius than to the microcosmographers of *le Grand Siècle;* and their moral vacuity is such as to drive one to the masterpieces of magnanimity which were more or less their contemporaries: the letters of van Gogh to his family and friends, and the letters of Camille Pissarro to his son. Lucky the age, and lucky the school of painting, which could follow the Journal of Delacroix with two books which, like that Journal, belong as much to the history of literature as to the history of art!

# Gibbon in Lausanne

Le Journal de Gibbon à Lausanne, *edited by Georges Bonnard. Lausanne: Librairie de l'Université, 1945*

### The New Statesman and Nation, 1948

*Living in Switzerland off and on after World War II, I got fascinated by the idea of Gibbon, toiling away above Lausanne at his* Decline and Fall of the Roman Empire, *and yet well aware of the life that was going on around him.*

In Loudon's *Encyclopaedia of Gardening* the opinion is ventured that "a great part of the Pays de Vaud is like the best part of Berkshire." This can never have been true of the view from Gibbon's *berceau* of acacias, and it is not true today of the *berceau* itself, since this was replaced in 1901 by a monumental Post Office in the style of Louis XIII. From December to March it is difficult to get in or out of this building, or to station oneself in front of it, without damage from the picks, axes, runners, and spikes of the winter sportsman. In Gibbon's time the mountains were politely and justly ignored by the cosmopolitan society of Lausanne; faro, gossip, and private theatricals were their normal employments at this season; but today the collective porcupine of skiers enjoys pre-eminence. "Not with a bang, but a Whymper" should be the English blazon of these formidable persons. Softer tastes have recently been indulged, however, by the publication of the full text of Gibbon's Lausanne journals. These were kept in French; they cover the later period, from August 1763, to April

1764, of his second visit to Switzerland; and they have been edited on the spot, with all possible care, by M. Georges Bonnard.

Gibbon was twenty-six when, in May 1763, he recrossed the Swiss border. He was newly liberated, after three and a half years' service with the Hampshire militia. War, not peace, gave then the signal for a travel ban, and the negotiations at Fontainebleau had sounded the music of freedom in his diminutive ears. Pausing only to applaud a performance of Mallet's *Elvira,* he darted across to Paris, and there began the round of enlightened pleasures which was to give him, when finally he reached Lausanne, so complete an assurance of his superiority to other young Englishmen abroad. Most of these seemed to him mere louts, fit only to make sport of their tutors; but Lausanne was then, as now, the rendezvous for a thoughtful and animated society of Swiss and an international society of exiles. These jointly became Gibbon's companions. Among them he could shine at his ease, while in an adjoining room the blubbering boys and the knicker-hungry Guardees bickered sullenly around the billiard table. Ten years had transformed him. No longer did he sit speechless, a disgraced undergraduate, at the parsonical table of Monsieur Pavilliard. The world had claimed him, and he had claimed the world. "It appears," he noted in his Journal, "that the Prince of Wurtemberg has a great liking for me. He has an easy and natural politeness for everyone, but with me he adopts a tone of confidence, of esteem, and almost of affection." The Lausanne notebooks may not be among their author's Lapidaria, and indeed M. Bonnard lists a number of battles, atrocious but decisive, between himself and the grammar, syntax, and orthography of the diarist. The Gibbonian forefinger was none the less raised as effectively in French as in English, and never more so than in describing the human curiosities of the town. His reading offered, in relation to these, a series of prompt, if involuntary, parallels. From the Third Satire of Juvenal he learned how quickly a plain and pious people may be debauched by the amenity of foreign manners. In November, when the first layers of snow had fallen upon Lausanne, he discovered from the *Travels in Greenland* of the Danish traveler Hans Egede that even in the Arctic Circle certain simple pleasures could still be enjoyed. *"Oui,"* he noted, *"l'homme est naturellement bon! J'en appelle à ces Greenlandois, qui connaissent l'amour au milieu de leurs frimats..."* The eternal snows of Chimboraxo and the discreet withdrawal ("two yards every hundred years") of the sea from the coastline of Sweden offered further points of interest to a visitor who perforce gazed daily on the Dents du Midi and the variable delta of the Rhone.

Scrutiny of Nardini and Cluverius persuaded him for the moment that "the geographer sees, perhaps better than the historian, what it cost the universe to become Roman"; but when he looked at his companions in Lausanne, it was with a more than geographical eye. Count Golovkin, for instance, whose father and grandfather had held high positions under the Czar of Russia, was diminished in the sentence: "he is said to be witty and, among his own friends, may be so." Baron de Wolf was the subject of a long anathema which begins: "brought up in frugality and in trade, he is by no means accustomed to the great wealth which now falls to his share." Gibbon exacted French standards of courtesy and amenity, and in consequence passed

the winter in a nearly permanent state of social condescension.

A few elderly and distinguished Swiss were alone admitted to rank with himself. Monsieur de Chandieu-Villars, who had spent his life in the French Army, was one of these—"a man of great politeness, with an easy and lively intelligence...almost the only foreigner who has acquired the smoothness of French manners without at the same time giving himself noisy and idiotic airs." Intellectuals had not this facility, and of poor Woest, the faithful philosophical chopping-block of Gibbon's restless hours, the diarist remarked that "one may discern his nationality from the coarseness of his manners." One man, however, he did absolutely detest: Colonel Juste Constant, who "unites in his person even those bad qualities which are most remote from each other— grossness and artifice, malice and stupidity, avarice and prodigality. He is in effect *Monstrum nulla virtute redemptum.*" The allusion to Juvenal's great attack on Crispinus ("a sickly creature, vigorous only in debauch") may have solaced Gibbon for the tiny slights and distresses which Constant inflicted upon him; in these he would seem to have shown a dexterity worthy of the nobler causes to which his son Benjamin later devoted himself.

The English themselves were very mixed. There were decent, studious, and inhibited travelers like Lord Palmerston, and ill-conditioned beasts like Sidney. There was the amiable and alcoholic Guise, and Captain Clarke, the retired Naval man. There was John Holroyd, later to become the dearest of Gibbon's friends, and there was Mr. Beckford, the author not of *Vathek* but of *Thoughts on Hare and Fox Hunting.* There was Mr. Shuttleworth: "How much soap it would take to get him clean!" and there were the anonymous others who, while Gibbon was deciphering Spanheim and Vossius at his desk above the Leman, would vex him with the clinking of their billiard balls, and later turn his rooms into their habitual café. Had these been all, he must have been very discontented; but there were also such dependable friends as Saussure and Deyverdun; and there were the ladies.

While in no sense an amorist, Gibbon was a flirt. The air, if not the fact, of sex was indispensable to his existence. Like Stendhal, he was enraptured by the phenomenon, common to both Lausanne and Geneva, of the unmarried young girls (exemplary vestals, moreover) who went everywhere unchaperoned, and offered to the goatish pretensions of traveling Englishmen a resistance as effective as it was delicate. Gibbon was happy with them, and enjoyed, too, the dwindling but still potent attractions of his former attachment, Mademoiselle Curchod. Can it be by coincidence, however, that during the first week of February he made the acquaintance both of Madame de Seigneux and of Ovid's account, in the *Fasti,* of the Floral Games of ancient Rome? He was experiencing at that time one of those rebounds of animal interest which often accompany the check or dismissal of more elevated appetites. He had not prospered in society as much as he would have wished; there had been a rebuff at the Cercle (the White's of Lausanne); he had been dropped from houses at which the Prince of Wurtemberg dined; the senior personages of the town no longer showed him, he complained, "that respect, those flattering distinctions upon which I used to count." He was reduced, in fact, to enjoying the weather.

At this low point in his fortunes he went to a party at which was a youthful but practiced enchantress. She was from Aarau, but had married into the first

society of Lausanne. "Not pretty," Gibbon noted, "but with a vivacity, and a rumpled and mutinous manner, which render her very interesting. She always grasps one's meaning, never takes offence, and replies in the same tone. What temperament she has! There is an evident and very decided lubricity in her eyes, her gestures, and everything she says. For this reason they had to marry her off at the age of fifteen, because...." Warmed by this new acquaintance, and stirred by Ovid's explicit, though glacial narrative, Gibbon noted on the following day that "the flower-season has always aroused licentious ideas...even in men who were very certainly ignorant of the story of the courtesan Flora."

It came to nothing, of course. After seven weeks of delicious maneuvering for wind and station, Gibbon broke a new signal: "disengage" read the flags at his masthead. A week or two more, and he had left Lausanne for Italy. He had passed a pleasant and economical summer and winter. His studies had been monumental in their scale and scope. "Reading" is not the exact word for his treatment of Strabo, Pliny, Pomponius Mela, Tacitus, Rutilius, Horace, and Ovid; one should rather say that these authors, and the encyclopedic provision of the Bibliothèque Raisonnée (Vols. XIII-L), were stripped, gutted, and razed. The history of cannibalism, the newly printed Letters of Lady Mary Wortley Montagu, the exact size of the Roman circus, the voyages of Anson, the location of Egeria's wood, and the expectation of life among the Dutch—all were received indifferently by this commodious intellect, and all were ground equally fine. His central preoccupation was always, however, to equip himself as the historian of Rome, and once or twice this imposed an unusual formality upon his comments, and he felt bound to speak of Trajan's Column as a sublime example of "that architecture which addresses itself to the mind as much as to the eye, and which the Romans understood better than all the other peoples of the earth." The historians of the past were examined with awe, but also with a cold eye for their defects. Livy, through these binoculars, became "a man of letters, reared in the dust of the schoolroom, ignorant of the art of war, neglectful of geography"; but in Polybius Gibbon saluted the author who, like himself, based his conclusions upon a close examination of original sites.

Intellectually, his visit had been a success. Not only had he mastered the geography of ancient Rome, and made careful recensions of many classical authors, but he had examined several contemporary explorations of the antique world. He had gained knowledge of the world. He had been interested, though not implicated, in a prosecution for disorderly conduct; he had averted a duel between two friends; he had taken lessons in French declamation; he had been cupped. Yet there were things which rankled, and as he left Lausanne for the second time he confessed to disappointment. Where once he had seen a paradise, he now saw "a town, ill-built in a delightful landscape, which enjoys peace and quietude, and mistakes them for liberty.... Affectation is the original sin of the Lausannois. Affectation of wealth, nobility and intelligence— the first two being very common and the third very rare." Did there rise before him at this point a lubricious but inaccessible image? He turned, at any rate, and with outstretched forefinger continued: "Their love of ostentation accords ill with their taste for nobility; yet they would die rather than renounce it or embrace the only profession which would allow them to keep it up."

# Voltaire in Geneva

Voltaire: Lettres Inédites aux Tronchin. *3 vols. Geneva: Librarie Droz.;* Correspondence avec les Tronchin. *Etablie et Annotée par André Delattre. Paris: Mercure de France, 1951*

**The Times Literary Supplement, 1951**

*Delicious, too, was a glimpse in close-up of Voltaire settling into Geneva in the 1750s like a dog into a new and very comfortable blanket.*

One of the unamiable features of our age is its ingratitude toward Voltaire. Few of us can afford the Beaumarchais edition, in which the act of reading is raised to the level of the highest pleasure. The sheer profusion, the sheer variety of Voltaire's works are in themselves an impediment to our esteem. The sad pastors of contemporary opinion read for information, not for art; and much of Voltaire's information is obsolete. Besides, the judges of our own day are firmly, unsmilingly ethical, and Voltaire's super-Shavian immunity from conventional ethics has earned their sharpest reprobation. Even the "circumfusion of bright light," on which Lord Morley commented in a memorable phrase, is unpopular in an age of mourning shadows.

Even the gravest of censors, however, must yield to Voltaire's correspondence, in spite of the fact that there is too much of it. There is something irresistible about his letters. They combine, after all, the intellectual animation of a Nobel prizeman in science with the never-repeated formal perfection of a snowflake. They have engendered tributes in the least expected quarters—in the opuscula of Mallarmé, for instance, where the author of *Toast Funèbre* refers to them as "the very apotheosis of the French language, in a stable of casual undress that is the equal of nakedness itself. In every least scribbled note, there is a concision, an apparently offhand quality that reminds us of the unpretentious furniture of the eighteenth century, or of Haydn's way with tonic and dominant."

For ease, rapidity, charm, and variety of attack, Voltaire's letters have never been excelled. Their command of expression is both more and less than

human, and one cannot read them without realizing the extent to which the language of Voltaire is also the language of France. He is one of the very few writers who may be said to have annihilated the hazards of human communication.

With the exception of one letter dated 1741, the Tronchin letters cover the period from 1754 to 1778. They begin, that is to say, almost immediately after Voltaire's return from the court of Frederick the Great, and they run up to the time of his death. The Tronchins' own collection included 555 letters from Voltaire himself to various members of the family, and 63 from his niece, Madame Denis. When it was acquired in 1937 by the Geneva Library, a large part of the material was found either to be quite new, or to have been inaccurately published. The present editions may therefore be considered as new contributions to our knowledge of Voltaire during his last twenty-five years. In contrast to the animated and often ridiculous chronicles of his Berlin period, the new material is for the most part marked *andante tranquillo;* it is, in fact, a sobered and contented Voltaire who confronts us.

For this contentment, the Tronchins were in large part responsible. They provided him, from among themselves, with his doctor, his lawyer, and his banker. The Conseiller François Tronchin guided him in his numberless embroilments with Genevan law; Jean-Robert Tronchin doubled his fortune in a decade; Dr. Théodore Tronchin kept him alive. Between them, and with the help of various auxiliary kinsmen, they supervised his installation at Les Délices (a large country house on the lake near Geneva) after the period in which, for lack of more stable moorings, he had envisaged living at Schwetzingen, or Colmar, or Plombières.

Lac Léman was what he had always wanted. "I revere your government," he wrote to François Tronchin from Prangins in January 1755. "I adore liberty, and I love retirement. I have always said that at 25 one should live in Paris and that at 50 one should live here." The Tronchins were wealthy and influential, and they had an unblemished record of resistance to oppression. They loved literature and painting and (unlike many Genevese) they loved the theater. But what really endeared them to Voltaire was their efficiency.

It was all very well for him to write and say, "I am founding Carthage." Without the Tronchins he would have been hard put to found a summerhouse. With them, and with his imagination steam-heated by their unvarying complaisance, he never hesitated to ask these elderly and rather eminent persons to carry out the humblest of commissions. Did he need lavender water? A length of Utrecht velvet? Some silver hot-plates? A barrel of olive oil? A thousand gilded nails? A bottle of gum, some Egyptian onions, and two *bidets*? The Tronchins were always delighted to get them.

It is thus hardly surprising that the correspondence should open upon a note of lyrical effusion. Voltaire had two head gardeners, twenty laborers, and twelve domestic servants. Everything was in perfect order, even down to the bunches of thyme, rosemary, tarragon, hyssop, and rue with which he ornamented the borders of his kitchen garden. He was uncommonly well suited. And his situation was the more agreeable in that, not two years previously, he had been a man on the run. "Rebuffed on every side," as M. Delattre remarks, "reduced to begging favours from German princelings in whose company he

would be no safer than he had been in the Free City of Frankfurt, he thought at one moment of leaving Europe and settling in Philadelphia."

Princes, whether small or great, were unkindly disposed toward him. The Empress Maria-Theresa had made certain uncharitable observations about the relative locations of Grinzing and Parnassus; and as for the King of England, he had not taken at all to the suggestion that Voltaire should be welcomed with an annuity of £800. In the case of Frederick the Great, Voltaire had anticipated the maxim of Talleyrand that "in the great business of life, women must be made to work for us"; but, although the Margravine of Bayreuth had marched as fast and as far as anybody could have expected, her brother was not impressed. All this gave a particular price to the beneficence of the Tronchins.

It would be a great error to see the Tronchins, in their relations with Voltaire, as a band of awed provincials who were only too flattered and pleased to be associated with the greatest luminary of the Occident. Not only would such an attitude be quite contrary to the Genevese character, but the Tronchins were personages in their own right. Voltaire was not the only great man whom they had frequented, and Dr. Théodore Tronchin, at any rate, had no illusions about his character. As early as 1738 he had written to his friend the Chevalier de Jaucourt that, mortifying as such a conclusion might be, he had made up his mind that Voltaire was "an irresponsible rogue, a man as defective in manners as in judgment." As a young man, Dr. Tronchin had lived in England and known Bolingbroke, Swift, and Pope; he had been the preferred pupil of Boerhaave at Leyden; he was a Fellow of the Royal Society; he had given his name to the "tronchine," a short walking-dress of therapeutic design; and he was one of the most elegant of letter writers. To him, Voltaire was just an unusually demanding and rather treacherous patient who might claim at any moment to be afflicted with dysentery, nephritis, erysipelas, dropsy, paralysis, apoplexy, sciatica, or scorbutus; who boasted that he suffered thirteen hours out of every twelve; and who liked to say that he frequented doctors much as he frequented theologians—for the pleasure of their conversation. No doubt he was gratified to see Voltaire sign himself "a man who loves two things most tenderly—the truth, and yourself"; but he knew just how much the declaration was worth, and there is no trace of pleased fatuity in his famous analysis of the state of mind in which Voltaire was likely to die.

Nor was the banker, or the lawyer, more impressionable than the doctor. If Jean-Robert Tronchin, the friend of Diderot and Condorcet, was primarily a financial intelligence of the first order, the Conseiller François Tronchin, in his moments of leisure, was an impassioned enthusiast for both literature and painting. He was an indefatigable amateur dramatist; and one would have to go to the correspondence of Gray and Mason to find the equal of the delicacy with which Voltaire contrived to tell François Tronchin that his plays were simply not good enough for the stage.

When he addressed the aspirant as "Mon très cher confrère" he was moved by considerations of fact, rather than of quality; for the Conseiller's career as a failed playwright extended over more than fifty years, and it was at the age of eighty-two that he saw his *Terentia* (which Diderot had done his best to put into passable order) performed on the Genevese stage. As a connoisseur of painting, on the other hand, François Tronchin could look after himself. Like

many another good judge, he enjoyed making and remaking his collection; and after Catherine the Great had bought, in 1772, the great majority of his pictures, he formed a second collection, which included several Rembrandts and was diversified by his friendship with Liotard, Joseph Vernet, Soufflot, Falconet, and Jean Huber.

From all this it is apparent that, then as now, the great families of Geneva were used to the best—and that, then as now, they found it none too good. Geneva was not the heart of Europe, but it was an unsurpassed observatory; and, with the Tronchins to polish his lenses for him, Voltaire had every reason to be content. The material circumstances of his life can never have been more agreeable; and when he goes on about the pleasures of evacuation, or the status of Rousseau as an enemy of the human race, or the necessity of getting five percent on the least of his loans, then all is for pleasure and delight. When he canvasses *les grands* for a subscription on behalf of Corneille's granddaughter, or when he bestirs himself in connection with the unplanned and unwelcome pregnancy of his niece's personal maid, his letters take on the unwonted ring of ordinary humanity. And then there is the background: the spectacular skyline of Lac Léman, the discreet wealth of the grey-faced hill-streets of Geneva, the mingling of tourists and spectators in the village of Ferney, the interminable theatricals, and the dawn-lit supper-parties. The scenes of village life might have been written by an eighteenth century precursor of Georges Bernanos; the botanical notes, by a narrower Madame de Sévigné; the allusions to public life, by a more irritable Bertrand Russell. And when Voltaire asks Jean-Robert to find him "a Beaujolais that I can palm off as Burgundy" he speaks the language of Everyman addressing his wine merchant. But the ensemble of the letters could only have come from one hand; and it is a hand on which Mallarmé said the last word when he wrote of the "miraculous vocable of Voltaire, in which are summed up in one and the same word both the flight of the arrow and the vibration of the bowstring."

# An Odd Couple:
# Flaubert and Turgeniev

Lettres Inédites de Flaubert à Tourguéneff, *edited by Gérard Gailly. Edition du Rocher, 1947*

### The New Statesman and Nation, 1947

*Even in the Paris of their day, which was completely cosmopolitan, there was something remarkable about the friendship between the author of* Madame Bovary *and the author of* Fathers and Sons. *To one who then prized Paris above all other cities, their correspondence was irresistible.*

Writers, like most other people, travel mainly in the hope of renewing themselves. The English Channel, for instance, is well known to have in its deeps a briny magic, a power to transform even the inmost metal of an outgoing traveller. In middle life an author may perhaps count upon a further intoxicant—that of an assured reputation in some foreign country. In such a case all his visits will be honeymoons. He will have aimed, after all, to present in his work the perfected image of his best self; at home, the absurd baggage of circumstance too often prevents us from setting a contemporary upon this absolute plane, and a hundred years may have to pass before he can stand in something approaching an ideal relation to his public; but a foreign audience will ask nothing so much as to cherish him, if not in the likeness of eternity, at any rate in something most agreeably similar. Skirting such current examples as may leap to mind, it will be convenient to take Turgeniev as our noblest instance. When, in October 1883, Renan pronounced his melodious farewell over the bier of the great novelist, he spoke for the whole of France. In French eyes, Russia and Turgeniev were one. Renan had none of the doubts and reservations which were to afflict so exquisite a judge as Maurice Baring; for him Turgeniev was the appointed voice of "that great Slav people whose appearance among the first races of the world has been the most surprising phenomenon of the century." It was not phrase-making to say that Turgeniev seemed "to have lived for thousands of years before the day of his birth," and that "no other man had been, to such a degree the incarnation of a whole people." Tolstoy and Dostoevsky, after all, were obscurities at this time, and Pushkin and Gogol the concern of specialists. For Daudet, Zola, and the Goncourts, Russia was simply the home of the colossus whom they had encountered—and with what great pleasure!—usually on a sofa, with his enormous frame looped like a python among assuaging cushions.

Turgeniev for his part was a convinced Francophile. So gladly did he respond to the canons of French talk that even when he lay, without anesthetic, on the operating table, he set himself to turn the incident to some conversational advantage. "I wondered," he said to Daudet, "how best to convey to you all exactly how the knife slits open the outer skin and then gets down to the

flesh below—rather as if one were slicing a banana." This trait must have appealed particularly to Flaubert, who of all Frenchmen was most devoted to Turgeniev. Those curious to know more of this friendship will find a great deal of new matter in *Lettres Inédites de Flaubert à Tourguéneff*. Nearly a hundred and thirty new letters are given in this book, which, if read in conjunction with Halpérine-Kaminski's *Turgeniev and his French Friends*, reveals to us a large part of the dialogue which sustained the two friends during the years in which they wrote, among other things, *L'Education Sentimentale, Bouvard et Pécuchet, Virgin Soil*, and *Smoke*.

Flaubert first met Turgeniev in February 1863. The two great inflammables were quick to kindle, and in Flaubert's first encomium there is more than civility, and more than casual appreciation. Turgeniev, for him, had all the gifts—tenderness, irony, observation—and the power to combine them; the Russian landscape was so beautifully evoked to become the thoughtful accomplice of the narrative, and Turgeniev knew, as no one else, how to disengage from ordinary life the poetry of indecision. In *First Love* Flaubert retrieved the sensations of his own youth; and of Russia itself he had the strongest vocal impression—as strong as when, "reading *Don Quixote*, I long to go on horseback along a road white with dust, and later to eat olives and raw onions in the shade of a rock." Turgeniev had, above all, the supreme quality of devotion to art. Distinction, without loss of power—this was also Flaubert's ideal, and one which, as he later lamented, had gone quite out of fashion. "My friends, Sainte-Beuve and Taine," he wrote, "do not pay enough attention to *art*, to the fact that books exist in their own right, to composition, to style—in short, to the elements of Beauty. In La Harpe's time critics were grammarians; now they are historians—that's the only difference." Turgeniev became his confidant, "the only man in the world with whom I care to talk," and the witness of his efforts to raise French prose to unimagined levels of beauty and authority. He retained to the last the quality of an apparition. For some years it seemed that, like Encke's comet, he would reappear at ever shorter intervals; but Flaubert soon found that Turgeniev's visits were governed by a failing to which no celestial analogy can be found. In brief, he chucked. In the end he went so far, though with an infinity of polite evasion, as to chuck Flaubert four times in eight days. Sometimes he did it at long range, in order to go to Pitlochry and shoot grouse, or to attend the Scott centenary celebrations at Edinburgh; sometimes he wished only to remain in Paris and to conserve that purposeful mobility which was, for him, the first requirement of polite life. Behind many of these excuses, moreover, we sense the switch of Madame Viardot's skirts. It is our good fortune that this pliability drew from Flaubert not only the letters in which he likened Turgeniev to a man of rags and straw, or to a rotting pear, but also others in which he exposed hurts and urgencies which would otherwise have been relieved in talk.

The last twelve years of Flaubert's life were marked by the gradual withdrawal of everything which might have consoled him for the failure of his best work. He had lost the company of Bouilhet, Gautier, George Sand, Jules de Goncourt, Sainte-Beuve. The defeat of 1871 marked the end of a regime in which he had at least been secure; and within his own family his nephew's needs quietly bled him of every penny he possessed. To all this, Turgeniev was

the counterpoise. Flaubert could say to him, in June 1871:

> You must think it foolish of me to nourish such a hatred of Prussia. That is
> exactly what I so much resent—that the Germans have made me feel like
> some savage of the twelfth century. But what else can one do? In no other
> epoch would educated men behave like wild beasts…In Paris the mental
> state of the people is even more lamentable than any physical destruction.
> One picks one's way between cretinism and raving madness.

And fifteen months later:

> Apart from my personal motives for grief (the death, these last three years,
> of nearly all of those for whom I cared) I am prostrated, really prostrated by
> the state of the country…The Bourgeoisie is so bemused that it no longer has
> the instinct to defend itself; and what comes after will be worse. I am heavy
> with the sadness which afflicted the patricians of Rome in the fourth century.
> I sense that an irremediable Barbary is rising from the depths of the earth,
> and I hope only that I shall be dead before it carries everything before it.
> Even now it's no laughing matter…never has it been so plain that these
> people hate what is noble, disdain what is beautiful, and hold all literature in
> execration. I have always tried to live in an ivory tower; but now a great tide
> of filth is lapping against its walls, and before long it will be overwhelmed.

Thenceforward there would be no shelter for the artist, no silver mines of
Laurium from which he could draw the price of silence and privacy. Irony was
his best weapon against a world in which the present was a constant irritation,
and the future a thing of foreseeable dread. When Marshal Bazaine escaped in
1874 from his prison on the Ile Sainte-Marguérite, Flaubert gave one of his
rare shouts of amusement; and later, when a great personage (director, among
other things, of the *Revue Catholique*) was detected in an act of immodesty in
the Champs-Elysées, Flaubert perceived that, there also, was matter for a
topical farce: "Do you not feel all the delights of revenge when something of
this kind happens to such an imposing figure? When heaven's rays merge with
the folds of his anus and the judge's toga is hoisted a little too high?" The
theater, however, was never Flaubert's ploy; like many imaginative writers he
detested the shifts and adjustments to which playwrights are driven.

At such times Flaubert amused himself with the idea of visiting Turgeniev
at Spasskoïe. Himself "the poor wreckage of a vanished world," he found this
vision as distracting as Herod's court or Roman Carthage. The endless white
silences of a Russian winter contrasted, in Turgeniev's account, with the
scorched *allées* of a summer garden, set amid an encircling infinity of rye.
"What would I not give," Flaubert wrote, "to lie at ease in your hay!" And as for
the veranda, the apron-string of Russian country life—Flaubert was glad to
think that his letters, at any rate, would travel as far. In the event he made only
such outings as his new book required—the book in which he hoped to exorcise
the bourgeois once and for all. He did go, for his health, as far as Switzerland;
but he disliked the Alps ("they are too big to be of any use to me"), there were
too many English in his hotel, and he was no longer of an age to enlist noble
scenery as the auxiliar of romance. Besides, rest only made him ill. Thence-
forth he never rested; and if *Bouvard and Pécuchet* plunged him in too hideous
a bath of stupidity, he found relief in the composition of *Trois Contes*. A great
local patriot, he never minded being at Croisset; his old red divan, a roast duck

stuffed *à la Rouennaise,* and some pages of Corneille were three unfailing stimulants of local origin. Turgeniev sent him salmon and caviar; later a fastuous Russian dressing-gown coaxed Flaubert into oriental fantasies; "I should like to be stark naked inside it," he declared, "with one or two Circassian beauties to keep me company." Plutarch and Saint-Simon he could read for pleasure; and, apart from the hundreds of miscellaneous volumes which had to be read and marked for *Bouvard,* there came occasional welcome gifts. An amusing book called *Vathek,* for example, which Mallarmé had discovered; and near the end of his life, Turgeniev sent him *War and Peace.* It was a great excitement for Flaubert, and the first two volumes seemed to him tremendously good; but the third fell badly away. "In it one becomes aware of Tolstoy as a man, an author and a Russian; previously one had seen only Nature and Humanity personified." Turgeniev agreed that Tolstoy's great fault, as a novelist, was "his philosophy, which is at once that of a mystic and that of a bumptious child."

Nobody in Flaubert's circle was ever very well. Anemia and perpetual headaches were the least of their ills, and even the young Maupassant was branded by Flaubert as "gouty beyond relief, rheumatic beyond endurance and neurotic beyond all hope of a cure." (Maupassant's enervation was such that even "ces dames" could not distract him; but Flaubert thought that perhaps this was as well, since the zeal of visitors to the Exposition of 1878 had put a great number of these meritorious persons completely out of action.) Toward 1880 Flaubert's own illnesses become ever more vexatious, but his greatest pleasure was always to see Turgeniev, and to correspond with him. Turgeniev for his part had tried hard to secure Flaubert a lucrative sinecure, the care of the Mazarine Library, but although he went so far as to plead with Gambetta himself, he had no success. Four years later, with Flaubert already long in the grave, Turgeniev experienced that mortal collapse of health which was, vis-à-vis his French friends, his final, if involuntary, gesture of affiliation. His doctor was surprised to find that he believed himself to be withholding a siege by a large force of Assyrian soldiers. "That's from the ramparts of Nineveh!" he would cry, as he made as if to throw a stone at his visitor's legs. Readers of M. Gailly's book will find in it more tender and more attaching images of the great man whose passage gave to Ventnor, and to Six Mile Bottom, and even to 30, Devonshire Place, their first whiff of poetry.

# John Ruskin: A Deep Well of Words

### The New York Times, 1977

*No critic of a later day has had either the colossal output or the vatic eloquence of John Ruskin (1819–1900). So it amused me to try to sum up in a line or two the huge, free-rolling achievement of the one who never had to hear the words "Make it short, old man. Space is tight today."*

Somewhere behind the shoulder of everyone who writes about art there stands the intimidating figure of John Ruskin. How much he wrote, and how well he wrote! How early (at the age of sixteen) did he fix upon J. M.W. Turner, the painter whom destiny called upon him to defend, and with what a prodigious eloquence did he set about it! How vast was his audience, and how devoted! People would work for Ruskin, and stint for Ruskin, and all but starve for Ruskin, in ways for which our own era has no parallel.

One of the great repositories of Ruskiniana is the Pierpont Morgan Library, right here in New York City. The Morgan Library owns thousands of Ruskin's letters. It owns hundreds of his drawings. It owns the manuscripts of several of his most important books. It owns the toy soldiers which he played with as a boy, and the specimens of rare minerals which he collected as a grown man, and the blue feathers which a favored correspondent sent him in the mail. It owns his check books and his account books and an invitation to the memorial service for him in Westminster Abbey. Simply to work through this material would take years; to master it might well take a lifetime.

So maybe it's just as well that the Morgan Library's Ruskin exhibition is modest in size and does no more than hint at the full scope of the library's resources. Fashions in such things come and go, and it may well be that at this moment the literary manuscript most in demand in this city is the diary of Virginia Woolf, of which the complete text is in the Berg Collection at the New York Public Library. But not so long ago the secret which people most wanted to probe was the break-up of John Ruskin's marriage. Exactly why did his wife go off with their friend, the painter John Everett Millais? For that, the Morgan library is indispensable, in that it owns the Bowerswell papers, in which the whole matter is spelled out at first hand by those directly concerned.

The Bowerswell papers are still there, of course, and Millais's penciled portrait of Ruskin is the most considerable work of art in the show. But its prime object is to mark the arrival in the library of the collections bequeathed to it by Helen Gill Viljoen, who for many years taught at Queens College. Ruskinians recognize one another on sight, and Professor Viljoen's collection began when she called on one of Ruskin's biographers and he gave her a canceled check in Ruskin's own hand as a souvenir of the occasion. Another great Ruskinian, F. J. Sharp, left her his own holdings when he died in 1957, and now that the Viljoen Collection is known to be in the Morgan Library

other Ruskinians have come forward in the same spirit to give, or to promise, further material.

How to explain the exceptional hold which Ruskin had on his readers? He had it in life, as we know. No commonplace crank could have persuaded Oscar Wilde and the young Arnold Toynbee, among others, to help to build a road on the outskirts of Oxford. But he went on having it, and a small but effective brotherhood is in being seventy-seven years after his death.

Ruskin for much of his later life was off his head, as most people now know, but this does not mean that his ideals were ignoble. It is touching to come on the manuscript of "Fors Clavigera" at the Morgan Library and see how he urged upon "the workmen and laborers of Great Britain" the deeds of Hercules, the patience of Ulysses, and in public affairs the probity of Lycurgus. This was the turn of mind which in 1858 had caused him to write to his friend Charles Eliot Norton that among the things he wanted was "to get everybody a dinner who hasn't got one."

The point of John Ruskin was that he did not write about art as a superior distraction. Art and life were one, in his view; and his writings on the state of society were fired by the same inspired exasperation which prompted him to write on J. M. W. Turner at the age of sixteen: "I saw injustice done and tried to remedy it. I heard falsehood taught, and was compelled to deny it." Even in the most ecstatic of his descriptions of things seen and things deeply understood, Ruskin always remembered that there were political and economic realities to be made known and to be fought for.

There is, of course, no shortage of material. Ruskin had the graphomania of which Henry James may well have been the last great example. His hand was never still. If it wasn't writing it was drawing; and even when it was drawing we can see from a sketchbook in the present show that it was impelled to write as well. "Can't get it right" he would say in the margin of his account book; and "Got tired, left off" in the margin of a drawing of the Grand Canal in Venice. A collector who gets hooked on Ruskin can always count on finding more material.

Still, a man can write a lot and yet be a terrible bore. What makes certain collectors cleave to Ruskin is that he really cared about the conditions in which other people had to live. He himself did not lack for money. He was one of the greatest esthetes of all time, with a puissance of evocation which no writer on art has ever surpassed. He could have lived a life of exalted enjoyment, with just enough in the way of a charitable contribution here and there to keep his conscience quiet. He had no need above all to invite ostracism by advocating a form of paternal socialism which was abhorrent to the great majority of his readers. (Thackeray, the novelist, printed a piece of this sort in his magazine and very soon wished he hadn't.)

Quite apart from his more political speculations (some of which have proved all too accurate), Ruskin has two other claims upon our attention. He had what in the eighteenth century was called "a bottom of good sense." If asked to characterize the first Duke of Wellington's qualities as a commander in the field, he could do it better than most full-time military historians. Set before a portrait by Sir Joshua Reynolds, he could say that, for all his high-flown references to Michelangelo, "the especial Englishness and perfectness of

Reynolds is in little Lady So-and-so with her round hat and strong shoes."

And what the Morgan Library show also suggests is, finally, that Ruskin was a part of the great Victorian network of Persons of Consequence. He knew everyone, and until he went overboard in politics everyone knew him. To anyone who has ever thought about the poet William Wordsworth and his sister Dorothy, there is magic, for instance, in the letter in this show from the poet Samuel Rogers. Rogers speaks in a tone of everyday conversation of calling on Dorothy Wordsworth: "a little withered old woman with a ghastly countenance, but with eyes lighted up and fixed upon me." We do not often come face to face so directly with the stuff of legend. This is a show which touches upon literature, touches upon art, touches upon the state of society, and touches upon the misfortunes of a poor crazed old man, and has something of importance to teach us about all of them.

# Sainte-Beuve,
# The Weekly Achiever

Sainte-Beuve: Correspondence Générale. *Vol. VI. Editions Stock, 1950*

**The New Statesman and Nation, 1950**

*Neither as a man nor as a critic does Sainte-Beuve have a good name. (Cyril Connolly once said to me, "What is there to say about someone who did nothing all his life but sit on his bottom and write reviews?")*

*But to anyone who has tackled, in no matter how small a way, the deadline of a weekly article on a large subject, there is much to admire in Sainte-Beuve's seamless, easy-seeming, conversational approach. As for Sainte-Beuve the man, he is one of the great comic figures of the French nineteenth century.*

The revolt against Sainte-Beuve has always been led from the top. With Flaubert to scorn his feminine phrasing, Musset to speak of "Sainte-Bévue," Proust to flinch from his "shoddy affability," and Gautier to remark that never once had he struck the bronze medal of a lasting fame, there is no lack of

precedent for those who consider that real criticism began with the first number of *Les Temps Modernes*. In recent years, however, controversy about the method of Sainte-Beuve has largely given place to discussion of his personality. The release of *Mes Poisons* in 1926 revealed even to the most obtuse of readers that when it came to concentrated unpleasantness not Pope, not Swift, not Martial himself was more terrible than Sainte-Beuve. In this wonderful little book, which must rank with the infernal machines of Sainte-Beuve's favorites, Chamfort and Rivarol, there is nothing of the deft accommodation which made him so many enemies in his lifetime. "Squeeze the sponge," he had said of his essays, "and the acid will run out." In *Mes Poisons*, Sainte-Beuve himself did the squeezing, and amply did he repay the insults which he had endured, throughout a life of almost maniacal diligence, from Nature, Art, and his fellow-men.

One should not underestimate the degree of his provocation. Sainte-Beuve is a man about whom it is almost impossible to find a kindly or favorable anecdote. His legend is that of an ill-natured, ill-favored, ill-breeding, and ill-uttering freak. The lisping, half-bald lecturer at Lausanne; the duellist, discharging his pistol beneath an open umbrella; the scribbling hermit in his dressing gown of coarse white wool; the social animal, dressing for a grand dinner party with his complexion freshened by the timely use of an enema; the inappropriately youthful waistcoats, and the loud *"Hum! Hum!"* with which he filled out the pauses in his conversation—all these amount to the portrait of a grotesque. The melodious suavity of the *Lundis*, the sculptural grandeur of *Port-Royal*, and the illimitable, broadly affectionate curiosity of the *Portraits*—all are discounted, now that their creator has fallen into his own trap and become the victim of those who believe that the personality of an author cannot be transcended by his works.

With the publication last autumn of the sixth volume of M. Jean Bonnerot's monumental edition of the *Correspondance Générale de Sainte-Beuve*, it does, however, become possible to see that Sainte-Beuve has been unfairly treated. Not that M. Bonnerot has completed his task: he is at present cutting his way out at a cost, in text, commentary, and notes, of several hundred thousand words for every year of his subject's life. The first volume of his gigantic enterprise was issued in 1935, and covered Sainte-Beuve's career as far as December 1835. With Volume II, published in the following year, M. Bonnerot spurted in Leander style and carried the story up to 1838; but since then insufficient public support, the hazards of war, and the demands of a full-time public office ( M. Bonnerot is Librarian of the Sorbonne ) have slowed the work; despite the encouragement of many an amateur coach upon the towpath, the latest volume, a packed octavo of 622 pages, covers only the years 1845–46. That it, and indeed the whole venture, should not have been more loudly applauded in England would certainly have offended Sainte-Beuve, who delighted in his English blood and went so far as to say "I wish I were English; after all, an Englishman is always *somebody*" ; it is also particularly unjust, in that it was during the course of an Allied air raid on Mayenne, in June 1944, that the 840 manuscript pages of Volume V were destroyed at the printers, leaving hardly an entry intact. M. Bonnerot's perfectionism is of the kind that will dedicate a fortnight's searches to the identification of a volume which

Sainte-Beuve may have borrowed for two days from a public library; the result will stand forever.

Sainte-Beuve was not a great letter writer, and many of the letters in this stately series of volumes reflect little but the predictable traffic of the professional literary man; but there are certain categories which lie very differently on the page. The rare holidays, for example: and especially the visit which he paid to England in 1828. "What a funny sort of life," he wrote from Oxfordshire, "is that of the Country-Esquires—hunting, fishing, dining out, horse-riding, preaching on Sunday (most of them are the parsons of their parish); everybody I see here is really a parson—not that you would think it, for they go dancing, get married, are agreeable in their way and, though they are genuine believers, do little to show it." At that age (he was then twenty-four) Sainte-Beuve had not yet scaled down his judgments to the perfect moderation of his maturity. "Take away from St. Paul's its towers and its domes," he wrote to Victor Hugo, "and you are left with nothing but the carcass of a Dutch barge." The relationship with the Hugos is only one of the many strands in Sainte-Beuve's life which M. Bonnerot has enabled us to follow not merely in the great critic's own letters, but (in a great many cases) in the replies he received and—most revealing of all—in the drafts which he decided not to send. Sainte-Beuve would have liked to excel as a poet, a mystic, and a lover; but by the time we have finished Volume VI his failure in all three spheres is decisively apparent.

As a poet, Sainte-Beuve must rank—well, higher than his admired Madame Tastu. As a mystic, he measured his chances exactly when he wrote to Lamennais in 1831 that "Christianity…is indeed the true and only religion. But the difficulty is to make it a rule of life, the sovereign arbiter of one's habits and desires; for in the distractions, the daily seductions, of even the simplest Parisian life, the struggle between the beginnings of a faith and one's frantic desires, one's deep-rooted habits, can never be equal." As a lover, he was haunted and humiliated by his defects of voice and person. "You cannot imagine," he said in 1865, "what it is to feel that one will never be loved, that one's love can never be declared, because one is old and ugly and would make oneself ridiculous." Even as a young man he had reason to doubt his powers; and in the new volume we find him in the *malheureux midi,* the sad noontide of his affections.

Yet high noon has its consolations; and nothing in the years 1845–46 is more curious than the dialogue between Sainte-Beuve and Madame Allart de Méritens. Hortense Allart was gifted with an unlimited capacity for intellectual attack; at once novelist, historian, and philosopher, versed equally in dead and living languages, she had corresponding powers of erotic enterprise. ("And why," she once wrote to Sainte-Beuve, "should the number of my lovers be limited otherwise than by the liberality of Providence?") Chateaubriand and Bulwer-Lytton were the most eminent of those who had preceded Sainte-Beuve in her affections; but it appears from these letters that for once Sainte-Beuve was insensitive to the charm of historic associations, for their liaison had hardly begun before he rebuffed her in one of the most ungallant letters ever committed to paper. "When I see you, I weaken, and desire gets the better of me. Endless disquiet results. I want to find in you a bulwark against

yourself, and a bulwark against myself also. You will always have in me a caring friend, but let there be a barrier between us—and let me always stay on the right side of it!"

It says much for the accessible Queen of the Blues that even after this she continued to send him the letters which bring to these rather severe pages so welcome a touch of fantasy. Sainte-Beuve did not answer regularly; and only once—in a daring conceit, drawn from the Palatine Anthology, on the superior qualities of autumnal fruit—did he go out of his way to compliment her. In no wise discouraged, she set herself to win him; and we, as much as he, are teased and charmed as she rattles on, now singing the praises of her country retreat, now wishing herself some Oriental bird of prey, now likening Chatham to "those holy men, those *priests* whose lives are dedicated to the highest passions." The Pitt family is responsible, in fact, for the most fully developed of her fantasies—that in which she imagines Sainte-Beuve metamorphosed as the younger Pitt. "Chatham would have loved you tenderly," she bursts out, quite demented by the phantasmal glories of the scene. "You would have played a great part in Parliament, with your eloquence, your authority, your powers of expression...but would you have been an inflexible Minister, a firm rock among the hurricanes of war? Of that I am not so sure."

Sainte-Beuve was not so sure, either, though he rather liked being called *"Mon Pitt."* He confided to Hortense Allart that it was rather in a novel that he thought of expressing his political conclusions. *Ambition*, the novel so often forecasted in his middle years, would contain "everything true and original that I have to say about politics...and in the background some waning passion, in that last bitter and disillusioned phase that I know so well and could render with such dreadful veracity." Perhaps he exaggerated a little, for he retained to the end that predisposition to *ennui* which is the mark of those who read *Obermann* in early youth. There are other, more fugitive romances in this new volume (among them one so ardent that, having strained a ligament while searching for a book in a dark corner, he caused himself to be carried in a chair to the salon of his beloved); but it is the correspondence with Hortense Allart that carries us nearest to Sainte-Beuve. "The great thing," as he said in old age, "is to have tried everything and believe in nothing." In 1846 the tremendous effort of the *Lundis* was yet to come; the long years in which Sainte-Beuve, walled up in his study like Hans d'Islande in his cave, was to produce a weekly article of twenty pages—those years began only in 1849. In old age he liked to say that the *Lundis* were written to restrain, if not to suppress, an overwhelming sensation of emptiness and despair; but one cannot read the articles on the ancients, or on the masters of the seventeenth and eighteenth century, without fancying that Sainte-Beuve saw himself as the guardian of civilization. "I believe," he wrote to Hortense Allart in 1845, "that society is an *invention*, that civilization is an *art*, that it has all had to be *discovered*, and that it could equally well never have existed, or existed only in an infinitely lesser degree." Of these inventions, arts, and discoveries, Hortense Allart was herself a worthy fragment; and it was perhaps a little with her example in mind that Sainte-Beuve later declared that *"il n'y a rien de vrai que la femme."*

# III.

# PORTRAITS
# IN MINIATURE

The first duty of the professional critic of art is to go to exhibitions and say
whether they are good, bad, or awful.

Where the work on view sweeps us away, we cannot resist speculating
as to the personality of the artist. This is a tricky business. Many good
artists keep the best of themselves for their work. Some, for reasons that
are none of our business, are gifted dissemblers. Others seem easy of
access, and have in their work a distinguished openness that makes us feel
that they are already our friends. But every case is unique.

# Jean-Honoré Fragonard

## The New York Times, 1988

The youth and early manhood of Jean-Honoré Fragonard (1732–1806) are a
joy to contemplate. He was quick, gifted, eager, and adaptable. In a stocky,
well-fleshed way he was very good looking. Everything went well for him,
though he missed out on the classic art education that he could have got from
the Académie in Paris. To have studied reputedly with Chardin and beyond
question with Boucher was as good an introduction to the practice of art as
could have been hoped for.

Urged on by Boucher, he won the coveted Rome Prize when he was only
twenty-one and had no academic credentials whatever. His long sojourn in
Italy (1756–61) was for the most part under ideal auspices, and he made the
best use of it. Hardly was he back in Paris than he made a sensation, alike as
draftsman as a painter in oils, and in the first half of the 1760s there seemed no
limit to his energy, his versatility, his inventiveness, and his ability to please.

Our pleasure in reading about all this is unaffected by the fact that much
of it is based upon evidence that is fragmentary at best. We want to believe it,
and we do believe it. To write about Fragonard is to fall a little in love with him.
We become convinced that in an earlier incarnation we were right there with
him, throughout the years in question. And we feel that when we put pen to
paper he is sitting beside us—laughing, eating an ice cream of the highest
quality, sizing up every pretty young woman in sight and telling us how it was,
back when.

To anyone who has ever been a prey to this most irresistible of fallacies, the
Fragonard exhibition at the Metropolitan Museum will be a delight without

alloy. Organized and catalogued by Pierre Rosenberg, now chief of the department of paintings in the Louvre, the exhibition is very large, but it is never too large. Fragonard's drawings rank equal with his painting, as is their right, and we move from one to the other and back again with never a hint of monotony.

Moreover, the show has been installed at the Met with a sense of order and proportion, finesse and telling contrast, that could not be rivaled when the show was first seen, last fall, in the decrepit spaces of the Grand Palais in Paris. Fragonard at the Met can breathe, stretch, and look around, whereas in Paris the work was often put up against the wall as if waiting for the firing squad. This is, on every count, a show to be treasured. And if it is short of some wonderful things from the Paris version, it has picked up others on its way across the Atlantic.

As everyone knows, Fragonard looked on the bright side of things. The elegiac poetry of Watteau, the frenzied melodrama of Greuze, and Chardin's sublime contentment with the humblest of still-life subjects—all these were alien to him. We can scour his paintings and drawings and never happen on anyone who is sick, ill-natured, ugly, or vicious. His is a world dedicated primarily to pleasure, and one in which unwelcome advances and relationships headed for the rocks are taboo. All suitors are lusty and well favored. Young women make them welcome. Spirits are always high, and no one ever begs off with a headache. No one ever gets hurt or disappointed, and every bolt is well oiled against the next emergency.

It could be cloying, but Fragonard has a way of coming through with common sense at just the right moment. Here and there we sense, moreover, that he was not quite as straightforward as he is sometimes thought to be. During the early 1770s, around the time of the great *Fête at Saint-Cloud,* which has been lent to the present show by the Banque de France in Paris, we notice a recurrent image that may well stand, consciously or not, for disquiets that elsewhere are kept out of sight.

The image in question is of a tall and well-grown shrub that has been overturned by an unidentified but powerful agency. There it lies on the ground, still in the rectangular wooden support that had held it upright. It is the very picture of catastrophe, and yet no one takes any notice. Life goes on around it. No gardener comes running. It is as if it were not there at all, and yet we remember it in puzzlement. What can it be, if not a signal of some sort? Or a warning that enigmatic forces beyond our control are everywhere at work? It turns up in the *Fête at Saint-Cloud,* and again in *Blindman's Buff, With the Pink Parasol*—emblems, both, of an untroubled felicity that cannot quite be depended upon.

For further evidence, in this context, we have only to look at one of Fragonard's most famous images, the so-called *Island of Love.* In this, a festive boat, crammed to the gunwales with well-dressed young people, makes landfall on an island shaded from the sun by deep tunnels of dense green foliage. The island is love's rabbit warren, in other words, and these particular rabbits are all set to go.

It has always been seen as an idyllic image. But this visitor was not so sure. What about the rock-strewn shallows, all afoam with moving water, that will make the return journey a test of the navigator's skills? What about the dead

tree that streaks across the middle distance? Are those not warnings from both above and below that nature may not always be benign?

Pierre Rosenberg inclines to date all these paintings from either immediately before or immediately after Fragonard's second trip to Italy (1773–74). It is possible, therefore, that these portents rose up, unbidden, from his unconscious and corresponded to the self-defeating side of Fragonard that seems to have come to the fore from 1774 onward. This was clearly a period of doubt and demoralization for Fragonard. Two major projects had ended unhappily—one for Madame du Barry (now in the Frick Collection) and the other for a celebrated dancer, Mademoiselle Guimard.

Not only did he have trouble coming up with the major painting that would have earned him the title of Academician, but he was called "capricious" and "irresponsible" by the committee concerned. "It is a matter for regret," a commentator wrote, "that M. Fragonard has not attained greater heights." Times were changing. Taste was changing. And Fragonard had lost his gift of adaptation.

And yet a great potential was still there. The drawings that he made in Italy in 1773–74 include many a marvel of plain statement and human sympathy. These qualities come out strongly in a painting like the *Heureuse Fécondité* in the present show, which seems to date from 1774–75. There could be something sentimental about this portrait of a high-lit young mother, with her children all around her, her admiring husband leaning over the window and even the family donkey lost in admiration at the scene.

But Fragonard gives its every detail a naturalness, an unforced weight, and a beauty of execution that make us pore over the painting and decide that it is one of his best. Fragonard has brought to this scene of everyday life something of the rapt attention that we expect to find in paintings of the Nativity. The husband doubles, in fact, as one of the three kings, and even the donkey has overtones of awe.

What seemed like "caprice" to the Académie in Paris may have been no more than a readiness to tackle new subjects in a new way for a new public. The last room at the Met is a curious mixture, but it is also a reminder that Fragonard never quite lost either his old élan or his ability to bring panache and a sense of high drama to new subjects. Above all, he gave of himself as much in the quiet, reflective, and implicitly moralizing tableaux of domestic life as he had in the carefree couplings and the accelerated brilliance of the portraits of men that were known to his contemporaries as *figures de fantaisie*.

It is, in the end, this readiness and this ability to *give*—totally, freehandedly and on the instant—that endears Fragonard to us. Quite clearly, he thought of painting and drawing as a conversation between himself and us. Witty himself, he makes us feel that we are his equal in that regard. As much as any artist in history, he personified a certain tone, a certain touch, a certain way of looking at life and making the best of it. It may be apocryphal that he dropped dead while walking along in Paris and eating an ice cream in the open air, but even if that isn't true, it ought to be true, for he of all people would see the joke.

# Berthe Morisot

**First printed in June 1941, in *La France Libre,* a French-language
magazine, edited by Raymond Aron in London.
Put into English by J. R. in August 1988.**

Can it be a hundred years since Berthe Morisot was born in Bourges on
January 14, 1841? Nothing that she did has aged. Nor is there anything that, by
distancing her from ourselves, could suggest a hundred years' span. It would
be ridiculous to look for anything that has gone out of fashion in a body of work
that still sparkles from end to end, speaking up at every point for the element
of festivity in everyday life and suggesting to us that we, too, can find marvels
everywhere if only we know where to look for them.

Much of her work relates to a Passy now long distant from us. Passy in the
1880s was discreet, well-to-do, and still had much of the character of a
provincial town. The Morisots lived on the rue Guichard. Whether in the arts,
or as public servants, they were people of reputation. Tiburce Morisot, the
father of Berthe and Edma, had studied at the Ecole des Beaux-Arts and was a
man of genuine cultivation with a passion for the ancient civilization of the
Mediterranean. Opting eventually for a career in the public service, he became
successively *préfet* for the Calvados and *préfet* for the Cher.

Despite the demanding character of these posts, he took care to watch over
the gifts of his two daughters. (Edma Morisot had shown a portrait of her
sister, Berthe, at the Paris Salon of 1868.) Domesticity was to be the prime
motive of Berthe Morisot's work, all her life long, but from the age of seventeen
onward she was given a strict academic art education according to the fashions
of the day. Drawing from casts was the foundation of her art.

She came to know a great deal about music. As a correspondent, she
delighted Stéphane Mallarmé. Once her innate reserve and timidity were
broken down, she revealed herself as a conversationalist who numbered among
her admirers painters like Auguste Renoir and Edgar Degas and poets like
Jules Laforgue and Théodore de Banville.

She was a true Frenchwoman—one who knew how to discriminate in all things. Reputedly a great-great-niece of Fragonard, she ranked the authority of the eye very high indeed. Edouard Manet painted Berthe Morisot over and over again, and when we have studied the luminous green depths of her eyes, delicately frontiered with black, as Manet sets them before us, we have no trouble believing that among all her gifts there was no mistaking the pre-eminence of the eye.

Paul Valéry got it exactly right when he said of Berthe Morisot that she "lived with and by her enormous eyes and was attentive in the extreme, and at every moment, to their functioning and to their eternal activity." She had an evident originality that set her a little apart from everyone else. But she had also an innate wildness. Rowing close to the swans in the Bois de Boulogne, she made drawing after drawing of them, only to throw them overboard, one after another, when they did not satisfy her.

In the Parisian art world in its more decorous aspects, she was a familiar figure. She would rather copy a Veronese, any day, than go out to tea. Croquet and badminton were all very well, but she preferred the company of the fellow-enthusiasts—some of them very distinguished indeed—who she met while working in the Louvre.

In this way she became a close friend of the Manets, and of Fantin-Latour, and eventually the wife of Manet's younger brother, Eugène. A "Manétiste," through and through, she showed with her friends, took part in the celebrated Impressionist sale at the Hotel Drouot in March, 1875, and endured her share of the hostile reviews of the day. But there was nothing of the public figure about her, and when she showed on her own at the Goupil Gallery someone said quite rightly that it was "like a reception in a private apartment."

Never one to court a spectacular success, she hated to be interviewed. As Madame Eugène Manet, and as the mother of little Julie Manet (one day to emerge as a remarkable diarist), she lived a quiet life behind the shutters of her sitting room in the rue Villejust (now rue Paul Valéry). Through those half-closed shutters, she could see the little garden, green with bushes and trellised in blue, that guarded her discretion, and even her isolation, in the very center of Paris.

People often say that her interiors are her best work and that, owing as much to the makeup box as to the palette, they catch the sixteenth arrondissement of Paris on the wing. And they do, in effect, present us with a dandified version of the *mundus muliebris* in all its variety. Jacques-Emile Blanche, the painter and autobiographer, once drew up a list of all the now-vanished apparatus of life that it amused her to put into her paintings—the objects of ivory and mother-of-pearl, the richly bound albums, the rings terraced in velvet boxes, the big plump rice powder puffs, the free-standing mirrors framed in cream lacquer—and all of this in a room decorated in pink cretonne.

Yet I for one prefer her landscapes to her interiors. We have paintings by the hundred of people at home. But what fascinates us in Berthe Morisot is the way in which she can match and mate her human beings with their immediate surroundings. Nature, for her, is something gentle and well balanced. Sublimity is nowhere present. Ferocity, likewise. No walks alone, or in despair, in

her paintings. Supernatural forces never wreak their way with them. All that happens is that they come together in a landscape that is made for them and has been tranquilly awaiting their arrival.

Her powers of observation were virtually perfect, moreover. With people, as with objects, she had a sense of hierarchy that never failed her. She knew the place of everything and everyone, and the source of everyone and everything.

When she had worked with Camille Corot, he urged her everyday to "use plenty of air, and everywhere." From Corot she learned to sniff, to breathe deeply, to animate her every touch of the brush. Thanks to her, we know precisely what the Channel breezes were like in the little port of Ramsgate in 1875. Thanks to her, we can smell the *langues de chat* that had just come in from the great pâtissier Petit. We feel between our fingers the odor of a handkerchief newly drenched by Pivert. And we overhear the conversation of the farm women who smell of newly gathered hay. So far from celebrating the centenary of Berthe Morisot, we welcome her as our contemporary.

# Thomas Eakins

**The New York Times, 1982**

There never was an American painter like Thomas Eakins, who was born in 1844, died in 1916, and is the subject of a great exhibition that has just opened at the Philadelphia Museum of Art. It is not simply that in his hands painting became an exact science, so that if he paints two men rowing on a river we can tell the month, the day, and the hour that they passed under a certain bridge. We admire Eakins for that, but we prize him above all for the new dimension of moral awareness that he brought to American painting.

The question that he asks is not "What do we look like?" It is "What have we done to one another?" "And it is because he gives that question so full and so convincing an answer that we ask ourselves whether Thomas Eakins was not the greatest American painter who ever lived. Even if the question strikes us as meaningless we find it difficult after an exhibition such as this to think of a convincing rival.

This is a very large claim. Let us see on what it is based. Eakins never had (nor ever craved) facility in paint. As a pupil of Jean-Léon Gérôme in Paris, he did not stand out. But as a sixteen-year-old draftsman he could draw a lathe, or any other piece of machinery, in such a way that we can see through it, and around it, and know exactly how it works. There is no arguing with work of that class. What we see, we trust.

That element of trust is not the whole of art, but it is difficult to conceive of a representational art in which it plays no part. And Eakins inspires it in the highest degree. We can say of him what Ralph Waldo Emerson said of Thoreau—that "his powers of observation seemed to indicate additional senses. He saw as with microscope, heard as with ear trumpet, and his memory was a photographic register of all that he saw and heard."

Eakins saw that particular capacity as a part of manhood, and one not to be talked of too much. "Every man should be able," he said, "to plot a field, to sketch a road or a river, to draw the outlines of a simple machine, a piece of household furniture, or a farming utensil, and to delineate the internal arrangement or construction of a house." To draw right is to live right, in other words.

Whence came the wonderful preliminary drawings with which Eakins foresaw every possible perspectival problem in his paintings of oarsmen. Once seen, those paintings stay with us for ever as paradigms of American practicality, American physical vigor, and American delight in the open air. We just *know*, without being told, that Eakins in those pictures left nothing to chance.

And, sure enough, when the late Theodor Siegl was cataloguing the Eakins collection at the Philadelphia Museum, he was able to prove that in the *Pair-Oared Shell* the size of the boat, the angle of its movement, and its exact location in relation to the old Columbia Bridge on the Schuylkill River had been worked out to the nearest inch. More than that, we can be quite certain from the evidence of the painting that the boat passed under the bridge at precisely 7:20 P.M., Eastern time, on one of two summer evenings in either early June or mid-July in the year 1872.

Eakins could, of course, have made all those calculations and been no more than a first-rate engineering draftsman who couldn't bear to make a mistake. Throughout his life, as we see in the Philadelphia exhibition, he stood for an absolute exactitude. It was basic to his art that everything should be got exactly right, no matter whether it was the movement of a horse, the workings of a precision instrument, or the precise degree of squalor that comes over the bed linen in a rudimentary operating theater at the end of a long day.

It was the same with the human body. Eakins was not content with the traditional art-school approximations. Digging deep into human cadavers with his own two bare hands, he got to know their ins and outs as well as any surgeon. Though hampered hardly less than Cézanne by the pseudo-moral standards of the day, he also managed to work both from the living human body, male and female, and from photographs made by himself.

Among many of his contemporaries—above all perhaps among those who had not seen them—those photographs were thought to be outrageous in their matter-of-factness. That was not how Eakins saw them. Life for him was too important for prevarication. The artist was there to tell us how it was, and not

to dress it up with bravura, like John Singer Sargent, or sprinkle it with confectioner's sugar, like Mary Cassatt.

Once again, this could have been a matter of objectivity fortified by conscientiousness. But Eakins was not just a man who simply kept the anatomical score. He was one of the great American moralists. Looking at his fellow human beings, whether singly or in groups, he remembered that there are truths that could cure, and truths that can kill. He also knew that it is our human duty to tell one from the other, difficult as that may very often be.

Walking from room to room in the Philadelphia exhibition—which was organized and catalogued by Darrel Sewell, the museum's curator of American art—we recognize a steadiness of moral purpose that shines out as much in the commissioned portrait of a well-to-do Philadelphian taking the air in his four-in-hand as it does in the two huge medical panoramas, *The Gross Clinic* and *The Agnew Clinic.*

Those two panoramas were to Eakins what the *Night Watch* was to Rembrandt. They spell out the alphabet of attention with which grown men address themselves to weighty and often disagreeable tasks. To see them together is a prodigious experience, and one unlikely ever to be repeated.

In the two great medical panoramas, as in all the other symphonic subjects to which Thomas Eakins addressed himself, there is "more than meets the eye." In both *The Gross Clinic* and the big painting of the prize ring called *Between Rounds* there is, for instance, the figure of a man in sober black whose function it is to keep the record straight. Pen or bell in hand, he bends over his task. How can we doubt that he is more than a humdrum recorder? Is it not likely that he is to prose what the painter is to poetry, and that Eakins has included him as a point of reason and stability in a world given over to an ordered violence? Surgeon and bruiser are one, after all, in that their function is to spill blood as efficiently as possible.

But it is within four walls and on a one-to-one basis that Eakins the moralist is at his very best. It is relevant in that context that one of the few total failures in his career was the portrait of Walt Whitman that makes so unhappy an appearance in the Philadelphia show.

Everything was in favor of that painting. The No. 1 painter was faced with the No. 1 poet. What could go wrong? Even the photographs that Eakins took of the aged Whitman are unforgettable. But the painting just doesn't ring true. Whitman looks like a summer-stock Falstaff. That huge vacuous grin might reach to the rear mezzanine, but we don't for one moment believe that this is a great poet, let alone the man who took the whole of this country in his embrace in ways that are still valid.

We cannot doubt that Eakins was paralyzed by Whitman. He loved the work, he knew the man, but just for once he shuddered before the evidence of physical decline. As with the portraits of his father-in-law, William H. Macdowell, he allowed a histrionic element to intervene. How much finer and more stringent are the other portraits in the show! Eakins was never better than when cataloguing the ways in which life in the end withdraws its benefits from those who have fought a good fight but have not come out on top. And when he was face to face with a young actress who had everything on her side—talent, money, and looks—he made us feel exactly how anxious she was to get back to

the full life that most of his sitters had never known.

So what Thomas Eakins sets before us is a touchstone of American truth. "Best" is a big word, but if there are better American paintings than these I for one cannot for the moment think which they are.

# Walter Sickert

### The New York Times, 1979

Walter Sickert in this country and at this moment has not a great name, but at any time between 1881 and his death in 1942 he could walk into virtually any society in London, or Paris, or points in between, and be accepted at once as the most remarkable man in the room.

Just two examples will prove this. In 1883 James McNeill Whistler asked Sickert—at that time a young painter, just twenty-three—to accompany his *Portrait of the Artist's Mother* to Paris, where it was to be shown in the Salon. (It is still there, in the Louvre, and to many a European visitor it is the most famous of all American paintings.) Sickert delivered the painting, spent the night in Paris at the Hotel du Quai Voltaire as the guest of Oscar Wilde, and in the morning paid his first call on Edgar Degas. Degas was ill and didn't want to be bothered; but after a few minutes the two were fast friends, and remained so for more than thirty years.

Forty years later, Virginia Woolf went to one of the most memorable of all Bloomsbury parties. "Suppose one's normal pulse to be 70," she wrote in her diary. "In five minutes it was 120; and the blood was not the sticky whitish fluid of daytime, but brilliant and pricking like champagne." After dinner there were homemade entertainments. "Lydia danced; there were charades; Sickert acted Hamlet." As "Lydia" was Lydia Lopokova, one of the greatest of all Russian dancers, the competition was stiff. But Sickert had been an actor, after all, and was good enough to appear with Henry Irving, the supreme English actor of the day. Nor was he the kind of man who makes a fool of himself at parties.

Sickert was a terrific character, quite clearly. But art history is about what can be put on the wall, and in that respect Sickert is lasting very well. (He was not vain, by the way. "What puzzles me," he once said of art critics, "is the cocksureness of writers who cannot even draw as well as I do, which isn't saying much.") The friend in youth of both Whistler and Degas, he had been a privileged visitor to Manet's studio and was the author of essays on J. F. Millet and Camille Pissarro in which every word still seems exactly right. He had, all his life, a gift for reasoned admiration. (It was in his hates that he went astray. "Picasso," he wrote in 1924, "is not a patch on Poulbot, or Genty, or Metivet, or Falke, or the amazing Laborde.")

The etchings on view at the Yale Center range in date from 1883 to 1929. Their subject matter is drawn from everyday life (and every-night life, for that matter) in Venice, Munich, Dieppe, London, and Bath. They are bulked out with some paintings, at least one of which—a London music hall scene from the late 1880s, lent by the Yale Art Gallery—could hang with a theatrical subject by Degas and not look secondrate. There are some related drawings, too, but fundamentally this is a black-and-white show in which Sickert stakes everything on the etcher's needle.

He had strong views about printmaking. They were conditioned by the fact that his father was from 1859 to 1868 a regular contributor to a German magazine called the *Fliegende Blatter*. The Sickerts lived in Munich at that time, and every Thursday evening young Walter would monitor the woodcuts that were the source of the family income. "To rise occasionally to perfection in a weekly publication is to be immortal," he wrote later; and he didn't at all go for the "fine art print" that was all the rage in Edwardian England. Still less did he foresee a world in which people would take to printmaking and make a fat living out of it.

He liked a print to tell a story, and once said that "The end of drawing must be supposed, until anything can be alleged to the contrary, to be illustration." He knew that the journeyman-printmaker has to catch and hold his audience the way the great vaudeville performers caught and held the man in the back row of the balcony. And he thought very highly of the printmakers who could do that week after week, year in and year out. Ever delighted to provoke the pundits in London, he said flatly that a German illustrator called Adolf Adam Oberländer had "probably carried the art of drawing in its purity farther than anyone has yet done." And when it came to nominating the greatest British art of the nineteenth century he thought that "it would be difficult even to find a candidate to set against Charles Keene, a draftsman on a three-penny paper."

And most of his own prints do indeed tell a story. Sometimes, as in *Jack Ashore*, it is the kind of story that V. S. Pritchett tells so well in print. Sometimes, as in *A Little Cheque*, the story could have come from one of the more disreputable pages in the novels of Arnold Bennett. One of the finest prints in the Yale show bears an Italian motto that Sickert got word for word from Degas. It says in effect that you often have to dirty your hands to make an honest living, and in just a square inch or two Sickert sets the scene like a master of the naturalistic stage. He drew men and women as they are when we catch them off their guard. Nobody is perfect, in the world of his prints, but nobody is a great criminal, either.

He could characterize a townscape as sharply as any artist of his time. There are parts of London that are forever Sickertian. In Dieppe, we find Sickert at every street corner. Delacroix, Degas, and many another painter loved Dieppe, but it is Sickert who fixed it once and for all. Perhaps the most memorable of the prints in the Yale show is the *Quai Duquesne, Dieppe, 1915*, in which the figure of a solitary woman is outlined against the once flawless but now sadly battered waterfront. Sickert's feeling for the ups and downs of life is here perfectly matched with his feeling for space and order and a marine sparkle in the air.

# Beatrix Potter

**The New York Times, 1988**

When Beatrix Potter's achievement as a writer and illustrator of books for children was set out at the Tate Gallery in London last year, people came in the tens of thousands and stood in line forever to get into the show. Substantially the same exhibition can now be seen, through August 21, at the Pierpont Morgan Library. During the first half an hour of its run in New York, more than three hundred visitors were admitted. And every morning, before opening time, people cluster round the steps of the library, and on every face there is a look of pleasure and shared expectation.

They are not disappointed, either. The exhibition reveals Beatrix Potter as someone whose claims upon us far exceed her status as best-selling author. She appears before us in revealing detail as a scientific investigator, a human being undefeated by misfortune, a conservationist of rare gifts and even rarer discretion, a farmer who consistently beat out her male rivals, and—not least—an artist whose images, once seen in childhood, are never forgotten.

As a watercolorist in the great English tradition, she cannot be said to be in a high class. But as an illustrator, and as someone who knew how to mate word with image, she would be hard to fault for wit, for exact observation of animal behavior, and for the adroitness with which human follies and frailties are grafted onto antics that can be credibly ascribed to rabbits, ducks, and mice. (Who else could make us cherish the sight of a rat taking snuff?)

Consisting in all of more than three hundred items, the show covers both the known and the unknown of Beatrix Potter's career. We see her as scientist, archeologist, and large-scale sheep farmer. All the dear, dumpy little books are

there, in the format that she chose herself and would never agree to change. There are the private prints that she made for herself without regard for anyone else's opinion. We see her shaping and reshaping the texts, with "the shorter and the plainer the better" as her guiding principle. That way, we see how she arrived at what Graham Greene called, more than fifty years ago, "those brief, pregnant sentences which have slipped, like proverbs, into common speech."

We look over her shoulder as she researches the eighteenth-century settings for *The Tailor of Gloucester,* both in Gloucester itself and in the collection of historical costumes in the Victoria & Albert Museum in London. We see her slipping a study of foxgloves, doubtless with mischievous intent, into "Jemima Puddle-Duck," in which a fox plays so bad a part. We see her hat, her still-muddy clogs, and her coronation teapot. (The coronation was that of King Edward VII and his queen in 1901.) And we see how she looked at every stage in life—a model of pent-up intelligence in first youth and a great old lady carefully downplayed some sixty years later.

And, of course, we follow her whole career as a writer and illustrator from the legendary moment in 1893 when she wrote to a very small boy and struck a note that can still be heard today: "My Dear Noel, I don't know what to write to you, so I shall tell you a story about four little rabbits whose names were Flopsy, Mopsy, Cottontail and Peter..." When we are all through with this exhibition we know her as well as if she had been our favorite aunt.

In a subtle way, and without ever condescending to teach, Beatrix Potter tells us how to behave to one another. In that context, she was one of the great moralists. And a life led according to her principles will never be an ugly sight. We already know that, but in the exhibition at the Morgan Library it is as if she were right there beside us and we had her sole attention.

That is why the enduring popularity of Beatrix Potter (1866–1943) is the real thing, not the confected thing. Her work could by now have dated, staled, and come to seem irrelevant. The very names of her characters—Peter Rabbit, Jemima Puddle-Duck, and Squirrel Nutkin—could have cloyed. The unchanging format of her books could have come to look dinky and dowdy. In the heyday of the Muppets, what kind of a place could there be for Beatrix Potter, who detested personal publicity and never so much as heard the names of video or television?

Perhaps the answer is that Beatrix Potter was a true High Victorian. She believed in the redemptive power of hard work, intellectual curiosity, and a well-developed business sense. And she also believed that it was possible for us to leave the world better than we find it.

She loved the English language and taught herself to use it with perfectly sprung rhythms that were hers alone. She had decided, almost in childhood, to be an artist, and she knew exactly within what limits she could succeed. She could tell a very good story—lightly, easily, without preaching or diversing—and she was not at all sentimental. She knew what it was to love and to lose, and she knew what it was to take a wrong turn in life and have to pay for it. (Her brother and one of her uncles died of drink, and a partner in the firm that published her books was sent to prison for forging bills of exchange.)

She also had a High Victorian background of a kind that often produced

achievers, along with a minority of idlers and debauchees. Hard work in pioneering times had made her family more than comfortably off. Large country houses with stacks of servants and thousand-acre estates bred not only a sense of security but a delight in country pursuits of all kinds (hunting excepted). Her father, an obsessive early photographer, was as familiar with the High Victorian art world as he was with the leading politicians who were glad to come and stay for part of the family's ten-week summer holidays.

Beatrix Potter's privileged upbringing also included that slight admixture of loneliness and ill health that so often fosters an exceptional power of imagination. Add to that her generation's faith in science as something that could only lead to our general betterment, and you will find nothing untoward in the activity of a young Beatrix who made drawings for *Alice in Wonderland* in the same year as she produced a large-scale microscopic study of Sheet Web Spider. Fancy was all very well, but it had to be founded on fact, and fact could not possibly be too accurate. ("If you can't keep a bat alive, stuff him" were her instructions to her younger brother when he was still a schoolboy.)

She had from the beginning a remarkable gift for a phrase. Who else would have said of the local mailman that he reminded her of a "damaged lamp post"? She was also a genuine scientist, whose paper on "The Germination of the Spores of Agaricineae" was presented to the Linnean Society in London in 1897. But even with all her heterogeneous advantages there was no reason to suppose that she would emerge as someone who would invent a world of her own, in word and image, that would give pleasure (and discreet instruction) to millions of readers, worldwide.

The precipitation of that gift remains mysterious. In her absolute command of an invented world, Beatrix Potter was like all three of the Brontë sisters rolled into one. Furthermore, she knew when to begin, how to pace her career, and when to stop. She never obtruded herself. (She kept for many years a diary in code, the secret of which was not cracked until after her death. It does not appear to contain anything revelatory.) Her debut was a trouble-free unconditional success of a kind rare in publishing, and her instinct for the continuance of that success was flawless. In all professional dealings, she acted as an artist who was also a first-rate businesswoman.

When she turned farmer and conservationist in the Lake District, after her marriage in her late forties to a local solicitor, she made a great success of that, too. Her sheep were the best sheep. Her benefactions to the National Trust were among the noblest and most imaginative that the trust had ever received. These were great achievements, perpetrated almost in secret by a shapeless old lady whose bizarre appearance in an unvarying coat and skirt of thick and badly cut tweed can only partly be explained by the fact that the cloth in question was woven from the wool of her own sheep.

All of this has lately been made known in detail in an exemplary biography by Judy Taylor, published in this country by Viking Penguin. (A portrait of a Viking penguin by Beatrix Potter would be something to see.) But what no book can give us is the variety and delicacy of Beatrix Potter's drawings, as they are presented at the Morgan Library. Nor can a book give us the excitement of seeing her stories evolve under her very own hand, with preliminaries, revisions, and re-editings all intact.

# Willem De Kooning

**The New York Times, 1978**

For a famous artist to live as a recluse in East Hampton is a very neat trick—and one about which no novelist and no moviemaker could hope to persuade us. But Willem De Kooning is undeniably a famous artist, and he does undeniably live as a recluse in East Hampton, and there is a legitimate and general curiosity as to why he does it.

"To get on with his work" is the true answer.

When Mr. De Kooning first went to live all year round in East Hampton, it was the winter of 1962–63. At fifty-eight, he was the best-known and the most immediately recognizable of living American painters. As a pioneer of Abstract Expressionism he was known above all both for the series "Women," which he began in 1950, and for his ecstatic adaptations of American landscape. There were several other major painters in the first New York School, but in a mysterious way, Mr. De Kooning was Mr. American Painting to thousands of people who would not have spotted Franz Kline, Barnett Newman, or Clyfford Still if they had chanced to see them in the street.

It was a burden, that recognizability. Mr. De Kooning in physical terms was small and delicate, with an altar-boy's fringe of fair hair, an almost weightless walk, and a quickness of response and perception which most people lose in first youth. Fame had come to him only recently, but it had come in superabundance, as if there were about him some magical property which would rub off on everyone who shook his hand or had a two moments' conversation with him.

He had lived for years on virtually no money and in the kind of disused commercial or industrial buildings that people had not yet learned to call

"lofts." With his friends Edwin Denby, the dance critic, and Rudy Burckhardt, the photographer, he pioneered that mode of life in the 1930s (he had arrived here as an illegal immigrant from Holland in 1926), and he had no wish to change it. By the beginning of the 1960s, he had one of the handsomest lofts in town at 831 Broadway—"a big one," as Thomas B. Hess remembers it, "with beautifully polished floors, painting-walls on casters so that they could be moved to catch the best light, elegant modern chairs (the gift of a friend), and a telephone with a tape-recorded answering service ("it never worked").

But it was hopeless. If he stayed home, people hammered on the door, bellowed through the keyhole, lurked in the lobby. If he went out, they were on top of him before he could even cross the road. In bars, he was mobbed; in restaurants, beset by table-hoppers and senders of notes.

Much of his time was spent in wondering how not to be interrupted. "Leave town" was the only answer. De Kooning had spent summers in East Hampton, like everyone else, and he liked the unemphatic inland light and the unemphatic inland landscape. People who lived there all the year seemed to like it. His brother-in-law had a little house and was interested in selling it. De Kooning looked no further.

He could have afforded even then to live in the grander part of East Hampton, where nothing much has changed since Childe Hassam made his etchings there, during World War I. Give or take a tree or two torn up by the great storms which afflict the Hamptons from time to time, those well-painted square mansions on their squares of immaculate grass are just as they always were.

But De Kooning wasn't tempted. "I like to bicycle," he said to a visitor this winter. (Sure enough, a bicycle of conservative design was almost within reach as he spoke.) "I like to go out when I feel like it, maybe for an hour in the morning and again in the afternoon, and I like to ride around without being bothered. It's the only exercise I get, except for moving pictures. If I lived in Lilypond Lane or somewhere like that I'd always be mistaken for someone's gardener. 'Good morning, my man,' people would say. 'Be good enough to give your mistress this message....' But here nobody takes any notice."

De Kooning sees very few people nowadays, and he doesn't much care to be interviewed or photographed. He spends virtually every day in the studio and virtually every evening at home, by himself. But when he does have visitors he has a great deal to say in a light and rapid utterance that is full of unreconstructed Dutch vowel sounds. With his baggy white pants rolled way up above the ankle he has a somewhat Chaplinesque appearance, but there is nothing clownish about that nimble intelligence as it grasshoppers from one subject to another.

Insofar as he is formal at all, in his capacity as a host, it is in relation to two monumental rocking chairs that he salvaged from a resort hotel. Square-built, busty, and Wagnerian in their general presence, they respond to the slightest pelvic pressure. Their unlimited embrace makes De Kooning seem even slighter than he really is. Curled up in one of them, the favored guest has a grandstand view of the work in progress, which is likely to fill every corner of the big studio. Now that De Kooning rarely leaves East Hampton and turns down even the most tempting of foreign invitations, these giant rockers seem to

precipitate a free-running conversation in which memory and speculation, out-of-the-way knowledge, and shrewd comment all play a part.

For De Kooning is not one of those artists who revert to shop talk as often as they can. For instance, when Edwin Denby was writing about Nijinsky on the basis of the few photographs that survive, it turned out that De Kooning knew them well. "Why, yes," he said, in a phrase that Mr. Denby was happy to annex (and to acknowledge). "Nijinsky made the human body do all the things that it was never intended to do—and he made them work."

Like every painter of real consequence, De Kooning likes to interfere when it comes to building and rebuilding. His living quarters in East Hampton will never make the illustrated magazines, but the studio is quite another matter. "I made my own drawings for it," he said. "And the builders were delighted with them. *Very* clear, they said, and they had no trouble at all."

The studio is large, as one might expect, but in architectural terms it is more like an engineering workshop than a place in which paintings and sculptures are made. Metal structures whizz this way and that across the ceiling. Thousand-watt Klieg lamps would have been strong enough for the lobby of Grauman's Chinese Theater in the heyday of Hollywood. An enigmatic platform is cantilevered high into the air.

Though close in its design to the free-flying pulpit from which Lenin was expected to address the faithful in the early days of the Russian Revolution, this pulpit has no political implication. "Not at all," De Kooning said. "It's just that when I make lithographs I like to look down at them from a height and see how they are getting on."

Even the studio floor bears his personal mark, in that beneath every painting in progress sheets of newspaper are laid out to catch the paint that drips down (or is wiped off) as work goes forward. They have a curious effect upon the visitor, these sheets of newspaper. The palette is inimitable, and yet the marks are completely unorganized. The touch, the guidance, the ferocious intent—all are absent. But De Kooning keeps them around.

"You remember how it was with Matisse," he said. "Matisse at one time used to cover the studio floor with sheets of newspaper. Everyone thought he was anxious to protect the floor, but Matisse said no, he didn't care at all about the floor, but he did like the way the light was reflected off the sheets of newspaper."

One advantage of East Hampton is that there is a great deal of light to reflect. Prowling about the little estate, we may think that the grass would not pass muster at the All-England Lawn Tennis Club, but we couldn't fault either the design or the siting of the studio. The light comes pouring in from all over; it changes every hour of the day; and although most times it is a delicate and steely gray in color, it can take fire at sunset, with conjunctions of red and purple such as Mondrian used to monitor as a young man when he was painting landscapes in Holland.

De Kooning in his seventies has no trouble getting started on a new picture. "You get old, you get used to yourself. A painter can go down, way down, when he's waiting to begin. Franz Kline went very down, and I used to be so nervous I got palpitations. Now I don't have that trouble. I see the canvas, and I begin. But you have to keep on the very edge of something, all the time, or

the picture dies."

If readiness is not all, in this headlong art of De Kooning's, it is a great part of the battle. His studio tables look like a cross-mating of the workshop of a Renaissance chemist with the kitchen of a very good cook who is big on sauces. In bowl after bowl, inscrutable mixtures quietly get themselves together. To make precisely the right sexy juices for those new paintings demands an enormous application. Oil paint is thinned with water. Safflower oil, kerosene, and mayonnaise are pressed into service as binding agents. "One day," he said, "I'd like to get all the colors in the world into one single painting."

People often think that a great painter has to have great brushes, and it's true that some of them insist on hair so fine that it could put the silkworms out of business. But De Kooning uses (apart from knives and spatulas) everyday housepainters' brushes that come in a "Pak-o-Four" for $1.49. He also has devices of his own invention—pullings and tuggings and overlayings—for the perfecting of the licked look that gives so sumptuous a consistency to his recent paintings.

He likes to paint on a thick, resistant support, and in 1964 he painted a series of pictures on thick wooden doors, tall and narrow in shape, that he had bought in bulk from the manufacturer. "But with big paintings like these the stretcher can weigh fifty or sixty pounds, and I can't manhandle them as I used to. So now I put the canvas on a Styrofoam backing and then, when it's finished, my assistants do the stretching and mounting."

He has no plans to go anywhere at the moment, but in the 1960s he had some fruitful travels. In 1964, at the age of sixty, he went to Paris for the first time. He thinks of himself as an American painter, and as a painter who was formed by specifically American experiences; but even so he was amazed by the amplitude, the unerring command of scale, that comes out in the gigantic paintings of Delacroix and Courbet in the Louvre. From a visit to Japan, five years later, he got the impulse for some freely calligraphic prints. And from a sojourn in Rome, that same rich year, he got the idea of making sculptures.

His sculptures have the same basic subject matter as many of his paintings. Quite clearly he will never exhaust the possibilities of the human figure. Male or female, most often stark naked with limbs askew and eyes flaring, the figure has nourished his art almost continuously. His paintings may vary as to the amount of decipherable detail which he sees fit to include, and of late an ever-greater wildness and fragmentation may be said to have entered into the process, but fundamentally De Kooning is still a figure painter.

It is a vision which carries over directly into sculpture. The Long Island clamdiggers turn up almost unaltered, for instance, as do full-length figures of men or women, seated or standing in attitudes expressive of some trenchant but undefined purpose. There are no portraits of identifiable people, but one of the heads does seem to him to look rather like his friend and regular visitor Salvador Dalí. "I didn't mean it, but there it is—the mustache, the big eye, everything. I like Dalí very much. He's very quiet now—not like he used to be—and when I said to him 'Why did you paint those Salvation Army pictures?' he said, 'Maybe I'm not really a good painter, after all.'"

As to whether De Kooning himself is "a good painter, after all," we can all make up our minds. But he doesn't intend to shut up shop just yet. Many

people would be happy for him to go on forever with the life-size frontal figures of men and women for which he is best known, but he has a more ambitious plan. "I'd like some day to do a studio," he said. "A studio like Matisse used to do, with two or three figures in an interior and maybe a table.... Anyway, a big interior with figures." Since Velázquez, since Courbet, and since Matisse, there is no more taxing subject for a painter. But the recluse of East Hampton does not daunt easily.

# Joseph Beuys

**The New York Times, 1986**

If there is any one thing that can be said with certainty about the great sculptors of the past—Phidias, Michelangelo, Donatello, Giovanni Pisano, Bernini—it is that they would have rolled on the ground in disbelief had someone told them that in the last half of the twentieth century a major sculptor of our own day would have taken time off to give a public lecture to a dead hare on the meanings of art. Yet Joseph Beuys did just that, during the course of his all-too-short life, and nobody in the audience walked out.

As for the people who were not there, a lot of them blew their collective top when they heard about it. But then it would have been difficult to set foot in the European art world any time in the last twenty-five years and not get caught in the crossfire of a verbal shoot-out as to the genius, or otherwise, of Joseph Beuys. Alike as sculptor, teacher, performance artist, one-man university, and non-party politician, Beuys was the most controversial artist of his generation in Europe.

A prime example of his power to startle is the sculpture called *The Pack* of 1969. Himself a legendary survivor, Beuys well remembered the time when a quick and unwilling getaway was the law of life for whole populations. He also knew that millions of people in Europe were wondering how soon they might have to do it again. So he took a beat-up Volkswagen bus, symbol of everyday nondescript journeys, and filled it with an archetypal instrument of escape—the little sled, kitted out with felt for protection, fat for food, and a flashlight

for orientation. Believing, as he did, that "the most direct kind of movement over the earth is the sliding of iron runners on a sled," he trusted to the sled as the prototypical image of survival. The chaotic tumble of the sleds as they got free of the unattended bus had overtones of which no sensitive observer could be unaware.

Was he shaman or charlatan, sage or pest, saint or silly? Everyone had an opinion, and everyone gave it. But in the context of the times Joseph Beuys was the inevitable and the indispensable man, the man who stirred the scene with a very long spoon and brought it to the boil. And while it would be too much to say, with W. H. Auden, that when he died of heart failure on January 23 "the little children cried in the streets," it was undoubtedly the end of a phenomenon that, for better or worse, will never recur. Never again is an artist of his stature likely to go from place to place, like a wandering friar, and talk to small groups of people in hopes of saving the world by individual regeneration.

Born in Krefeld, Germany, in 1921, and raised in the town of Cleves, Beuys was—aptly enough, in view of his later preoccupation with sustenance—the son of a fodder merchant. He had in boyhood an exceptionally vivid imaginative life in which botany, biology, and the debris of the Industrial Revolution all played a part. He also became conscious of the hare as an archetypal migrant of the Eurasian plain that stretched eastward forever (more or less) from his front door, and of the beneficence of the European bog, which he once characterized as "the liveliest element in the European landscape, not just from the point of view of flora, fauna, birds, and animals, but as storing places of life, mystery and chemical change, and preservers of ancient history."

After graduating from secondary school in 1940, Beuys joined the Luftwaffe and became a bomber pilot. In 1943, when his aircraft crashed in the Crimean mountains, he was saved by Tartars who wrapped him in layers of fat and felt to keep him from freezing to death. Even at the height of the war between the Soviet Union and Germany, the Tartars in question operated as free spirits who regarded both sides with equal disdain. Thereafter, felt and fat stayed with Beuys as symbols of regeneration and turned up in a wide variety of unexpected contexts.

After the end of World War II, Beuys took a while to get over what had been, by any standard, a traumatic experience. But as of 1961 he began to exert an ever-wider fascination by virtue of a combination of qualities that was peculiar to himself. He had one of the great European faces—gaunt, hollow-eyed, marked by horrendous tribulations and crowned at all times of the day and night by an ancient and battered hat from the best hatmaker in London. Such was the hold of this felt hat upon the public imagination that in 1978, when Beuys was a guest at a state luncheon in Aachen, television commentators spent more time on the implications of his hat than on the results, if any, of the discussions between Helmut Schmidt, chancellor of West Germany, and Valéry Giscard d'Estaing, president of France. (A sleeveless gamekeeper's vest was also fundamental to his wardrobe.)

He had exceptional charisma as a teacher—so much so that when he was reinstated in the Academy of Arts in Düsseldorf in 1978 after a long period of wrongful dismissal, his students rowed him in triumph across the river Rhine. As a sculptor, he had a gift for the unforgettable image that made him a

favorite with more than one major European museum director. These images were like nothing that anyone had seen before, and there was heated discussion—especially among artists of an envious and ungifted sort—as to whether they could be called sculpture at all. But they turned out to last very well, both as examples of covert autobiography and as encapsulations of the landscape and the mythology of an ancient and haunted civilization.

In postwar Germany, Joseph Beuys had a unique situation. No one was ever less on the make than he, and in the art world of the 1960s he broke the mold of the "career in art." To the fast-money men who, then as now, were everywhere in the art world, it was an exasperation that he spent so much of his time in unmarketable activities, and was ever ready to take part in open-ended discussions which, though searching in content, were invariably pacific in tone.

To the leaders of an industry that was predicated on the uniqueness of the individual artist, it was simply intolerable that Beuys should put it about that every human life could be a work of art. Unsurprisingly, he attracted extremes of admiration and contempt, with not much in between in the way of objective assessment. But at all times—and not least during the illness that led to his death—he went his own way, said his own things, and acted upon his belief in what he called "direct democracy."

The essence of that democracy was that human beings should think things out for themselves and make their views known by referendum, rather than through what he regarded as an outmoded political party system. (He did, however, once stand as a nonparty candidate in a local election in Germany, and professed himself well pleased to have wrested two percent of the vote away from the rival party machines.)

It was also a dream with him that a parliamentary system would one day be devised in which the voice of the unaligned voter would be heard and could have some effect. In 1971 he founded what he called a Free International University. Liberated from the constraint of buildings, faculty, degrees, examinations, fees, and formal curricula, this was in essence a formulation of his activity as a vagabond magus for whom art and political discourse were one. (When I asked him when he would start making sculptures again, he replied, "But my speeches *are* sculptures.")

His work in sculpture stayed close to his innermost concerns. Sometimes his own life motivated it, and sometimes the life of the society in which he had been raised. The forms that his sculptures took were undeniably peculiar—and all the more so when he himself appeared as presenter and performer. Chatting on art to a dead hare, tapping out codes with lumps of sugar, dumping gelatin on his head, clashing cymbals while a horse munched hay, and releasing a duck during what passed for a concert, he served society as a cross between a seer, a safety valve, an inventor of enduring metaphors, and a holy idiot. In West Germany, which had need of all these things, he was an irreplaceable human being, and was regarded as such even by those who found him most exasperating.

Beuys first visited the United States in 1974. Instead of mounting a conventional exhibition, he arrived from Kennedy Airport in an ambulance rented for the purpose and spent a week in his dealer's gallery, fenced in with a

live coyote. The performance in question, "Coyote: I like America and America likes me," aroused widespread astonishment and was intended as a healing ritual that related to the American Indian's regard for the coyote.

In the winter of 1979–80 he had a full-scale retrospective of his sculptures at the Guggenheim Museum. So remote were the objects in question from anything that is normally called sculpture that they were received with consternation by many visitors. Felt and fat had not previously ranked among the predestined materials of sculpture, and the experiences to which Beuys's sculptures related were remote from those of most of the people who went to the show. Only later did it become clear that World War II and its aftermath had nowhere been more tellingly epitomized.

If Beuys did not always fascinate, in other countries, as he fascinated in German-speaking Europe, it was because he was profoundly and unalterably German. He had the perseverance, the craving for absolutes, the hallucinatory poetic fancy, and the gift for abstract formulation that had always characterized the German genius. But in his case those attributes were used in the service of mutual understanding and free human exchange, rather than of any more injurious ambition. He was big, generous, and tireless, and he never lost hold of the idea that one human being, working with small numbers of other human beings, could change the world for the better. Even those who found him a pain in the neck will miss him.

# James Turrell

**The New York Times, 1986**

One of the undecided problems of our time is the final status of the earthwork as artwork—the huge construction that is set up in remote places, often at great expense, and is necessarily accessible to only a very few people. Is it a moral breakthrough, a parable of purity that could be acted out in no other way, and a lasting enrichment of human awareness? Or is it the very rich man's last ridiculous toy, and the natural descendant of the eighteenth-century folly that looked like a castle, a bridge or a tower and served no practical purpose at all?

We have had about twenty years to make up our minds, but the subject is still approached almost entirely in a spirit of preformed prejudice. Michael Heizer's *Double Negative,* Walter de Maria's *Lightning Field,* and Robert Smithson's enigmatic and now-submerged *Spiral Jetty* in the Great Salt Lake have served more often as photo opportunities than as objects that we can actually go to see. During the years in question, more people have been to see the statues on Easter Island, or the turtles on the Galápagos Islands, than have seen Smithson's *Amarillo Ramp* in Texas. To go and see the *Lightning Field* is not an everyday outing, like going to see Mount Rushmore. It involves a long and awkward journey, an overnight stay in a remote place, and an investment of time, money, and patience that not everyone cares to make.

For this reason, most people "know" such pieces the way that they "know" bird behavior—through the medium of an illustrated book. (The sponsor of one early piece of this sort knew it primarily from having in his library a set of on-site photographs in an album bound with steer hide.)

But a new era may have begun with the recent acquisition by the Museum of Contemporary Art in Los Angeles of Michael Heizer's *Double Negative,* a deep twofold cut in the Nevada Desert that cannot be moved to Los Angeles or duplicated, but has to be visited in situ. The role of the museum, in this case, is to record it, to publish it (in art historical terms), and to make it possible and relatively easy to go and see it through periodic air trips to the site. (Maintenance is minimal, since Heizer wishes the piece to take its chances in nature.)

As to what it means to make an on-site visit to an earthwork, this particular critic lately spent an afternoon, an evening, and an early morning with what may well be the most ambitious work of art now under construction in the United States—James Turrell's reshaping of Roden Crater. The work in question is going forward not in a studio, a public building, or a metropolitan open space, but in the crater of an extinct volcano in Arizona which stands more than 5,000 feet above sea level and is within sight of the Grand Canyon as well as of the Painted Desert at its most subtly chromatic.

Access to this undertaking is possible only on foot—or, in my case, on all fours—up a steep slope some 700 feet high. The terrain gives way at almost every step, and the ascent was made at dusk. "Some way to earn a living!" I said to myself as visibility diminished with every stumbling step. Yet no sooner did our little party stand on the rim of the crater—which is to the plateau below what the top of the Chrysler Building is to the street level of midtown Manhattan—than an exuberance beyond measuring took hold of us and we felt ourselves, as Emerson said on another occasion, "glad to the brink of fear."

But would not any old mountaintop have had the same effect? Everest, for instance? High places are traditionally awesome. Every man, as he comes down from one, feels himself the equal of Moses. But there is a difference between other high places and the crater that is being reshaped, tunneled into, and fitted out with mysterious inner chambers by the California artist James Turrell. Other high places, where not disfigured by tourism, are much as nature left them. In Roden Crater, experience is directed, transfigured, and elucidated by art. Art, in its turn, is backed up by calculations of a kind that have only lately been possible due to advances in astronomy. (The region surrounding the volcano is ideal for astronomical studies and is used exten-

sively for that purpose.)

The reshaping of Roden Crater has a particular objective. At any time, and on any day, it will put the visitor into a direct relationship with our universe that can be obtained in no other way and in no other place. Turrell's calculations take care of the visitor who will come to the crater thousands of years from now. They take care of an alignment of the moon that will occur once every 18.6 years, and they renew and revalidate an experience that humankind has always craved.

Lying at the bottom of the crater and trying to avoid its more thorny or cindery deposits, we position our heads lower than the rest of our persons and open our eyes wide. What happens then is that we experience the universe as a perfect sphere, with the rim of the crater—more than 1,000 feet in diameter— as its terrestrial frontier. Above that rim, the sky hovers over us, boundless and immaterial. To an extent not paralleled in other places, all that is contingent or superfluous is abolished. As far as is possible on earth, movements and noise do not exist. Not only are we in the presence of an absolute sublimity, but our stillness, our isolation, and our receptivity are fundamental to it. As the art critic Robert Hughes said, "Turrell's art is not in front of your eyes. It is behind them." In other words, Turrell is not simply working with a sublimity that comes ready-made. He makes sure that, by watching ourselves see, we compound the sublimity.

It is relevant to this huge adventure that Turrell has often worked with the firmament, both as a professional aircraft pilot and as a man who has repaired and restored vintage aircraft for a living. He dealt with wind and weather when he sailed for his college team in the 1960s. He has studied both the psychology and the physiology of perception, and he has worked with projected light in ways that compel us to re-experience the very act of seeing. As the architect Craig Hodgetts once put it in relation to Roden Crater, "The perception of light involves not only the physical state of the external environment, but the internal physiological and psychological states of the perceiver."

The Roden Crater project is still a long way from completion. Financed initially by the Dia Foundation, and more recently by the MacArthur Foundation, the National Endowment for the Arts, and James Turrell himself (with virtually his entire income from smaller works elsewhere), the Roden Crater project was begun in 1979, two years after Turrell bought the 1,100-acre site for just under $6 an acre.

It will be completed in the 1990s if the Skystone Foundation, which Turrell formed in 1982, manages to raise the rest of the needed backing. So it will be a while before visitors can make their way in twos and threes up the walkway, thereby embarking upon a long cycle of experiences in which what Turrell calls "prejudiced perception" will play no part. Neither what we shall see, nor the way in which we shall see it, will have any parallel in our everyday experience. Ever since the great and final eruptions which are believed to have occurred just over nine hundred years ago, Roden Crater has been a privileged place. Standing, as it does, in a volcanic field, with more than two hundred other extinct volcanoes nearby, Roden Crater is the living image of geological time. "It has knowledge in it," Turrell once said, "and it does something with that knowledge."

When shaped and perfected in ways that relate as much to the elegant forms of eighteenth-century observatories in India as to the all-seeing installations of our own day, the crater will mediate on our behalf between geological time and celestial time. It will be a masterpiece of exact calculation, in which space and time will be in majestic equilibrium. But it will also be a place in which we come to know ourselves by forgetting ourselves.

Perhaps it is the Italian patron and collector Count Giuseppe Panza di Biumo who put the matter best when he said that "the Roden Crater project is one of the few things that must be made, to prove that the light in the human mind is not gone." Flying above the crater in a tiny aircraft that seems rather to paw the air than to thrust behind it, we feel as the ancient Greeks might have felt, had they been able to fly over the unfinished Acropolis. Going round James Turrell's current exhibition at the Museum of Contemporary Art in Los Angeles, we see how Turrell has confirmed the perception of the German Romantic painter Caspar David Friedrich—that the origins of the universe lie in sourceless, shadowless, unanchored light. Coming home from Flagstaff, we realize that what we have just seen is not a privileged playpen, but an attempt by a greatly gifted and still young man to come to terms with the universe in a way, and on a scale, of which Walt Whitman would have approved. In no other country, and at no other time, would such an adventure have been undertaken.

# Anselm Kiefer

The New York Times, 1987

At the Marian Goodman Gallery, 24 West 57th Street, there can be seen an exhibition, that is not like any other. In the big room, there are exactly two paintings, on the theme of Isis and Osiris. One measures roughly eleven feet by eighteen feet. The other is a little larger. They are huge, therefore, and they are also dense and dark and, at first sight, cryptic. They stand at opposite ends of the room, like altarpieces that have mislaid their altars, and we sense at once that they deal with weighty matters that will take some unriddling.

Ranged along the other two walls of the main room are thirteen books, dated between 1969 and 1987, that stand on black iron lecterns. With one exception they are as big as the chained Bibles of long ago. Lead plays a great part in them, and has been used to weight and thicken their pages. At once heavy and soft, unctuous and impenetrable, the lead slows the act of turning the big double-spread pages. On those pages, the images often have a disconcerting complexity. For instance, in *Martin Heidegger,* the progress of the philosopher's tumor on the brain is charted in detail in terms of homemade photographs by the artist that have been painted over with acrylic and oil paint. Mixed in with those photographs are pages of wallpaper soaked in black oil and shellac. The result has a daunting and disturbing quality, as if mental dissolution were taking place from page to page. The lecterns look as if they had been run up by a jobbing blacksmith. The general effect of the room is august, awesome, disorienting.

Like the succinct and seductive paintings in the small adjoining room, the big paintings, the big books, and the gaunt lecterns are the work of Anselm Kiefer, who in the opinion of many a good judge is the most remarkable artist to have emerged in Europe in the last quarter of our century. It was in 1973, when he was in his late twenties, that he began to be talked about. Then, as now, his paintings caused wonder and consternation.

His energy was prodigious, his ambition without limit, his range of reference as broad as it was disconcerting. Even the titles of his exhibitions made people uneasy. What manner of a man could it be who made his debut with *Nothung* in 1973 and followed that with *Sorrows of the Nibelungs, Alaric's Grave, Heliogabalus, The Song of the Burnt Earth, Operation Sealion,* and *Siegfried Forgets Brünnhilde?* The ancient German myths were very much out of favor during the years in question, and the intrusion of Operation Sealion (the code name for the projected German invasion of Britain in 1940) had also its tantalizing side. Over and over again, these titles touched on raw wounds and memories long tabooed.

Who was Anselm Kiefer, to go rooting among legends best forgotten and a military venture that, luckily for the rest of us, never got off the ground? The paintings were widely misinterpreted. Kiefer was known to live among deep woods and centenarian forests in the Odenwald, a part of Germany that had more than its fair share of the far past. This, he said, was Siegfried's own country, and the scene of his death. It was the scene, likewise, of the Hunnenschlacht, the stupendous battle in 9 A.D. in which the Germans routed the Roman armies in the Teutoburg Forest. Was it possible that Kiefer was the bearer of crazy and contaminated tidings? The prophet, in other words, of a revived German nationalism of a kind that mercifully had been dormant since 1945?

He was no such thing. But, as a young German born in March 1945—a moment at which the prestige of Germany stood at an all-time low—he was entitled to find out why it was that his country was beset by a universal and deserved obloquy. What his elders had blocked out and preferred to forget, Kiefer dug up and looked over, piece by piece. He looked at the good people, and he looked at the bad people, and he exerted the inalienable right of a free human being to form his own opinion about them. He knew of the importance

of Siegfried, for instance, but the Siegfried who turned up in his paintings was the man who had been drugged by his enemies and become untrue to himself. Past and present were one, in his researches, and he darted back and forth from one to the other.

When it came to the hideous prologue to his own birth, he said straight out that in killing the Jews, the Germans had killed an irreplaceable part of themselves. (From 1980 onward he often treated the theme of love and trust between Germans and Jews, and the impossibility of their being reconstituted.) And when he came to make his own honor roll of Germans who had deserved well of their country, he pictured them in images that were in black on white, thereby recalling the great days of the German woodcut.

He has, moreover, a universal curiosity. One of his books in the present show is called *Women of the French Revolution,* and was inspired by reading the great French historian Jules Michelet. Since visiting Israel, where his exhibition in Jerusalem in 1984 roused an enthusiasm that has had no parallel in his native country, he has read widely in both Talmud and Kabbala. And the two big paintings in the Marian Goodman Gallery were prompted by the Egyptian legend of Isis and Osiris. Anyone who expects a ponderous, one-note, ever-continuing re-examination of the German past will not find it here.

One painting is about Isis's determination to reassemble the fragmented body of Osiris, her brother and husband. At the very top of what looks like the Great Pyramid of Giza, but was prompted in point of fact by some Roman ruins in Israel, there is a rectangular box that might be an abandoned television set. In reality, this box functions as the computerized G.H.Q. from which the search for the scattered body of Osiris goes forward. We may judge of its success by the number of bone-white fragments, each wired up to the G.H.Q., that can be found on the lower reaches of the landscape. Electric wires—a surrogate for spiritual contact—link them one to another.

What looks, in the landscape, to be a definitive, ineradicable dryness and dustiness is there to remind us that in ancient Egypt the tears of Isis were believed to cause the Nile to flow again. In both paintings, we sense that the search had the character of a rampaging treasure hunt in which the earth was not so much plowed as torn up, gouged out, and peeled over. Kiefer-watchers will remember the painting of a few years ago in which both ax and blowtorch were applied to the image. Fire, for Kiefer, is not so much a destructive element as a cleansing and reviving one.

With that in mind, we turn to the second big painting. In this, the body of Osiris has been reconstituted and Osiris himself is all set to pursue a career for which wisdom and integrity in a supreme degree are needed. In the foreground of a gigantic landscape that stretches both away and upward is a group of rods. They are spouting flame, like overheated organ pipes or candles fitted with a booster. There is much else to look at in the painting—notably the skeleton of a skate on which Isis had flown across the ice in the course of her search, and some redoubtable furrows that Kiefer built up with thrown lead before painting them—but those burning rods hold fast to our attention. It is in the rods that the main point of the painting resides.

Just as in *Isis and Osiris* the search for the body of Osiris was carried on with the help of the latest in twentieth-century technology, so in the second

painting the bunched rods in the foreground reveal themselves in time as emblematic of a nuclear reactor. In the right hands, the rods could be a force for unlimited good. In the wrong ones, we all know what could happen.

As it happens, the myth of Isis and Osiris is prefigured in the earliest book in the show. Done when Kiefer was hardly more than a student, it deals with a teapot that was first broken and then put together again. But then Kiefer's whole career has been a continuing conference call, in which he summons up himself, the past, and the present, and monitors the conversation. It is fundamental to his view of the world that nothing is ever either entirely old or entirely new. ("Airplanes are atavistic," he said when he was in New York the other day.) Alike in his paintings, his visionary watercolors (none of which are included in the present show), and his books, he has demonstrated an astonishing gift for the image that startles, provokes, and enlightens.

As to the variety of means that he has developed for himself in a studio that looks more like an experimental laboratory than a sanctuary for painting, it is a never-failing source of surprise and enrichment. He has given back to the act of making art that primacy among human activities that it has elsewhere lost. For art as a commodity, we must look elsewhere.

# Gilbert & George

**House & Garden, 1985**

As a "good address," Fournier Street, London, E.1, is never going to rival Piccadilly or Belgrave Square, but it has its place in social history, the history of architecture, and the history of art. (Habitués of the Market Café that is one of its attractions would add that it has its place in the history of fair dealing, too.) Dominated at one end by one of the noblest of Nicholas Hawksmoor's London churches, it is within a moment or two of a public house that is named after Jack the Ripper, once the terror of the neighborhood. The street as a whole dates from the early eighteenth century, a time at which unornamented London row houses had both a plain grandeur of proportion and an exceptional finesse of detail. The houses in Fournier Street were mostly lived in at one time by Huguenot weavers, and for that reason many of them still have broad panoramic windows that open onto bagfuls of sky.

This was from its beginnings a cosmopolitan quarter, and there is a building not a minute away that has served successively as a Protestant church, a synagogue, and a mosque. Fournier Street has a very good tailor, Mr. Lustig. At the Market Café, porters from the nearby market can count on getting straightforward food of a quintessentially English kind at almost any hour of the day. There is also another café, not five minutes away, in which a small group of the faithful gathers daily in the belief that any day now the Savior will walk in there in the guise of a Bengali social worker.

Fournier Street is anything but dead, therefore. But my favorite house in Fournier Street is No. 12, which belongs to two still quite young British artists who call themselves "Gilbert & George, the sculptors." Gilbert & George today are international celebrities, preeminently because of their work but also for the strange and symbiotic persona that drew large audiences when they appeared as performance artists and is hardly less remarkable in private life.

It was from No. 12 Fournier Street that, in common with other fortunate people, I began in the late sixties to receive in the morning mails a series of unsolicited and undeniably peculiar communications. Gilbert & George at that time had a surreptitious reputation. Neither then nor since have they been sculptors in the sense that Donatello and David Smith were sculptors, but they had appeared here and there as living sculptures. They were Pygmalion, but they were also Galatea. In the best known of their pieces, they powdered their faces bronze, stood on a table with an old-fashioned wind-up phonograph between them, and did a mime routine to an ancient 78 rpm recording of "Underneath the Arches," a song that had been made famous before World War II by two great English vaudevillians, Flanagan and Allen. Sometimes they did this routine in public for eight hours on end, like eighteenth-century *automates,* with never a sign of fatigue or a lapse of concentration.

They were also known for their courtly and obsolete mode of speech, for their matching English schoolboy suits of gray flannel (rather short in the leg), and for their ritualized manner of getting through the day. At all times and everywhere they were together, looking alike, behaving alike, and talking alike in a precise, perfectly modulated and understressed way. Such was their apparent twinhood that it was difficult to remember that while George was in all things English, Gilbert had been raised in the Dolomites.

What came through the post was a single sheet of deckle-edged paper printed on both sides and folded across the middle. There was a drawing of Gilbert & George exploring the English countryside, a line or two of prose or verse, a personal dedication to each recipient. At the end were a laconic "Goodbye for now," a reproduction (unauthorized) of the Royal arms, and two signatures in red ink. "Gilbert," read one, and "George," the other, and it would have taxed even the FBI to tell one hand from the other.

Before long, these communications were much talked about, and a complete set of them became an envied possession. They were the very antithesis of the hard sell. The drawings might have been made by a very intelligent dormouse. The verses could have come from a Victorian keepsake that had passed into rather strange ownership. Storm and stress played no part in them. Nor was there ever an indication that anything was expected of us in return. Given that they clearly cost money to make and money to mail, I

eventually asked if I could not contribute to those expenses. "Absolutely not," said George, lightly. "Quite unnecessary," said Gilbert, more lightly still.

So there the matter rested. I left England forever. Gilbert & George became famous. So far from continuing to work in miniature, they began to draw on sheets of brown paper that measured in all fifty, sixty, and seventy square feet. They were shown, here and there. People bought them, all over Europe. And they went on to work with enormous photographs—all taken by themselves—that they turned into accumulative images on the scale of Veronese and Tintoretto, often with legends of their own devising, and before long with areas dyed bright red and brighter yellow. These too were shown, bought, and shown again and again in museums. They had a flat, frontal, all-out attack that was very different from the hesitant imagery and the reticent turn of speech that had marked the postal pieces. All that they had in common with the postal pieces was the fact that they too originated at No. 12 Fournier Street, London, E.1.

Since their student days Gilbert & George had had a studio at street level in No. 12 Fournier Street. (It had previously been a motorcycle repair shop.) Later, they bought the whole house and set about its rehabilitation. It took three years to get it back something like its original plain state, and meanwhile the interior of the house turned up in photo-pieces like the "Dusty Corners" series of 1975 and the "Dead Boards" series of 1976. Though by then relatively clean, the house was a disaster area. Nothing worked. Every ceiling gaped. It had no furniture. Veterans of World War II could remember bombed houses that were in better condition. In the landscape of alienation—human, social, architectural—that was the prime subject of the photo-pieces of the mid-seventies, No. 12 Fournier Street came in right on cue.

But the activity of Gilbert & George is in essence an optimistic activity, and with time No. 12 came to look very beautiful indeed—so much so, in fact, that everyone who came to see it said, "It's quite perfect as it is. Don't do anything to it." Now, one of the "Four Laws of Sculptors" that Gilbert & George wrote out for themselves in 1969 was, "Never worry assess discuss or criticise but remain quiet respectful and calm." Even so, they got tired of hearing that No. 12 was "perfect as it is." Their needs were few—they take breakfast, lunch, and dinner at the Market Café every day, and in close on twenty years they have never cooked a meal at home, let alone aspired to entertain there. Still, they didn't like it that they weren't even allowed to go out and buy a couple of chairs.

So they went looking for chairs. They went to office suppliers, and they looked in at auction houses, and they called on antiques dealers. They had trouble finding anything they really wanted, but finally they settled for two chairs which, unbeknown to them, spoke for the Arts and Crafts Movement of late Victorian times. They were the kind of chairs that a rather decadent doge of Venice would have sat in, had there been doges at that time.

Thus launched, Gilbert & George began to furnish No. 12. It is relevant that they are tremendously, unremittingly, and unsurpassably organized. Their archives are both impeccable and out of sight. They never make an unnecessary move. "If someone gives us something to wear, we put it on at once. Otherwise we have everything made exactly alike by Mr. Lustig." One of their

recent photo-pieces measured 166 by 424 inches, but they planned it, plotted it, and put it together in quite a small studio/darkroom at the back of No. 12, and it came out perfectly. That is why they often spend up to fourteen hours a day in that studio. "Everything has to be double, treble, and quadruple checked in the dark. Not that that is the difficult part. We physically make the pieces, but that is completely separate from actually creating them. Once we have made the design, the model, it's just physical work. Apart from the physical work, what we do goes direct from the brain to the wall." It was in this way that in 1984 they made fifty-four big photo-pieces without any help, and also designed their catalogues, planned the installation of every show, and made working models of every gallery.

No. 12 today is filled, as much as furnished. It is in fact a small museum of the more insubordinate activity of the decorative arts in England in the last part of the nineteenth century. If an Egypto-Japanese chair with overtones of African tribal art came on the market, Gilbert & George are bound to have it. If pieces of furniture were sold off from the House of Commons in the thirties and forties, Gilbert & George are getting their hands on them. (They never go shopping any more. Offers come every day in the mail.)

But the real collection, and the one that marks out No. 12 Fournier Street as one of the most astonishing houses in London, is the collection of late nineteenth-century British pottery and ceramics. There is something almost demented about the size of this collection. There are areas in which Gilbert & George own fifteen or twenty times as many objects as any museum in Britain. Begun in 1979, the collection has a growth record that would set new records in the stock market, and sometimes we feel that, like the protagonist in Eugène Ionesco's play *Le Nouveau Locataire*, Gilbert & George will end up by being walled up alive among their Aesthetic sideboards; their Brannam art pottery; their "Clutha" art glass, designed by Christopher Dresser; their huge and self-contained collection of work by the visionary potter Sir Edmund Elton; their oak neo-Gothic furniture by Augustus Pugin; their "Watcombe" terra-cotta collection; their Gothicized chair by the great architect and designer William Butterfield; their medieval revival bookcase designed by Charles Eastlake; their neo-Gothic buffet (by Pugin, again); their mahogany lily-pad occasional table; and the early twentieth-century Celtic hunting rug carpet by Charles Bain.

Even the cast-iron hall stand on which they hang their matching overcoats by Mr. Lustig is part of the collection in that it was designed by Christopher Dresser in 1876. As Gilbert & George are, in their photo-pieces, paragons of individual effort, they are drawn by instinct to the work of people who, like themselves, struck out on their own. If Christopher Dresser (1834–1904) is a great favorite of theirs, it is not merely for the beauty and strangeness of his designs but for his peremptory and highly unfashionable technical demands. Dresser insisted, for instance, that only recycled glass should be used in the manufacture of his glass pieces. Even more disconcerting, by the standards of the day, was his insistence that no piece of his glass should ever take more than three minutes to make.

Demands of that sort put a heavy burden on craftsmen who had been trained in quite other ways, and Gilbert & George delight in the memory of one

particular man who would sit for hours at his bench, staring at his hands, only to say very loudly, toward the end of an apparently infertile day, "These are the hands that can do it," and forthwith set to work. What to most people would seem merely eccentric is to them one of the touchstones of creativity. What they cherish about Sir Edmund Elton (1846–1920) is, for instance, that he was the exact opposite of Christopher Dresser. Where Dresser would do anything, go anywhere, and collaborate with any manufacturer who would take his designs and carry them out to the letter, Elton was a lone dreamer who virtually invented the profession of studio potter. Self-taught, he refused all technical advice, dug his own clay, found out how to build his own kiln, never formed himself into a company, and until the day of his death had only one assistant, a boy whom he had picked out when he was about to leave school. Between Dresser, who thought nothing of exchanging vases with the emperor of Japan, and Elton, who pursued a solitary activity in the big house that he had inherited in Somerset, there was nothing in common except the will to go their own way.

Like many other people whose life consists primarily in making images, Gilbert & George do not "collect" pictures. In fact the only picture in the house is a visionary painting called *The Flaming Ramparts of the World* by Reginald Hallward, who has the distinction of being mentioned by name in *The Picture of Dorian Gray* by Oscar Wilde. (Gilbert & George also own a particularly beautiful photograph of Oscar Wilde as a young man.) What they have just begun to collect, on the other hand, is the illustrated book, in a form that was brought to near perfection by Christopher Dresser and others in the period of which they are especially fond.

Seen in the context of the silk-and-velvet chairs by A. W. Pugin, the wall hangings designed by Bruce Talbert for Templetons of Glasgow in the 1870s, and the tables crammed with pots and ceramics and renderings in colored glass of strange vegetable fancies, these magnificent books in gilded leather bindings add a note of final, definitive luxury. ("That one was sold off by the Gloucester School of Art," they will say of some particularly sumptuous example.) But then No. 12 Fournier Street has settled into its new life as if it had never had any other. Climbing the stairs, moving from floor to floor and room to room, we remember the historic misjudgment that was made by the principal of their art school when someone asked his opinion of Gilbert & George. "Whatever you do," he said, "don't get involved with those two. They'll never get anywhere."

44

# IV.

# PERSONS ONE IS
# GLAD TO HAVE KNOWN

Where people are artists in life, it would seem to me a great misfortune if posterity were to have no idea of what they did, what they said, and what they looked like. The example that I always have in mind, but despair of ever rivaling, is the portrait in prose of the English poet Samuel Taylor Coleridge that was handed down to us by his friend, the English essayist William Hazlitt.

# Meyer Schapiro

Modern Art: 19th and 20th Centuries, *by Meyer Schapiro. Braziller, 1979*

**The New York Times Book Review, 1979**

To be in the hall when Meyer Schapiro speaks in public is to see exemplified a learning process of the highest and finest order. But Professor Schapiro is now well beyond academic retirement age, and although his name will be perpetuated at Columbia University by a professorship (financed by artists who donated their work to be sold for the purpose), he no longer teaches a regular course. For this and other reasons, the publication of this book has been most keenly awaited.

Not long ago, during the run of the Cézanne exhibition at the Museum of Modern Art, Meyer Schapiro made an unscheduled appearance at an evening seminar organized by the museum. Allotted twenty minutes for his intervention, he began somewhat haltingly, with protestations of inadequacy and unreadiness. What he had to offer were mere scraps, he said—notes for an unfinished article. Neither they nor he would detain us for long.

And his first formulations did indeed seem both hesitant and flat. Undeterred by this, we sat tight and waited for the equivalent of the sonic boom: the point at which conventional "lecturing" is transcended. And, sure enough, it came: Ideas and connections of ideas poured forth in a continuous and only partly premeditated flood, lighted from above by lightning-flashes of intuition and signaled on the speaker's face by a look of all-embracing glee. All thoughts of time were discarded (the talk lasted an hour and forty minutes) and we realized all over again that an idea is the most exciting thing there is. What we had in front of us was a demonstration of selfless intellectual energy, the like of which we encounter only once or twice in a lifetime.

On that particular evening the immediate subject was Cézanne's intellectual development. Did he read the Latin classics by rote, for instance? Or did they come to inhabit, and even to infest, his inmost being? What exactly was the high-school curriculum in the department of the Bouches-du-Rhône in the 1850s? Everyone knows that Cézanne's friend Emile Zola defined art as "a corner of Nature seen through a temperament"; but what did the word "temperament" mean to Zola, and to Cézanne? Meyer Schapiro had studied the question until he could have doubled as a classmate of Cézanne's and got away with it. All this he brought out with ever-increasing confidence, until for the last hour of his talk it was as a case of vatic possession, almost, that he confronted us.

When it was over, we knew what we knew already: that Meyer Schapiro can look at great paintings with an exceptional intensity and penetration. But we also knew how those paintings can be related to the life of the mind with a vigor, a freedom, and a breadth of reference that are peculiar to himself. The collective excitement that he can generate does not derive merely from the fact that a very learned man is sharing his knowledge with us. What excites us is the vertiginous proximity of Thought itself; or, to put it another way, the certainty that by the time we get up and go out of the room we shall see certain things of enduring importance in a completely new way.

For many years, people have been trying to perpetuate such evenings by making Professor Schapiro publish his lectures, or at any rate republish such papers as have already appeared. Some of them are known by name to every serious student of modern art; but it is not everyone who can lay his hand on the *Journal of the Courtauld and Warburg Institutes* for that gloomiest of years, 1941, or the *Festschrift,* published in Mainz, West Germany, in 1976, in memory of Otto J. Brendel. Those are the kinds of publications that Meyer Schapiro has always favored. Unlike those younger art historians who will seize any and every chance of getting into print, Meyer Schapiro would seem to believe that print kills; or, more exactly, that it freezes a discourse that ideally should continue forever.

It was doubtless difficult, therefore, for him to pass the proofs of Vol. I in this series: his *Romanesque Essays.* Some of those papers date from the 1930s. Their subject matter is lodged for the most part in the eleventh and twelfth centuries. He had had almost fifty years, in at least one case, to perfect what he had written. The transition from Mozarabic to Romanesque in the abbey church of Silos, in Spain, to take only one subject, is not exactly a matter of everyday discussion, even among specialists. But it was with the greatest reluctance, and with talk of "imperfections, inconsistencies and unclear formulations" that Professor Schapiro finally gave these papers to the printer.

How much the more daunting, therefore, must have been the prospect of handing over his papers on modern art, where the issues involved are in continual evolution. Meyer Schapiro has been both witness and participant where modern art is concerned. At a time when academic art historians were by no means confident of modern art, he proved that it could be as rewarding, and should be studied as stringently, as the art of any other period. What he had to say was heeded by other scholars, by gifted students, by collectors, by museum people all over the country, and by more than one generation of

artists. It would hardly be too much to say that in this matter he has been the conscience of this country for the best part of half a century. This is true with regard to older modern art, from Courbet and Cézanne onward; and it is also true with regard to the American artists of his own day, for whom he spoke out in the 1940s and 50s with a clarity and a freedom from condescension that put new ideas into many a thick head.

Much of what appears in his *Modern Art* already has classic status—notably, "The Apples of Cézanne: An Essay on the Meaning of Still Life," "Courbet and Popular Imagery," "On a Painting of Van Gogh," and "New Light on Seurat." Anyone who supposes that Cézanne's paintings of apples stand apart from his paintings of the human figure will be put on quite another path by Professor Schapiro. He will learn about the significance of the apple throughout history, about its appearances in Horace, Virgil, and Propertius, and about its effect on Emile Zola when he came upon it in the markets of Paris. He will then move from the meanings of the apple in Cézanne's paintings to the meanings of still life in general.

Cross-references to Yeats, Bergson, Kant, the *Saturnalia* of Macrobius, and the conversation of André Breton and Alberto Giacometti will keep him on the alert; and, just in case it might seem that Meyer Schapiro is one of those art historians who are happier in the library than they are in front of a work of art, I must instance one of the many allusions to individual works of art that can serve as a model to aspirant critics. In a lifetime of looking at the Giorgione *Concert Champêtre* in the Louvre, how many of us had realized that the young men in the foreground stand for a social and aesthetic duality in matters of love, and that whereas "the shepherd's head resembles the great oak in its shaggy silhouette," the young courtier's with its hat is in tune with the pitched rooflines of the distant villa?

But these are auxiliary benefits. "The Apples of Cézanne" is fundamentally what its title suggests: an inquiry into the role of the object in still-life painting, and into the way in which that object can stand for the vicissitudes of human feeling. Professor Schapiro spells this out in one of the ruminative conclusions that he puts forward rather quietly and with no wish to parade his own cleverness or put other scholars down. "In paintings of the apples," he says, "Cézanne was able to express through their varied colors and groupings a wide range of moods, from the gravely contemplative to the sensual and ecstatic. In this carefully arranged society of perfectly submissive things the painters could project typical relations of human beings as well as qualities of the larger visible world—solitude, contact, accord, conflict, serenity, abundance and luxury—and even states of elation and enjoyment." That Cézanne should trust his deepest feelings to that "carefully arranged society of submissive things" makes perfect sense, in view of what we know about his upbringing, his character, and his relations with other human beings; but it took Meyer Schapiro to have that particular perception, and to work it out with a conclusive fullness.

Much in these essays defies quotation, so dense is the argument and so cumulative its effect. Sometimes the title gives no indication of the chief interest of the essay. Who could guess, for instance, that the paper (dated 1950) on the Armory Show carries secreted within as telling a brief history of

the origins of the modern movement as we shall find anywhere? Sometimes, as in the essay on Courbet, there are sidelong glances of a kind that would have occurred to no other writer at the time: the account, for instance, of Rodolphe Toepffer's pioneer investigation of children's art, which first appeared in 1848. Sometimes there are instants of autobiography that bring a whole period to life, as when Professor Schapiro recalls how Arshile Gorky was as far, in terms of space, from the European masters he admired as the painters of the Renaissance were from the ancients in terms of time. In the 1930s, he tells us, Picassos, Braques, and Mirós appeared in New York the way "Roman statuary has emerged from the ground in the 15th century to join the standing objects in the ruins."

The last third of the book is taken up with papers on abstract art, and more especially on Mondrian. Meyer Schapiro knows very well that among the people who will read him there are some who still resent the idea, and still more so resent the fact, that "in the 20th century the ideal of an imageless art of painting has been realized for the first time." He also knows that many of those people value abstract painting, if they value it at all, for what they consider its undemanding and decorative aspect. He himself believes, on the contrary, in imageless painting that is "without objects, yet with a syntax as complex as that of an art of representation." How to justify that belief in terms that are universally persuasive is one of the central problems of the art of writing of the last sixty or seventy years.

In the case of Mondrian, he starts from the *Composition in White and Black* of 1916 in the Museum of Modern Art and shows that "what seems at first glance a square set within a diamond square—a banal motif of decorators and doodlers—becomes to the probing eye a complex design with a subtly balanced asymmetry of unequal lines." He then moves from these formal considerations to the notion of the seventeenth-century master Pieter Sanredam, for instance, who included a large diamond-shaped escutcheon in his interior of the church of St. Bavo in Haarlem and also pioneered the kind of cropped or lopped-off composition that Mondrian used over and over again.

It is the further particularity of Meyer Schapiro that by reason of the date of his birth (1904) and his enforced emigration at a very early age from his native Lithuania, he had an exceptional sympathy both with American painters such as Barnett Newman, whose experience paralleled his own, and with the more general phenomenon of exile that brought Mondrian to New York during World War II. No one either older or much younger than he could bring comparable depth and immediacy of feeling to the predicaments in question. Every student of Mondrian knows by now that *Broadway Boogie-Woogie* has to do with jazz, on the one hand, and with the grid-patterns of Manhattan on the other. But Meyer Schapiro was there at the time, and still quite young; and he spotted at once that in addition to the two self-evident themes the painting is remarkable for its "vigilant planning for variation, balance and interest." To be there at the time, and to look at new and difficult art in exactly the right way: those are the decisive challenges of art criticism, and the ones in relation to which almost all of us can be faulted.

Meyer Schapiro is not a brilliant writer, as that word is generally understood. When on his way to an important conclusion, his manner of speech is

often workman-like at best, as if he were out to avoid the kind of surface gloss in which we simply see the author's face reflected. But by getting his thoughts down on paper complete and entire, with nothing superfluous and nothing left out, he arrives at a precision of statement that makes us think of "brilliance" as something to be shunned.

Nor does he write for a chosen few, or without regard for the exceptional demands that are made upon the observer by the art of our own time. Where others give in before what he calls "the exceptional variability of modern art" and wall themselves up with one single limited notion of it, Meyer Schapiro tells us that living art "requires from its audience a greater inner freedom and openness to others, and to unusual feelings and perceptions, than most people can achieve under modern conditions." Of that openness, and of that inner freedom, he is our great exemplar.

# Kenneth Clark

Civilization, *by Kenneth Clark.*
*Harper & Row, 1970*

**The New York Times Book Review, 1970**

*When Kenneth Clark first addressed himself to television a lot of people thought that he was demeaning himself and that, like an Afghan hound harnessed to a garbage truck, he would do himself some kind of injury. But he soon turned out to excel at it—and, even, to need it. He seemed, in fact, to need it the way Dr. Schweitzer needed Lambaréné. In the one case the organ-loft, in the other the pure scholar's isolation, had proved incompletely satisfactory. The television industry drew on qualities in Clark which craved for exercise: among them were a residuary Scottish toughness, a High Victorian sense of mission, and an old trouper's delight in an overflowing house. He loved the box, and the box loved him; and when the British Broadcasting Corporation took him out to luncheon and suggested that he should survey the whole of Western civilization in thirteen hour-long programmes he accepted before anyone could say "Brandy and cigars?"*

What we have here is "the book of the movie." The programmes themselves were an ingenious, high-souled epigrammatic mix of narrative, and music, and declamation, and a most artfully contrived ebb and flow of images, many of them of supreme beauty and taken on location in the high places of the western world, from Chartres to the island of Iona and from St. Peter's in Rome to the University of Virginia in Charlottesville. The English are a nation of sight-seers—Tolstoy remarks on this, none too favorably, in *Anna Karenina*—and the programmes were a great success. Not even "The Forsyte Saga" had a more loyal audience; and when it was all over Clark was given a seat in the House of Lords almost before his technicians had turned off the microphone.

Much of all this gets lost in the book. The 286 illustrations look stiff and postcardy by comparison with what we saw on the screen, and we miss the sight and sound of Clark himself padding tirelessly to and fro with never a hair out of place or a participle left unsupported. Text and image alternate, of course, where on the screen they duetted like tenor and baritone in early Verdi. The balance shifts, therefore, and we focus less on Giotto and Rembrandt and more on Erasmus and Charlemagne, Descartes and St. Francis, Isaac Newton and J. S. Bach, Jefferson and Jean-Jacques Rousseau. It was no small achieve-ment on Clark's part to make half a million people sit up straighter, in pride and emulation, when he made them feel that these great human beings were their own kinsmen.

Clark is a champion elucidator, and a man who can say with Montaigne that "No pleasure has any savour unless I can communicate it." Reading the text in book form I was, however, all the more conscious of its verspertinal tone. The civilization which Clark describes is one which has had its day and will not be seen again and there is a note, almost, of apprehension in the way in which he passes it in review. I was reminded, in fact, of what the great Swiss historian Jakob Burckhardt wrote in the early 1840s: "We may all perish, but at least I want to discover the interest for which I am to perish—namely, the old culture of Europe."

If I am right in this, posterity will recognize in *Civilization* the under-stated *Liebestod* of an attitude to life which was initiated by Walter Pater, codified by Bernard Berenson, and propagated by the generation of aesthetes, art historians, collectors, and museum men who held sway in the Western world between 1914 and 1965. This generation had no higher praise than "life-enhancing"; it ranked each civilization in terms of the art objects which it left behind it; and it had no doubt at all that the supreme periods of art had been and gone.

The great men of the past were all contemporaries, for the generation of which I am speaking; but that their own contemporaries could be men of the same stature they found it hard to credit. Values, for them, were fixed and final; standards were immutable. What Clark here calls "the dazzling summit of human achievement" had been reached for a mere twenty years in Florence and Rome early on in the sixteenth century; thereafter, all was second best. Faced with analytical cubism, or with *Ulysses,* or with the achievement of Klee, Schoenberg, Duchamp, Matisse, Mies van der Rohe, Wittgenstein, Lévi-Strauss, Jasper Johns, or Anthony Caro, they turned aside and said, with Sir Thomas Browne, "'Tis too late to be ambitious. The great mutations of the

world are acted."

Kenneth Clark's programmes gave great comfort to such people. Faced with Buckminster Fuller, the British Establishment now remembers a text from Clark: that "sweeping, confident articles on the future seem to me, intellectually, the most disreputable of all forms of public utterance." All over England balding heads nodded in approval, and decorated breasts heaved with relief, when he was heard to say, with that offhand assurance of his which makes demurral seem merely bad form, that automation, planners, and computers "threaten to impair our humanity," that modern art is an undifferentiated chaos, that Marxism was morally and intellectually bankrupt, and that the last two great achievements of European civilization were the ending of the slave trade in the 1830s and the design of certain bridges and tunnels in the Railway Era. From the great sea of twentieth-century imagery—a source as well stocked as that of any one period in the past—Clark brought to the surface one specimen only: a studio-portrait by Karsh which happened to remind him of Rembrandt. That is the impasse which orthodox elitist aesthetics have reached.

This accounts, I believe, for the extremes of poignancy, hardly less intense than King Lear's six-times-repeated "Never," which belie the after-dinner informality of much of Clark's text. It really is "Never" for the things he prizes so highly; as for the things which are taking their place, they baffle and displease him. But meanwhile, like a well-bred passenger on a sinking ship, he goes on talking, easily and with point, about matters remote from the business in hand. Why is there no such thing as clear, concrete German prose? How admirable that Coleridge should have walked sixteen miles to post a letter! What a fix we should all have been in if Charles Martel had not won that battle at Poitiers in 732! I wonder if you know why H.G. Wells never dared to drive a car in France? Outside, the old world crumbles: but while Kenneth Clark is on hand to keep the conversation going there will be many to vote that the twenty-first century be kept waiting a little longer.

# A. Hyatt Mayor

## The New York Times, 1983

In almost every museum in the Western world there is at this moment a new generation of curators. Not yet broken on the wheel, they can't wait to excel. They are out to form collections without parallel, to organize exhibitions that will draw visitors from all over, and to publish scholarly catalogues that will rival those of the National Gallery in London. Organized, motivated, competitive, driven, and most often specialized, they came qualified, they came recommended, and they're all set to go.

Yet being a curator is like conducting an orchestra. You can pass all the exams. You can be a doctor a dozen times over. But in the one case, as in the other, the only way to learn it is to do it. The great conductor of the past did not come to prominence by winning an international competition. He began as a coach in some ratty little town in the Austro-Hungarian provinces, and he did everything, all day and all night, till one day the top man got sick and someone told the coach to come running.

Getting to be a great curator is not necessarily quite like that, but neither has there ever been one standard way of going about it. One of the most remarkable men who ever held a curatorial post was indisputably A. Hyatt Mayor. Born in 1901, he joined the staff of the Metropolitan Museum in 1931, was curator of its print room from 1946 to 1966, and died in 1980.

In addition to all his other attributes, some of which will be listed here, he had a way with language that made him one of the best talkers of his time. (It was inherited, by the way. One of his uncles once called him from the Hispanic Society and said, "Can you come up here so quickly that the air closes behind you with a snap?")

We can't hear him talk anymore, but we can read a slim memorial volume called *A. Hyatt Mayor: Selected Writings and a Bibliography* that has just been published by the Metropolitan Museum with an appreciation by Lincoln Kirstein. It's just a wonderful book, and I only wish that it had been six times as long.

Hyatt Mayor was not a predestined curator. (He once spoke of a new-model, single-track curator as "that heartless cherub.") He was not a specialist. "Specialists have never bothered me or intimidated me," he once said. "I wasn't hired to know things, but to know where to look things up. I feel that everybody is a specialist. I know the contents of my pants' pockets better than anyone else. I'm a specialist on that."

He never collected credits, either. When asked what he had majored in at Princeton, he said "I never realized I was majoring in anything. But when I had my cap and gown on that rainy day of the graduation, there was a program and I discovered that I was graduating with high honors in modern languages. Someone had kindly added it all up and said I could rate that."

Nor did he ever pass an exam in art history, though he very much enjoyed Frank Jewett Mather's lectures on the subject in Princeton. ("A fascinating man," he said later, "a little sort of rabbit-shaped, hairy man, very impulsive,

warmhearted, charming. I loved him.") He could have stayed with art history, then and there. But he was also a linguist, a prodigious mimic, a classical scholar, an archeologist, and an actor who could have prospered on the professional stage. His forebears had included a German consul to the United States from the State of Württemberg, a paleontologist, a hugely successful grocer in Baltimore, and a man of science who had helped Thomas Alva Edison to perfect the telephone and the phonograph. With a family tree like that, you don't care to be pinned down.

When Lincoln Kirstein got Hyatt Mayor to write for *Hound and Horn* magazine from 1929 onwards his subjects included "Gordon Craig's Ideas of Drama," "Picasso's Method," "Translation," and "Towards Stronger Reasons for Deploring American Painting." Whatever he did, he did very well indeed. The great French poet St. John Perse once said that Hyatt Mayor was the only American who spoke classic French in such a way that Diderot or Voltaire could have taken him for a Frenchman. How can we wonder that Mr. Kirstein should characterize him as "the embodiment of a small-scale artillery, charged with iron and irony in baby-tiger velvet paws." Mixed-up as that image may be, it has the essentials within it.

Hyatt Mayor was a natural wanderer, with curiosity as his radar. But in 1931 he was newly married, and had bills to pay, and couldn't get a teaching job. So he went to the Met and got himself hired by William M. Ivins, Jr., who was then curator of prints. Ivins hired him knowing full well that he had no qualifications whatever, beyond his command of languages. "I was simply turned loose," he said later, "with no instructions except that I was to learn the collection."

Museum men are often wonderfully odd, but it took Hyatt Mayor to tell us quite how odd they really were. "Ivins was a very tall slatternly kind of man. He didn't quite shamble like the two halves of a camel, the way Edward Steichen did, but he walked a little like that. He looked like a sort of Goethe, consciously sloppy. And he had the Harvard hat, all in holes and tatters; but that wasn't because it was an old hat; it was the style; it was quite deliberate."

The print department of the Met, as it was eventually reshaped by Hyatt Mayor, has the peculiarity that it includes material of almost every imaginable kind. It has the masterpieces that people expect to see in a great museum, but it also has areas in which Hyatt Mayor did the work of a pioneer. Among them are British catalogues (dating from the 1760s) for brassware, silverware, and pottery; American commercial catalogues of everything from clothing, china, and glassware to rattan furniture and the decorated toilet bowl; and a treasury of sheet-music covers. Many such things are rarer than Rembrandt, yet Hyatt Mayor was able to buy them for almost nothing.

With time he came to write at least one classic in its field—*Prints & People: A Social History of Printed Pictures*—but meanwhile no detail of curatorial activity escaped him. ("How to Bake an Exhibition" is the title of one of the best essays in the book that has just appeared.) He was, for instance, a master of the exhibition label, and saw those labels as "very brief notes, in the style of telegrams, scattered here and there like a paper chase."

In such diminutive essays, he went on, "every word must act like a fish-hook to catch the visitor as he drifts along. One hook ill baited, or a paragraph

that looks long, and he is on his way elsewhere." Moreover, "each caption should tease the reader by taking a different tone, or opening on a fresh note."

It helped that he had the kind of roomy, cross-referential intelligence that brings the past alive. We have a new vision of King Charles II of England when Hyatt Mayor has told us in a characteristic aside that on October 22, 1666, he "appeared in a black-and-white suit that is said to have established the combination of trousers, waistcoat and jacket that prevails to this day." And how the Venice of three hundred years ago comes to life when he tells us of the poor busy jobber who ran from alley to alley, offering to unstop sinks, tinker pans, mend broken earthenware with wire, and castrate cats!

Though no one was ever less of a careerist than Hyatt Mayor, he was full of good advice for ambitious young people. He even told them how to deliver a paper at what he called "the spring slave auctions" at which art-historical aspirants show off their paces. "A talk is not a dissertation read aloud," he said. "It is a performance." As much as the young actor essaying his first Fortinbras, the art historian should study the mechanics of diction. "Is the column of air robust enough to launch the vowels smack at the back wall? Do the consonants clip the flow of vowels into unintelligibility?," and so on.

He also had advice that applies equally well to the rest of us. "Read all the great poems, plays and novels that you can, for Dante will lead you into the dramatic economy of Giotto, Racine will help you feel the balanced organization of Poussin, Flaubert will show you how the Impressionists looked at life. The more you know, the more you see. Read general history, the history of science, of economics, of ideas, for these, like the history of art, are all peek holes into the central mystery of man. Any one approach, if pursued without reference to others, dwindles into something like 19th-century theology—a complex dissertation about nothing in particular."

I don't know how that went down as an after-dinner speech in Princeton in 1977, but to me it looks like one of the best things ever said on the subject.

# Clive Bell

### Encounter, 1964

Clive Bell (who died in September, at the age of eighty-three) had been a part of English intellectual life since the day in October, 1899, when he went up to Trinity College, Cambridge, and found that his fellow-freshmen included Lytton Strachey, Leonard Woolf, and Thoby Stephen (brother of Virginia, who became Mrs. Woolf, and Vanessa, who became Mrs. Bell). Bloomsbury, as a group, was in being from that very day, although Clive himself dated its origin not so much from the Cambridge reading society which the four friends founded with Saxon Sydney-Turner as from the time in 1904 onward when the group met constantly in London and was enlarged to take in Duncan Grant, Roger Fry, John Maynard Keynes, and one or two others.

Even quite young people knew the outline of his career: that he had worked with Roger Fry on the Post-Impressionist exhibitions of 1910 and 1912; that his books and ephemeral writings, and above all his concept of "significant form" had had an immense influence in their day; that he was as much at home in France as in England, and that Picasso, Matisse, Derain, Segonzac, and others had prized his friendship and kept it in good repair. The uncompromising view of aesthetic experience which he put forward throughout his life sometimes led strangers to picture him as a wincing aesthete in full withdrawal from the hard realities of the day. ("To appreciate a work of art," he had written in perhaps the most famous of his polemical passages, "we need bring with us nothing from life, no knowledge of its ideas and affairs, no familiarity with its emotions.") But until his first and last illness made its cruel inroads upon him, Clive Bell looked what he was: a prosperous country gentleman who would be as good company in brushing-room and butts as he was in the National Gallery or the Tate. And he was a country gentleman of the kind whom Charles James Fox would have been happy to stay with: a scholar who had mastered the Greek and Latin classics in the original, and yet knew the world of power and privilege at first hand. He was ready to talk about anything: and however feebly the ball might be put up, he would always give of his best.

He had in a very rare degree the sense of occasion which makes even chance encounters memorable. Equally gifted as guest and as host, he had an Edwardian fondness for the full-scale anecdote and an Edwardian readiness to bring one out when the conversation seemed to demand it. But he never hogged the floor, and he contrived to make even the timid and the ineffective feel that they too had contributed something to the talk. His voice called for the open air: undeniably loud, it was never overbearing, and its characteristic note was one of high expectation and shared enjoyment. He had an enormous amount of style in everyday life, and it was the style of someone who had never had to hurry; like all the founder-members of Bloomsbury, he had also a highly developed sense of the ridiculous, and applied it to subjects and situations which it is traditional to take very seriously indeed. He had passed all his life among people who knew how to take care of themselves in conversation, and he

never resented plain speaking. "Yes," he would say after some notorious *mauvaise langue* had been to see him, "He spoke a good deal of ill of all of us, but I must say I found him very agreeable."

Not much of this came out in his later writings, and his reminiscential sketches, *Old Friends,* are too courtly and digressive in style to give the full flavor of his company. Some idea of that flavor can, however, be got from his essays of fifty and more years ago, for he perfected in his twenties and thirties the robust and antithetical style which made him famous. If he was outrageous, it was because only outrage would penetrate at all deeply; and he used in his earlier writings the techniques of calculated overstatement which he later reserved for conversation. Here he is (again from the opening section of *Art*) at his most characteristic:

> Most people who care much about art find that of the work that moves them the greater part is what scholars call "Primitive." Of course there are bad primitives. For instance, I remember going, full of enthusiasm, to see one of the earliest Romanesque churches in Poitiers and finding it ill-proportioned, over-decorated, coarse, fat, and heavy....But such exceptions are rare. As a rule primitive art is good, for, as a rule, it is free from descriptive qualities. In primitive art you will find no accurate representation; you will find only significant form. Yet no other art moves us so profoundly.

In *Art* (1914) he bit off more than could be chewed by any one young man, and no doubt today thin-lipped censors would find much to mock at in that book's wilder and more panoramic allusions. But the feat of demolition: that no one can deny. Clive Bell took the agreed hierarchy of aesthetic values and destroyed it forever. Any first-year student at the Courtauld Institute can mug up arguments to show that *Art* can be faulted. But the point is that all subsequent writing on art in this country has benefited by the climate of freedom which Clive Bell initiated. "We are not yet clear," he wrote in one chapter of *Art*, "of the Victorian slough. The spent dip stinks on into the dawn." That second sentence—and how many people now writing on art would have been capable of it?—describes a state of affairs which Clive Bell did more than anyone to destroy. What he did was to carry over into the field of aesthetic speculation the concept of total freedom in the discussion of human affairs which was common to all members of Bloomsbury. *Anything,* however contrary to accepted form, could be discussed, much as the great navigators of an earlier century would flout the hypotheses of their predecessors.

He was very good, too, at getting a situation down on paper in such a way that the reader says to himself: "I wonder what happened next." When he first wrote, in 1912, that "the Romantics and the Realists were like people coming to cuffs about which is the more important thing in an orange—the history of Spain or the number of pips," it really did tidy up a still-straggling discussion; and it seemed inevitable to the reader that something allied to neither point of view must come into being. (Ibsen was the subject of the essay, but it applied equally to Cézanne.) It is possible, of course, to fall into a habit of heavy emphasis, and in this way to give an impression of unvarying dogmatism. Clive Bell sometimes did this, both in writing and in conversation. There was nothing tentative about his opinions, and he felt it only fair to everyone that he should express them as forthrightly as he could. But it is worth saying that

about the notion of "significant form" he was a great deal more modest and diffident than legend suggests. The problem as he defined it was: "Why are we so profoundly moved by certain combinations of forms?", and his answer had by no means the Sinaitical assurance which it acquired in the minds of people who had never read the original text. "I suggested very cautiously.... I was, and still am, extremely diffident....": these are the phrases which he used of the notion of significant form at a time when he might have been expected to lash out at the opposition.

He never allowed himself to get far away from the firsthand shock, the intimate and lasting disturbance, of actual contact with first-rate works of art. Nor did he allow that disturbance to lose the kindling element of sensuality. Abstract thought was one thing—and no one had a greater respect for it—but it was never allowed to take precedence over the senses. Bonnard, for instance, will be all the rage, this next year or two, with our local band-wagoners, but I doubt if anyone will get much nearer to the truth about Bonnard in a few lines as did Clive Bell in this passage, now nearly fifty years old:

> The first thing one gets from a picture by Bonnard is a sense of perplexed, delicious colour: tones of miraculous subtlety seem to be flowing into an enchanted pool and chasing one another there. From this pool emerge gradually forms which appear sometimes vaporous and sometimes tentative, but never vapid and never woolly. When we have realised that the pool of colour is, in fact, a design of extraordinary originality and perfect coherence, our aesthetic appreciation is at its height. And not until this excitement begins to flag do we notice that the picture carries a delightful overtone—that it is witty, whimsical, fantastic.

The language dates a little? Yes, but how assuredly is authentic perception allied to a thought-out and consistent point of view! A reproach often leveled at Clive Bell was that in later years his perception was confined to a limited range of works of art; initially he argued that a knowledge of Kandinsky and the *Blaue Reiter,* of Brancusi, of the Italian Futurists, and of Larionov and Goncharova, was indispensable to the critic of modern art; but he himself did not pursue the study of these artists very far. Parisian loyalties proved too strong, as did others bred within his own household, and with advancing age he inclined to settle for what he knew and liked already. Too little of a humbug to ape an enthusiasm which he did not feel, he did not go much beyond Victor Pasmore's landscapes of 1945, in English painting, or the friends of his own generation in France. I remember Ben Nicholson saying, "He got so near to the point of what we were doing, and then he didn't carry it through...." Well, perhaps he didn't—any more than he "carried it through" to the newest in literature, preferring to re-read *Paradise Lost* and *Tristram Shandy.* But he was in the right at a great moment in the history of painting. He and Roger Fry (and he was more independent of Roger Fry than many people suppose) were right about Cézanne at a time when even Sickert thought Cézanne was *"un grand raté"*; right about Cubism when Tonks said "this talk of cubism...is killing me"; right about Matisse when intelligent people from the Art-Workers' Guild shouted "Drink or drugs?" when Fry showed them one of his paintings. He helped to bring about a decisive shift in the history of taste: thanks to Fry and Bell, French painting of the period 1880–1914 became

recognized as one of the greatest of human achievements in art. He had his shortcomings, even at that moment, but in the context of his own generosity and impetuosity of mind, and of the general thickness and dullness of the opposition, those shortcomings were remarkably few. He was the right man in the right place at the right moment, and there are not many art critics of whom that can be said.

# Russell Page

**The New York Times, 1983**

It is beyond dispute that Russell Page, an Englishman now in his seventy-seventh year, has designed more gardens for more people in more parts of the world than anyone else in history. He has been doing it since 1928, and a short list of the countries in question would include Britain, France, Belgium, Germany, Italy, Spain, Portugal, Switzerland, Egypt, and the United States, plus the West Indies. One of his smaller gardens is in the courtyard of the Frick Collection, on East 70th Street between Fifth and Madison avenues; you can see it from the street, and it is at its very best.

"I don't discuss my clients, ever," he likes to say. But it is a matter of record that among the first people for whom he worked on a large scale in Britain some fifty years ago were the future Marquess of Bath, who had and has still a colossal park in Wiltshire, and the future King George VI, who lived at the time in a neo-Gothic *cottage orné* in Windsor Great Park. The words "beginning at the bottom" do not exactly come to mind.

But it is also a matter of record that he did very well indeed with an amusement park—the Festival Gardens in Battersea Park in London—that raised the spirits of hundreds of thousands of Londoners after World War II. And he is a master of the short-lived exhibition, like the first Floralies in Paris

in 1959, where 50,000 plants were assembled "with one aim only—to enchant."

His gardens may be large, like the 140 acres of the Pepsico headquarters in Purchase, N.Y., on which he has been working this spring. It may also be private, secret, and just a few square yards in area. Whatever it is, it will bear his unassertive but inimitable stamp. He has moreover had for many years an underground celebrity as a master of English prose, on the strength of his book *The Education of a Gardener.*

In life Russell Page cuts a remarkable figure. One of the tallest men around, he has a way of sitting that suggests that his bones have been unpacked in a hurry and will never be put together again. Gifted with the face, the diction, and the timing of a great Edwardian character actor, he can put a loose ball away in conversation in a manner that very few tennis players can match on the court.

He is also good at laying himself on the line. Witness this magisterial plain statement in his book:

> I like gardens with good bones and an affirmed underlying structure. I like well-made and well-marked paths, well-built walls, well-defined changes in level. I like pools and canals, paved sitting places and a good garden house in which to picnic or take a nap. I like brickwork and ashlar and coursed drywalling, a well-timbered bridge, well-designed wooden gates, simple wrought iron balustrading or a wooden grille through which to peer. I like bands of round cobblestones quartering a graveled space, a courtyard of granite setts, painted shutters, well-made wooden doors, trelliswork of good proportions and, rarest of all these, good garden furniture, seats and benches in wood and metal, tables of stone or slate, simple lanterns and effective scrapers.

That's a man who knows his own mind. He also once said that "the amateur can scarcely be blamed if he mistakes good cultivation and a confused riot of color for gardening." But as to his pre-eminence, he makes little of it. "I don't think I'm well known at all," he said recently. "I'm a word-of-mouth boy. Besides, gardening is a very ephemeral occupation. So many gardens have just gone, and when they're gone who remembers who made them?

"There are no really big gardens to be made anymore," he went on. "There's no one to maintain them, and without maintenance they can't exist. It's very hard to find a young gardener. Desperately hard, in fact. After World War II no one in Europe wanted to be in service, as it was called. Then when the age of the hippie came along there were two in every ten thousand who liked plants and wanted to learn about them.

"I'll see anyone who wants to see me," he said. "After I've walked around a garden with them for 10 minutes I know if they'll be any good. But in any case you can't learn about plants in this country. American landscape gardeners get to know their 40 plants in school. That's their palette and they stick with it. Besides, no one ever made any money out of knowing about plants. What they like is to design 200 or 300 miles of parkway. That's where the money is.

"I'm a plant man, myself. I have a friend—a diamond merchant who lives just outside Antwerp—who is the greatest collector of seeds in Europe. He bought 18 acres beside the railroad track just to be sure of getting one plant that grew there. He has 300 acres now, and you'd never believe what he has

there. He has 320 kinds of willow, for instance.

"When I stay there I often go out after midnight with a flash lamp so as not to miss what's going on. The amount you can learn in a place like that is just unbelievable. It's a matter of looking, but it's also a matter of feeling the plants, in a way that is difficult to explain but quite indispensable."

Some other comments:

"The Pepsico headquarters at Purchase is a small park by European standards, but in this country it's a big deal. It was a polo ground before, and then a golf course, and now it's full of sculptures, some of them very big indeed. I'm enjoying it very much. I use the trees as sculptures and the sculptures as flowers, and then I take it from there. It's a cross-current thing.

"The way you can buy trees in this country is fantastic. Imagine the opportunities! It's like nowhere else in the world. You can find an 80-foot-high tulip tree, 2 feet 6 inches in diameter, and move it anywhere you like. You can move a house. And you can also move the oak tree that's sat over it for generations.

"With private American clients I find that they are enormously open to ideas. But there's one thing that they say almost without exception. 'You must do exactly as you think best,' they say, 'but we do need a big piece of perfectly plain lawn for our daughter's wedding.' Once they have that, they're happy.

"I'm trying to retire as fast as I can, but of course it's nice to be asked. If a place doesn't have something to say to me, I don't do it. Either it sings a song or it doesn't. What I really rather like is rushing round the house and taking a quick look at the ashtrays. When I've done that, I feel I know everything about the people.

"The point is that I can't really do anything that's better than the clients are. The garden is going to be their portrait as much as mine. And when it's done it has to look as if it couldn't ever have been any other way. I worry about that sort of thing, but now that the great-grandchildren of my first clients are coming back to me, I assume it must have been all right."

It is not in his nature to travel the world and "do a Russell Page garden" wherever he goes.

"I have to respect the place I'm working in," he explained. "If I'm in France the garden has to smell French. If I'm in England I bear in mind the delaying, gentle, half-spoken, tentative British way of getting things done. Besides, music and gardens have in common the element of time. You never get the same day twice, and every garden is different from minute to minute." That is why no gardener, least of all Mr. Page, can be a prima donna in his relationship to nature.

He is not, in conversation, the least exacting of men. (It helps for instance to be quite sure that the Temple of the Tooth is not the headquarters of Californian dentistry but an ancestral temple in Sri Lanka from which magnificent drumming can be heard across water.)

Although he has often in his life done grand things for grand people, he is just as attentive to the experiences that can come the way of all of us if we know how to look, how to listen, and how to smell. Once we have learned that, "each second is new," as Russell Page once said, "and in each second are implicit a hundred gardens."

# Betty Parsons

The New York Times, 1982

Just the other day, a dealer died. It might have happened any time, since she was born in 1900 and had had a stroke earlier this year. But it left many people in the art world—and many people outside it, too—with a sense of emptiness and pointlessness, as if a favorite compass had lost its needle and would never be put together again.

Betty Parsons—for that was her name—had for many years had a gallery at 29 West 57th Street. She was not "famous," in the way that some dealers are famous. Nor was she notorious. She dressed like the distinguished American lady that she was, and she spoke in a light, unemphatic, slightly husky and unmistakably patrician manner. Her thoughts would jump this way and that, like the thoughts of a grasshopper with a college education. But even in her gallery she looked as if she might at any moment begin to empty her mind and still her emotions in the ways promoted by the Indonesian sage whose teachings she studied twice a week.

She had lived for art and for artists ever since she had been taken to the Armory Show in 1913. As an aspirant American artist in Paris in the 1920s she had been a classmate of Alberto Giacometti in the studio of the sculptor Bourdelle, and she had had a large and lively acquaintance in a Franco-American art world that had a particular fascination. But she was not at all nostalgic by nature. Today was her thing, and she never tried to show Parisian art in New York.

As a gallery owner, her methods were her own. She never hustled for a sale. She could be a very good businesswoman, but it was not in her nature to be chained to the bottom line. She never sat snarling in the sixth row at "big auctions." Nor did she host rowdy parties at restaurants, although for many years she was famous for her lightness, agility, and inventiveness on the dance floor.

Least of all did she join the pack in the chase after established "big name" artists or try to wrest them away from other dealers. She ran her gallery in a caring but pleasantly relaxed way. Other dealers might do everything but wrestle the visitor to the ground at the hint of a sale, but she was more likely to stay in the back room discussing Chinese poetry or the evolution of Merce Cunningham. As Clement Greenberg once wrote, her gallery was "a place where art goes on and is not just shown and sold."

It might have been all these things and still been somewhere on the periphery of art. But the remarkable thing about Betty Parsons was that in the course of a career that lasted more than forty years she showed almost all the best American artists of the day—and showed them, what is more, when they needed the exposure and in many cases could not get it anywhere else.

The names and the dates speak for themselves. In 1940 she was invited to open a gallery in the empty basement of the Wakefield Bookshop on East 55th Street. It was in this hospitable dungeon that she showed Joseph Cornell in 1942, Saul Steinberg in 1943, and Adolph Gottlieb in 1944. As these names will

suggest, there was nothing uniform about Betty Parsons's taste. In 1945 she showed Mark Rothko, Ad Reinhardt, and Hans Hofmann with an Old Master dealer called Mortimer Brandt who wanted to get into modern painting, and in 1946 she opened up on her own on 57th Street.

Hardly was she in business than Barnett Newman, Jackson Pollock, Mark Rothko, and Clyfford Still joined the gallery of their own accord. Exactly what happened thereafter we shall not know until Lawrence Alloway publishes the history of the Betty Parsons Gallery on which he has been working intermittently for many years. But we do know something of what Betty Parsons thought about her four new recruits.

"I realized," she said to Calvin Tomkins of *The New Yorker* in 1975, "that they were saying something that no European could say. Europe is a walled city—at least, it's always seemed that way to me. Everything is within walls. Picasso could never have done what Pollock did. Pollock released the historical imagination of this country. I've always thought that the West was an important factor in the art of the 1940s and 50s here. Pollock came from Wyoming, Clyfford Still grew up in North Dakota, and Rothko in Oregon—all those enormous spaces. They were all trying to convey the expanding world."

It is important to remember that in 1946 not one of these artists could be called a commercial proposition. But they knew, and she knew, that they were some of the best painters around. She might have had a proprietary attitude towards them. But—and here I quote again from Mr. Tomkins—that was never how she operated. "I'm not the possessive type," she said. "Possession is entirely an inner thing with me. If I fall in love with a picture, then because I love it it's mine. It doesn't matter where it is or who owns it."

That is the way to have a happy life, but it is not the way to make a fortune, either for oneself or for others. (Betty Parsons had been born to a fortune, as a matter of fact, and until the crash of 1929 she never had to worry about money.) She never thought of herself as a teamster. If artists thought they could do better elsewhere, they were welcome to try. She would always find new ones (in fact she rather preferred them) and the new ones she found over the next ten or fifteen years included Richard Lindner, Ellsworth Kelly, Jack Youngerman, Alexander Liberman, Paul Feeley, Agnes Martin, Richard Tuttle, and Mark Lancaster.

It helped very much in her dealings with artists that she was an artist herself. She never stopped working. (If she stayed with friends in the country they would come down to breakfast and find that she had been up for hours and had already painted at least one watercolor and maybe written a poem as well.) Her sculptures had an individual presence that more and more people found irresistible. She showed them all to the world, and saw no reason to conceal the delight that this gave her.

Made for the most part of found objects that she picked up on the beach and painted, where painting seemed necessary, her sculptures were provocative in shape, vivid in color, and epigrammatic in their concision. They never repeated themselves, and they never went on too long.

Shown at 20 West 57th Street, at the gallery of her friend Jill Kornblee, they looked wonderfully direct and unstuffy. Shown at a gallery on Nantucket, where I once happened to see them, they looked as if they had walked up off the

beach. Shown in London, they spoke for the candor, the fearlessness, and the sense of American fun that she had somehow preserved throughout a long, expensive, mainline upbringing in Newport, Rhode Island, and elsewhere. They were not like anyone else's art, and they looked everywhere at home, just as she did herself.

And that's the way Betty Parsons was—an artist in life, and an artist in her art. What more can one ask?

# Anthony and Violet Powell

### House & Garden, 1988

When I first went to stay with Anthony and Violet Powell, rather more than thirty years ago, they had only recently left London and gone to live in the country. It was known to be a pretty house, built in the 1820s, with a nice bit of land, an artificial lake, and some grottoes. But where exactly was it?

Bent over the Ordnance Survey map of the region in question, and delighted as ever by the perfection of its engraving, I soon became aware that this was inmost England—an area in which English place-names took on their full and wayward sublimity. In what other country could one pass in an hour or two from Stoke Trister to Compton Pauncefoot, from Fifehead Magdalen to the Devil's Bed & Bolster, from Cricket Farm to Murder Combe, and from Vobster to Upper Vobster?

British Railways at that time had not yet been streamlined. Trains nosed their way through the landscape in conversational style, pausing at stations now long extinct. I had time, therefore, to look forward to the weekend ahead. Then as now, Anthony Powell and his wife were delicious companions, ever ready to act upon a principle that he later set down in his memoirs—that "one of the basic human rights is to make fun of other people, whoever they are."

As to which of them was the better at that pastime, it would be difficult to say. But it was often evident that he was measuring the innate absurdity of this person or that against the dictates of the novel-form. "Simply extraordinary!" he would say of some bizarre coincidence in human affairs. ("Extraordinary"

on such occasions seemed to run to sixteen syllables.) "But of course one could never get away with that in a novel. No one would believe it."

Once aboard that unhurried train, I had time to date almost to the day the moment at which I became addicted to the novels of Anthony Powell. In the spring of 1947 I passed the night in the little harbor town of Newhaven, on the English Channel coast. In my pocket was a ticket for the steamboat that left for Dieppe the next morning. The hotel was grim, the dinner absurd, the bed penitential.

Before going to sleep, I opened a copy of *From A View to a Death*, a pre-war Powell that had been recommended to me by one of the author's Pakenham sisters-in-law. Something in the completely original tone of voice in which it was written banished all thought even of the 25-watt lamp by which I was trying to read. At the perfectly contrived climax of a lengthy and circuitous account of an insubstantial horse-race, I laughed so much that I fell out of bed.

Anthony Powell at that time was not yet the author of *A Dance to the Music of Time*, the twelve-volume series of novels that was to give me—along with countless others—an auxiliary and a parallel life, no less real than my own, to slip in and out of at will. For many years, I have never let those books out of my sight.

In the late 1940s no one knew what Powell would do next. Yet the tone of voice, the refusal to "tell a story" in standard style, the apparently broken-backed but precisely effective syntax, the ellipses that keep us ever alert, the omnipresent sense of human absurdity—all promised something out of the ordinary.

When Anthony Powell published in 1948 a long and scholarly biography of *John Aubrey and His Friends*, there were portents in plenty for an attentive reader. Aubrey's *Brief Lives*, written between 1669 and 1696, has no rival as a free-form index to the ins and outs and the ups and downs of human nature in England. It was therefore natural almost to the point of predestination that Anthony Powell should have fastened upon them in first youth and in due time raised to a monument to their author. When he speaks of Aubrey's "tumbledown, but one would hesitate to say unhappy life," the words would apply to many a character in his own *Dance* series. But for the Powell-watcher the indispensable passage in the biography is one that relates to Powell himself, no less than to Aubrey:

> He contemplated the life around him as in a mirror—the glass of The Lady of Shalott—scarcely counting himself as one of the actors on the stage, caring for things most when they had become part of history. He was there to watch and to record, and the present must become the past, even the immediate past, before it could wholly command his attention.

This was the stance before life that was to power not only John Aubrey's chaotic and barely transcribable series of more than four hundred short biographies but—three hundred years later—one of the great symphonic achievements of the English novel: a grand design so unemphatic that the casual reader, buoyed along by one incident after another, may never notice it.

When I saw something of the Powells, in the London of the early 1950s, *Dance* was in full germination. (The first volume appeared in 1951.) At that

time they both seemed quintessential Londoners. He had been born in London, by his own account, "on 21 December 1905, the winter solstice ('tis the year's midnight, and the day's'), feast of the sceptical St. Thomas, cusp of the Centaur and the Goat." He also tells us in his memoirs that for a long time after his marriage in 1934 to Lady Violet Pakenham, they would have looked on existence anywhere else but London as exile. Living at No. 1 Chester Gate, on the edge of Regent's Park, they had all around them the incomparable townscape that had been run up by John Nash in the 1820s.

Where practicalities were concerned, however, this period was the very nadir of life in London. Nothing worked. No one would come to fix it. Everything was in short supply, and almost everything was of wretched quality. People coughed and ached, year-round, and came to dread the tall staircases, floor after floor, that were integral to Georgian design.

The Powells had across the road an unspoiled and archetypal London pub, the Chester Arms, which was much favored at lunchtime by fugitives from postwar housekeeping. Still, this was an era in which the dream of a house in the country, no matter how long dormant, became compelling.

Meanwhile, Anthony Powell had in London an incomparable source of the chance encounters on which he loved to draw. London had also a range of street-spectacles that could be turned to symbolic use. One such was the performer—a huge, wracked figure of a man in middle life—who earned a pitiable living by freeing himself, day by day, from a set of apparently formidable chains, in front of the statue of the great Victorian actor Sir Henry Irving, at the back of the National Portrait Gallery. The Londoner's living Laocoon, he raised in many a passerby dark thoughts as to the eventual futility of all human effort.

In 1950, a legacy from one of Powell's aunts made it possible for them to think seriously of leaving London. After seeing candidates by the discouraging dozen, they settled on a house called The Chantry, not far from Frome, in Somerset.

Though dated from the same decade as the Regent's Park Terraces, it was not at that time what realtors call "a show-place." Running water and electric light had the status of exotic and precarious novelties. During World War II, The Chantry had sheltered successively some bombed-out families, a school with zero attendance, and a chocolate factory. Such was the density of the bramble, laurel, elder, and long grass all round the house that many people who had looked over the wall at the edge of the property were of the opinion that the house must no longer exist.

In the choice of The Chantry, as in its eventual decoration, predilections of both Powells found outlet. Family portraits played their part, for instance. A French interviewer may recently have described the portraits in question as "awkward and sepulchral," but to the Powells they are living presences whose every quirk is known.

As genealogists, they are both in the Olympic class. Violet Powell's family tree is so luxuriant as to have made her familiar from the nursery onward with tables of descent. In Anthony Powell's case, the passion was certainly not inherited. "My father regarded his own advent into the world as a phenomenon isolated from the mainstream of human causation. He was not merely bored by

genealogy, he was affronted. But I have always found pleasure in genealogical investigation. When properly conducted, it teaches much about the vicissitudes of human life; the vast extent of human oddness."

Given—as is the case with Anthony Powell—an ancestry that can be traced without fakery or interruption to a Welsh lord called Rhys the Hoarse (1169–1234) who died at the age of sixty-five from wounds received while storming Carmarthen Castle, it would be possible to look back in complacency upon an eight hundred years' lineage.

But although he did once say that "it is incontrovertibly smart to have been compared to King Lear in 1499, a century or more before Shakespeare standardized the story," no one was ever less likely to boast of such things than he. If one of his ancestors went bankrupt, was accused of physical assault and was sent to prison (even if for one day only), he likes to tell the tale. If a member of his mother's family, the Dymokes, acted as King's Champion (a spectacular but largely rhetorical role) at the coronation of King Richard II in 1377, he will say only that "it looks very much as if the whole business of the King's Champion might have been a put-up job."

If a later Dymoke—a clergyman, moreover—fell down a well when drunk and drowned himself, that too is part of "the vast extent of human oddness." Nor does he gloss over the fact that later relations sometimes fell short of their potential. "What's the use of being at Eton and Balliol with the poet Swinburne if you don't remember anything about it? My mother's family lived about six miles from Tennyson for six years and they too had absolutely nothing to say about it."

Even the stylish portrait of the 1st Duke of Marlborough over the fireplace is quietly undercut. "As he was an ancestor of Violet's, it's all right for him to be here. But there are people who say that the costume is the wrong date, and that it may not be him at all, but some Frenchman or other." Remarks of this sort are followed by a grin of delight at the Aubreyesque macedoine of fact and fun that runs throughout the house.

The Chantry in its present well-developed state bears the mark of both its owners. "Tony has undergone only two conversions," Violet Powell likes to say. "One was early on in our marriage, when he stopped liking modern tubular furniture." From that epiphany, there followed the large, commodious, handsome but by now well-worn pieces of Empire furniture that could until quite lately be bought for almost nothing.

"The second conversion was to wallpaper." Wallpaper did not sit well with tubular furniture in London, but in the country both Empire furniture and family portraits seemed to call for it. But what kind of wallpaper? An interesting question. Though not normally given to flamboyance, Anthony Powell went up to London and bought a dark, sonorous, broad-ribbed paper for the library and, in time, a festive military motif, all piled trophies in black on mulberry-red, for the staircase.

People said "Now the Powells have gone too far." But they hadn't. Those papers give weight, in the one case, and a glowing brilliance in the other. Both by inheritance and as a result of his own war service, Anthony Powell often thinks in terms of the British army, both in its majestic and in its occasionally ludicrous manifestations. ("I wonder if I dare tackle the army," he said to me

when the events of *A Dance to the Music of Time* reached the outbreak of World War II.)

Once again, the evidence is carefully undercut in The Chantry. Military prints are hung against yellow wallpaper speckled with blue. If military helmets are on view, they turn out to be sitting on top of bound sets of *Chums* and *The Boy's Own Paper* of many years ago. But in earlier years, when Powell was writing his *Dance* in an upstairs room on a typewriter dating from the year 1931, a visitor might notice, ever near at hand, a small autographed photograph of Field-Marshal Montgomery with a group of foreign military attachés, at a late stage in World War II, and their liaison officer, A. D. Powell.

The Powells are kept informed of today's goings-on both by their own children and grandchildren and by a vast, much-ramified cousinage. An accomplished biographer and memoirist, Lady Violet has a sense of period that is quite as acute as her husband's. Occasionally he will feign to be an antic old stager. "I never cared for decimal coinage. What's good enough for Charlemagne was good enough for me." But fundamentally they both watch and wait for the moment at which "the present becomes the immediate past," to be discussed and dissected with a relish undimmed by time. If Violet Powell makes a patchwork quilt, it is made up not of Victorian patches but of scraps of early Laura Ashley. And it was she, not he, who initiated the *Album of "A Dance to the Music of Time,"* lately published in England, which is a patchwork of Old Masters, prints, cartoons, photographs, and evocative souvenirs of every kind that relate to the *Dance*.

Memories are long, in this house, where the Army List of 1796 is as vivid as the newly arrived London *Times* and we sometimes ponder the fact—awesome, among today's galloping actualities—that our host's grandfather was born in 1814, the year before the battle of Waterloo put Napoleon out of business. But then The Chantry, like the countryside in which it stands, is inmost England, and never more so than now.

# V.

## A SENSE OF GLORY (AND ITS OPPOSITE)

The title of this section is taken in part from Henry James's reminiscence of a visit in boyhood to the Louvre. He never got over that first glimpse of the Galerie d'Apollon, any more than we today get over our first glimpse of many a great American museum, or its counterparts in Europe.

The idea that that sense of glory might one day be tarnished, if not actually lost, is painful to us. It is the critic's duty to give warning of danger, in that context, and it is his privilege to offer reassurance where reassurance can be justified.

The pieces in this section deal primarily with this question as it has presented itself in the last ten or fifteen years. They were difficult years, and much contested. Dreadful things were done, here and there, and they made us rethink about the role of the critic, the role of the museum, the role of the auction house, and the workings of art itself.

# Farewell to London

The Sunday Times, London, 1974

Close on twenty-five years ago, and in circumstances wholly creditable to himself, my predecessor as art critic of *The Sunday Times* was relieved of his duties. Confusion followed; but when it became clear that art still had its place in these pages the post was offered to me.

I recommend it very highly. The art critic, like the sheepdog, spends much of his working life in the open air. Swinging along on his own two feet, he moves at a pace of his own choosing from one source of exalted pleasure to another. The company he keeps can be the best imaginable. He is paid to educate himself every day of the year. It is a continual challenge to deal with the past, the present, and the future of one of the most valuable of human activities. The art critic can never know enough, think enough, or feel enough, but at least he can try.

Twenty-five years can be a long time in the history of art. The period from 1889 to 1914, for instance, is still a long way from having been finally disentangled. The period from 1949 to 1974 poses, on the other hand, a completely different set of problems. For anyone who lived through it as a practicing critic there is a temptation to see himself as the guardian of a necropolis. In 1949 the great names of the modern movement were still alive and active, almost

without exception. The roster had changed little since 1914; yet Matisse, Braque, and Picasso had still surprises to spring. Brancusi, Duchamp, Léger, Rouault, and Derain were still around; and although Klee, Munch, Mondrian, and Kandinsky had all died in the 1940s, the full extent of their achievement had still to be recognized. The modern movement as it had existed before 1914 was still very much in being.

It still is, for that matter. There is work from which time takes everything away; and there is work to which time adds, continually. The death of the work is the only death that matters, in art; and where it has not occurred it is the funeral oration that dates, and not the work—even if (as in the case of Braque) the orator was André Malraux. The best art never stales. Munch was a new artist at the Hayward Gallery last winter. Kandinsky was a new artist when he was shown in bulk at the Lefevre Gallery last year. Mondrian was a new artist when his late, unfinished works were shown a month or two ago at the Sidney Janis Gallery in New York. Matisse will be a new artist when the National Gallery in Washington shows the outsize cut-paper paintings which it has lately acquired. In such cases, death is kept at bay; even Juan Gris (d. 1927) is a new artist at the Orangerie in Paris at this moment.

To be encouraged to comment on these matters, week after week, is a privilege at which I have never ceased to marvel. Two quite separate things have to be kept in mind. One is the work, considered as a finite object; the other is the work as it affects, and is in its turn affected by, every other work of consequence that has been produced, before or since. It is in the interaction of these two that fascination lies. What we have seen this week will not look the same when we see it again next week. It changes all the time, in relation to the totality of other works of art; and we ourselves change, or are changed, with it.

Exposure is fundamental, of course. We cannot know about works of art if we never see any. In this respect the period from 1949 to 1974 has had a specific and, on the whole, a constructive character. Official exhibitions tended to have a concise and logical intention; and there were a great many of them. In terms of revelation (and in terms of sheer size, also) they rarely rivalled the mammoth exhibitions which before 1914 brought the newest art to London, Cologne, Berlin, Munich, and St. Petersburg. None of them had the irresponsible magnificence of the great exhibition of Italian Art at the Royal Academy in 1930, to which the Italian authorities sent work after work which today would never be allowed to travel. But anyone who mastered the catalogues of the exhibitions organized by the Council of Europe will know a great deal about the history of Europe from the age of Charlemagne to the age of King Edward VII, and he will have learned it in the pleasantest possible way.

To the Arts Council, and to its equivalents abroad, we owe a debt which should be spelled out more often. All such organizations have their defects, and a lot of more or less informed people think that they could do the job better if they had the chance. No doubt it is true that every nation will push its own artists, if it can; certainly we have all seen dismal exhibitions to which no other motivation can be ascribed. Isolated episodes from the past can always be adduced in support of the merits of private enterprise; I remember, for instance, a Cézanne exhibition at Wildenstein's, in 1939, which few museums could rival today. But we just can't have such shows any more, as a matter of

physical and financial possibility.

What we have instead is something quite different: the argued exhibition, which works with whatever it has to hand and aims to put a particular point of view. To aspire to shape the taste of a whole generation is not an ignoble ambition; and a great exhibition on an unhackneyed historical subject is a masterwork in the field of human communication.

It is, however, with new art that the critic's task is at its most exacting. Ever since Baudelaire spoke of "the cult of images—my great, my primal, my only passion," it has been taken for granted that modern art is the key to modern sensibility. It was for many years a key to which relatively few had access: in the 1930s the audience for a truly modern art in London numbered perhaps twenty people, and Mondrian for one could find hardly any takers here for his pictures even at £40 a time. But between 1949 and 1974 it somehow got around that there was a white magic in modern art and more and more people wanted to get close to it.

This suits just about everybody, but it doesn't always suit art. It suits the Government, which can send Henry Moore where once it took a battleship and a couple of cruisers to show the flag. It suits the auction houses, which can play upon the disquiets of the rich with an ever more dexterous hand. It suits the dealers. It suits publishers, who look back in amazement at the 1920s, when a very good art-book might sell six dozen copies. It suits the critic, who could go to a new country every month of the year if his editor would stand for it. And it suits some artists, who get to live in houses that Gatsby himself might have thought ostentatious. A really successful artist in 1974 has the prestige of Tennyson in his heyday; he can earn as much money in a decade as Bernard Shaw earned in his whole lifetime; and he has the potency of myth. He is the accredited seer, the keeper of the public conscience, the man in whom we see ourselves fulfilled.

It's dangerous, even so. It's dangerous for the individual, and it's dangerous for art itself. It contributed, beyond a doubt, to the suicide of Nicolas de Staël in 1955; and in the United States, in particular, it sets up tensions between artist and dealer, artist and curator, artist and collector, artist and critic, and artist and artist. None of them are beneficial. To surmount them, by whatever means, burns up energies that should go into the work. It is very difficult to be at all good and not to be caught up in it; I can think of artists who lived for years like wandering friars, lodged and fed by sympathizers as they moved from town to town, only to catch on, quite suddenly. Thereafter the fundamental thing is to buy time, and buy silence, and buy secrecy; and not everyone can manage it.

In this, as in much else, the great exemplar is Marcel Duchamp. Year after year he listened with the utmost courtesy to people who asked why he had "given up" painting as a comparatively young man. When he died, at eighty-one, it was found that for more than twenty years he had worked on the panoramic résumé of all his interests, which is now in the Philadelphia Museum. And even there he bucked the system; for the work in question may not be photographed, still less reproduced, and can only be seen by visitors who stand, one by one, to look at it through two very small peepholes.

Duchamp it was who undermined the idea of art as something that took a

great deal of skill, was made where possible of rare materials, and should join the huge family of portable, saleable, and immutable works of art. So successfully did he do this that in retrospect a great part of the new work of the period of 1949–74 is in effect, and wittingly or not, a dialogue with Duchamp.

Sometimes that dialogue is carried on quite consciously and against a background of close knowledge and affection, as in certain paintings of Jasper Johns which I would rank with anything produced in this century. Sometimes the intention to produce substantial art of a lasting kind has in itself the character of a riposte: to name names here would be invidious, but those most affected are the artists who came into their own in the sixties, only to find that what they did was talked of as tautologous, market-oriented "bow-and-arrow art." It was not for art, the opposition said, to be bought and sold in the interests of people who wanted a quick return on their capital; and the artist who allowed this was the accomplice of a bad system. Art of a momentary, incorporeal, dreamlike sort could alone outwit the system.

"To each age its own art" is written above the doorway of the Secession building in Vienna. It's still true, and yet we none of us quite like to believe it. "Real art stopped with ME," we think, thereby falling into the trap which we should most try to avoid. Not to fall into it, we need two traits which are rarely found in combination. We need the kind of infallible instinct which wears out in youth, like that of the mathematician or the racing motorist. We also need the accumulated wisdom of a Judge Learned Hand. I had neither, and I knew it; but to those who put up with me, year by year, I send my most heartfelt and unforgetting thanks.

# Luminism:
# The Healing Art

American Light: The Luminist Movement 1850–1875, *edited by John Wilmerding.*
*Harper and Row, 1980.* Nature and Culture: American Landscape and Painting
1825–1875, *by Barbara Novak. Oxford University Press, 1980*

**The New York Review of Books, 1980**

There has lately been set before us, in exhibitions and critical essays, a twofold
proposition: that there is such a thing as a specifically North American light,
with physical and moral properties not quite to be paralleled elsewhere, and
that that light, and those properties, were captured once and for all in the third
quarter of the nineteenth century by a group of painters who now bear the
name of "luminist."

As to the first part of this proposition, we need expect no rebuttal. Visitors
and citizens alike have always agreed that American light is not like any other
light. Maine light, Arizona light, Marin County light, Chicago light, and
North Carolina light have an irreducible something which makes them as
distinct from light in any other country as they are distinct from one another.
It is as if chapter one, verse three, of the Book of Genesis had been revised for
local usage and "Let there be light" had been scrapped in favor of "Let there be
American light."

Painting today is as sensitive to this amendment as ever it was. Richard
Diebenkorn's *Ocean Park* series is as full of an unmistakable West Coast light
as Willem de Kooning's landscapes are full of an unmistakable East Coast
light. We could argue about precisely what constitutes the light of Winslow
Homer, the light of Edward Hopper, the light of Fairfield Porter, and the light
of Alex Katz, but we know it when we see it. We also know that no foreign
painter has ever quite caught it, and that most foreign painters know better
than to try. They sense instinctively that American light is fundamental to
American human nature. To an extent not quite to be met with in other parts of
the world, American light is a family matter on which the outsider should
forbear to intrude.

It is for this reason that "American Light" at the National Gallery of Art in
Washington, D.C., gives off so hefty an emotional charge. "American Light" has
as its subtitle "The Luminist Movement: 1850–1875," and it sets out to prove
that the achievement in question was a landmark not only in the history of
American art but in the history of American self-awareness. Even as we walk
from room to room, inspirational texts smile down at us from somewhere near
the ceiling; and the show will have as its lasting memorial the densely argued
book to which no fewer than nine scholars have contributed. As in a famous
Victorian boat race, we can say of these nine savants that "All rowed fast, but
none so fast as stroke": "stroke" in this instance being John Wilmerding, chief
curator of American Art at the National Gallery and prime instigator of the
show. It is the contention of Mr. Wilmerding and his colleagues, as it is of

Barbara Novak in her new book, that the luminist achievement should be ranked level with the achievement of American literature in the 1850s; and John Wilmerding goes so far as to compare a painting by Fitz Hugh Lane— *Brace's Rock* of 1864—with its contemporary, the Gettysburg Address.

These are prodigious claims. Many visitors to the National Gallery will have never so much as heard of Fitz Hugh Lane, Martin Johnson Heade, John F. Kensett, Sanford Robinson Gifford, and Jasper F. Cropsey, on whose behalf these claims are made. And although Frederic Edwin Church in his lifetime was rated very highly indeed he has only lately re-entered the popular imagination on the grounds that his *Icebergs: The North* made a colossal price at auction. (Those are grounds that Church himself would have heartily approved, by the way.) It is not necessarily the act of a philistine to wonder whether the achievement of these painters can really rank not only with a speech that bound up the wounds of the nation but with the achievement of Melville, Whitman, Thoreau, Hawthorne, and Emerson.

To live up to the claims that are now being made for it, the luminist achievement would have to be one of the great human formulations. Furthermore, it would have to be seen to have come about at exactly the right time and remind us of what Emerson said in *Representative Men:* that "there is a moment in the history of every nation when…the perceptive powers reach their ripeness and have not yet become microscopic. That is the moment of adult health, the culmination of power."

And, sure enough, it is upon Emerson that the case for the luminists has drawn heavily ever since luminism itself was first given its name, just twenty-six years ago. It was John I. H. Baur, as early as 1947, who made a first attempt to isolate the luminist element in American nineteenth-century landscape painting. "Pantheistic realism" was one of the ways in which he described it then, and he said among other things that "American light *looks* quite different from that of Europe," thereby singling out the indigenous quality that has been made so much of by later enthusiasts. But the American light in question did not function merely as a form of garnish unavailable elsewhere. It was what Emerson could be presumed to have had in mind when he wrote in *The Over-Soul* that the soul in mankind was "not an organ, not a faculty, but a light…"

Emersonian, likewise, is the trait by which a painting can be recognized as specifically luminist: the absence of "stroke" (in other words, of any visible movement of the brush). Absence of stroke is fundamental to luminism as it was defined by Mr. Baur in 1954 and as it is redefined with an exceptional cogency by Professor Novak in the Washington catalogue. Here is Mr. Baur in 1954:

> Luminism is a polished and meticulous realism in which there is no sign of brushwork and no trace of impressionism, the atmospheric effects being achieved by infinitely careful gradations of tone, by the most exact study of the relative clarity of near and far objects, and by a precise rendering of the variations in texture and color produced by direct or reflected rays.

And here, a quarter of a century later, is Barbara Novak:

> The absence or presence of stroke would seem to be a decisive factor in determining whether we are dealing with luminism. Stroke carries with it

the sense of paint. When this happens, the idea of light as pure emanation gives way to an idea of paint that approximates or represents light. The illusion is lifted. We remember that we are dealing with a *painting* of light, not with light itself. The reminder of the actual process of painting recalls to us the agent of process, the painter. It denotes not only the artist's activity, but the artist's presence. That presence introduces us to a self who, as it were, stands between the image seen and the spectator. The more that artist's self, embedded in the "signature" of stroke, occupies our attention, the less we are dealing with the selfless image of luminism.

And, later, in the same passage:

Stroke lessens the hyper-clarity of object penetration central to Baur's 1954 definition of luminism. In luminism, the absence of stroke heightens the textural properties of natural elements beyond the compass of normal vision: the hard, taut ripples in a lake, the crystallinity of rocks, the minute identities of pebbles. Luminist anonymity erases both artist and spectator and penetrates thingness, the *Ding an sich*.

Professor Novak here identifies two key elements in luminism: the abdication of the ego, which normally can find exalted expression in brushwork, and the crystalline vision. Both can be linked to an Emersonian view of the relationship between mankind and nature, even if Emerson himself knew nothing of the luminist painters and did not even care much for landscape painting. (Conceivably his relationship with nature was so intense that he resented the intrusion of another human being upon it.) There is a famous passage in his *Nature* in which Emerson describes how "all mean egotism vanishes" when he is in the presence of Nature: "I become a transparent eyeball: I am nothing: I see all." And the "selfless image" of luminism does indeed find its equivalent in Emerson's account of how water looks when seen from a canoe: "I had never seen such transparency, such eddies: it was the hue of Rhine wines, it was jasper and verd-antique, topaz and chalcedony, it was gold and green and chestnut and hazel...."

That luminist practice ran parallel to certain aspects of Emerson's transcendentalism and can therefore claim kinship with one of the more consequential climates of feeling in nineteenth-century America is not difficult to accept. But it should also be said that the Emersonian eyeball was only a part of Emerson. The entranced spectator of life in the deep forest was also the man who said that "banks and tariffs, the newspaper and the caucus...rest on the same foundations of wonder as the town of Troy and the Temple of Delphi." Luminism has nothing to do with banks and tariffs, and the luminists in general did not think it their business to bother with Delphi or Troy. If they were Emersonians, it was in relation to one aspect of Emerson only.

It must further be said, and it is amply made clear at the National Gallery of Art, that they took a view of the constituency of painting which by the standards of their immediate predecessors, and of many of their contemporaries, was decidedly limited. Except as a spatial coordinate, the human figure plays almost no part in luminist painting. Cities and towns, likewise, are banished. If there is a house, here or there, no one is ever at home. Birds and beasts are out of favor. With the exception of Church, whose credentials as a luminist are at best intermittent, the luminists tended to the European point

of view that spectacular natural beauty and high art do not sit well together.

In this way the luminists cut themselves off from many of the more robust satisfactions that painting has to offer. The disappearance of "stroke" could well be, and in particular may seem to some of us today, the mark of a superior selflessness, but to those who had been brought up on stroke (and plenty of it) it seemed a deprivation. Thomas Cole had accustomed his countrymen to the idea that an American painter could take the whole of human history for his subject matter and not be worsted. The Hudson River painters had worked with the illimitable profusion of America's natural resources, seeking to prove that no matter how multitudinous the leafage or how far beyond measurement the tonnage of moving water, the steady and visible to-and-fro of the brush would be equal to the occasion. George Caleb Bingham had taken the rough-and-tumble of everyday life on the Mississippi and elsewhere and mated it with European notions of classical figure-composition. Others worked with the facts of American social history the way an experienced middleweight works with the facts of a fifteen-round fight. To those who took the importance of American people and their appearance in close-up as fundamental there might seem something passive and finical about the activity of the luminists.

This question is not shirked either at the National Gallery of Art or in the book that goes with the show, which includes a great picture by Caleb Bingham, *The Jolly Flatboatmen* of 1846, to speak for the uninhibited physical activity that is banished from luminism. There are mainline Hudson River paintings to put the case for a more inclusive art. Robert Salmon's *Wharves of Boston* (1829) points up the difference between the straightforward steady-handed recording of a given scene and the poetics of luminism. No one who loves these things can say that they are scamped. But when we come to the luminist paintings of Fitz Hugh Lane there can be no doubt, at least for me, that a wholly different presence transforms the secular scene. It is with us as it is with the soprano soloist who steals in upon the last movement of Arnold Schoenberg's String Quartet no. 2: we seem to breathe an air that is different from any other that we know, an air "from other planets."

The paintings in question are small in size, introspective in tone, and elegiac in their subject matter. Never was painting further from rhetoric than in Lane's glassy and vespertinal "Brace's Rock" series, with its minutely plotted lines of bare rock, salt water stilled by low tide and windlessness, once-sturdy boats long beached and derelict, and scant and wry allusions to the tenacity of nature. It is difficult not to see in this deserted cove, from which the tide seems to have ebbed once and for all, a place in which great hopes have been laid to rest and great hurts endured in solitude.

If this reading is correct, Fitz Hugh Lane here presents us with images of bereavement that are as remarkable for subtlety and discretion as they are for depth and straightforwardness of feeling. Lane himself was a cripple: a man condemned to sit on the seashore and watch the life of the seafaring man from a safe distance. Necessarily he had sat out the years of the Civil War in a privileged immunity. So far as conventional reporting is concerned, no man could have seen less of action. But visitors to the National Gallery may doubt that the Civil War was ever more finely memorialized than in these restrained and quite small paintings, where all nature is at half mast and a universal tenderness can

be sensed but never turns oozy. It is on this reading that "Brace's Rock" may be compared without hyperbole to the Gettysburg Address.

It was the particular grace of Fitz Hugh Lane that he could build up, piece by piece, an iconography of consolation at a time when his country had most need of it. He knew that what Emerson called "the moment of adult health, the culmination of power" might also be the moment at which collective griefs need to find outlet in emblems of a timeless, egoless character. He also knew that, given his particular gifts, those emblems could not be cobbled together in improvisational style. There is in fact a sense in which the "Brace's Rock" series is anti-Emersonian. Emerson had once asked himself, "Do not the great always live extempore, mounting to heaven by the stairs of surprise?" and the form of the question implied the answer "Yes." But there is no question in the "Brace's Rock" series of "living extempore," let alone of "mounting the stairs of surprise." Not until Georges Seurat worked at Gravelines in 1890 were paintings more carefully plotted or more exactly adjusted toward a long-foreseen end.

It is relevant that more than one of the luminists had served an apprenticeship as an engraver. (There was even one who had been put to engraving banknotes, than which no firmer way of eliminating the individual ego in art has yet been devised.) The engraver learns to subdue his hand, to arrest the spontaneity of his eye, and to keep in mind an ideal of infallible measurement. Engraving, thus described, can sound like serfdom, but it so happens that the traits in question reappear, exalted and transcended, in the poetics of luminism. Barbara Novak put this well in her earlier book, *American Painting of the Nineteenth Century* (1969): "Measure was one of the most important aspects of the luminist sensibility—not only for ordering the space of the picture, but also for controlling by careful degrees the tonal modulations by which the object could emerge from ideograph to thing and then out into the palpable, radiating presence of the luminist light." Whether the luminists were born with, or had grimly to learn, that "natural skill for mensuration" which Emerson admired in Thoreau, they put it to great uses. It is not only time that is suspended in their best paintings, but human frailty also.

But what if the "air from other planets" gets thin after a while? And what if there are states of mind and attitudes of being, not to mention *données* of nature, which cannot be fully rendered within the limits of a chastened ego and a meticulous and strokeless arrangement of horizontal planes in an uninhabited universe? What, in a word, if there are situations to which the poetics of luminism are irrelevant? An angelic presence is all very well, and there are wounds which must be bound up if we are not to die of them, but there is also such a thing as a whole human body which has need of terrestrial presences. What if luminism, if seen in the setting of a nation reborn to health, were to seem like a conspiracy of invalids?

To uneasinesses such as these, John Wilmerding has a five-word answer: "Look at Frederic Edwin Church." It is not his only answer. There is for instance the fact that elements of luminism found their way into American photography at that same time, thereby suggesting that the luminist aesthetic corresponded rather to nationwide concerns than to the whim of half a dozen painters who lived in the East: but we sense that for Mr. Wilmerding, Frederic Edwin Church is the indispensable complement to the exact, delicate, small-

scale, introspective, and stay-at-home art of Fitz Hugh Lane and Martin Johnson Heade.

It is for instance with reference to Church, if at all, that Mr. Wilmerding can justify one of his earlier salvoes in *American Light:* the claim that luminism's "crystalline pictures of the 1850s stand as supreme manifestations of Jacksonian optimism and expansiveness." There is nothing Jacksonian about sitting still and minding your own business. Nor are "optimistic" and "expansive" among the words that come to mind when we look at paintings that have to do above all with stillness, inactivity, and inwardness. It was Church who had the measure of what is sometimes called "the Era of Manifest Destiny," and it was in paintings by Church that the Americans of the 1850s recognized a heroic projection of themselves. With *New England Scenery* (1851), with *Niagara* (1857), and with *Twilight in the Wilderness* (1860) he habituated his fellow-countrymen to the idea that landscape painting should be all-encompassing. Church had unlimited energy (he could spend ten hours at the easel and not feel exhausted). There were no limits to his ambition. He was an annexationist by nature: a man who no sooner heard of a new and strange landscape, whether in the tropics, in the Andes, or in the Arctic, than he burned to possess it. Where Fitz Hugh Lane may put us in mind of one of the noblest of all human utterances, it has to be said that Frederic Edwin Church in his larger undertakings was not merely the contemporary, but the peer, of P. T. Barnum. What less can we say of a man who could make even an iceberg look gaudy?

Church was fine-looking, born to money, an immediate social success, a man with a hard head for business and a prodigious worker and self-improver. He was a born explorer, a master of spectacular effects and an inspired showman. But he had very little to do with luminism. Rarely has an ego been more strongly developed, or more fiercely to the fore, than his. He was big on stroke, moreover. So far from craving the holy quiet of the transcendentalist, he exemplified what one critic (in 1859) called "the onward march of civilization, characteristic alike of the western backwoodsman, the Arctic explorer, the southern filibuster, and the northern merchant." His was a nationalist without nuance and a religiosity that makes us want to call Lucifer long distance and set up a luncheon date.

The fact that Church was a master of the small oil sketch from nature and a man of untold vigor and resource who gave pleasure to hundreds of thousands of people does not make it any the less inappropriate to discuss him along with Lane, Heade, and Kensett, or to hang his flamboyant and huge-scale undertakings with their smaller and less assertive ones. (There is also the matter of the world view to which Church subscribed. "The faith in Manifest Destiny"—according to David C. Huntington in his *The Landscapes of Frederic Edwin Church,* first published in 1966—"was the faith that natural history had dictated the Anglo-Saxon domination of the great North American continent. By extension, this preferred nation was ultimately ordained to regenerate the whole world.")

During the early years of the luminist revival no one bothered about Church. John Baur never mentioned him. In the Karolik collection, which was given to the Boston Museum of Fine Arts in 1949 and precipitated the

rediscovery of luminism, Church had only a very small part. In Barbara Novak's earlier book, eleven years ago, he was roasted on a slow fire until she decided to take him down. (There were references to "the morality of the Hollywood spectacular," to "a rhetoric of grandeur," to "a domestication of Wagnerian titanism for democratic purposes," and to "parodies of high-mindedness and a magnification of popular taste.")

But then major paintings by Church began to be bought once again for major American collections, and it became clear that in any discussion of nature and culture in American history (such as is the subject of Barbara Novak's new book), Church would necessarily be important. It became clear, moreover, that when Church was still a wonder-boy in his twenties, and before he got hold (from 1856 onward) of a whole new gamut of synthetic colors, he did undeniably have an influence on the luminist painters. It is not easy to admit Church to the luminist canon without its being crushed by the sheer weight of his output, but in that particular crisis John Wilmerding may be said to turn on a dime as he finally comes up with his conclusion: that "while Church's handling of composition and paint only peripherally borders on Luminism, the sense of vast stillness verging on an imminent crescendo of light and sound had a profound impact on the movement."

As will by now be clear to those who are familiar with American art history, there is in the rediscovery of luminism, and in its elevation to the highest rank in American painting, an implicit affront to the Hudson River School as it is traditionally constituted. John Wilmerding spells that out, indeed, for anyone who has not got the point already. "By proposing Luminism as the conclusive development of early American landscape painting (in contrast to the traditional and often uneven Hudson River School surveys), one can view it as the central movement in American art through the middle of the nineteenth century."

As to this, we shall doubtless hear something from those who still believe that luminism was a subdivision of the Hudson River School which happened to have an outpost on the seashore between Newport and Narragansett. Meanwhile it is fair to say once again that long before luminism reached a safe and luxurious harbor in the West Wing of the National Gallery, much of the rough work in its defense was done by Professor Novak. She it was in 1969 who spoke in passing of "the so-called Hudson River School" and derided "Durand, Kensett, Church and Bierstadt" for having practiced ("sometimes almost interchangeably") a formula composed of "bucolic sentiment, Claudian design, and 'near-looking' detail." In reading this and other passages of hers we remember what Emerson said of American controversialists—that they "all lack nerve and dagger"—and we regret that he did not live to eat his words after reading these particular pages.

In *Nature and Culture,* Professor Novak's intentions are not polemical. What she has in mind is a philosophical interpretation of mid-nineteenth-century American art. Instead of proceeding from one artist to another and giving each one of them grades, she examines the implication for American painting of religion, philosophy, science, exploration, ecology, modes of transport, cloudscape and cloud structure, the garden and the wilderness, botany, geology, and natural history. It is a thinker's book, as much as a looker's, and it

could be read with pleasure and enlightenment even by people who have never looked at a painting and have no intention of starting now.

Partisanship plays almost no part in her analysis—Church's *Twilight in the Wilderness* is the jacket illustration—and it is only tangentially that we can work our way back to the subject of the luminists. We can hardly fail to think of them, for instance, when Barbara Novak quotes Emerson as saying that "Good as is discourse, silence is better, and shames it." With the necessarily immobile figure of Fitz Hugh Lane still in our minds, we find a particular meaning in a remark which she quotes from Thoreau: "He will get to the Goal first who stands stillest." But this is too capacious a book to be given any one meaning or assigned any one limited terrain.

Meanwhile what was initially a minority cult has turned in recent years into something of an East Coast orthodoxy. Theodore Stebbins, Jr., of the Boston Museum of Fine Arts has been an enthusiast of the luminists ever since he was a graduate student at Harvard in 1966 and addressed himself to the problem of "Luminous Landscape: The American Study of Light 1860-1875"; and in his contribution to *American Light* he proves a powerful and committed ally of John Wilmerding and Barbara Novak. His brief is to outline what might be called "international luminism," as it can be found in major museums all the way from London to Leningrad, but before beginning on that he speaks of Heade and Gifford as having "produced some of the most intelligent and poetic of American paintings." (He also, by the way, has a stab at defining the position of luminism in American art once and for all by saying that it was not a progressive movement, but rather "a last-ditch attempt to make the Hudson River School serve the complex psychic and aesthetic needs of post–Civil War America.")

Something in this near-unanimity among scholars who are also contemporaries is owed, beyond a doubt, to a sense of common enterprise. To have been in on the rediscovery of luminism during the 1950s and 1960s was an adventure of the kind, and of the size, that binds people together for life. (A similar collective warmth is characteristic of recent studies of Georges de La Tour, likewise long neglected.) Something is owed to the fact that luminism is presented by many—though not by all—of its champions as wholly indigenous to this country. But to this foreign observer it seems relevant that luminism has been rediscovered in times that in many ways are similar to those in which it first came into being. May it not be for this reason, as much as for any other, that it arouses so intense a loyalty?

To be precise: luminism flourished after an ugly and demoralizing war. It was a time—here I quote Bishop McIlvaine—of "rebuke, and darkness, and apparent deep discouragement." It was a time, as Walt Whitman said in 1871, when "the official services of America...are saturated in corruption, bribery, falsehood and maladministration...." We do not need to press these parallels point by point to agree that in the America of the 1870s luminist painting was a school of consolation. *American Light* may cause hard feelings here and there, but American light as captured by the luminists is today what it was in the 1850s and 1860s: healing light.

# Harold Rosenberg and the Role of the Critic

Barnett Newman, *by Harold Rosenberg. Harry N. Abrams, 1979*

**The New York Times Book Review, 1979**

The last book Harold Rosenberg completed before his death last year at the age of seventy-two was devoted to his old friend and colleague Barnett Newman. It is a physical object of exceptional beauty: Newman's work has never been so well reproduced. It includes a lot of valuable documentary material, both by Newman himself and by his adversaries or interlocutors, and Rosenberg wrote it as someone who had made the long march within earshot of Newman (even if it does not appear from the bibliography that he had written on him before 1963). He is good on Newman himself, good on the controversies in which Newman often found himself embroiled, good on the titles of his paintings, and good on their critical reception. That his contribution is of essay length only is not necessarily a defect; Rosenberg knew how to condense his thought.

In Barnett Newman he had, moreover, an artist who tried all his life to protect his work from what Rosenberg called "the alternate stripping and bloating to which works of art are automatically subjected when they are considered merely as visual phenomena." "The central issue of painting is the subject matter," Newman often said, and Rosenberg was very adept at isolating and defining the metaphysical concepts that in his view had motivated Newman's paintings and sculptures.

At the heart of this lively and contentious text, however, there is a certain blankness in regard to what these works are really like. It is a mistake to consider paintings as "merely visual phenomena," and by implication to downgrade or deny their status in the history of ideas; but it is also a mistake not to consider them as visual phenomena at all. Paintings are not only there to be thought about, but—some would say, primarily—they are there to be looked at. And the fact remains that almost every word in Rosenberg's text could have been written by someone who had never looked at the art. Most people agree that Newman's paintings are more than "visual phenomena," but that doesn't mean that the critic does not need to declare what they look like to him, and to hazard an opinion as to their rank among the strictly visual experiences that are open to us.

If Rosenberg's last book reveals an imbalance in this respect, it is an imbalance that marked his career from the very beginning. For much of his life, Rosenberg functioned as a practicing and peremptory critic of art, literature, and society. In all three contexts he had something of his own to say, and he saw no reason why the three domains in question should not overlap. He had lived through some of the most harrowing times in all human history and had missed not a moment of them. He was a true reader: To see him with a book

or journal in his hand was to think all over again of reading as a sacred act. Nor was he the man to sit cowering behind his typewriter until he could dispatch the week's thunderbolt from a safe distance by first-class mail. He had been educated, as he said himself, "on the steps of The New York Public Library," and he believed in disputation of a Talmudic sort: face to face, and with his whole energies committed.

In writing about art, he expressed himself as someone who summered with artists, talked the night through with them, and was prized by many of them for his quirky, unpredictable turn of mind. His involvement with living art dated from the 1940s and 50s, and in dealing with the work of artists who first came to notice at that time he displayed an ideal largeness of comprehension. Not only did he stand up for them in bad times as much as in good ones, but he was always ready to take on the opposition—or what he conceived to be the opposition—with a wrecker's ball in either hand.

He saw himself as a teacher, not an entertainer, and he never wrote a line that was not intended to make his readers think straighter, see the world more clearly, and stand up for themselves in debate. The University of Chicago had the right idea when it appointed him in 1966 to its Committee on Social Thought and to its art department; but most of his teaching was done in the magazines. Magazine articles as such are perishable goods, and their republication in books is a well-known form of professional suicide; but anyone who looks at Rosenberg's *Discovering the Present* (1973) will find that the articles and addresses reprinted there speak for three decades of high-souled worrying on a remarkably wide range of subjects, from "Are we faced with the end of work as we have known it?" to "Is there a Jewish art?" and "Do we need a university course in alienation?"

In talking of these matters, Harold Rosenberg had in life a distinctive and unforgettable tone of voice. In print, his best sentences had an inimitable sound to them: a sound like gravel rolling around at the bottom of a sieve. He was by nature a conclusionist: a man who was at his best when rounding off a long argument in a single sentence. He did not excel at book-length exposition, and indeed he never attempted a full-length book. Many of his essays were, in effect, fine single sentences that he took a long time to elaborate. When he had a subject, a verb, and an object, and had either no wish or no opportunity to run on, he could be counted on for all that he had to give.

One or two instances of his powers as an aphorist will prove this:

> With the cult of masculinity put aside, maleness might have a better chance to develop in the United States.

> Scholarship is valuable for its own sake, criticism for what it effects.

> Uniforms and ideology are magical substitutes for thinking about the problem of political power. So are uniforms and anti-ideology.

> The mass demonstrations of the 20th century provide a paradigm of the two poles of modern creation: 'expressionism' and 'depersonalization.'

> Jewish passion...is hopelessly at odds with the neutral arrangements of good sense, but one may see in it some of the wonderful gifts of unreason by which great peoples and classes give life to what truly concerns them.

This last sentence comes from an article written in 1947 entitled "Letter to a Jewish Theologian." Rosenberg at that time had published a book of poems *(Trance Above the Streets)* and was shaping up as a heavyweight controversialist, but he had not attained anything like the almost universal celebrity that came his way after he published a manifesto called "The American Action Painters" in *ARTnews* in 1951. That article was a most remarkable document. Thomas B. Hess liked to have poets write for *ARTnews,* and showed no concern if they strayed far from the traditional clip-clop of exegesis. And the incantatory tone of "The American Action Painters" does indeed belong as much to poetry as to prose. Once again, a few samples will prove the point:

> At a certain moment the canvas began to appear to one American painter after another as an arena in which to act—rather than as a space in which to reproduce, re-design, analyze or 'express' an object, actual or imagined. What was to go on the canvas was not a picture but an event.

> With a few important exceptions, most of the artists of this vanguard found their way to their present work by being cut in two. Their type is not a young painter but a reborn one. The man may be over forty, the painter around seven. The diagonal of a grand crisis separates him from his personal and artistic past.

> The American vanguard painter took to the white expanse of the canvas as Melville's Ishmael took to the sea.

> In our form of society, audience and understanding for advanced painting have been produced, both here and abroad, first of all by the tiny circle of poets, musicians, theoreticians, men of letters, who have sensed in their own work the presence of the new creative principle.

> So far, the silence of American literature on the new painting all but amounts to a scandal.

Even in this fragmented state, "The American Action Painters" still impresses us by the depth of its conviction and the effort Rosenberg was clearly making to present the new American painting to people who didn't understand it, didn't respond to it, and didn't want to place it in any kind of cultural context that they could accept. He himself loved the art in question and had a near-genius for formulation; he was out to correct, once and for all, the bizarre injustice that he defined as follows: "The vanguard artist has an audience of nobody. An interested individual here and there, but no audience. His paintings are employed, not wanted. The public for whose edification he is periodically trotted out accepts the choices made for it as phenomena of The Age of Queer Things."

And he succeeded, insofar as the article is still, after twenty-eight years, a basic text to which people refer, even if they refer to it primarily in order to disagree. There were earlier articles—some of them very good indeed—by various critics on individual artists; but Rosenberg's was the mesmeric general statement. Hedge-hopping among his three chosen domains, he borrowed from social history, the history of ideas, and the history of art—and quickly made sense of it all. Rereading it, we see again his customary look, that of Michelangelo's Moses after a long night on the mountaintop.

This essay could have been simply a brilliant intervention of the kind that

in the past was made on behalf of a favorite painter by statesmen such as Clemenceau, economists such as John Maynard Keynes, poets such as Ezra Pound, philosophers such as Maurice Merleau-Ponty. But in Harold Rosenberg's case it was the keystone of a career that was to be made above all in the criticism of art on a regular basis. As such, it has some strange characteristics. No artist, for instance, is mentioned by name. No individual work of art is evoked. Even the enemy is not identified. It would be difficult for a novice to infer that the unnamed painters in question differed enormously from one another, either in their work or as human beings.

Harold Rosenberg went on writing about art for another twenty-seven years, and for eleven of them (1967–78) he was art critic of *The New Yorker*, with all that that implies in the way of space, freedom of action, and a presumably intelligent audience. He did not disguise the fact that in his opinion the state of art and the state of the art world had been in a continuous decline since the late 1940s and early 1950s. Not only did he go into high gear as a conclusionist—"The art of the sixties is not *worked*—it is *done* according to plan"—but he saw iniquity everywhere and set himself the task of rooting it out.

From this there sometimes resulted a rampaging unfairness that expressed itself in high-energy invective. Rosenberg was against everyone and everything: artists, curators, critics, collectors, dealers, museum trustees, and publishers. Looking around him, he saw "white-collar art" made by university graduates and acclaimed by curators who doubled as critics, teachers, and historians. ("Minimal art and so-called color-field paintings arise from the classroom in art-history and remain enclosed in it on principle.")

When Frank Stella was given a major retrospective at the Museum of Modern Art at the age of thirty-three, Rosenberg wrote of his "cocktail-lounge taste in color": "From the can't-go-wrong all-black paintings of his early period, he shifted to the seductive sheens of copper and aluminium paint, to the eloquent simplicity of unmodulated rust, yellows, and blues of some of his shaped canvases, and, finally, to the over-luscious candy-box lavender, salmon, lemon, lilac, and apple-green fluorescent hues of his 'protractor' series."

But Rosenberg's objection was as much moral as aesthetic: He just didn't believe that genuine art could be produced without the kind of struggle that his friends and heroes had gone through. The major artists Rosenberg knew had toiled hard and long in poverty and obscurity, and it disturbed him to see people just out of college become rich and famous with no outward effort and in no time at all. "The American, from Allston to Gorky, who searched for genuine art has been fated to spend half his life in blind alleys," he wrote. "Often it required a second 'birth' to get him out of them. One thinks of the radical break in the careers of Rothko, Guston, Gottlieb, Kline—a break with the decisiveness of a conversion. The indispensable qualification of the creators of American art has been longevity. Our national personification of the creative adventure has been not the genius in his teens, a Rimbaud or a Keats, but the 'good gray poet,' beard included, who wrote bad verses for Brooklyn newspapers until, in his early thirties, he heard the song of himself."

Harold Rosenberg never lost his intellectual curiosity. Given a text on art by a Frenchman such as Henri Focillon or a Welshman such as the poet-

painter David Jones, he could ruminate to great purpose. He was loyalty made flesh where his old admirations were concerned: Philip Guston and Adolph Gottlieb were the objects of memorable summations in *The New Yorker*. He was grouchy more often than not, but then he undeniably had to deal with many an idiotic pretension. When common sense was needed, he had it. But there are areas of human achievement in which common sense is not decisive, and sometimes his monumental put-downs were about as effective as describing Mikhail Baryshnikov as a man who makes his living by jumping up and down in time to a band.

Above all, Rosenberg in his later years dealt less with art than with the strategies of art. He did not so much fail to meet as flatly ignore the fundamental test of an art critic: his ability to analyze a given work of art in depth and at length. All true critics have excelled in this, and they continue to excel in it today. Rosenberg was a master tactician, a stern moralist, a veteran surveyor of the scene, and a cultural diagnostician of a high order, but he was not a critic. He was not, that is to say, a man who could focus on a single canvas, the way Meyer Schapiro focused on van Gogh's late painting of a wheat field or Leo Steinberg has lately focused on Picasso's *Three Women*. By that criterion— and in the long run it is the one that matters most—it was only intermittently that Harold Rosenberg was a critic of art.

# It's Not "Women's Art": It's *Art*

**The New York Times, 1983**

There are more good women artists in the United States than in any other country. This has nothing to do with the size of the population, or even with the overall number of women artists. It has to do with the quality of the work, but it also involves a social factor, a professional factor, a liberationist factor, and even (in one recent interpretation) a neurological factor. It stands for the demise of an ancient, cumbersome, and quite pointless distinction. There is no such thing as "women's art." There is just good art, and a great deal of it is now being made by women.

It is a matter of fact, and not of opinion, that in the New York of the 1980s shows by women artists have been just as rewarding, and just as widely remarked, as shows by men artists. This is as true of the museums as of the dealers' galleries. If one of the functions of art is to make trouble for the stuffed shirt, then that function could hardly have been better fulfilled than by Louise Bourgeois in the retrospective exhibition of her sculptures last winter at the Museum of Modern Art (which, by the way, has not always been ideally receptive to women artists). Miss Bourgeois has few rivals when it comes to looking into corners of the psyche that are normally kept dark, and she does it with a finality that can leave the observer gasping.

In the current show of recent acquisitions at the Modern Museum, paintings by Elizabeth Murray, Susan Rothenberg, Jennifer Bartlett, Pat Steir, and Katherine Porter have no trouble in holding their own. At the recent Whitney Biennial a film by Mary Lucier called *Ohio at Giverny* had an unmistakable poetic distinction. The distinction held firm in surroundings where competition was raucous, if not always stiff, and the viewer was continually distracted by passersby. In painting, Melissa Miller (born 1951) and in photography, Cindy Sherman (born 1954) made it clear at the Whitney that the supply of good women artists has by no means petered out. As for the Metropolitan Museum, it is very pleased with a painting by Louisa Chase that it lately acquired.

Women artists have had a very good play in the dealers' galleries, too, even if some of those galleries are bastions of a histrionic masculinity. Good art by women in the context of the galleries runs the gamut of age from Georgia O'Keeffe (born 1887) and Louise Nevelson (born 1899) to Marcia Dalby, twenty-five this year, whose sculptures of wire mesh and cheesecloth made so hallucinatory an effect both at Artists Space on Hudson Street and more recently at the Daniel Wolf Gallery.

There is no mistaking the undeviating candor that Alice Neel brings to the scrutiny of human beings (herself not excluded), the undiminished sense of wonder and amusement with which Marisol reanimates the art of portraiture, or the covert sleight of hand with which Jane Freilicher brings the outdoors indoors (and vice versa) in her Water Mill landscapes. Lists are tedious and not seldom unfair, but it has to be said that the look of New York in the 1980s has not often been as well monitored as by Helen Miranda Wilson, that Barbara Zucker has revived the sense of intelligent play in sculpture, and that Dorothea Rockburne once killed off the notion of art as something that called for a heavy, congested, self-evidently muscular paint structure.

Even those who most rejoice in these achievements find it hard to say what, if anything, they have in common. But insofar as I regard the experience of art as the highest form of adult education, I was struck by something that Dr. Lewis Thomas has to say in his latest book, which is called *The Youngest Science: Notes of a Medicine Watcher.*

As everyone knows, Dr. Thomas—known above all as the author of the best-selling *Lives of a Cell*—is one of the wisest men around. Somewhere in the book he says that "family education is something women are better at than men.... All the old stories, the myths, the poems comprehended most acutely by young children, the poking and nudging and pinching of very young minds,

the waking up of very small children, the learning what smiles and laughter are all about, the vast pleasure of explanation, are by and large the gifts of women to civilization. It is the women who remember and pass along the solid underpinnings of culture, not usually the men."

Cogent in itself, that seems to me to go some way toward explaining the fascination of what we learn from Georgia O'Keeffe about bones long bleached in the desert, from Louise Bourgeois about what she calls "the impulse to murder those one loves the most," from Helen Frankenthaler about the storm clouds of the heart, from the early work of Susan Rothenberg about the phantomatic properties of the horse, from Nancy Graves about the metaphoric hoops through which nature's odds and ends can be made to jump, from Jennifer Bartlett about the survival of hearth and home in circumstances no matter how daunting, and from Helen Miranda Wilson about the distillation of the eternal from the particular.

What Dr. Thomas calls "the vast pleasure of explanation"—and what writer will not envy him the phrase?—can operate directly, as it does when Isabel Bishop shows us a race of clear-browed young people who stride across campus as if they had nothing to fear from the future. It can be set off indirectly, as when Alice Aycock builds her cryptic architectures in the open air. It can tremble on the very edge of invisibility, as it does with Agnes Martin, and it can fill the whole room—walls, ceiling, floor, and the spaces in between—with an all-American vivacity, as it does when Judy Pfaff lets fly with one of her environmental pieces. It can survey the possibilities of human entanglement, from pillowfight to mayhem, as it does when Dorothea Tanning sets giant to tussle with giantess. It is as various as communication itself.

Many of the people mentioned have come up since the bad old days when women artists had at best an auxiliary identity and quite often had no identity at all. There were times when men thought of Georgia O'Keeffe as Mrs. Alfred Stieglitz, and the subject of many of his finest photographs. Lee Krasner was Mrs. Jackson Pollock. Louise Bourgeois was Mrs. Robert Goldwater, and the object of polite interest on the part of scholars who came to consult the distinguished art historian whose wife she was for more than thirty years. Elaine de Kooning was Mrs. Willem de Kooning. Dorothea Tanning was Mrs. Max Ernst. Henchpersons they were presumed to be; henchpersons they were expected to remain.

We have come some way since then, but the prejudice in question is not extinct. To this day a woman artist has to deal with prejudice from dealers, from the public, from men artists (and sometimes from older women artists as well). That prejudice may have somewhat abated, but it is still there. Crow may well be the daily diet of the woman artist in what is primarily a man's world. As one of the most gifted woman artists of our day once said to me, "I always hoped that those bastards would treat me as an equal, but now I know that they never will."

That attitude was not confined to this country. Even at its worst, the American attitude was never quite comparable to that of Auguste Rodin. Rodin was quite pleased to have as his student and mistress the sister of Paul Claudel, whom many people then thought of as one of the great French writers. But when he had had enough of her he turned her loose, and the fact that she

would end her days in a madhouse did not disturb him at all. No comparable case disfigures the history of American art, though once or twice it may not have been for want of trying.

Rare, nonetheless, in English-speaking countries was the woman painter who could rise above the problem of professional status with the equanimity displayed by Vanessa Bell, sister of Virginia Woolf, in the 1930s. "She seems more than usually cheerful," Virginia Woolf wrote to a friend. "She's taken her own line in London life; refuses to be a celebrated painter; buys no clothes; sees whom she likes as she likes; and altogether leads an indomitable, sensible and very sublime existence."

That particular kind of "sublime existence" has become somewhat easier to achieve in the last twenty-five years. Much is owed to the women's movement in general. Something is owed likewise to those members of that movement who have tunneled away within the art world itself. And because it is difficult to be a good artist at all, and doubly difficult to be a good woman artist in an art world dominated by men, it follows that the women who have made it are often of heroic stature. They are not people to tangle with, either. The man has yet to be born who could sass some of those great seniors and get away with it.

Overseas approval helped, too. People in London soon knew of the celebrated moment in 1952 at which Helen Frankenthaler took hold of the notion of stain painting and ran with it. To many an experienced European observer it was clear in 1962 that Louise Nevelson's was the most remarkable show of recent sculpture at the international Venice Biennale, just as it was clear at the Whitechapel Art Gallery in 1965 that in the paintings of Lee Krasner the great pounding rhythms of Abstract Expressionism had found themselves a new drummer.

Still, the decisive factor was beyond a doubt the ability of American women artists to come on as free and independent human beings, rather than as the tolerated appendages of men. This specific character has not been found elsewhere on anything like so large a scale. When given equality of opportunity, they were well able to take it. When denied that equality, they went ahead all the same, as Louise Nevelson did when she was just the daughter and granddaughter of timber merchants in Minsk, and as Lee Krasner did when she produced the early paintings that now look so strong and not a man in sight bothered to look at them.

Quite apart from the factors so far mentioned, there may also be a neurological factor of a kind not yet brought into the open. Dr. Lewis Thomas has something to say about that, too. "It is my belief," he says, "that childhood lasts considerably longer in the males of our species than in the females. There is somewhere a deep center of immaturity built into the male brain, always needing steadying and redirection, designed to be reconstructed and instructed, perhaps analogous to the left-brain center for male birdsong, which goes to pieces seasonally and requires the reassembling of neurones to function properly when spring comes. Women keep changing the upper, outer parts of their minds all the time, like shifting the furniture or changing their handbags, but the center tends to hold as a steadier, more solid place."

How about that, for something to think over on the beach? Rash as it may be for a layman to comment, there is undeniably about some of the women

artists I have mentioned a steadiness of development and a sense of pacing that contrasts with the career style of many a male artist, here and elsewhere. Nothing could be farther from that style, with its compound of aggressiveness and opportunism, than the development of Agnes Martin, or of Elizabeth Murray. As provocative ideas go, I rate that one very high.

# What Happened to Men?

**The New York Times, 1981**

Whatever happened to men? That question may have occurred to those who think that the two most compelling male presences that we have lately seen on the New York stage are those of Jack the Ripper, in Alban Berg's opera *Lulu* at the Met, and the Elephant Man in the play of that name. There are pleasanter people to look at when the curtain goes up, but those two are the ones that weld us to our seats. And they are, respectively, a mass murderer and a freak.

It's a strange business. Men were big in ancient Egypt, big in Greece and Rome, big in the Middle Ages, big in the Renaissance. You only have to look at the history of art to see that men were once the measure of all things. Their physical proportions were ideal (see Vitruvius). A man's brain could hold, unaided, all the knowledge there was. Our notions of wisdom, justice, regularity, and endurance were man-based, man-oriented, man-regulated. Great architecture was predicated on a man's reach, a man's height, and a man's stride. "Man-sized" was a compliment. "Manliness" was a digest of all the virtues. God had made man in His own image, and He had done a great job.

High art propagated all this whenever it could, and popular art was glad to take it up. There was no limit to what people would believe about men. If a head of state was spoken of as Stupor Mundi—Wonder of the World—no one laughed. If the young Albrecht Dürer painted himself as the most beautiful human being who ever trod the earth, no one reached for the word "narcissist." When Goethe died, people looked his body over and wrote home that even his feet were beautiful.

In the theater, playwrights fell over themselves to write great parts for men. If you were an English actor, you had Shakespeare to prompt you not only with Hamlet, Othello, and Lear but with the subsidiary parts—Enobar-

bus in *Antony and Cleopatra,* for one—that put the case for manhood in a way that can never be surpassed. If you were a French actor, you had Racine to give you the role of Titus, the most selfless of recorded emperors, and Corneille to give manhood a new momentum in *Le Cid.* If you were a German actor, sublimity was second nature to you, and you lived for the day when you would do better than the academics and crack the celebrated riddles of *Faust, Part II* by Goethe.

In the opera house, Giuseppe Verdi put the case for man as a moral being with a fervor and a fullness that we cannot imagine being bettered. In that context his Philip IV, face to face in his study with the Grand Inquisitor in Act IV of *Don Carlos*, is as compelling an image as we shall ever have. As for Tolstoy—a man's man, if ever there was one—he lavished on his favorite male characters an affection so heartfelt that it rises off the page like steam. Who can forget Vronsky riding his beloved horse in the steeplechase, or Levin working his heart out with his men in the fields? These were centered human beings, one and all.

But then, around a hundred years ago, man began to run out of manhood. Something of wholeness, something of assurance, something of reason, and something of proportion was lost. It was all very well for Friedrich Nietzsche in the 1880s to go on and on about the concept of the Superman, but the news from the front line, as transmitted by high art, was that man was in trouble wherever you looked. In *Tristan and Isolde* he was duped and doped. In Strindberg's *The Father* his own family put him in a straitjacket. In Richard Strauss's *Salome* he was served up on a platter, like a dessert, and in Ibsen's *Peer Gynt* he regressed into childhood. Stupor Mundi was out, all over the Western world.

He never got back in, either. By the time the nineteenth century turned into the twentieth, he was on the run, everywhere. Hamlet may have said of man that he was "in action, how like an angel!" and "in apprehension, how like a god!," but by 1900 what had really got to people was that Darwin had traced our descent from the apes, and that many of us seemed to be reverting, fast. Everything was under review: man's statecraft, his systems of belief, his ruthless behavior to subject peoples, his embroilment in industrial disputes that seemed to allow of no solution, and—not least—his attitude to women. If he had ever had a God-given mandate to run the world, it seemed that God had decided not to renew it.

Echoes of this state of affairs began to turn up in the arts with an ever greater frequency. Where male characters of mythical stature have been thrown up by the theater in the last few decades, for instance, they have mostly been men who were dealt a bad hand from the start and had no idea how to bluff their way out of it. We remember Willy Loman in Arthur Miller's *Death of a Salesman.* We remember the father and his two sons in Eugene O'Neill's *Long Day's Journey Into Night,* who are good for little but to tear one another apart. We remember the head of the household in Edward Albee's *Who's Afraid of Virginia Woolf,* as he slowly drowns in the sewer of his own invective, and we remember the pretty young man in Tennessee Williams's *Sweet Bird of Youth* as he is led away to be castrated.

The images that have remained with us from great evenings in the theater

and the opera house have to do, as often as not, with grown men brought almost to the discomfitures of babyhood. We remember Jason Robards cradled by Colleen Dewhurst in Eugene O'Neill's *A Moon for the Misbegotten*. We remember that remarkable singing actor, Kenneth Riegel, cradled by a no less remarkable singing actress, Teresa Stratas, in Alban Berg's opera *Lulu*. And we remember Donald Sutherland in Robert Redford's film *Ordinary People*, at grips with the realization that, as Vincent Canby put it in his review, "Recently achieved economic and social privilege is no defense against emotional chaos."

This is not of course a local phenomenon. We also remember the husband in Samuel Beckett's *Happy Days*, crawling around his wife like an earwig at the root of a lettuce. And in Germany, the homeland of sublimity, what a falling-off since the heroic wife in Beethoven's *Fidelio* got her husband out of jail and the whole town turned out for an exchange of lofty thoughts! We remember from our own day the not-so-heroic wife in Rainer Werner Fass-binder's movie *The Marriage of Maria Braun*. She got her husband out of jail, all right. But what did he do when he came home? He got himself a bottle of beer, sat in a chair in his underclothes, and watched a football game on television.

Anyone who looks closely at the ways in which we habitually present ourselves might well infer that modern man was oppressed by stresses that he didn't know how to contend with. He might also infer that in man's own self —so long the bastion of willpower, moral judgment, fortitude, and per-severance—he was necessarily divided. Freud told him that the odds were stacked against him in childhood. Marx and his followers told him that individual sensibility was a bourgeois fallacy and that in any case the impor-tant decisions were made for him by economic and political forces. D. H. Lawrence told him that ever since the arrival of syphilis in Western Europe the jig had been up for man as the untroubled lord of life. R. D. Laing in our own day told him that the nature of society was such that the connotations of "sane" and "insane" might as well be reversed.

Many of these observations were of course addressed as much to women as to men. Freud's patients included as many women as men. Marx knew per-fectly well that women were part of the labor force. D. H. Lawrence in his novels was aware of women in a way that still touches us by its immediacy and its depth of feeling. But from the very formation of the word "mankind" it is clear that men thought of the human race primarily in terms of men. It was men, not women, who fought the wars, did the exploiting of inferior races, locked out the workers, and gave women a terrible time. By the end of World War I there was a general predisposition to think badly of men as the governors of our destiny.

And they haven't done too well since. It was not simply for political reasons that people all over the world have lately been so glad to see the statues of dictators pulled off their pedestals. It was as if we just didn't want to have a man—any man—stand up there in bronze or marble and say, "Do as I tell you!". "Unhappy the land that needs heroes," said the poet and dramatist Bertolt Brecht, who had seen quite a few heroes come and go in his lifetime.

Sculpture is a good index, in that context. There are people in this country who can hardly get out of bed in the morning without buying a sculpture by

Henry Moore. In sixty years Mr. Moore has never been short of a new metaphor for the female body. But if the collector wants a metaphor for man, by way of a change, he had best look elsewhere. In World War I, Henry Moore himself did all that a man of honor can do, but the image of soldiering that has lately fired his imagination is that of the fallen warrior. And his warrior, once down, will never get up again.

The human images that have a large popular constituency in recent art have been of women: doughty and all-enduring in the case of Henry Moore, ample and placidly observant in the case of Auguste Maillol, bouncy and Sousa-esque in the case of Gaston Lachaise. Men shrank, meanwhile, until we came to hear Hamlet's "What a piece of work is a man" as ironical.

No matter how you look at it, there's no doubt which way is up. Men blew it. They blew it as statesmen, as thinkers, as managers and coordinators, and they blew it as lovers. The philosopher Bertrand Russell was a very clever man indeed, by any standards, but as far as posterity is concerned he blew it when he told his first wife not to bother educating herself on his account. ("You really need not trouble yourself about your degree of intellect," he wrote to her. "No woman's intellect is really good enough to give me pleasure.")

Clever women have known about that particular prejudice for a very long time. George Eliot for one got it exactly right when she wrote in one of her novels that "A man is seldom ashamed of feeling that he cannot love a woman so well when he sees a certain greatness in her: nature having intended greatness for men." But where it was at all possible to put off the undesirable day, men preferred not to acknowledge that women could have an autonomous greatness of their own, as distinct from one that was learned or reflected. What did that great poet and no less great preacher Dr. John Donne have to say about women when he got up in the pulpit of St. Paul's Cathedral in the year 1630? "Many times," he said grudgingly, "women have proxies of greater persons than themselves in their bosoms; many times women have voices, where they should have none; many times the voices of great men, in the greatest of civil or ecclesiastical assemblies, have been in the power and disposition of women."

That may have passed in the 1630s, with the authority of the Dean of St. Paul's to back it up, but in the 1980s it is as offensive to reason as it is to the climate of the day. The creativity of women in the 1980s is one of the incontrovertible facts of life. The older we are, the more we are likely to regret that part of our lives that was lived in a different climate of opinion. In that climate it was customary to laugh at Gertrude Stein for having tried to make—as early as 1906–8—what she called "a beginning of the way of knowing everything in everyone, of knowing the complete history of each one who ever was or will be living."

It was also customary to believe that the painter Sonia Delaunay was nursed along by her husband, the painter Robert Delaunay, and without him would have foundered in fashion design. There have been among women certain stupendous natures who survived the worst that our century could inflict upon them—Anna Akhmatova, the Russian poet, is the supreme example of this—but when older men look back today on their youth they are likely to remember talent after talent that had a good beginning, a sad middle, and an invisible end. Anyone who lately saw Vera Brittain's *Testament of*

*Youth* on public television may be assured that as a study of a young professional woman at odds with a man's world in England it was absolutely true.

In this matter, as in all others, we look to high art for timeless insights. In a beady and often surreptitious way, Henry James knew all that there is to know about men and women. We remember from *The Portrait of a Lady* that he could tell us exactly—step by repugnant step—how a gifted and intelligent young woman can be destroyed by second-rate men. But in general it is in the nature of great men writers—even the best of them—to shift the balance involuntarily in favor of their own sex. If this were not so, how is it that there are so few great parts in world drama for actresses who can no longer play young women? When a great part of this kind surfaces, as it does in Brecht's *Mother Courage*, we feel almost as if the collective will of womanhood were revenging itself on the past (and, in the case of Brecht, on someone who was particularly rapacious and insensitive in his treatment of women).

It may also be the case that the creativity of women now operates on terrain, and in terms, that have until now been considered the preserve of men. Looking at the two hundred and some drawings on a single theme by Jennifer Bartlett that are on view at the Paula Cooper Gallery, the visitor may decide that the achievement in question has nothing to do with what was once called "feminine sensibility." It has to do with the drive, the concentration, the power of self-renewal, and the gleeful thrust that it was once mandatory to call "masculine."

Another key example of this is *The Transit of Venus*, by Shirley Hazzard, which seemed to many good judges—in particular those of the National Book Critics Award—to be the best novel of the year 1980. Miss Hazzard is a very good storyteller, and (as in the evocation of her native Australia) she can sum up a whole society as well as anyone now writing. But what stayed longest with this reader for *The Transit of Venus* was something that we find in the great male aphorists of the distant past: insights that we bear away with us like iron rations in time of war. (Of one of the characters in her book she says that she "had discovered that men prefer not to go through with things. When the opposite occurred, it made history.")

From these and many other portents it seems to this particular observer that, no matter what men may have done, women are not going to blow it when they at last get to deal with men as free and equal spirits. There is just no limit to what can be done by gifted and perceptive women who want to treat the current situation of women as the current situation of men has always been treated by gifted and perceptive men. Why should there not be a female counterpart to Abel Gance's *Napoleon*, all fire and flame and soaring fancy? Why should we not have in music a late twentieth-century counterblast to that monsterpiece of male chauvinist complacency, Schumann's song cycle *Frauenliebe und Leben*?

Why should we not have a great woman architect? Why should we not find in all the arts the distinctive input of the New Woman (more compelling by far than Ibsen's or Bernard Shaw's) whom we meet everywhere in life but don't always recognize when we go to the theater or the movies or the concert hall or get the newest book from the stores? Even the imaginary exhibition of "Post-Masculine Painting," dreamed up not long ago by Lawrence Alloway, the art

historian, might have its place in this catalogue of possibilities, though it might harbor fewer surprises.

Mark you, prognosis is heady stuff. What is the maxim that first comes to mind in that context? "Among all forms of mistake, prophecy is the most gratuitous." Savoring those words, we note their masculine concision. We listen to their specific ring, which is that of a gold coin thrown down on the table by a man's firm hand. We hesitate, and we are right to do so. But who is it who actually wrote that sentence, and by doing so gives us pause? A great woman writer: George Eliot.

# Art Tells Us
# Where We Are

**The New York Times, 1981**

It is fundamental to the white magic of art that it does away with the nightmare of disorientation. Not only does art tell us who we are, but it tells us—or it used to tell us—where we are. And "Where am I?" is, after all, one of the most poignant of human formulations. It speaks for an anxiety that is intense, recurrent, and all but unbearable. Not to know where we are is torment, and not to have a sense of place is a most sinister deprivation.

We look to painting, to the novel, to the movies, and to the theater to relieve that deprivation. Poetry is likewise a sovereign specific: with just a line or two by Elizabeth Bishop, for instance, we can feel our way around Washington, and around Paris, and around the forests of New Brunswick as they look from the window of a bus.

Music works less directly upon us, though the harmonic system as it existed for several centuries can be read as a sustained metaphor for losing and finding our way. When Robert Browning wrote about "the C major of this life" as an image of health, vigor, and stability he knew what he was talking about. Just occasionally, too, music in the hands of a great eccentric can

operate in terms of place, as happened when Charles Ives wrote "Central Park in the Dark."

But what is being discussed here is the interlock of personality and environment. When that interlock has once been made vivid to us—as it is in play after play by Ibsen, for instance—we are like strayed travelers to whom someone has handed a compass. Experiences of that kind and that order are available all over our city, now as at every other time. Among movies now playing, four in particular come to mind: *Oblomov, Confidence, Breaker Morant,* and *Atlantic City.* In the bookstores, we can quickly verify that Elizabeth Bowen in her short stories—just republished by Knopf in a collected edition—has no equal when it comes to the evocation of London in the days when it was being bombed. And for the sense of place as it once operated in the European theater, we have a capital little show at the Cooper-Hewitt Museum of nineteenth-century German theater designs. Especially relevant, in that show, are the light-handed designs with which the audience for Ferdinand Raimund's classic *The Peasant as Millionaire* was given just enough to keep the imagination alert. We know at once where we are. We recognize the great Viennese town house sketched in a line or two—just as we recognize the garden filled with obelisks as one that could border the sloping terraces of the Belvedere. Even the stone faces near the roofline of the house stare down at us with a mischief that could only be Viennese.

In everyday life, Where am I? often gets a simple answer. On 36th Street, just east of Second Avenue, some kind person says, and with no more ado the questioner heads for home. But if the answer is Shea Stadium, and it's out of season, he starts to wonder in what state of amnesia he got there. And if no answer comes at all—why, then he experiences a breakdown of orientation and feels himself the archetypal lost soul, condemned to wander forever.

And he's right. Not to be able to tell one thing from another—to have no sense of place, in other words—is one of the nastiest things that can happen to us. Everywhere looked alike, the traveler says of a new country that he didn't care for. We couldn't find our way around, he says of Tokyo, where street names and street numbers are rare. On bright, broad, faceless boulevards, as much as in the "dark forest where the straight way was lost" that Dante evokes in the opening lines of the *Inferno*, we have trouble making out unless we have a sense of place.

It was always so. What was it that Sigmund Freud most dreaded when he was taking his ax to the dark forest of human motivations? "At that period," he wrote later, "I was completely isolated, and in the network of problems and accumulation of difficulties I often dreaded losing my bearings, and also my confidence." Bearings lost, and confidence lost: what could more succinctly define the ultimate in human disarray?

That is why we are trained to have a sense of place. From the moment of birth we are kept busy, orienting and being oriented. It is in a frenzy of identification that we seize upon certain vital concepts: "crib," "lap," "carriage," "food," "light," "dark." "Indoors" and "outdoors" come later, followed by a huge apparatus of codes cracked and conundrums happily resolved. We take it as the highest and most metaphorical of compliments when someone in later life says to us "You certainly know your way around."

But we cannot go everywhere, let alone be everywhere at one and the same time. That is where art comes in. We rely upon art, whether we know it or not, to fortify our sense of place and keep it in good trim. The great novelists help enormously, for instance, and time lies lightly on their definitions. No amount of computerization in Wall Street can stop Herman Melville, in *Bartleby the Scrivener,* from giving us a sense of that particular place. Paris has changed very much indeed since Gustave Flaubert, and even since Marcel Proust told us what it was like to visit friends for dinner. But what they have to tell us is still our best orientation when we step out of the elevator and press the bell.

What is true of this country, and of France, is true of other countries as well. Much of Munich was destroyed in World War II, but anyone who treads the parched grass in the Englische Garten at the stale end of summer will find an overwhelming rightness in the opening pages of Thomas Mann's *Death in Venice.* If Anthony Trollope were back among us today, he would hardly recognize either the England or the English of whom he wrote with such penetrating skill in the Palliser novels. But no matter where the tour bus takes us, we are likely to find that Trollope has still, against all the odds, an incomparable sense of place.

Painting helps, too. Before photography, before the illustrated newspaper, before the movies, and before television, it was the role of painting to make us feel at home in the world. The more attentively we look at the work of certain painters of the past, the more we wish that we could see as they saw. What would we not give to have, for instance, Carpaccio's eye for the detail of townscape, and Constable's eye for the how and the why of everyday life in the country, and the young Corot's way of making us feel that paradise was wherever he happens to be? As for the fall of light on an American croquet lawn, Winslow Homer got it once and for all.

Painting sharpened our sense of place in a documentary way—in the Netherlands in the seventeenth century, for instance—but it also did it in a coded, emblematic, and deeply emotional way. There was a delight in the vigor and the accuracy of human perceptions, but there was also a sense of regret, and almost of terror, at the fidelity with which the waxing and waning of any given scene mirrors the waxing and waning of our human affairs. In how many of those stone-cool Dutch church interiors is there not a memorial tablet fresh from the mason's yard! How often in the landscapes of Caspar David Friedrich in Germany, and of Fitz Hugh Lane in the United States, is there not a note of mourning, an unheard passing bell, in their perfectly calculated stillnesses! A sense of place may involve knowing not only where we are, but why we are there.

It was also a part of the message of painting that places are made up of people, just as much as they are made up of architecture and landscape. Wilderness apart, there is something downhearted, something basically stunted and abnormal, about a place with nobody in it. (Even Robinson Crusoe, most self-sufficing of men, felt better when Man Friday showed up.) George Stubbs—than whom no one was ever better at painting a horse—knew that a racecourse was nothing without its jockeys. Winslow Homer knew that a croquet lawn is nothing without croquet players, and Edward Hopper knew that the disinherited look of a rundown rooming house is all the more telling

when the guest of the moment is done for the day and stays home staring at the wall.

Among the accredited masters of European nineteenth-century painting, none had a keener sense of place than Edgar Degas. Not even in the great age of the French novel was there a writer who could more memorably set up a human situation than Degas. He missed nothing, forgot nothing, and got everything to fit together. But he had to work at it. "A good picture," he once said, "requires as much planning as a crime."

In this he was as far as possible from the nonchalance of the natural impressionist: the man who could sit down pretty well anywhere and get straight down to work. When Degas came to this country in 1872 to visit the branch of his family that had established itself in New Orleans, he was completely disoriented. Everything put him off—the glary light, the enigmatic folkways, the oddities of color, the non-European pace of life, and even the very profusion of new subjects that suggested themselves to him. It wasn't that he was "against" the United States, it was just that he couldn't make head or tail of it. He was in torment, and he couldn't wait to go home.

Yet it was this same famously difficult Edgar Degas who produced then and there one of the best pictures ever painted in America—and one of the most faithful to the spirit of place. *Portraits in an Office—The Cotton Exchange in New Orleans* has everything in it, not least the loose-jointed way in which American men of business stand or sit while waiting to strike a bargain. We come to know that bookkeeper, upright at his ledgers. We know those windows, open to the least puff of a Louisiana breeze. We know exactly the degree of professional conscience with which one man runs a handful of cotton through his fingers while others stand at ease.

Degas in this painting got everything right, down to the title of the newspaper, the feel of the heavily woven trash basket, and the stiff white cuffs of the men whose status entitled them to take their coats off in the heat of the day. That is what is meant by the sense of place—allied, in Degas's case, to a feeling for the thing that, when once done perfectly, need not be done again. And, of course, he never did do it again. After his six-week stay he went back to Paris, having said the last word about that particular aspect of American life.

Yet painting in the 1870s was already on the very edge of losing its historic function as the primary locus of our deepest feelings about the look of things. That function was being eaten into on every side—by mechanical engraving, by the mass-produced image, by the photograph in all its forms, and eventually by the moving picture. Photography in particular seemed to have everything in its favor. It was instantaneous (by the standards of the easel painter). You could do it anywhere. In its early days it had an element of surprise, and almost of the supernatural, that painting had long lost. It didn't take half a lifetime to learn, and it was a democratic art, one in which all began as equals.

Above all, people said, the camera did not lie. Born with a brevet of authenticity, it functioned as the original plain dealer in its negotiations with the visible world. "Top that!," photography said to painting. It was in photography, if anywhere, that the sense of place would henceforth find its home. They were not altogether mistaken, either. Walker Evans, for one, could point

his camera at a big-city stoop anywhere in the United States and come up with the quintessence of that place at that time. (He could wreak the same magic with a shop sign, by the way.)

As for the movies, they were predestined to see all and tell all. What medium could hope to compare with them when it came to telling us what we wanted to know about a named place? And if the movies could do that in black and white, how much better would they do it in color and on a gigantic screen?

These were colossal opportunities, beyond a doubt. It was within the potential of photography—so people thought—to put painting out of business, to make the printed word seem like a quaint survivor, and to exert over our thoughts and feelings a power without precedent. Besides, how can we lack a sense of place today when there is virtually no such thing as a part of the world that cannot be brought up on a screen? When Frederic Edwin Church came back from painting the Andes, one hundred and more years ago, he was making a contribution to knowledge as well as turning out a huge painting that everyone and his brother wanted to see. But now we have the Andes in the image-bank, along with just about every other place in the gazetteer. Our every whim can be satisfied, and our every appetite slaked. We need never lose our bearings, let alone our confidence.

On one level, that is. On the level of literal acquaintance and documentary charting we have a degree of orientation that even our fathers did not dare to dream of. But on the level of imaginative re-creation? That is another matter. The great paintings of the twentieth century are not concerned with the spirit of place to any significant degree, even if we can learn a great deal about the cultivations of the Nile valley from one or two small paintings by Paul Klee. The great music of the twentieth century skirts the spirit of place, likewise, even if there is in Bartok's *Bluebeard's Castle* a stupendous evocation of a broad, smiling landscape that defies the horizon to bring it to an end.

With one or two glorious exceptions such as these, painting and music are not the domains in which the spirit of place has taken refuge from the computer. The neat trick, and the definitive one, would be for the spirit of place to insinuate itself where—against all the forecasts—it has not fared too well: in the movies, above all. Was it not in the movies that our perceptions of place were to be reinforced, multiplied, and enriched? Yes, it was. But all too often the enriched perceptions in question turn out to be like enriched bread: spurious.

For seeing is not knowing, in this context, and where there is no imaginative re-creation we respond momentarily or not at all. Besides, we like to do some of the work. When Viola in *Twelfth Night* says, "What country, friends, is this?" and the Captain answers, "This is Illyria, lady," Shakespeare doesn't have to describe Illyria, but the very name sets our imaginations racing. But when we see film after film in which Berlin is the Wall, and Egypt is the Sphinx, the Great Pyramid, and the Valley of the Kings, and London is a few well-kept house-fronts, we tune out. The people have our attention, more or less, but the places do not. No matter how accomplished the cinematography, we notice the place as we notice the landscape in a cigarette ad, and with about as much credence. We believe when we are made to believe, in other words, and not otherwise.

What makes us believe is imaginative re-creation, on the one hand, and a

readiness to let us do some of the work, on the other. This particular capacity has made nonsense of nationalism by turning up in country after country throughout the history of the movies. At this moment Hungarians have it, in *Confidence*. Australians have it, in *Breaker Morant*. Russians have it, in *Oblomov*. In England it has lately nested primarily in series made for television, but in *Atlantic City* a Frenchman, Louis Malle, has persuaded environment and human personality to work together as only a true poet can. The spirit of place is alive and well in all these movies, but it is not brought to life in a literal, one-to-one way. The directors in question know that diamonds are to be used sparingly, not strewn around like jelly beans.

That is why we do not forget the hunted Jewish woman, in *Confidence*, who sits alone in a Budapest tearoom, surrounded by well-dressed people who would not hesitate to turn her in. That is why we remember how the huge, steaming, providential mushroom pie turns up in the snow in *Oblomov*. That is what holds us in the bandstand scene in *Breaker Morant*, when violence strikes from the veldt and the everyday life of a colonial town goes on just as usual. A poet has done the choosing, in every case, and trusted us to see the point.

It doesn't seem to matter, though in logic it might, that some of the places we most remember from movies are not what they pretend to be. In *Breaker Morant*, for instance, the veldt is not the veldt, and Pretoria is not Pretoria, since the movie was made in Australia and not in South Africa. Lifelong readers of *Oblomov* will not quite believe in the blue-and-white palace that appears to such stunning effect at one moment. It's beautiful, but it isn't right. Nor do we feel that Oblomov's apartment in the opening scenes of the movie is set, as the novelist tells us, "in one of those large houses which have as many inhabitants as a country town." But we accept the veldt as the veldt, and Pretoria as Pretoria, and the palace and the apartment as plausible, because we are having too good a time to stop and argue. We feel, in fact, about these discrepancies the way van Gogh felt about what people called his distortions: that when the emotional impact is right, what is "untrue" can be truer than true.

And that is, after all, what the spirit of place is all about. Gifted people say "This is Illyria, folks," and we clap our hands and ride along with them.

# Postmodern— The New Flower on Diction's Dungheap

The New York Times, 1982

The big new flower on diction's dungheap is four syllables long, blooms all the year round, and is omnipresent in discussion of new architecture, new art, new dance, new design, new music, and new theater.

It can be applied to a tall public building in Portland, Oregon, and to the future headquarters of Humana, Inc., in Louisville, Kentucky. Both of these are designed by Michael Graves. It can be applied to a teapot that looks like a combination of Gothic tomb and fringed Victorian piano leg (likewise designed by Mr. Graves), and to a piece of music by Steve Reich for unaccompanied clapping hands, a painting by Malcolm Morley in which camels bulk and bulge in ways unknown to zoology, a song by Laurie Anderson that might have caught the fancy of just one or two people but happens to be high up on the charts, and a dance piece by Charles Moulton in which very good dancers stand around and pass small rubber balls from hand to hand.

"Postmodernist" is the word in question, and if it means anything at all it has big implications. It suggests that there is no longer any such thing as modernism, and that a long series of historic achievements in every department of art has therefore come to a definitive halt. Those achievements include the poems of Stéphane Mallarmé, the later paintings of Paul Cézanne, the apparition in the theater of Gordon Craig and Vsevolod Meyerhold, the publication of Marcel Proust's *Remembrance of Things Past* and James Joyce's *Ulysses*, the intrusion upon traditional musical life of Arnold Schoenberg's monodrama *Erwartung* and the *Amériques* of Edgard Varèse, the *Cantos* of Ezra Pound, and the dance pieces in which Merce Cunningham gave us a new idea of what can be done on the stage. Hugely different as these things may be from one another, they have in common a shared intransigence that we recognize as fundamental to the modernist aesthetic.

Modernism is several things in one. It is a body of work—one that extends from painting and sculpture through architecture and design to music, dance, poetry, and the science of human nature. It is an attitude before life—one that believes that there is more to be felt, more to be known, more to be defined, and more to be expressed than has been formulated before, and that these are cumulative and continuous processes to which no limits need be set.

Modernism is, finally, an environment. Over the last hundred years it has penetrated every department of life in the developed world. Even those who cannot name a great painter, a great composer, a great architect, or a great poet from our century have been affected directly or indirectly by the achievement of modernism. To a degree not always acknowledged, modernism made us.

But in the past few years a new set of imperatives made itself felt. The thrust of those imperatives was not so much to counter modernism as to supplement it. What has been kept out of modernism—illustration, story-telling, a deliberate incongruity, aesthetic bad manners—is often fundamental to postmodernism. Huge, scrawly calligraphic images that mock the sobriety of high art turn up in postmodernist art in the United States, in Germany, and in Italy.

All across the board the new work has aroused responses that are often startling in their intensity. Laurie Anderson, for instance, is a young performance artist who for a long time worked as far as possible from the big-money, big-promotion world of pop music. You could hardly get farther from that world than by playing a violin in the street in Genoa, Italy, while standing in a box of ice. (When the ice was all melted the performance was over.) The songs that she sang in her little girl's voice were wisps and shards of sound and speech, as if she were the last person left alive in the world and was trying to remember how things had once been. But today, and with the help of a band, projections, and every kind of electronic support, Laurie Anderson holds huge audiences captive by touching a nerve that had not been touched before. That is what postmodernism is all about.

In painting, likewise, postmodernism has thrived by treading ground that modernism has ruled "off limits." Among its influences are bodies of work that were outlawed by modernism—the paintings in which Giorgio De Chirico remade and debased the visionary art of his youth, for instance, the deliberately awful paintings of Picabia's old age, or the images steeped in kitsch that Magritte produced during World War II. Whatever had an inscrutable motivation and a deliberately rough, unfinished, and generally provocative look served to stoke the fires of postmodernism. This was a generation that behaved toward the Old Masters of modernism as high-spirited prisoners of war behaved toward their captors—by making for themselves an alternative world.

Some of them won an instant celebrity of a kind which once again was the antithesis of the protective quiet in which so many of the Old Masters of modernism had lived much of their lives. There can be few readers of popular magazines who do not know by now of Julian Schnabel's studding of his canvases with pieces of broken china plate. The upside-down images of Georg Baselitz have likewise passed into popular mythology. Among the Italians, Sandro Chia stands out for the affectionate glee with which he takes the conventions of Italian Old Master paintings and turns them inside out. There

is in all this something of the fairground, as distinct from the hermit's cell in which Mondrian, for one, made his contribution to modernism.

Modernism taught us to see, to hear, to read, and to reason in ways unknown to our predecessors. Its achievements have always been difficult and demanding. They are still so today, no matter whether they are fifty, sixty, or a hundred years old or date from last week. There is no easy, fast way into the *Large Glass* by Marcel Duchamp, or into Anton Webern's late cantatas, the drawings of Jasper Johns, the text of Samuel Beckett's *Not I*, the string quartets of Elliott Carter, or the stories of Guy Davenport.

Even the villa in Vienna that was designed by the philosopher Ludwig Wittgenstein has a gaunt hermetic quality. (Looking at it, we remember how Wittgenstein was so sensitive in matters of proportion that he could detect an error of even one centimeter in the height of a ceiling without reaching for a tape measure.)

These are achievements that never give up their last secret. To come to terms with any one of them is a long, slow, exacting, and exalting adventure. They remind us that modernism in all the arts has been one of the supreme adventures of our century, and that like all such adventures it has the character of a sacred ordeal—or, as today's cant would have it, "a rite of passage."

We do not like to think no new adventures of this kind will come our way. Human nature has lived a long time with modernism and left us the better for it. We hate to think that modernism's particular brand of ardor has vanished from the world. We remember the dense, compact, inexhaustible achievement of Braque and Picasso before 1914, or of the layers of meaning that Marianne Moore, Elizabeth Bishop, the young Robert Lowell, and John Ashbery have lately coaxed from our language, or of the ways in which Roland Barthes renewed the very notion of reading.

We also remember what Samuel Johnson said many, many years ago— that "There are few things not purely evil of which we can say without uneasiness that *this is the last.*" "The secret horror of the last," Johnson went on, "is inseparable from a thinking being."

Quite apart from that, we are entitled to wonder if there is not in the very notion of postmodernism an element of that vindictive philistinism that now permeates so many departments of our national life. Is it not likely, we ask ourselves, that postmodernism stands for a dilution, a trivialization, an end of effort on our part, and an undemanding easiness and littleness?

Yet "postmodernist" is a word that won't go away. It changes weight, color, and direction according to who's talking at the time. It can be insult or accolade, hypothesis or statement of fact. It can close the door on all that we most love, and it can sign a long-delayed order of release. It can be thrown like a hand grenade, but also—and just occasionally—it can put an end to pestilence.

Among other things it stands for a free-stepping, unballasted approach. The impulse to get modernism off one's back may be a sign of juvenility or philistinism, but it may also be a sign of energy, independence, and freedom from intimidation. What is this country, after all, if not a place in which people can "make it new"? It was a part of modernism that, as Paul Klee once said, the

artist should make art as if no one had ever made it before. Looking at Malcolm Morley's recent paintings with that in mind, we may wonder if their very rambunctiousness is not a continuation of modernism by other means.

What we have to do is to distinguish between due reverence and paralysis. When we are confronted with one of the monuments of modernism we owe it to ourselves to say—as Robert Schumann said when he heard Chopin's Opus 2— "Hats off, gentlemen! A genius!" But we also owe it to ourselves to put our hats back on again and start work on whatever is right for us. If the German painter Georg Baselitz thinks that his images look better upside down, or if the American painter Robert Kushner doesn't stint with the sugar in his decorative paintings, it is because their natures demand it. It is for time to validate the results.

Meanwhile it is in architecture, the most inescapable of the arts, that the role of postmodernism has been indisputably benign. Architecture differs from poetry and painting and music in that it is a matter on which literally everyone has an opinion and everyone's opinion may have some weight.

The Emperor Franz Joseph of Austria-Hungary was no one's idea of an aesthete, for instance. But he did the work of a pioneer in this respect when he drove out of his palace in Vienna not long before 1914, got his first glimpse of an austere, unornamented facade by the Viennese architect and theorist Adolf Loos, and blew up. "Don't ever bring me this way again!," he said to his coachman. "That house is like a face without eyebrows." With these words did the old gentleman formulate the classic anti-modernist point of view. Buildings need eyebrows, he thought.

Loos was a major artist as well as a major innovator. He stood for the elimination of the superfluous in architecture. (He thought that the Bunker Hill monument in Charlestown, Massachusetts, was an absolute model in that respect, by the way.) He also thought that architecture was about happiness, and about the creation of an ideally congenial environment.

But insofar as any one style of building was accepted by laymen as "modernist" in the third quarter of this century, it was the monolithic, disornamented, impersonal, straight-up-and-down tall building that did indeed dispense with the superfluous, though in ways that grew ever more inhumane. It could find noble expression—above all in the Seagram Building by Mies van der Rohe and Philip Johnson—but in its derivatives it was the kind of thing that gave modernism a bad name. As the architectural historian Vincent Scully once said, "It looked as if the faceless boxes were going to take over everything, and they almost did so."

Here, if ever, was the time for a postmodern esthetic to change our lives for the better. And there were signs that it could be done. The taste for ornament came back with the Museum of Modern Art's Beaux-Arts exhibition of 1975. (The rendered drawings in that show were unforgettable for their elegance, their complication, and their felicity.) The architect Robert Venturi showed that there could be a place in architecture for fantasy, wit, and a vernacular idiom. The architectural critic Charles Jencks put it about that there was such a thing as a language of postmodern architecture and that enjoyment was fundamental to it. Before long, people got so that they would almost have eaten the restored Chrysler Building if it had been made of candy and been just a

little bit smaller.

It was around that time that the postmodern architect Michael Graves won the competition for a new Public Service Building in Portland, Oregon. It was as unlike a curtain-wall-and-mirror-glass building as it could possibly be. It had color. It had mythic monumentality. It mixed well with its neighbors and with the basic character of Portland, and it was prodigious in its richness of invention and allusion.

Vincent Scully wrote initially of "a gigantic piece of monumental sculpture (Portlandia), fiberglass swags at a colossal scale, and a whole Early Christian settlement on the roof" as characteristics of the Portland building. Thus far, it might have sounded merely spectacular. But now that the building is up, Professor Scully sees in it a triumph for postmodernism in its capacity as righter of wrongs.

"One is at home there," he writes, "as one never expected to be in a modern office building. It is neither reductive nor alienating in its effect. The eye slides over nothing. Everything is singular, important, a little dark, and not very large. It all celebrates the decent penury of municipal space, in shocking contrast to the empty luxuries of the commercial office buildings around it. It makes one proud to be decently poor; the word *citizen* takes on a special physical credibility. In this way the building brings some not-so-old but almost forgotten American traditions to life."

This is therefore a textbook case of the way in which good art can drive out bad art in such a way that a whole city may eventually be turned around. If the same were true of postmodernism across the board we could only clap our hands. But it isn't entirely true even of architecture, and it is anything but entirely true elsewhere. I long ago lost count of the flaccid and vacuous decorative paintings that go under the name of postmodernist art, just as I lost count of the regressive pieces of music, the inept and untalented specimens of dance, and the pseudo-experimental plays that travel on the same passport.

It is, however, very important in this context not to take up an either/or position. In every department of the arts, creative people move at their own speed. They do not go to pieces—and neither should we—when new names are touted around and new kinds of work engage the attention of people who are as attentive to new names as other people are to new hemlines. It is perfectly possible to be a major modernist today. Degas lived through the heyday of Fauvism and Cubism. Matisse lived through the heyday of Surrealism. In this country Edwin Dickinson lived through the heyday of Abstract Expressionism. So far from thinking that the world had turned upside down by the work of others, they went ahead at their own pace.

Theirs is a good example to follow in times when a combination of creative restlessness and hard-sell international marketing suggests that a whole new era in art is at hand. It is important to keep our heads and remember that a great many terrible artists claimed to rank as modernists and that one or two very good ones can be ranked as postmodernists.

Wassily Kandinsky was absolutely right when he said before 1914 that although the potentials for abstract art were virtually unlimited, bad abstract art would rank no higher than a necktie in the balance of human concerns. Anyone who knows the domains in question can make up an anthology of bad

modernist painting and sculpture, bad modernist music, bad modernist design, and bad modernist poetry that would cause even the strongest among us to run up the white flag. The great artist is the one who makes nonsense of all the labels and seems during his working career to gather to himself the very quintessence of art.

Meanwhile, just one word of advice. You can wait a long time for Anton Webern's Cantata No. 2 to turn up at Carnegie Hall. But if it ever does come up, listen to the opening words of the second section, and remember that Webern was writing in one of the worst periods (1941–43) in human history. The words that he set are as relevant to postmodernism as they are to everything else in life. "Stay deep down," the poem says, "for the innermost life sings in the hive." And it's not the name on the hive that matters, either. It's the staying deep down, and the way the honey tastes.

PORRET.

# VI.

## SOME EVENINGS
## ON THE TOWN

A brief spell as drama critic in London at the end of World War II left a lifelong infection, a longing to see the curtain rise, of which I have no wish to be cured. Many of the best hours of my life have been spent in theater and opera house, and from time to time in a ramshackle and disorderly way I have tried to pay off the debt. The list is lopsided—almost weirdly so—and not at all comprehensive. But this is what came down the pike in one context or another.

## Eugène Ionesco:
## A School of Vigilance

Le Rhinocéros, *by Eugène Ionesco. Paris: Gallimard, 1960*

**The Times Literary Supplement, London, 1960**

*At a time when the well-made full-length play was still the staple of the Parisian theater, Ionesco's early one-acters—*The Bald Soprano, The New Tenant, The Chairs—*had a freshness and an originality that were irresistible.*

The date was April 23, 1956, the newspaper *Le Figaro*, the pretext a revival of Eugène Ionesco's *Les Chaises*, the writer the most consistently successful of living French playwrights. "I do not know M. Ionesco," M. Jean Anouilh wrote, "and as a play of mine is running at the theater next door I have no personal interest in sending people to the wrong entrance. But," he said, "any Parisian who cares for the theater will one day blush to admit that he missed the chance of seeing *Les Chaises*...."

The tribute cannot be called prompt, since *Les Chaises* had been given its first performance in Paris just four years before. Nor was it unqualified, since M. Anouilh considered that the play was flawed, near the end, by "just a touch of outdated avant-gardism." Still, he ranked it as "better than Strindberg"; he held that it could be talked of in the context of Molière and not diminished; and even those who least like M. Anouilh's own plays must admit that the article was mightily effective in persuading *le gros public* that M. Ionesco was a writer of substantial and enduring stature. April 23, 1956, is, in fact, a date of

some consequence, almost midway between May 11, 1950, when M. Ionesco made his début as a playwright with *La Cantatrice Chauve,* and January 22, 1960, when his *Le Rhinocéros* took its place beside plays by Marivaux, Claudel, and M. Anouilh in the repertory of what was till lately the Théâtre de l'Odéon.

In England, where M. Ionesco is still regarded mainly as a short-winded saboteur, a "central European fantast with a flair for the macabre," this consecration may seem unduly rapid. But the first thing to be said of M. Ionesco's plays is that they really *work* in the theater. The late Robert Kemp, of the Académie Française, spoke scornfully in October, 1955, of "the small, the very small group for whom M. Ionesco is a *libertador,* a sort of theatrical Bolivar..."; but time has shown that that group is not so small after all, and that many people in many countries are glad to be liberated from the kind of experience which the theater has lately had to offer.

What M. Ionesco has to say about *la condition humaine* is, in fact, of much more than Parisian interest. In Düsseldorf, *Le Rhinocéros* sells out every time the Intendant likes to put it on. In Warsaw, where the two main characters appeared in workmen's overalls, *Les Chaises* struck as deep as ever. In Madrid, the Professor in *La Leçon* was taken by the audience to have local and political implications and the run was cut short by the authorities. The first performance of *Le Nouveau Locataire* was given in Swedish in a theater in Finland. In Haverford College, U.S.A., Swinburne and Tennyson stood in for Sully-Prudhomme and François Coppée in the coda to *La Cantatrice Chauve.*

In all this the professional dramatic critic has not been to the fore. What M. J.-J. Gautier wrote in *Le Figaro,* less than five years ago, now reads like a testament of imperception. Nor was he alone. What kept M. Ionesco's plays alive, as theatrical organisms, was not, therefore, any impulse of tenderness from the professional midwives; it was their own vitality on the stage. Much in them is superficially startling, outrageous, unaccountable, and strange; but the strangeness would not "tell," theatrically, if it did not relate to fears and longings deep-seated in human nature; nor would these intimations hold together as a coherent stage-experience if there were not somewhere in each play a substructure of classical technique.

M. Ionesco, though Rumanian by birth, is entirely French on his mother's side, was brought up in France, returned there in 1938 at the age of twenty-five, and has remained there ever since. His formation is, therefore, almost entirely French and it is not surprising that his mastery of dialogue can be traced back, through Courteline, Tristan Bernard, and Henry Becque, to Beaumarchais and Marivaux and, eventually, to Molière (the Molière, above all, of the shorter pieces which prefigure the special genius of music hall). Like M. Raymond Queneau, to whose delectable *Exercices de Style* M. Ionesco admits a particular affinity, the author of *Le Rhinocéros* has a gift of pure exhilaration which often causes the reader to lay the book down the better to laugh himself to the point of exhaustion.

Parody has in it a destructive element, and in some of M. Ionesco's plays the movement of the fun is so demonic as to suggest to some observers a Swiftian disgust with humanity. Certainly the portrait of family life in *Jacques ou la Soumission,* of police activity in *Victimes du Devoir,* and of the world of letters in *Le Maître,* would prove disquieting to that large section of

the French public for whom the Whiteoaks saga, Inspector Maigret, and the laureates of the Prix Goncourt are objects of reverence. But the energizing force behind these memorable episodes is not derision, as has lately been suggested, but pity: pity for the fact that relationships intrinsically honorable should be put either to evil uses or to no uses at all. M. Ionesco's plays are as displeasing, in political terms, to stalwarts of the Right as they are to stalwarts of the Left, and it is sometimes argued that, here also, he has defected from the prime duty of a writer, which is to communicate, and preached instead the futility of any attempt at communication between human beings.

The insufficiency of these judgments is the more remarkable in that M. Ionesco has been generous to the point of imprudence in dealing with his adversaries. His point is the *difficulty,* not the impossibility, of communication: and his plays, if rightly read, constitute a school of vigilance in human affairs. No one who has taken his work as it is meant to be taken will ever again accept the texture of everyday conversation at quite its apparent value, any more than they will take quite the same view of the functions of marriage, of family life, and of society as a whole.

M. Ionesco's plays are, in one sense, without precedent. Never before, that is to say, has a play hinged upon the inconvenience of having in the house a corpse that grows bigger every day, or the advantages of marrying a wife with three noses, or the delightful surprise in store for two strangers who discover in the course of conversation that they are husband and wife. But in emphasizing these things, and seeing M. Ionesco as a pioneer of "anti-theater," we lose sight of the fact that he belongs to a great European lineage, not merely as a theatrical craftsman but in the particular vision of human affairs which he wishes to illustrate afresh. The authors with whom he feels a particular affinity are not the destructive buffoons of the dadaist and surrealist movements but those whose basic theme is the fugacity and evanescence of human affairs: Proust, the Flaubert of *L'Education Sentimentale,* the Chekhov of *Three Sisters,* and even, impossible as this may seem in certain quarters, the Brecht of *Mother Courage.* "That play is, of course, an anti-war play," M. Ionesco once wrote, "but that is merely its secondary theme. Brecht takes the opportunity of the Thirty Years' War to show us, in a heightened and accelerated form, the destructive action of Time; but his subject is not the disintegration of our race by war, but its disintegration by time, and by the fact of existence."

These are dark sayings, and for those who look beyond the irresistible hilarity of many a favorite page in *Théatre I* and *Théatre II* there are many to match them. M. Ionesco's occasional writings also contain passages indispensable to the understanding of his plays; in July 1956, for instance, the *Nouvelle Revue Française* published a review of Sorana Gurian's *Récit d'un Combat,* in which M. Ionesco said:

> The world of the concentration camps, as described by Rousset, was not an exceptionally monstrous society. What we saw there was the image, and in a certain sense the quintessence, of the infernal society into which we are plunged every day. The nightmarish and odiously real society, already revealed to us by Kafka, is our real society, and it is dominated by fear, by that cruelly perfected form of egoism to which fear gives rise, and by the absurd craving for power.

These are the realities which M. Ionesco puts forward in his plays, inexhaust-ibly funny and diverting as they are for much of their length. These, and the existence among us of an "ugly, pointless hatred."

A favorite theme of M. Ionesco is the disintegration of everyday Man in the face of gratuitous, irresistible evil. In the short story which was the origin of *Tueur sans Gages,* this collapse is summarized in half a dozen phrases. In the play it is traced phase by phase in a long monologue which is, as the author says, "a little act in itself." In conjunction with many preceding indications that this is one of M. Ionesco's most deeply felt plays, it justifies us in seeing the *Tueur* as Part I of a message more immediate, and perhaps more urgent, than most of those which M. Ionesco has presented to us. There is the contrast, for instance, between the ghastly metropolitan area in which Béranger, the hero, has always lived, where "everything is damp: the coal, the bread, the wind, the wine, the walls, the air, even the fire," and the ideal city, the *ville radieuse,* which he thinks to have happened upon, no farther than a tram ride from his home. (The mirage of the *ville radieuse* occurs elsewhere in Ionesco: "Mirages...," says Béranger, "nothing is more real. Flowers of flame, trees of flames, lagoons of light, they are the only things that are really true, in the end...") And, as often when M. Ionesco's feelings are most deeply engaged, there is bound in with the action a passage or two from his private *poétique*—reflections lifted direct from his own childhood, or this meditation of Béranger's:

> "Inner world" and "exterior world" are improper expressions, in that there are no true frontiers between these two so-called "different" worlds. There is an initial impulse obviously, which comes from ourselves. When that cannot be externalized, when it cannot be realized objectively, when there is not the completest agreement between the inner and the outer self, then catastrophe follows, and a universal contradiction, and a breakdown.

And yet, even in this metropolitan Eden, where the word "hope" comes spontaneously to mind ("Hope is no longer a French word, nor a Turkish, nor a Polish...Belgian, perhaps...and even then...") the Killer is there, the wordless force, Hatred personified, before which Béranger's "correct" morality and textbook arguments collapse, one by one, until at last, in spite of himself, he finds arguments in the Killer's favor, drops his pistols, and succumbs.

Perhaps the Killer's knife had lost its sharpness; or perhaps Béranger is indispensable to M. Ionesco's expositions. He recurs, in any case, as a principal character in *Le Rhinocéros,* which we may consider as Part II of M. Ionesco's most urgent communication to date. This play is not, as has lately been said, "an attempt to write three full acts round the central theme of solitude." It is, on the contrary, a study of Trotter's "instincts of the herd"; and its argument is that there is no mutation, however monstrous, which society will not accept as normal once a majority of its members have been affected by it. Like most of M. Ionesco's longer plays, *Le Rhinocéros*—which is shortly to be performed in this country—is based on a short story. That story derives, in its turn, from an idea which first came to him in the middle 1930s, shortly after the rise of the Nazis to power. It is not, for all that, an anti-fascist, any more than it is an anti-communist, play. It is not a propagandist play in any sense; and yet he will be a brave man, or an insensitive one, who does not find, somewhere in *Le Rhi-*

*nocéros,* a message with his name and address upon it.

The play is an important one, also, in M. Ionesco's professional evolution, in that for the first time he draws near, in structural terms, to the "well-made" play. The flexible, seemingly arbitrary methods of his earlier plays are laid aside, and for the first time he has one plain theme (not plain enough, it would seem, for the professional critics of drama) and sticks to it throughout. Against the background of a small French town, laid in with his habitual mastery of high-comedy techniques, M. Ionesco places, in Act I, an unaccountable incident: an ordinary citizen changes into a rhinoceros. Initially the source mainly of a merely practical disarray (how to fill in an insurance claim, what to say to the metamorphosed man's trade union, and so forth), the incident is first duplicated, then multiplied, and speedily becomes an epidemic. Rhinoceritis is rife throughout the little town, and in the second scene of Act II, M. Ionesco shows us Jean, Béranger's best friend, in the very act of "going over," with his skin turning green and leathery, his tusk sprouting from his forehead, his speech turning into a rhino's grunt, and—here is the crucial point—his mind turning over in justification of the change. "We must go beyond morality.... Nature has laws of its own. Morality is contrary to nature. Once civilization is swept away, we shall all feel better. Let me no longer hear the name of 'man'! Humanism is out of date...."

By Act III we hear of a citizen whose last words as a human being were "We must move with the times"; we watch Béranger's beloved Daisy as she says, "We must be reasonable, we must find a *modus vivendi,* we must try to reach an understanding with the rhinoceroses"; and the play ends with Béranger in the position of the last man in the world in Thomas Hood's poem. He alone has not "gone over." He would like to, now, but he cannot; and so he barricades himself in with his carbine and, as the rhinos mass all around him, he cries out in the play's closing lines: "I am the last man, I shall remain a man to the end! I shall never capitulate!"

This last moment contributes directly to the dignity of man; but the truth is that all M. Ionesco's plays tend, however obliquely, toward the reconstitution of an honorable image of human nature, and of that nature in its relation with other natures. If they are a school of vigilance, as has been suggested above, they are also a school of self-knowledge. The human nature which M. Ionesco puts before us is girt round with enemies: hatred, treachery, and an ingenious, self-destructive conformism are the most obvious of these. The repertory of available experience is likewise of the blackest. "All that I have lived through has confirmed what I saw and understood in my childhood: pointless and sordid rages, cries stopped suddenly short, shadows vanishing for ever into the night...."

Yet it is not M. Ionesco, but his critics, who would seem to inhabit the "gibbering penumbra" of which one of them has lately spoken. His is, on the contrary, a world compact of intelligence, and invention, and language made new, and those "dreams, desires, moments of anguish, and obsessions which are part of an ancestral heritage, a deposit as old as our race."

# Nijinsky and Nijinska

Bronislava Nijinska: Early Memoirs, *translated and edited by Irina Nijinska and Jean Rawlinson, with an introduction by Anna Kisselgoff. Holt, Rinehart and Winston, 1981*

**The New York Review of Books, 1981**

*What was it really like to see Nijinsky on stage? Photographs tell something, but I almost prefer the word-pictures that were set down in old age by his sister, Bronislava. Those pictures are the most vivid, in a paradoxical way, for their very plainness and their technical exactitude. But then, from their childhood onward, Bronislava Nijinska was without equal as a witness.*

The early memoirs of Bronislava Nijinska have been highly praised, and rightly so. Even by the standards of the Russian nineteenth century into which she was born, they are remarkable for their charm, their substance, and their transparent integrity. They deal with a period in the history of dance that has yet to be surpassed for creativity. As autobiography, they impress by their modesty, their lack of malice, and their panoramic recall. As an index to the formation of the future choreographer of *Les Noces* (1923), *Les Biches* (1924), and *Le Train Bleu* (1924), they are clearly invaluable; and those three works are, after all, as fundamental to the dance history of their time as are the *paysages animés* of Fernand Léger to painting or the *Diable au corps* of Raymond Radiguet to the novel.

Bronislava Nijinska in life was too generous to resent it if people spoke of her as "Nijinsky's sister." She might not take it amiss, therefore, if I hazard that most readers will turn to her early memoirs primarily because they offer us— for the first time in the by now voluminous Nijinsky literature—a firsthand account of what Nijinsky said and did, on the stage and off, during the first twenty-five years of his life. When we close the book, we know him as never before. Nor can there ever be another book that tells us so much that is new, and

tells it with so evident a truthfulness and so little regard for the writer's own self. Bronislava Nijinska did not write this book to make herself seem interesting and important, but to set the record straight.

To say that we have been waiting for this book is not to decry the literature that has come into being since Romola Nijinsky's pioneering biography was published in 1933. Colleagues and friends of Nijinsky's, from Tamara Karsavina (1930) to Lydia Sokolova (1960), Michel Fokine (1961), and Marie Rambert (1972), have had their say. Richard Buckle's biography of 1971 laps us in a voluptuous eiderdown of detail. There are key events in Nijinsky's life— above all, perhaps, the first performances of *L'Après-Midi d'un faune* and *Le Sacre du printemps*—that we now know as well as many of the people who were actually there, so richly are they documented.

We also know—or think we know—what Nijinsky looked like in private life. Chunky in his person and oddly formal in his dress, he had none of the charisma that we find in the great male defectors of our own day. No Nureyev, no Baryshnikov he. No one was ever less "amusing" when asked out by strangers. No matter how we read and re-read the documents, they all say the same thing in the end: that for Vaslav Nijinsky the working life was the only real life, with human contacts as a pastime that was probably pointless, possibly dangerous, and in the end entirely destructive.

It would be unfair not to remark on what is perhaps the most remarkable single fact about the Nijinsky literature of the last fifty years: that when it comes to speculation about what Nijinsky actually did on the stage, our two most convincing witnesses are people who never saw him. Edwin Denby in 1943 and Lincoln Kirstein in 1975 worked from photographs, but we trust Mr. Denby's intuition absolutely when he says that "in the case of *Spectre,* the power of the arms makes their tendril-like bendings as natural as curvings are in a powerful world of young desire; while weaker and more charming arms might suggest an effeminate or saccharine coyness. There is indeed nothing effeminate in these gestures; there is far too much force in them."

We also believe Mr. Kirstein when he says of the *lezginka* that Nijinsky danced in *Le Festin* in Paris in 1909 that "it was not the imitation of a particular personage but the embodiment of a regional vitality." That particular insight is confirmed, as it happens, by the early memoirs of Nijinsky's sister Bronislava. She knew, as no one now living can know, exactly how, when, and where in his wandering boyhood Nijinsky mastered this or that regional dance. She was for many years the person who knew Vaslav Nijinsky best. And she knew, almost from the cradle onward, that people would think of her as "Nijinsky's sister." ("I cannot have two geniuses of the dance in one family," Diaghilev said.)

She herself had many admirers—did not Igor Stravinsky say of her in 1912 that she was a "fascinating ballerina, fully the equal of her brother"?—and she made a distinct mark even in a company that included Tamara Karsavina, Anna Pavlova, and Lydia Lopokova. In the early 1920s, when Vaslav Nijinsky had withdrawn once and for all from the world of the living, it was she who gave Diaghilev what he needed: new stage works of historic quality. But during the period covered by this book (1890–1914) it is primarily as Nijinsky's sister that she presents herself.

It takes a strong, unified, ungrudging nature to live in someone else's shadow and not resent it. If we do not protest Nijinska's subordination of herself, it is because we really do need to read what she has to say about Nijinsky, both on stage and in private life. We know how people were affected by his dancing, but what was it that he actually *did*, apart from jumping very high and seeming to stay there? No one tells us exactly, though Hugo von Hofmannsthal—no mean judge of performance—struck a new note when he told Richard Strauss that Nijinsky was "the greatest miming genius on the modern stage (next to Duse and, as a mime, greater than Duse)."

It is also true that we know remarkably little about what Nijinsky was like off the stage. Nijinsky in London and Paris was already a subject of universal curiosity whom people were "dying to meet." When met, he said little or nothing, picked his thumbs till they bled, and looked like a coachman on his day off. Diaghilev liked at that time to take him round the way other men take an ocelot around on a leash. He was famously uncommunicative, and for a good reason. Not simply was he a matchless performer, with all that that entails in the way of inward and outward preparation, but he wanted to change the whole notion of what could be done on a stage. What happened elsewhere— and we may guess that this applied as much to bedroom as to drawing room— was just an incidental nuisance.

Some people—among them Lady Ottoline Morrell—understood this. Others didn't. We do not need to believe Jean Cocteau when he says that Nijinsky was "a sort of middle-class Mercury, an acrobatic cat stuffed with acrobatic lechery." It is Bronislava Nijinska's account, and hers alone, that can help us to see Nijinsky not as an overdressed cipher in salons that bored him to distraction, but as he was in his formative years. Most biographers—and this applies even to Richard Buckle, who surpasses everyone in dedication to his task—naturally begin with Nijinsky's first arrival at the Imperial Ballet School in St. Petersburg in 1898, when he was nine years old. Was it not on that day that his professional life really began?

Undeniably that school to this day is very impressive. We tremble as we walk up those steps, pass in review those graduation photographs, and eavesdrop on classes that have changed hardly at all since Nijinsky was a student there. Mesmerized, we find it entirely conceivable that a student can walk into that school as nobody and walk out of it as somebody. All that he needs to know, he can learn there, surely. Guidance, comradeship, heroic emulation—all must be there for the asking.

Yet the truth is that long before he presented himself for admission to the Imperial Ballet School, Nijinsky was already Nijinsky. In fact, he was *born* Nijinsky: the son, that is to say, of Thomas Nijinsky, a dancer who on more than one count had quite astonishing gifts. A Pole, he performed across the length and breadth of Russia, causing astonishment wherever he went by his mastery of both classical and character dancing. Where other and much inferior dancers had tenure in this or that official company, Thomas Nijinsky lived from week to week and from town to town, like one of the street performers to whom Honoré Daumier had given a universal resonance. Set down in Tiflis or Baku, he did the *lezginka* better than those who were born to it. Taken to the Imperial Ballet School by his son and daughter as a privileged visitor in

vacation time, he got up without preparation and showed them—in Nijinska's words—"one dance after the other of a technical difficulty I had never seen before. To this day I cannot understand the mechanics of some of his dancing movements."

Thomas Nijinsky was in his forties at the time. His was a hardy, independent, improvisatory nature, and the security and continuity of life in a state theater meant nothing to him. Experience had taught him that, no matter how nomadic and precarious his existence might be, he would never quite starve. In this way Vaslav Nijinsky learned from infancy to think of dancing in all its forms as fundamental to Russian life. Classical ballet was a superior distraction, administered by court officials under the direct supervision of the imperial family. Dancing as such was something quite different: a necessity that cut across all considerations of class, education, and financial position.

For these reasons Nijinsky in his student days brought to his work an urgency, a sense of projection, a depth of experience, and a technical precocity that were quite out of the ordinary. They did not, however, endear him to his classmates. "Are you a girl, that you dance so well?" they asked him. Quite apart from the fact that in a general way all Russians despise all Poles, Nijinsky was small for his age and had none of the worldly ways that many of his fellow students affected. (Some of them thought it bad form to try too hard in class.) So far from finding in the Imperial Ballet School a source of exalted companionship, he was the victim of systematic hazing. (On one occasion, when he had been challenged to jump over a heavy wooden music stand, his tormentors soaped the floor from which he had to jump, and for good measure caught him by the ankle at the crucial moment. He fell, hit his head on the floor, and was taken to the hospital, unconscious, after the others had run away and left him for dead.)

In view of episodes such as this, and of his later medical history, it is important to say that Nijinsky was not one to give in easily. Fundamentally he had a vast and healthy appetite for life. There seemed no limit to what he could master when he set his mind to it. Bronislava Nijinska tells us for instance that he learned to play the accordion, the clarinet, the flute, the mandolin, and the balalaika without taking a lesson in any one of them. When he went to the opera, he could come home, sit down at the piano, and play through what he had heard.

There was no end to his energy. When in the country he ran, swam, fished, climbed, ran off with gypsy boys, crept out late, and got into every kind of scrape. He mixed easily—above all with circus people—and he had a free, ardent, and inquisitive nature. Only in his exaggerated fear of being punished does it seem with hindsight that some form of psychic disorder threatened him. His elder brother, Stassik, "went off his head," as people then said, around the year 1900. As against that his sister Bronislava was and remained all her life the personification of stability and good sense. But, as everyone knows, it was with Stassik, the sequestered invalid, not with Bronislava Nijinska, the lifelong worker and survivor, that Nijinsky finally sided.

Still, if the demons got him in the end, he gave them a very good run. On the stage there was never any question, whether in school or afterward, that he would set a completely new standard for male dancing. As is already well

known, Nijinska in these memoirs tells us exactly what he did on the stage. We need only a minimal knowledge of the syntax of the dance to see him, as she describes him, in his first appearance outside of Russia. We are in the Théâtre du Châtelet in Paris on the evening of May 19, 1909. Nijinsky has appeared from the wings in "a prolonged leap, *grand assemblé*," only to be halted by a huge outburst of applause.

> Suddenly, from *demi-pointe préparation*, Nijinsky springs upwards and with an imperceptible movement sends his body sideways. Four times he flies above the stage—weightless, airborne, gliding in the air without effort, like a bird in flight. Each time as he repeats this *changement de pieds* from side to side, he covers a wider span of the stage, and each flight is accompanied by a loud gasp from the audience.
>
> Nijinsky soars upwards, *grand échappé*, and then he soars still higher, in a *grand jeté en attitude*. Suspended in the air, he zigzags on the diagonal (three *grands jetés en attitude*) to land on the ramp by the first wing. With each *ralentissement* in the air the audience holds its breath.
>
> The next musical phrase is amazing for its dance technique—the modulation of the movement in the air, possible only for Nijinsky—executed on the diagonal from the first wing, *grands jetés entrelacés battus*.
>
> Throwing his body up to a great height for a moment, he leans back, his legs extended, beats an *entrechat-sept* and, slowly turning over onto his chest, arches his back and, lowering one leg, holds an *arabesque* in the air. Smoothly in this pure *arabesque*, he descends to the ground. Nijinsky repeats this *pas* once more, like a bird directing in the air the course of its flight. From the depths of the stage with a single leap, *assemblé entrechat-dix*, he flies towards the first wing.... He ends the variation in the middle of the stage, close to the ramp, with ten to twelve *pirouettes* and a triple *tour en l'air*, finishing with the right arm extended forward in a pose *révérence*. The *variation* has been executed from beginning to end with the utmost grace and nobility.

It is in this workmanlike and unrhetorical style that Nijinska details one after another of her brother's appearances. She also tells us how he worked at the *barre* and in his middle-of-the-floor exercises. Working at an accelerated tempo that allowed him to complete in forty-five to fifty minutes what would have taken another dancer three hours, he "seemed more intent on improving the energy of the muscular drive, strength and speed than on observing the five positions." (Anyone who has studied Rodin's little sculpture of Nijinsky in action can readily believe this.)

Certain other peculiarities emerge from her account: among them, that "in his *adagio* exercises, in the *développé* front, he could not raise his leg higher than ninety degrees; the build of his leg, his overdeveloped thigh muscles, as solid as a rock, did not permit him to attain the angle possible for an average dancer." And as to the celebrated leap, she has this to say:

> In the *allegro pas* he did not come down completely on the balls of his feet, but barely touched the floor with the tips of his toes to take the force for the next jump, using only the strength of the toes and not the customary preparation with both feet firmly on the floor, taking the force from a deep *plié*. Nijinsky's toes were unusually strong and enabled him to take this short preparation so quickly as to be almost imperceptible, creating the impression that he remained at all times suspended in the air.

Nijinsky never stopped working. When other students at the Imperial Ballet School were walking around the town with their hands in their pockets, he clenched and unclenched, hour by hour, the hand in which he held a black rubber ball. In this way he brought to an ever greater perfection the fluttery wrist-and-finger movements that he used in the "Blue Bird" pas de deux.

As the "Blue Bird" is so familiar to today's audiences it is of particular interest to learn from Nijinska of the way in which Nijinsky emended the original version. Dancing in London in 1911, he had Anna Pavlova as his partner. She was not the most generous of colleagues—Nijinska tells us that she once said, "I do not wish to see ovations being given to Nijinsky for a performance in which I too dance. Let the public that comes to see Pavlova see only Pavlova!"—but she did undoubtedly inspire him to surpass himself.

Nijinsky astonished the audience in London with the new technique he displayed in his *variation* of the *coda*, introducing a new step, *pas volé*, never seen before, in place of the series of *brisés volés* previously executed by the male dancer.

In the conventional *pas brisé volé* the weight of the body shifts from one leg to the other. Nijinsky felt that the movement of the body from side to side broke the impetus forward and impaired the thrust of the body upwards. In his new *pas* Nijinsky used a *grand battement balançoire* very effectively in combination with a *cabriole* (*en avant* and *en arrière*), and by developing a supreme coordination and synchronization of movements achieved a perfect balance of the body *en l'air*, rendering himself literally "weightless," high above the stage.

As to the dedication involved in feats of this kind, Nijinska has this to say: "During his school days he had been allowed to bring home barbells, and he had practiced with them during weekends and summer vacations until, while still a student, he was able to lift seventy-two pounds with one arm." While in Bordighera, ostensibly to rest, he went to a little room in the basement of his hotel that had a wooden floor and practiced there. "He would execute each *pas* or movement much more strongly than he ever would on the stage, thereby building up a reserve of strength so that, onstage, he could hide all the effort and tension required for his dances and make even the most technically difficult *pas* appear effortless."

He could have done all this and been no more than an incomparable gymnast. But what actually happened from the moment of his graduation performance onward was that he said something about the expressive potential of the human body that had never been said before. And what he created was not "beauty" so much as awe, stupefaction, and something akin to fear. Like the soprano soloist in Schönberg's second string quartet, he seemed to breathe the air of another planet. But, at the same time, he brought on to the stage a mysterious, unnamed, and entirely redoubtable *something* from the collective unconscious.

To do that is to bear a very great burden. Nijinsky in this was both favored and disfavored by his environment. There is a sense in which Diaghilev's Ballets Russes was the natural home of the new. There was a great company, there was great new music to work with, there was an enthusiastic international audience, and there were none of the petty interferences that officialdom brings with it.

For Nijinsky the performer, the change from the Maryinsky Theater in St.

Petersburg to the Diaghilev company was virtually all gain. For Nijinsky the aspirant choreographer the comparison could hardly be mooted, for it is inconceivable that *L'Après-Midi d'un faune*, *Le Sacre du printemps*, and *Jeux* would have been accepted by the Imperial Ballet. It is thanks to Diaghilev that the history of ballet now sometimes seems like a garden in which Nijinsky stands at the end of every *allée*. It was thanks to Diaghilev that Nijinsky was able to bring to ballet what Lincoln Kirstein calls "a new intensity of psychological characterization" as well as the unprecedented technical accomplishment of which his sister writes. It was thanks to Diaghilev that in a mere four years (1909–13) he who had been simply a stupendous performer became the originator of dance languages as radical as any that the avant-garde has produced since.

Bronislava Nijinska is as lucid, and as convincing, on the subject of Nijinsky's own ballets as she is about everything else. As on all other occasions, she is the complete workman, to whom fancy phrasing is alien. (It is left to Edwin Denby, writing in 1943, to say something definitive about the dance language of the *Faune*: "In *Faune* the space between the figures becomes a firm body of air, a lucid statement of relationship, in the way intervening space does in . . . Cézanne, Seurat and Picasso.") Nijinska keeps to specifics, here as in all things, and anyone who cares for dance will marvel at the way in which Nijinsky could invent and carry through three entirely different new idioms at a time when he was performing one arduous role after another on the stage.

No man can carry so great a burden if he feels unconfident of the conditions in which his work is going forward. Diaghilev could be uniquely "supportive," in today's language, but he was also volatility made flesh. With an unsubsidized company to pay for, with colleagues who thought only of themselves, and with a nature that thrived on intrigue and mischief, Diaghilev had at any given time a hundred things on his mind, of which ninety-nine were irresoluble. Nijinsky by contrast thought of only one thing at a time, and if Diaghilev wavered at any point it seemed to Nijinsky that the earth was opening beneath his feet.

There was also, of course, the sexual matter. Where that is concerned, Nijinska preserves a nineteenth-century reticence. If she thinks that Nijinsky was a "normal" man destroyed by homosexual intrigues, she never says so. If she thinks that he was fulfilled by homosexuality, only to be destroyed by the revisionist embraces of his wife, she never says that, either. In fact she never says anything directly on this subject, forthright as she is in everything else. If Nijinsky's friend and protector Prince Lvov gives him a gold ring set with a large diamond and "at least twelve pairs of elegant shoes," handmade by the best shoemaker in St. Petersburg, she makes no comment, any more than she does when Nijinsky stops wearing that ring and begins to wear another ("a massive, new platinum ring with a sapphire, from Cartier") that he had been given by Diaghilev.

In general she does not suggest that Nijinsky had any marked sexual drive in either direction, let alone in both. In this, as in so much else, he was brutally teased by his fellow students. His first flirtations were broken off, for one lofty reason or another, and when he was finally persuaded to go with a prostitute he was at once infected with disease. As late as 1912 he said to his sister that if he

ever married, it would be with one of Gauguin's girls from Tahiti, so that their children would have beautiful brown skins. Neither in his diary—admittedly a dubious source—nor anywhere else does he seem to have been other than passive and acquiescent in his relations with men.

But Nijinska does say that "with Diaghilev and his entourage, it seemed to me that Vaslav was never himself." And since she alone could crack the code of his famous silence it seems probable that a good deal lies behind that remark. "Vaslav seemed so much freer and more relaxed in his conversations with us in Monte Carlo, away from Sergei Pavlovitch," she also says; and although nothing but catastrophe came of his attempt to break away from Diaghilev and set up a company on his own, we sense that Nijinska felt an overriding delight in the idea that her old, happy, easy relationship with her brother might one day be resumed.

It is difficult to read a life of Nijinsky without a sense of overwhelming oppression as the narrative nears the thirty years' death in life about which nothing consoling can be said. If the early memoirs of Bronislava Nijinska are not oppressive in that way, it is because they are not "a life of Nijinsky," but a double portrait of an exceptionally full, rich, and trustful relationship. Quite apart from that, they remind us implicitly that although we shall never know what Nijinsky's *Sacre du printemps* was really like, it is still possible to reconstruct Nijinska's *Les Noces*, which in its way is no less remarkable as an evocation of ancestral Russia. And although we shall never see *Jeux* as Nijinsky conceived it, we have Nijinska's *Les Biches* to show that as early as 1924 ballet could refer to modern life and modern ways as freely and easily as Nijinsky had hoped for when he saw Duncan Grant and his friends playing tennis in Bedford Square.

For *Les Noces* and *Les Biches* and for much else besides, we must hope that the editors of this book are at work on "The Later Memoirs of Bronislava Nijinska."

# Hockney and Tristan

The New York Times, 1987

*That Hockney should design Wagner's* Tristan and Isolde *might have seemed a very curious idea. But in reality, and thanks in part to a revolutionary if not always reliable lighting system, the Los Angeles production made new sense of scenes (the end of Act III, above all) that often make us hang our heads.*

Three weekends ago, in a large rambling house high up in the Hollywood Hills, a party of three sat before a model theater. Built to a scale of 1 to 12, it mimicked exactly the Dorothy Chandler Pavilion in Los Angeles, complete with proscenium, flies, and a keyboard for the lights. The house was the home of David Hockney—painter, draftsman, printmaker, photographer, and stage designer—and the party of three had driven up from Santa Monica for a run-through in miniature of a new production of Wagner's *Tristan and Isolde.*

It will be a production unlike any other. Zubin Mehta, back for the occasion with the Los Angeles Philharmonic, which he led from 1962 to 1978, has never before conducted *Tristan* in the United States. Jonathan Miller, the English stage director, who has as many provocative ideas in his head as a camel has fleas, has never directed an opera by Wagner. David Hockney has in mind for the stage pictures an entirely new blending of color and light, constructed scenery (as opposed to painted flats), and flexible space.

One of the many unexpected things about David Hockney is that he has matured into a stern moralist, a polemical orator who excels in deflating cant and humbug at town meetings in Los Angeles, and an artist who sees the depiction of space as far more than a technical device.

"I think," he said recently, "that the way we depict space has a great deal to do with how we behave in it. When people go on about 'exploring outer space,' I tell them that we're in outer space already, if we know what to do with it." What he wants, on the stage as elsewhere, is space in which we can walk around corners in, as distinct from the regimented single-point perspective that Canaletto, for one, relied upon.

"You'd have to be an old bore not to enjoy Act II of Zeffirelli's production of *La Bohème* at the Met," Hockney said. "He makes it just what it is—a story of warm hearts in a cold place. But his space is literal space. What I want is to chop up space, and in *Tristan* we're going to do it."

The flexible space in question will be made possible primarily by an automated lighting system called Vari-Lite. Initially devised for use at rock concerts, Vari-Lite is said to allow a multiplicity of palette, a freedom of control, a degree of precision, and an instantaneity of response that have never been achieved before. As to that, the party of three could not judge, in that it would not be until the production got into the theater five days before the opening that David Hockney's ideas for *Tristan* could be tested on site.

But even with a rudimentary console and a restricted palette, there was no mistaking the ease with which space could be shaped and reshaped by color and responses fine-tuned to a fraction of a second. Color combinations pre-

viously unattainable can be summoned up at will. More important still, whole sections of the scene can be metamorphosed. Others can be made to vanish. Great trees can be whisked out of sight. The very nature of "scene-changing" no longer has its old meaning.

"At the end of the nineteenth century," Hockney said, "you could have thirty or forty men up in the flies, manipulating the lights. You couldn't afford that today, even if you wanted to, and with these new techniques you can do a hundred times as much by just pressing a button." Wagner's *Tristan and Isolde* needs just that reshaping, and just that instantaneity of response, if it is not to have once again the static quality that people have complained of ever since it was first performed (in soft, pearly gaslight) in Munich in 1865.

Outside, on that evening three Sundays ago, night fell. The room grew dark. On the stereo system, the prelude to *Tristan* came up from nowhere. (Carlos Kleiber's recording, with the Dresden State Opera Orchestra, was used.) The ambiguous altered diminished seventh in measure three wrought its habitual magic. So did the moment, not long after, that caused the French composer Camille Saint-Saëns to keel over in a faint when he first heard it at Bayreuth. This is music that cannot fail in the theater.

But when the curtain goes up, with four hours' traffic ahead on the stage, how often do we not remember what Richard Wagner said to his sometime friend, the philosopher Friedrich Nietzsche, when he learned that Nietzsche was going to hear *Tristan* for the first time? "Settle into your seat, put your glasses back in their case, and listen to the orchestra" was the composer's advice.

That is the paradox of *Tristan*. Wagner left stage instructions that are as detailed as they are precise. But there are long stretches when nothing happens, in conventional terms—more than three minutes after Tristan and Isolde have drunk the potion in Act I, for instance, and what seems to some people an eternity when King Marke pours out his heart after he has surprised them at their lovemaking in Act II. There are also moments at which all too much happens in a moment or two and the action on stage looks abrupt, perfunctory, and unthought-out.

When *Tristan* was first given in Vienna in 1883, even Eduard Hanslick, the foremost critic in town (and no friend of Wagner), had to admit that he had followed "the incomparably colorful, imaginatively interwoven line of this remarkable orchestra with excitement and often with admiration." But, he went on, Wagner forfeited all sense of true drama at the close of Act II, when "he avoids any kind of ensemble and fills the stage with deaf and dumb figures who take no more part in the shattering events than the park benches around them."

This dilemma has yet to be completely resolved. From the earliest stage designs—so touching in their fidelity to fact—to the majestic, uncluttered abstractions devised for Bayreuth after World War II by Wagner's grandson Wieland, productions of *Tristan* have left the ear overwhelmed and the eye on the edge of starvation. Is it possible that David Hockney will realize *Tristan* completely in its visual aspect?

"Show us!" his detractors say. Hockney at fifty has something of the reputation that he had at twenty-five—that of a minor poet of the poolside life,

a human sundial who blanks out all but the blissful hours. Who is he, some people say, to tackle one of the supreme human achievements and walk in step with what Wagner's biographer Ernest Newman called "a brain of the rarest and subtlest composition, put together cunningly by nature as no musician's brain has been put together before or since"?

As a matter of fact, Hockney has many of the qualifications. In the theater, as in life, he is clear-headed, straightforward, knows his own mind, and can get through to audiences no matter how large. Anyone who can draw 270,000 visitors to an exhibition of stage designs, as Hockney did in Mexico City, has to have done something right.

We know from *The Rake's Progress* (1975) and *The Magic Flute* (1978) at Glyndebourne in England, and from *Les Mamelles de Tirésias, L'Enfant et les Sortilèges,* and *Oedipus Rex* (all in 1981) at the Metropolitan Opera that Hockney the stage designer combines a sense of historical style with a sense of wonder and awe, a total practicality and the heavy duty good sense that are associated with his native Yorkshire in England.

And, unlike many artists who are successful even in their student days, he has never stopped growing. In his sets for *Tristan*, the manipulation of space relates to a late seventeenth-century Chinese scroll about which he recently made and narrated an hour-long film. Though a lifelong champion of freehand drawing from the model, he is fascinated by recent developments in commercial copying machines. (One such machine played a part in the designs for *Tristan*, by the way.)

His sets for *Tristan*, he says, are "both the most abstract that I've done, and the most realistic." The ship, in stage terms, is a real ship. Isolde's sofa on board in Act I is a real sofa, built in Saratoga, N.Y., to Hockney's specifications. The castle in Act II is a real castle, with moat and battlements, though it is pulled out of shape by Hockney's impatience with traditional fixed-point perspective. The forest in Act II is a real forest, too, even if its foliage owes more to Celtic ornament than to botanical precedent. Tristan's castle in Brittany is a real castle, set in a real Breton coastline. The costumes—all in velvet, to avoid reflected light—are adapted from a fourteenth-century source.

Altogether, Hockney is more faithful to Wagner than almost any designer in living memory. "Everything that Wagner asks for, you'll get," he says, and he means it. But how to manage the mercurial transitions of which Wagner was past master? How to get round the stiff predictability of sets that declare themselves at curtain rise and will be there till curtain fall? How to manage the last scene of all, in which almost all the characters have to sham being dead while the orchestra lifts off on to a plane rarely matched in music?

It is no small problem. After Isolde has said her last word and sinks, "as if transfigured," on to the lifeless body of Tristan, there follows a long minute (65 seconds, in the Kleiber recording) for which no one has found the right visual equivalent. What we hear from the pit is sublime, beyond either measure or expectation, but the group of people down front lie around like sedated picnickers.

"It's difficult, all right," Hockney said. "We did ten versions before we got one that seemed right. It can't be done quicker. We were seven months on this model here. My fee ran out after four weeks, so I suppose I've been subsidizing

it all. But I've come to take rather a Wagnerian attitude to money. 'Money? Who cares about money?' Besides, it's not just new technology that makes things better. It's *love*."

As to what love has done with this *Tristan*, this visitor is sworn not to tell. But let it be said here that if Vari-Lite delivers what it has promised, David Hockney will be able to build space, re-order space, abolish space, and make it new, all over again. Who knows? If Wagner could see it, it might make him get on the line to Nietzsche and say, "This time, Friedrich, keep your glasses on."

# Rachmaninoff as Songbird

**Programme notes written for Zaidee Parkinson, 1979**

*People today despise Rachmaninoff as a composer. Few of them, at this date, can have heard him play. But as a songwriter—or so it seems to me—he was in an odd, complex, fascinating class of one.*

Songs and singing were very important to Rachmaninoff, and his involvement with them began very early in his life. (When his short-lived sister was only sixteen years old she developed a fine contralto voice with a timbre that was not quite like anyone else's, and his family later remembered with what a total absorption Rachmaninoff would listen to her.) For much of his life he knew great singers and thought of singing and songwriting in terms of their individual utterance. It was with a song (*Fate,* op. no. 21) that he pulled himself out of a long dry period after the failure of his First Symphony in 1897. It was with that same song that he and his great friend Fyodor Chaliapin hoped to win the good opinion of Leo Tolstoy. (That was in 1900. Tolstoy heard them out, sat silent in a corner for some time, and finally rushed across the room and said, "I really must tell you, I simply *have* to tell you, that that was a very unpleasant experience indeed.") Throughout his life, and still today, his public craved a big romantic statement from a big romantic orchestra; but for Rachmaninoff himself the songs were coded messages from a world of feeling that he did not care to convey more directly.

His songs differ from those of most other substantial composers in that he never hesitated to let the piano go its own way. The piano part in Rachmaninoff's songs has a freedom and a momentum of expression that quite often make it the dominant partner. When he was arranging in 1906 for the first performance of his op. 26, he asked that the lyric tenor Leonid Sobinov (whom he greatly admired) should be warned that in one of the songs at least "it is not he who must sing, but the piano." "As for the accompanist," he went on, "I must say that his part is more difficult than that of the singers."

The songs that make up op. 26 were composed in the Russian countryside in the late summer of 1906, after a long, dismal, invalidish sojourn in Florence. Rachmaninoff made no claims for them—"insignificant things," he wrote, "on which I worked regardless of their merits"—but we are entitled to disagree with him. In *The Ring* we recognize, for instance, not only the incomparable pianist who allowed himself an ecstatic burst of expression halfway through the song but the operatic composer who was hypothesizing one project after another. (One of them, an operatic version of Chekhov's *Uncle Vanya,* is commemorated in another of the op. 26 songs: *Let Us Rest,* of which the text by Anton Chekhov is taken directly from Sonya's final speech in *Uncle Vanya.*)

In listening to *The Ring* (Rachmaninoff's, not Wagner's) we also remember that Rachmaninoff had an exalted notion of what could be done with vocal music that was half-song, half-declamation. He had Chaliapin in mind, then and always, but he also identified with the tradition exemplified by Felia Lhitvinne, the great singer who had learned from Pauline Viardot, the beloved of Ivan Turgeniev, who in her turn had learned from Manuel Garcia. He never had to make do with second-rate exponents of a second-rate tradition. What he had at his disposal, and what fired his imagination, was great singing over the whole gamut of human possibilities, from soliloquy in which every inflection heightened the language to the incorporeal lofting of his wordless *Vocalise.*

There was also the pleasure—almost everywhere evident in his songs—of dealing with forms that were quite unlike those of concerto, symphony, or opera. Rachmaninoff enjoyed setting a scene with just one vivid phrase on the piano. He enjoyed epitome: where the burden of the singer's part could be summed up in just one unpredictable outburst, he found the right notes for it. He enjoyed it when the imaginative energies implicit in the piano part could be allowed their own way even in the middle of a song, and he enjoyed it very much indeed when those same energies (see "On the Death of a Linnet") could be given untrammeled expression after the singer had had her say.

As to the choice of a text, he knew exactly what he wanted in the way both of length and of source: "Authors may be living or dead—it makes no difference!," he wrote in 1912 to Marietta Shaginyan. "But the poem must be original, and not a translation, and not more than eight or twelve lines, or at most sixteen. Also, they should be sad rather than gay: it does not suit me when things go too well."

Rachmaninoff had a conservative taste in poetry. In his two later series, op. 34 and op. 38, he ventured onto what was distinctly a twentieth-century terrain, but he did it as one who liked (as he said himself) to be pushed, rather than to go of his own accord. In op. 38, he was pushed in particular by his feelings for Nina Koshetz, the singer for whom he cherished an affection that

sent him scurrying back, just in time, to the safe harbor of matrimony. Rachmaninoff's career as a songwriter can be seen as one long prelude to his brief (1915–17) association with Nina Koshetz. Madame Koshetz was the apotheosis of certain things that he admired beyond measure. These included the dramatic power of Felia Lhitvinne, who had been her teacher; Stanislavsky's way with great literature (Stanislavsky had directed Nina Koshetz in a production of *Eugene Onegin* in 1912); and an extreme sensitivity to verbal inflection. It was thanks to her, primarily, that Rachmaninoff broke out of the enthusiastic but extremely conservative view of poetry that he had had since his first youth and took some note of what was being done in the second decade of the twentieth century. She was nearly twenty-five years his junior; he recognized in her the continuation of a great Russian tradition; and in the songs that he wrote for her the piano part has a prodigality of resource that goes way beyond even the precedent that he had set for himself as early as his op. 4. When the voice part comes to an end in a song like "Daisies," for instance, the piano part takes on a new lease of life—not in rivalry, but from a wish to stay within earshot of enchantment.

Nina Koshetz was no longer young when she made her recordings, but we can still hear in them the qualities that Rachmaninoff prized so highly. In dramatic moments she was grand, but never squally; in matters of nuance she was immensely distinguished without being in the least finicky; and she had an emotional drive that never got out of hand. She could project, the way the great Russian actors of her generation could project; and she could phrase with the kind of rightness that makes us say to ourselves "That is how it has to be."

Rachmaninoff relied on these qualities when he wrote his op. 39, but in point of fact he had been steering toward them ever since he wrote *In the Silent Night*, op. 4, in the eighteenth summer of his life. This song is an astonishing achievement for a boy of seventeen. Much in it—above all, the premonitory phrase in the right hand that occurs in the very beginning—derives from Tchaikovsky, who had predicted "a great future" for Rachmaninoff as early as 1888; and Rachmaninoff at that stage in his career did not care to let voice and piano part company for more than a moment. But the assurance, the harmonic subtlety, the command of mood, and the banked-up feeling that makes itself felt but does not overflow—all these are the marks of potential greatness.

As to the effect of Rachmaninoff's songs when he himself was at the piano, very few people can now be alive to tell us. He made no records in this capacity, and he does not seem to have played his songs in public after his last appearance with Nina Koshetz in 1917. Many hundreds of concerts lay ahead of him at that time, but in none of them could a song of his be found on that programme. It is for today's interpreters to recapture the confessional element which lies buried in even the earliest of his songs, and to set it before us with something of the distinction that, even as a dying man, he demanded of himself every time he set foot on the concert platform.

# La Bohème

## Programme Essay for Los Angeles Opera, 1987

*I don't, as it happens, ever want to go to* La Bohème *again, but I very much enjoyed this particular task, which came to me out of the blue.*

As everyone knows, *La Bohème* is indestructible. From the moment that the lights go down and the orchestra strikes up with the distinctive headlong motif to which Puccini gave the marking *ruvido*, audiences the world over are hooked. On stage, the immemorial horseplay zips along. So do the frisky melodic fragments—one of them lifted, like a good-luck charm, from one of Puccini's apprentice orchestral works—as they dart in and out of the score. This is an opera that is off and running almost before the scene has been set.

If that opening scene disconcerted the first-night audience in Turin on February 1, 1896, it was doubtless because they expected the lyrical expansion, the long soaring breath floated to perfection, with which *Manon Lescaut* had delighted them when it had its premiere in the same theater in 1893. What were they to make of the beginning of *Bohème*—a rackety, skittery scherzando, with overtones of college humor? With the young Arturo Toscanini in the pit, we may be sure that every nuance of Puccini's vocal and orchestral joinery was perfectly in place. "Paris, in 1830," was what the programme said, and the audience would have had no trouble accepting the four boisterous young men as archetypal Bohemians.

"Such harmless, buoyant lads!," they must have said to themselves, as Rodolfo, Marcello, Schaunard, and Colline horsed around. But this was music that moved fast and never took a break. *"La brevità, gran pregio,"* Rodolfo says early on, and Puccini bore him out.

Given the necessity of leaving out so much that gives authenticity to the novel by Henri Murger on which the opera is based, Puccini and his librettists were clearly right to press on to the point in Act I at which *La Bohème* takes on a completely new character. Puccini was, in all things, the complete professional. He knew to the last syllable exactly how many words he needed, and in what order they should come, just as he knew exactly how to create Parisian street noises. "Ensemble: xylophone, bells, carillon, trumpets, drums, cart-bells, crackings of whips, carts, donkeys, tinkling of glasses—a veritable arsenal" was how he defined his needs in a particularly telling passage.

And when the time came to stop the fooling around in Act I and adapt on the instant to the climate of love, Puccini did not need to force the transition. We note in the score, though we may not always hear it in the theater, that it is almost with awe that Rodolfo takes Mimi's fingers in his own. And it is in a passage marked *andantino affettuoso* that—singing *to her,* and not to us—he tells her that there is no point in looking further for her key. (We know, though she does not, that he has found her key and put it into his pocket on the sly.)

The scene that follows is one not easily restored to its original freshness and seeming spontaneity. But the fault lies with Puccini's audience, and not with himself. In a perfect world, no one would applaud until the end of the act,

and Puccini's delicate transitions would make their full effect. But we do not live in a perfect world, and the opera house is a place in which people respond deeply and immediately. If they want to applaud something well felt and well done, they are going to do it. Not even the police can stop them. Colline's farewell to his overcoat in Act IV of *La Bohème* brought out the best even in Chaliapin himself. Who are we to begrudge the Colline of the day his round of applause, however untimely it may be, with Mimi on her deathbed before him?

Besides, *La Bohème* in general is cut thick, not thin, even if a Thomas Beecham or a Carlos Kleiber can make it sound like chamber music from start to finish. It is big on local color, on rudimentary contrasts of character and temperament, and on huge irresistible outpourings—perfectly timed and calculated—that make us care tremendously, until the curtain falls, for people of whom we know little and, on the whole, do not wish to know more. We don't believe in Rodolfo as a poet, in Marcello as a painter, in Schaunard as a composer, or in Colline as a philosopher. Mimi is sweet, but droopy. Musetta works well as a reversed image of Mimi, and her busty, forthright ways give her a vitality that would survive the passage from stage door to street.

But in these matters it is Puccini who is the true seducer. Without him, we wouldn't put up with those people for two minutes. Giuseppe Giacosa and Luigi Illica had a great reputation as librettists—Giacosa as a man of letters, Illica as a fixer—but a staged performance of *La Bohème* without the music would not survive its first preview, whereas *Der Rosenkavalier* without the music stands up very well in the theater. (Clemens Krauss's libretto for Richard Strauss's *Capriccio* wouldn't do badly, either.) It is Puccini who puts these people together and makes us swallow the vacuous rhyme-schemes, the endlessly repeated platitudes, and the impassioned quartets in which almost no word can be made out.

Even so, the first intermission in *La Bohème* is a good moment at which to consider what was lost in the shredding process to which Puccini and his collaborators subjected Henri Murger's *Scènes de la Vie de Bohème*. Big shredders, one and all, they settled in the end for four acts, none of which was to last more than roughly half an hour. Taken from a book that is in itself episodic, those four acts were to be condensations, abbreviations, foreshortenings, and animated elisions. Uninformed to begin with, we were to end up pretty much where we began. Ensemble numbers and crowd scenes were to replace the discursive, conversational, low-keyed tone of the book. Murger lived among people who talked their lives away, whereas Puccini counted every word that was spoken or sung on the stage and did not see it as his duty to explore the contradictions inherent in human character. ("When I'm on to a good idea," he said on another occasion, "I'm not going to let some damned librettist get in my way.")

As between himself and Henri Murger, a fundamental difference existed. Murger was a proto-Parisian. "Bohemia could not exist anywhere but in Paris," he said, straight out. Puccini detested Paris. So far from welcoming a chance to study such nuances of Parisian life as might be useful to the composer of *La Bohème,* he longed to get back to the pine-scented Mediterranean seaboard, where his paunch could swing to and fro, unimpeded, in loose summer trousers and he could hear his own language all around him. Though given to subjects

first made famous by Frenchmen—*Manon Lescaut,* for one, and *Tosca* for another—he imposed upon them a purely Italian aesthetic. (When someone pointed out to him that Massenet's *Manon* was already regarded as an exemplary treatment of the subject, he said only that whereas Massenet had tackled it in terms of face powder and minuets, he would approach it "as a passionate Italian.")

This disposition worked in small things, as much as in large ones. Whereas Murger at one point lets on that Rodolfo, though not yet twenty-five, had already lost much of his hair, Puccini would never have asked an Italian audience to accept a bald principal tenor. Whereas Murger tells us how Schaunard once sent his girlfriend packing because he had noticed that one of her knees was prettier than the other, Puccini left out his love life altogether.

As for Mimi, it is fundamental to the tranquil delirium of the end of Puccini's Act I that she and Rodolfo were meeting for the first time and free, therefore, to present themselves to one another in whatever way seemed likely to be most ingratiating. Murger tells us, on the contrary, that Rodolfo had known her for quite some time and that she had been the mistress of a friend of his. And although Mimi in *La Bohème* is distinguished above all by a delicate passivity and an inability to fend for herself, Mimi in Murger's novel has a diabolical side.

"She was twenty-two years old," Murger tells us. "She was slightly-built, delicate. There were the beginnings of aristocracy somewhere in her face. Her features had an exceptional finesse and were sweetly irradiated—or so it seemed—by the expression in her blue and limpid eyes. But at moments of boredom or ill temper, they took on almost animal brutality. At such times, a physiologist might have recognized the marks of a profound selfishness or a total insensitivity." Needless to say, none of that comes out in "Mi chiamano Mimi." Nor does her volatility in matters of the heart and the senses peek through the recital of her days as a seamstress and her solitary evenings in a whitewashed *cameretta.*

Puccini in these matters wasn't lying or faking, but he was simplifying. Doing things his own way, as only he knew how, he could make two thousand people in a theater feel as one, in an uncomplicated trustful way. Murger had always lived in a sub-section of Paris where people changed lovers as often as they changed shirts. The short term was bred into him, and he could not conceive of people behaving in any other way, even though he knew how often his friends of both sexes had died of it. But the Italian opera public in Puccini's day craved ecstasy. If a price had to be paid for that ecstasy, the bill had to be rendered offstage, with at most a bout of coughing—and nothing too realistic, at that—to signal to the audience that something was seriously amiss.

Along with matters such as these, Puccini and his collaborators had to cut a great deal of what carries us along in the book. Schaunard in *La Bohème* is a steady, sturdy sort of fellow, and we quite understand that it is he, rather than any of the others, who first recognizes that Mimi is dead. But in the book he is a rounder, fuller, and more original character. No reader ever forgets his first glimpse of Schaunard, just out of bed and padding round his room in a pink satin petticoat that a temporary love once left behind her. And Schaunard the composer was way ahead of his time, with his *Symphony on the Role of the*

*Color Blue in the Fine Arts*. (His friends dreaded having to hear it.)

Whole scenes, and indeed whole chapters, were cut, necessarily, from a book that is undeniably digressive. But I for one miss, and should have liked to see on the stage, the episode in which Schaunard is evicted from his room for non-payment of the rent. A new tenant arrives, wearing a white hat in the style of Louis XIII and nibbling on a bouquet of violets. His furniture consists entirely of a series of painted panels, picked up that very day at an auction house. When turned the right way round, they turn out to constitute a complete palace in two dimensions, complete with columns of jasper, furniture in the most opulent Boulle style, bas-reliefs, and Old Master paintings. The room is transformed, transcended, unrecognizable.

But has he any real furniture? Some chairs, at least? "Chairs, never!" says the new tenant. "Chairs take up too much room. The moment you have chairs, you don't know where to sit down." And when, late that evening, Schaunard comes stumbling back home, having quite forgotten that it is home no longer, there follows a scene worthy of Feydeau himself as he tries to come to terms with what has happened. It is with passages of this kind that Murger builds up over more than three hundred pages a complete portrait of his four Bohemians. We know how they live, how they dress, where they get money when money is short, what they talk about and dream about and—important, this— how they conduct themselves with women. We also find out how firm is their determination to remain forever a Club of Four. Neither three nor five, but four.

Gradually we realize that in the ponderous, uncultivated way for which Henri Murger was derided by some of his contemporaries, he saw his four Bohemians as the personification respectively of Poetry, Painting, Music, and Philosophy. Not only that, but he regards membership of Bohemia as an indispensable way station in the career of artists, painters, composers, and men of letters. Bohemia, for him, was the antechamber that leads directly to the Académie Française, the city hospital, and the morgue. "True Bohemia consists," he said, "of those who know that they have been called and may one day be chosen."

As to that, Murger allowed himself a certain amount of verbiage of a kind that may not have passed muster even among those who made his book a best-seller in 1857. He recalled that, in ancient Ionia, the Bohemians of the day had gone from village to village, living on charity and hanging their lyres above the hearth of the house that took them in. There was a reference to melodious but undated vagabonds who had done much the same thing in Touraine, each one of them roaming the countryside with a troubadour's harp on his back. The Bohemian was a poet, a singer, and a man who could look after himself. Murger went so far as to say that he could have borrowed money from Molière's Miser and eaten truffles on the raft of the *Méduse*, where all about him were dying of thirst and hunger.

Puccini had an intuitive intelligence that would never have tolerated rhetoric of that sort. He took from Murger what would "tell" in the theater, and no more. If the audience had questions, he left them unanswered, trusting to his mastery of the stage and to the hypnotic effect of leitmotifs as haunting, in their way, as any that Wagner ever conceived. When Rodolfo and Marcello

burn their paintings and their manuscripts in Act I, he does not expect us to grieve as we would grieve for a vanished Leonardo or for the lost library of Alexandria. Nor would he have dreamed of tacking on an epilogue—as Murger did—in which Rodolfo published a book that was talked about for a whole month, and Marcello got to show in the Salon and had a painting bought by a rich Englishman who had been the lover of Musetta. Schaunard's songs—so Murger would have us believe—got to be sung over and over again, and Colline came into money, made a brilliant marriage and gave evening parties at which people listened to music and ate delicious cakes. Even Musetta—so Murger tells us—opted in the end for a safe marriage.

That was his idea of rounding off a long and complicated story. Puccini by contrast was a de-complicationist. We believe him when he suggests that Rodolfo will never be more than a good-looking hack. "Five minutes will be enough. I know what I'm doing" is all that he says when it is a question of his finishing the lead article for a new magazine. When Marcello's big painting of *The Crossing of the Red Sea* turns up as an inn sign, we do not see it as a tragic irony, but as a fair working arrangement.

Nor was Puccini the kind of composer who would try to put a major artist on the stage. We accept Cavaradossi in *Tosca* as a good-looking presence who has some gorgeous music to sing, but we can't help remembering that in the year 1800, in which the action is set, painting in Rome was at a very low ebb. Berlioz in *Benvenuto Cellini*, and Hindemith in *Mathis der Maler*, were working on a level of historical seriousness that was quite foreign to Puccini. In their art, his Bohemians were amiable losers and he saw no reason to pretend otherwise.

As between Puccini and Murger there was another, even more fundamental difference. Puccini had a capacity for involvement that was nothing short of prodigious. No matter what the subject, he could make himself transparently at home. Involved himself, he was the cause of involvement in others—and, above all, in the singers for whom he wrote such wonderful parts. No matter how hackneyed or novelettish the situation, Puccini made it work on the stage. He did this to perfection in *Gianni Schicci*, with its all-Italian appurtenances, and he did it just as adroitly in *La Fanciulla del West*, where the scene is set in a California mining settlement during the gold rush of 1849, or in the ancient Pekin of *Turandot*. In his art, he was the invisible intruder—the man who can look down the chimney, no matter where, and see at once what kind of life is being led in bedroom, living room, and kitchen.

Murger was completely the opposite. If he wrote about the Bohemian life, it was because he had lived it in its every detail. Not only that, but he had never lived anything else. Toward the end of his short life (1822–1861) he would have liked to turn into the kind of man of letters who wore a white waistcoat and yellow gloves when he was invited out. But if we may judge from the journal of Edmond and Jules de Goncourt (not exactly an unprejudiced source) this idea was hooted down. How Murger lived might be irrelevant to Puccini's opera if it were not that scene after scene is permeated with Murger's often painful and sometimes deeply humiliating experience of the Bohemian life not as a station on the road to fame and fortune but as a bog of failure, discredit, and disease.

Murger in life was, for instance, a compulsive borrower. When he writes in *Scènes de la Vie de Bohème* of how Schaunard kept a long list of people who might be good for a small seasonal loan, together with the dates on which they were usually in funds, he might be talking about himself. When he writes about the ups and downs of living with a woman, we remember what happened when the Goncourts went to stay in an inn near Fontainebleau with a group of friends. The walls were like cardboard. Their room was next to the one that Murger shared with a young woman. Every nuance of their lovemaking was audible, and so was the young woman's voice as she said to Murger at an inappropriate moment, "How much does that magazine pay you for a page?"

The last act of *La Bohème* is one of the great theatrical contrivances—a twenty-seven-minutes' traffic in which Puccini and his collaborators put the prettiest possible face on what it is like for a still-young woman to die. Mimi on stage dies in private, not in hospital, and with people who love her close at hand. Mimi in print goes off gamely to a hospital ward that smells horrible and is full of people who will never get out alive. On the way there, she is alert enough to stop the cab more than once to look at the new season's clothes in the shop windows, but she knows that she will never make it through to visiting day. And, sure enough, when Rodolfo next comes to see her she is already dead, and in a common grave.

In that passage, and in many others in Murger, there is the iron ring of the thing *lived*, rather than of the thing dreamed up among close colleagues. Murger remembered how a young woman known to him had made that same grim last journey to hospital. She too had stopped the cab. "I'd just love a dozen oysters," she had said. As to what it meant, in the end, to lead the *vie de Bohème*, Murger himself knew as well as anyone. (When he was dying at thirty-nine, it was thought that he would look better for a visit from the barber. It sounded like a good idea, until his upper lip came away with his mustache.)

The Alban Berg of *Lulu* might have tackled that, just as he might have tackled the fact—made clear in Murger—that Mimi's death was due primarily to her having swallowed a draught of disinfectant in an attempt to end her own life. Nor has there been lacking from time to time a move to make *La Bohème* conform more exactly to social realities than would ever have occurred to Puccini. (I remember one such move, in East Germany, where the programme listed not only the performers' previous credits but the figures for death from tuberculosis among Parisian seamstresses in the middle of the nineteenth century.)

But Puccini was not a teacher, however obliquely. He was the son, grandson, great-grandson, and great-great-grandson of professional entertainers. If he opened the valves of feeling among us, he thought the day well spent. Bohemia, for him, doubled as Wonderland, and he did not wish it otherwise.

PROGRAMME

# Falstaff

### Programme Essay for Glyndebourne Opera, 1988

*Who could not love Verdi's* Falstaff*? And where does it sound better than at Glyndebourne, with real English countryside only a yard or two away?*

Fifty summers ago, I was taken to Glyndebourne for the first time, and I have yet to get over it. Now domiciled in the United States, I get to Glyndebourne all too rarely. But when I turn in through that quite untheatrical gateway and come in due time to the opera house, I say to myself in silence what John Christie said not long before his death: This is the most beautiful building in the world.

We didn't quite say that in June 1938, but we knew that it had marked us, formed us, made us free of one of the most enduring of life's pleasures. "Tout casse, tout passe, tout lasse," the French say, but those of them who have been to Glyndebourne know better.

Beneficiaries in 1938 of the rule—long since abandoned—by which neighbors got tickets at an advantageous rate, we were dropped off each evening within walking distance. Thereafter, we made our way through covenanted paths and shortcuts picketed by high-summer butterflies.

Among the Oxford contemporaries who made up the party, it was common ground that the opera we should most like to find on the Glyndebourne playbill was Verdi's *Falstaff*. This one had been to it at the Metropolitan Opera in New York. That one had raced upstairs to the topmost side gallery at Covent Garden. Someone else had caught a broadcast from Salzburg.

In unison did we mimic the huge crescendo that leaps out of the orchestra pit, as if from nowhere, at the beginning of *Falstaff*, Act III. And when we breasted the top of the hill that leads down to Glyndebourne itself, we made a brisk though undeniably ragged attempt at the great final fugue that reminds us how often Verdi had had J. S. Bach open on his music-rest. That opening phrase—*"Tutto nel mondo e burla"*—hovered over the whole summer for us, even if the newspapers of the day did not bear it out.

Though doubtless wrong about many other things, we were absolutely right about Glyndebourne and *Falstaff*. *Falstaff* calls for the highest metropolitan standards of preparation and performance, but country sights, country sounds, and country smells are everywhere in it.

Verdi himself said that he would rather have it performed in his country estate, Sant'Agata, than in La Scala in Milan. It was written in the country—"just to pass the time," he said—and he hated to let it go. Faced with tiresome demands from this quarter or that, he said that he would rather burn *Falstaff* in manuscript than give in. Was he not old enough and grand enough to do what he liked? Of course he was, and he would have liked nothing more than to walk through a countryside in which Falstaffian overtones are everywhere and find *Falstaff* itself round the last bend in the road.

Unbeknown to us, two telegrams had gone out to Arturo Toscanini in the spring of that very same year of 1938. As he had cancelled his engagement at

Salzburg, would he consider an invitation to conduct *Falstaff* at Glyndebourne instead? He didn't answer, but Glyndebourne never had a better idea.

Was not Herne's oak everywhere around, in prototype? And Ford's manor house? And woods in which elves and antlers would be at home? Here, if ever, the place and the work would be one, and vice versa. The scale of the theater was just right. Every wink would tell, and Mistress Quickly would not have to come on, as she often does in larger houses, like a heavy-set middle-aged man in drag.

The look of the theater was just right, too. (In the inaugural brochure in 1933, John Christie described it as being "in Tudor style, and built of materials already mellowed by time.") The resident swans might have made trouble for Verdi, used as he was to take a boat out on the lake at Sant'Agata; but as for the dense foliage, the flowering shrubs, and even the ditch that Boito calls for in his libretto, all of them were there in profusion.

As we walked back up across the Downs at the end of the evening, with glow worms in action every inch of the way and a long line of cars calling to one another in the distance like Boito's forest-wardens in Act III, scene 2, the idea of *Falstaff* at Glyndebourne got better and better.

Besides, Glyndebourne had already given us a nudge or two in that direction. Act II of Mozart's *Figaro*, kept on so light and yet so tight a rein by Fritz Busch, had given us a new idea of what an extended and quick-witted ensemble in the opera house could be. What was *Falstaff*, after all, if not a series of extended ensembles with here and there an interruption?

Equally well, *Don Pasquale*, that same summer, had broken all the speed records for rapid, perfectly synchronized, and ever-audible articulation in Italian opera buffa. What better preparation for the nine-part ensembles in *Falstaff*? I remember that *Don Pasquale* every time I pass the prepotent and mulberry-red stage costume once worn by Salvatore Baccaloni that is preserved in a glass case at the Metropolitan Opera for all to see and admire.

We also knew that working conditions at Glyndebourne were of the kind that Verdi liked most. If he had come back to earth and asked to have the whole place to himself for a month, as happened at La Scala in January 1893, he would have got it. Although he once claimed that *Falstaff* was "the easiest of all operas to stage," and that "with a little instruction everyone—or almost everyone—could perform it," he liked to rehearse it all day and all night.

Not only did he make sure that the conductor did not over-interpret, but he insisted on jumping up and down onto the stage and walking the singers through their every entrance and exit. Their every movement on stage and the least nuance of their acting with the voice were likewise subject to his intervention five, ten, or even fifteen times over.

He could have done that at Glyndebourne, just as he did it with *Falstaff* at the Opéra-Comique in Paris when he was eighty-two years old and had spent a sleepless night in the train. In the feather-light, fat-free orchestration on which Verdi rightly prided himself, English orchestral players would have done him proud. He would have had no trouble casting *Falstaff* in a theater where it has always been taken for granted that no role is insignificant.

If he had suddenly craved a chocolate revolver of the kind with which he had once feigned to shoot himself in Genoa, one would have been sent down for

him from Victoria by the morning train. If his wife had got rather carried away, as she was wont to do, and walked ahead of him on opening night—"in majesty," as someone once said, "and with the gait of a carabiniere on parade"—no one would have laughed. And if he himself had walked through the main street of Lewes, "with his hat cocked over one eye, like a widower in search of a wife," as he did in Milan when he was eighty-four, that would have been quite all right, too.

If *Falstaff* goes better, and sounds better, at Glyndebourne than almost anywhere else, it is because Glyndebourne is still what John and Audrey Christie wanted it to be—a place in which (to quote once again from the initial brochure) "at all performances the feeling of happiness and benevolence should be conspicuous." What more could Giuseppe Verdi ask, who once said to his singers that the essence of *Falstaff* was "Gaiety! Gaiety! Gaiety!"?

That remark had long since enjoyed a classical status. And gaiety is, of course, fundamental to *Falstaff*. But it is not by any means the whole of *Falstaff*, and I wonder if Verdi was not thinking as much of his own delight in writing the opera as of its inmost nature. Thanks in large part to Boito, he had made the commitment to comedy that he had had in mind for much of his life but never quite managed to fulfill. Boito had given him an incomparable text, whose every well-chosen word cries out for music. Verdi laughed as he read it for the first time, and he laughed all over again when he got down to work.

That text set Verdi free from the bondage of grand opera. "Our mistake," he said to a visting German critic in 1892, "has always been to write interminable grand operas that last a whole evening. We always had to consider how to fill the four and a half hours with music. This meant big choruses that had almost nothing to do with the opera, and elaborate scenery, and solo arias with all manner of incidental episodes. All of this slowed down the action."

In *Falstaff*, there was to be almost none of that. It was an ensemble-opera, an opera made up of slalom and U-turn, with hardly a moment at which someone got to stand and deliver for minutes on end. Falstaff's outburst about honor in Act I, and Fenton's tantrum in Act II, were favorites with the opera's first audiences, and each of them fitted nicely onto one side of a 78 rpm gramophone record. But fundamentally there is something extraneous about them, and something alien to the innovative idiom of *Falstaff*.

By the end of the opening scene we know already that Falstaff bends the code of honor to suit his purposes, just as we recognize Fenton from the outset as someone who is potentially a very jealous husband. We don't need to have the action come to a halt while these things are spelled out in ways that speak for an earlier Verdi, and one that Verdi himself was glad to have discarded.

But then *Falstaff* in general will not sound to us in 1988 as it sounded in 1938. We have today what is called in the United States "a whole new take" on it. Fifty years ago, people used to sit back a little and wait for the famous episodes in *Falstaff* at which ensemble turns into soliloquy and we hear something approximating to the "Verdi aria" that even George Bernard Shaw regarded as the supreme expression of his genius.

They also loved the idea that in the final scene Falstaff was going to be baited and beaten. (Even Verdi wrote to Boito that he would like it if Falstaff were "thoroughly beaten.") But our century has seen too many people baited

and beaten, and I for one prefer the moment at which all hard feelings are forgotten and Falstaff goes off to dinner with his tormentors.

In that scene, as elsewhere, what we prize today is the firefly-flight of Verdi's genius as it darts this way and that and dares us to catch up with it. As to that, we shall be in the right place, for the woods around Glyndebourne have their full complement of fireflies, and on a fine evening in high summer they could not come in more exactly on time if Verdi himself had rehearsed them.

# VII.

## SOME LITTLE NOTHINGS

One of the more luxurious aspects of working for *The New York Times* is that you get to write little nothings which, with luck, may turn into little somethings. Here are some of them.

# Connecticut: Alpha and Omega

The New York Times, 1980

It is now all of twenty years since I became conscious of Connecticut. In New York, on a visit from England, I was roused early one morning in May and driven to lunch with Alexander Calder, the sculptor, and his wife, Louisa James Calder, in Roxbury. The Calders were everyone's favorite Americans. Spirits were high. It was really rather early, though, and quite possibly I dozed off. Waking, I found myself in wonderland.

The sun was bright, the air cool and fresh, the morning mist not yet quite burned away. Sliding by at exactly 55 miles an hour was a landscape as civilized as any in the paintings of Claude Lorrain or the English parks designed by Capability Brown. Trees were heavy with blossom. Great sheets of water knew their place as momentary vistas. Birds dived and swooped, unhurriedly. Perfumed breezes flowed in and out of our open windows. Stone bridges—no two of them alike—straddled the road. Hardly a house was to be seen, and I pictured Connecticut as a tamed, unending forest inhabited by wise men and beautiful women in comfortably small numbers.

"Where are we, anyway?" I said. "Are these green acres in thrall to Privilege? How come they let us in?" And when they told me that this was the Merritt Parkway, a public road open to all on payment of a fee in pennies, I thought that they had to be putting me on. Be that as it may, the Merritt Parkway stayed with me as a masterpiece of pacific invention. It was never too wide, too flat, too straight, or too fast. Never repeating itself, it gave nature her very best shot.

Not so long after that, I came to have the Merritt Parkway as my private drive. Other people were admitted, of course, after a pause at the tollbooth, but I saw the Merritt as the extension of my unmarked and almost clandestine driveway. My happiness as a Connecticut resident was—and still is—bound up with its blissful rise and fall, its discreet but consummate housekeeping, and its knack of editing out the developer and all his works. Who needs 10,000 feudal acres when the Merritt leads almost to his door?

Maybe it is to keep that dream intact that, when in Connecticut, we never go out. Day after day, winter and summer, we sit there like stoneware figures of Darby and Joan, perfectly content. Doubtless it helps that we live in a town that has no main street, no fun shops, no movie house, and no seductive little bistro that specializes in saddle of bear with fiddlehead ferns on the side.

But the fact is that, whatever we want, we can see it from our window. Some of the company that we most prize is within hailing distance. Out back we have a big field, of a shape unknown to the historian of agriculture, that is a yearlong source of wonder and delight. Sloping upward, bordered by maples that stand out against the skyline, it is the very paragon and epitome of New England fields, all gold and green and soft as suede at the crown of the year, all bitter-chocolate brown and crème-fraîche white in the snowy months.

Out front, we have a serpentine drive that winds through a forest grove. That grove calls out for cool, white neo-classical sculptures but has yet to receive them, thanks to our continuing penury. (In an attempt to break the mold of that particular idea, I once set my heart on a fiberglass dinosaur, not far short of lifesize, that was coming up at a local auction. Ever maladroit, I arrived too late to bid.)

We also have a waist-high wall made up of big stones left over from the last retreat of a milleniary glacier. It does not escape me that walls of this kind gave impenetrable cover against the British when the going got too hot for them, two hundred years ago. That wall binds us to the past of Connecticut, just as the unmistakable slap-slap of a wandering helicopter binds us to the present.

From the top of our field, we see Connecticut as it used to be, with its gneiss-schist outcrops, the all-but-Brazilian density of its forests, its mixed hardwoods, its chestnut oaks and its red-maple swamps. Down below, and just across the still not-too-much-trafficked road, no fewer than 116 species of tree and shrub were logged a few years ago in quite a small area. Though myself no great hand at identification, I rejoice in the multiplicity of Connecticut as it is made plain by the presence of quaking aspen, sweet pepperbush, black willow, shagbark hickory, and steeplebush. It would be a drab nature that did not respond to the pubescent fuzz of silky willow, the pea-bearing roots of the sassafras, the rare orchids that were found at the base of a moosewood tree, and the eminently edible beaked hazelnut.

After all that, the boisterous blue jay, the purple grackle—iridescent in the sun—and the rose-breasted grosbeak who visit our feeder and the stately, green-eyed and bottom-heavy cat who drops by to give new meaning to the words "eat and run," and you will agree that in our tiny corner of Connecticut we have the world in miniature. With one house, one field, one other person, and the Merritt Parkway, who needs more?

# Other People's Houses

### The New York Times, 1977

When we first go out in the world, there is a point in almost every conversation at which the other person can think of only one more thing to say. And that one thing is: "Where did you go to school?"

The answer I settled for was, "In other people's houses." School and college are all very well, but it is in other people's houses that we learn the complete alphabet—A through Z, with no exceptions—of other people's attitudes.

In this matter, first impressions mark us for life. From 1933 to 1937, I was in school in London. There was nothing wrong with the school—indeed, for the minority of forward little fiends of whom I was one, it was one of the two best schools in the country—but there was as much to be learned by walking past other people's houses on a fine summer evening as there was to be learned in the classroom. The heat was terrific, front doors were left open to catch the slightest breeze, and through big sash windows with clear glass panes we could see how the grown-ups lived.

And we never tired of it. We learned how to go into a house and how to come out of it. We learned how to walk up the tall narrow stairs and what to do when we came to the L-shaped drawing room on the second floor. We could see what was fun and what wasn't, and we learned to judge from the very look of a room whether the people who came home to it were old or young, dynamic or sunk in apathy, angst-ridden or perfectly secure. If ever there was "a liberal education," this was it.

We didn't always have to stay out in the street. In house after house, young people were regarded as a desirable garnish. A school as big as ours is a metropolis in microcosm, and before long we got to be asked first for tea, and then for after dinner, and then for dinner itself. In this way we saw a lot of houses. Some of them we wanted to scoop up like heavy cream, so completely did they come up to expectation. Some of them just sat there and glowered. Some of them made a great effort but never quite seemed to connect. Houses have a life of their own, and that life does not always correspond to the intentions of the people who live in them. "We were here before you," they seemed to say, and until the outbreak of World War II it was reasonable to think that they would outlive us.

We soon learned that in every house there is a point of maximum vitality. Sometimes it was the little room overlooking the perfectly kept but very small garden in which punctually at five o'clock every afternoon a methylated spirit lamp sat gurgling beneath an almost spherical teakettle. Sometimes it was the bookshelves—not a paperback in sight, in those days—that went back year by year to the days when Byron was savaged in the *Edinburgh Review*. Sometimes it was the round table where parties of eight and ten cackled half the night through. Sometimes it was the mantelpiece heaped with invitations, and sometimes it was the tray of drinks.

London in those days had a continuity now largely lost. It was possible to call on people then well over eighty who had lived in the same house since the

1850s and saw no reason to change it in any particular. (These were circumstances in which even immensely distinguished old minds were known to wander: "Just when is it," one senior poet was heard to say, "that I asked Lord Tennyson to tea?"

Servants in those days cost nothing and stayed forever. Where possible, time was arrested: A visitor to the Stracheys at No. 46 Gordon Square would walk beneath centenarian plane trees to an impossibly tall and quite elevatorless town house in the hallway of which a board equipped with sliding nameplates would say who was in and who was out. Lady Strachey had been dead for many years, and Mr. Lytton Strachey for five or six, but their nameplates were kept in perfect order, as if in readiness for the resurrection in which Lytton Strachey for one was not likely to have believed. No. 46 has long since been turned to institutional uses, but in the 1930s it was still the house of which Virginia Woolf once said, "Eleven people aged between eight and sixty lived there, and were waited upon by seven servants, while various old women and lame men did odd jobs with rakes and pails by day."

That particular England is almost as remote from today's conventions as is the Russia of Turgeniev, and the lessons that we learned in it might now be as obsolete as a crash course in the gavotte. But they aren't. It is true in all places and at all times that when the company is right it is more fun to dine off leftovers than to pick at food that has been flown over expressly from Maxim's. In all places and at all times it helps to know when convention should be flouted and when we can yield to it, as the captain of a big steamship hands over to the local pilot. It helps to know that famous people do not necessarily want to be run after. It helps to know that like every other living thing a house needs to rest up from time to time. Above all a house should be a source of moral energy, as much for those who come to visit as for those who live in it.

It is a very curious thing, that sensation of moral energy. It is not primarily a matter of architecture, though great architecture has a transparent rightness which suggests that it is high time that we put ourselves in order. It is not primarily or even usually a matter of "good taste." Few things are more debilitating than the kind of house which implies that everything worth doing has already been done perfectly. It has to do with our sense that one or more completely realized human beings have lived within these four walls. That sense cannot be developed in the classroom. It has nothing to do with formal education. Books can't help, music can't help, the theater can't help, the Great Outdoors can't help. Only the Great Indoors can do it, and it mustn't be our own indoors, either. Our own prior involvement is too great. Every complete human being should have somewhere in his *curriculum vitae* the four words, "Educated: other people's houses."

# From Aalen to Zypern:
# The Continental Timetable

### The New York Times, 1980

When I was in short pants, which was a year or two ago, it was everyone's favorite nightmare that a mad scientist would take over the world. All-seeing, all-knowing, and all-manipulating, he would bend us to his wicked will.

There was not a nation in Europe that did not spawn its variant of this fantasy, which found its apotheosis in 1932 in a movie by Fritz Lang called *The Testament of Dr. Mabuse*. Such was the power of Mabuse that his crazed fancies retained their thralldom even after his death, or so the story went, and when Fritz Lang told it there was not a disbeliever in the house. Our generation was hooked on Mabuse, the way a later one was hooked on James Bond and his adversary, Blofeld.

Though unable to picture myself as even a midget Mabuse, I did pore continually over a publication that made me feel that I saw all, knew all, and might one day manipulate all in an important department of life. The publication was Thomas Cook's *Continental Timetable*. It came as a paperback small enough to be held in an infant hand, and it impressed from the first as a masterpiece of design.

The typeface was clear, the page uncluttered, the maps a model of lucidity and concision. This was a book that told us exactly what trains were where at any moment in the year across the continent of Europe, and it also kept tabs on just about every ship that carried human beings around the Baltic, the Black Sea, the Mediterranean, and the eastern waters of the Atlantic Ocean. Dr. Mabuse would have kept it by his bed, as I did.

Train and boat were all-powerful in those days. There were airships that looked terrific, but they burned up or crashed into hillsides. There were commercial aircraft, but they had to stop every hour or two, as if amazed by their temerity in getting going at all. The automobile was living through what may well have been its finest hour, but as an epitome of society it could not compare to the great European trains. The man who was master of the trains was the master of Europe, and the man who subscribed to the *Continental Timetable* was halfway to mastership.

That timetable was a triumph of the will. It left out absolutely everything that was not to its purpose. Take the maps. There are high mountains in Europe, but they never appeared on those maps. There are great rivers, too, but neither Rhine nor Danube made it to the *Continental Timetable*. There were frontiers, then as now, that people dreaded to cross, but the timetable treated them as if they were no more daunting than the frontier between New Jersey and Pennsylvania.

Thomas Cook's stood no nonsense from nature in those maps, and it was not taking any from the engineers, either. All lines were dead straight, on those maps. Curves were unknown, and we saw at a glance what town was where and

how far it was from the next one. More curious still were the maps of town centers in which nothing whatever was shown but the configuration of the main railway lines. A great European city has an ecology that is the work of centuries, but did Thomas Cook's take account of that? Not at all. Its concern was with the way in which, in Leningrad, for instance, the line from Helsinki just would not link up with the line from Moscow. It took that personally, just as it grieved over the long walk in Paris from the Gare de l'Est to the Gare du Nord.

But the true fascination of the *Continental Timetable* lay in the antlike perseverance with which it logged every least movement of every least local train from Aalen to Zypern. Thomas Cook's never gave up. If the 23:58 from Cluj-Napoca to Sighisoara shed two minutes of its station stop at Teius, it soon got to know of it. It was big on exceptions, too: Phrases like "not on March 17, June 2 and August 26" were spelled out in small type, together with information about the changing of wheel sets at the frontier between France and Spain and the possibility that clocks in the summer might be imperfectly aligned as between Norway and Yugoslavia.

This was not just an ordinary timetable, of the kind that elsewhere blunders along in ignominy. It had a philosophical perfection, a Euclidean ease and grace and completeness, a built-in assurance that figure and symbol could between them produce a perfect world in paradigm.

It was too good to last, we thought during World War II. With the air forces of one nation or another doing their best to blow up every last station and every last length of track, the *Continental Timetable* would survive, if at all, as a mutilated curiosity. But not at all. Barely was the last shot fired when it came out again. Place names might be changed, whole countries might be struck from the map, huge tracts of land might be off-limits, but the timetable went on as before.

And it still does. We may not be allowed to visit Dr. Sakharov in Gorky, but the timetable tells us that the 0:45 A.M. from Moscow gets into Gorky at 8:45 A.M. precisely. The map of Southeast Asia has its former pristine look, the daily bus service from Peshawar to Kabul still shunts to and fro, and the long haul from Sharifkhaneh to Teheran is still right in there, even if Thomas Cook's can no longer guarantee the arrival time.

If anything, the triumph of the will is even greater, in that the timetable now covers the entire world, not excluding the New Haven Railroad and the Ibsenesque shipping line that plies between Nynäshamn and Visby. Such is the Mabuse-like grasp of detail in the great work that Thomas Cook's can even afford to print a list of "Places Not Shown in This Table." And very short it is, too, all things considered.

No daydreamer should be without it. Besides, how else should we know that (to quote the current issue) "the Transandine passenger service has been permanently withdrawn on the Argentine side in order to increase the line freight capacity"? It was on details such as this that the British Empire stood for so long. The world was the Englishman's oyster in those days, and Thomas Cook's *Timetable* told us where to look for the pearl.

# A Room with a View

**The New York Times, 1985**

There are hotels with which I identify to a degree that may well be aberrational. Such is their hold upon me that when I go to stay in one of them I foreswear the habits of a lifetime and give traditional sightseeing a miss. The hotel is the city, at such times, and vice versa.

This is what I do. I check in. I go up to a single room, long known to me, on the topmost floor. It has a view. I open the window, draw up a chair, sit down and look out. In other cities I should already be prowling the streets with a 1912 Baedeker in one hand and an 1897 Murray's Guide in the other. But in this case I sit there, motionless, like a frog in deep mud.

Unlike the frog, I am not crouching in readiness for an Olympic-style leap. I am waiting for the hotel to mediate between myself and the city. I call room service for lunch and dinner, and I discuss the state of the local theater and opera house with the concierge. Prompted by ruinous impulse, I make some intercontinental calls. But fundamentally the hotel, the city, and I are in conference from morning till night. And the hotel gives out, uninterruptedly.

When I was younger, and a charge on other people, they resented all this very much. "We did not bring you halfway across Europe to skulk in your room," they would say. But I did not agree. In Venice, I had only to draw them to the window to make my point. In Athens, there was the Acropolis just across the way, and in Istanbul the Pera bridge and the Golden Horn.

In Basel, the weight of traffic on the broad river Rhine, as seen from the top of the Three Kings Hotel, was worth a whole semester of geography lessons. In Vienna, there was a great museum, the Albertina, to the right, and the back of a great opera house, with scenery being trucked in and out every morning, to the left. These were historic spectacles, and brooked no arguing.

No matter where I was, I got the view by heart. I also noted every last nuance of my room—among them the design of the newspaper that came with

breakfast—and without even opening the door I monitored the alien voices in the corridor, the alien workings of the elevator, the alien tinkle of the orchestra that played for dancing, and the footfall of the blackstockinged housemaids as they went about their business.

In time, I could tell one country from another by sound alone. Church bells, street cars, taxi meters, street musicians, the beat of an express train coming into the main station and the cries of newsboy, lottery ticket seller, and flowergirl—all bore a specific brand. And they came filtered, by courtesy of the hotel. Without the planned neutrality of the hotel, no such concentrated stillness would have been possible.

In leading this possibly rather peculiar life, I was fulfilling the wishes of the inventors of the grand hotel. It was not their intention to cater only to the tourist, or to the person who wants to be taken care of. They wanted their clients to become part of the hotel, and to think of it as a place that fulfilled their every need, thereby making it unnecessary, if not actually futile, to confront the world outside.

Rooms were huge, so that in preadolescence we could have ceilings to bounce oranges off, closets big enough for a young elephant, and windows that started at the floor and rose to a height of fourteen feet. Service was highly characterized, with unmistakable ethnic overtones. And the city was omnipresent, though nowhere obtrusive. We did not so much see it as live it.

Sometimes the hotel brought the outside inside. The palm court spoke for the botanical garden. The thunderous colonnades spoke for parliament houses and law courts. The double staircase spoke for an aristocracy that had big ideas and lived up to them. The little shops spoke for the big shops outside. It was as if the city had been turned inside out, like a summer jacket, and shrunk in the wash.

If I do not include resort hotels—not even the best and most seductive among them—it is because one of the things that I prize in a hotel is the awareness of other people getting up and going out to work. I picture them cutting and slathering their way through a business breakfast, treading the lobby like racehorses waiting for the off, standing in line for taxis and waiting a little to one side for the limo that they feign to take for granted.

While dreaming of that purposeful hubbub, I go over my room piece by evocative piece, dating almost to the year the heavy glass inkwell that has long ceased to know ink, remembering the prehistoric telephone on its gibbet, unhooking the nineteenth-century battle piece from the wall and checking it for title, date, and exhibition label. If the writing paper is still headed with a steel-engraved view of the hotel, complete with phaeton and berline at the door, I clap my hands.

For I like above all things a centenarian design, a design so innately right that nothing would be gained by changing it. My favorite linen has been in the Hotel National in Moscow since before 1917, and my favorite lamps have been shedding the same pale gold light in the Hotel Lutetia in Paris, the Hotel Doelen in Amsterdam, and the Hotel d'Angleterre in Copenhagen since before World War I. I like bells that you pull, and pens that you can freshen up with— what else?—a penknife.

Room service, anyone?

# Love Me, Love My Luggage

**The New York Times, 1977**

Luggage used to be forever. It arrived almost of its own accord when people came of age, or got married, and it never went away again. To be seen with new luggage in middle life was thought of as pretentious and unbecoming. Luggage did not wear out, like shirts or shoelaces. It *wore in*, year by year.

This was not only true of grand luggage that came in numbered sets of five or six pieces. It was true of the simplest items of everyday use. A doctor who called at the house with a new bag in his hand would be thought of not as someone who kept up with the times but as a flimsy fellow not quite to be trusted. Designs never "went out of style," any more than it went out of style for a carriage to run on wheels. People did what they had always done; when E.M. Forster, the novelist, came up to London in his late eighties he prepared for the adventure in the way he had prepared for it sixty years earlier—by putting on a flat tweed cap of some all-but-colorless material and keeping a firm hold on an anachronistic piece of hand luggage.

Luggage in those days was not so much designed as built, thoughtfully and by hand. If there were prototypes, they were known not so much by the manufacturer's name as by the name of the man who first brought them into favor. When W. E. Gladstone was prime minister of England, for example, he was never seen without a bag which was broad, flat, and almost square at the bottom. At the top, it was arched, and sprung, and most elegantly curved, like the hull of a Viking ship turned upside down. This was the Gladstone bag, and very useful it was, too.

This was also a time when bags led a coded life. The schoolboy, the soldier, the sailor, the clergyman, the colonial administrator, the crack shot, and the cricketer—each had his own bag, and could be recognized by it at a hundred paces. The cricketer's bag in Edwardian England (and quite possibly still today) followed the shape of the cricketer's equipment. Long, thin, and narrow, it was of green canvas and came with leather handles and fastenings. Such was the prestige of our summer game that this particular bag aroused a total deference.

When Wilson Steer was the best-known landscape painter in England, he always took his painting materials around with him in a cricketer's bag. "I haven't played for years," he would say, "but it's the only way to be sure of good service."

Until the summer of 1939, luggage in Europe led a privileged life. No sooner was a suitcase set down on a train platform, a quayside, or even a curbside, than people came running to look after it. No matter how modest his means or how cumbrous his equipment, every traveler had at his disposal an affable Hercules who would see to it that his baggage was stowed and unstowed with never a scratch or a dent on its gracefully aging surfaces. Luggage was sacred—so much so, indeed, that a really good suitcase might well have something ecclesiastical about its profile: a rounded Romanesque arch here, a steep-pointed Gothic roof there and even a hint of the august constructions that were made in Limoges for the protection of holy relics.

Faint echoes of that happy state of affairs linger here and there in the luggage that is on offer to us in the stores today. But, between them, technology and social change have made sure that those echoes grow progressively fainter. Ancient classics like the steamer trunk are still made, for instance; but now that there are virtually no steamers to stow them away in, they tend to be somewhere at the back of the shop. As for the more specialized classics of a few generations ago—a *gibéciére,* or light "game-bag," for example, which Baedeker recommended for a walk in the Alps—they have become museum pieces, to be put behind glass and marked "Not for Sale."

Air travel did the most harm, in this context. The airline companies doubtless do their best, but we all know how often our baggage takes a beating at some point along the way. Anyone who submits a $1,400 suitcase to that kind of treatment is a fool. (He may well be a fool to have spent his $1,400 in the first place, but that's another matter.) Air travel calls for luggage that is the antithesis, the malleable, reversed image, of the classic suitcase.

There is also the social factor. People today like to have new luggage, the way they have new clothes—as often as possible, and without going broke in the process. "New luggage, new self" is the general idea, and stores have caught on to it. Every trip would be a honeymoon trip if the stores had their way, and in respect of his luggage every traveler would be the perfect polygamist.

A little fieldwork in the stores will bear this out. Crouch & Fitzgerald have been in business in our city since 1839, but age sits lightly upon them. Their shop is indeed a veritable dictionary of today's possibilities. T. Anthony is another alert anthologist, and at Mark Cross you will find not only the novelties of the day but an authentic and very small trunk that dates from 1904. With its coved top, its heavy metal studs, and its patterned lining, this little piece is history made visible. (It is not for sale, by the way.)

Where design is concerned, the luggage industry cannot be said to be bursting with new ideas. Forms appropriate to the last quarter of the twentieth century and unthinkable before it have yet to appear. Just as the automobile once looked like a horse carriage without the horse, so does the average big suitcase still look like something that an endless supply of very strong men will pick up for use at a going rate of 25 cents.

Air travel has in fact brought us one new design, and one only: the "carry-

on one-suiter," which together with its big brother, the "carry-on two-suiter," corresponds to a specific need and meets it down to the last quarter of an inch.

Aside from that, our decade's developments are mostly of a synthetic or spurious character. That great ethnic standby, the carpetbag, is as good as it ever was if we can run it to earth in the countries of its origin; but an imitation carpetbag is a pathetic affair. Tweed is as good as ever when it comes from Scotland or Ireland; but a suitcase covered with imitation tweed is like a walrus with a plastic mustache.

Implicit in those aberrations is the wish to keep up appearances, on the one hand, and the inability to scrap the traveling habits of our grandparents on the other. We know perfectly well that in modern times all we need to take with us on a journey is a pocketful of credit cards and some folding money for those who still exact it. Yet we insist on taking everything with us as if we were Scythian nomads who had no place to call home and had to carry their gold objects everywhere with them.

It may well seem to posterity an enormous joke that we spend so much time in one of the few activities—packing and unpacking—of which the microcomputer can never relieve us. Meanwhile, "Love me, love my luggage" is a better outlook on life than "Love my luggage, love me." But social historians of the future are likely to agree that in an age when ostentation in general had gone out of style, the name-brand suitcase was one of the last bastions of conspicuous expenditure.

# Wisteria
# (Rhymes with Hysteria)

**The New York Times, 1980**

It is in winter that wisteria rhymes with hysteria. It takes a level head to sit week after windswept week in a London house while those juiceless claws go tap, tap, tap at the windowpane and the tormented skeleton of one of nature's more peculiar inventions tears away at the very fabric of the house.

Wisteria in winter can shape up like a first draft for the Laocoön. The very look of those etiolated branches is like a preliminary sample of arthritis. The color, or lack of color, is that of a washcloth rubbed bare by long use. As the whole crazy structure inches its way across the window, we end up thinking that wisteria in winter is nature's vermin.

But all things have their season, and the day comes when those knotted boughs begin to float their blossom before our astonished eyes. Wisteria in bloom has a gamut of color—somewhere between mauve and lavender—that does wonders for stone, does wonders for stucco, and is even quite flattering to institutional red brick. We forget the ordeals of winter as those color-clusters give an air of leisured innocence to even the most heavily trafficked street.

Wisteria is like most other things in that its reputation varies from country to country. In England, it is the very pattern of untroubled seniority. People dream of ending their days in a little house with wisteria round the door, and in those dreams the wisteria blooms all the year round.

In France, wisteria is the victim of a certain snobbery. "Just about good enough for the concierge's lodge," is the verdict of those who see themselves as the cognoscenti.

In this country, where snobbery is of course unknown and all nature is taken on its merits, wisteria seems completely acclimated. When Tiffany lamps were all the rage, for instance, both the idiosyncratic forms of wisteria's branches and the heavy clusters of blossom looked as if they had been made expressly to please Louis Comfort Tiffany.

So much so, in fact, that when I first came to live here I decided that wisteria must have been named after a famous American: Owen Wister, let us say. Exactly how the author of *The Virginian* and the biographer of Theodore Roosevelt got mixed up with a leguminous woody twining vine was a problem I never had time to resolve. Maybe it was during his years as a student of music in Paris? A promising lead, but it got nowhere. Wisteria in point of fact takes its name from Caspar Wistar (1761–1818), an American physician based in Philadelphia who was descended from an early Pennsylvania glassmaker.

Caspar Wistar was terribly bright: He was the author of *A System of Anatomy*, the first American textbook on the subject, and he was also president of the American Philosophical Society and a man who liked to have young people and young ideas around him. He never lived to know of the honor that was paid to him when, a month or two after his death, the plant Linnaeus, named Glycine frutescens, became Wisteria.

He was not, by the way, the first man of learning to interest himself in wisteria. No less an enthusiast than Charles Darwin noted that wisteria shoots twine counterclockwise. Everyone who has tried to rear difficult plants will empathize with Darwin's vexation when his wisteria "tried for weeks to get round a post between five and six inches in diameter" and didn't make it. (What made it all the more galling to the great savant was that everybody else's wisteria did better than his.)

When faced with the heart-stopping sight of big-city wisteria in bloom, we should be grateful not only to the public benefactors who planted these trees but to those earlier enthusiasts who nurtured them in Cantonese gardens in the first quarter of the nineteenth century.

To get the first wisteria plants back to England was man's work in those days. The plants had to be got ready for their long journey; the captains of the East India Company's tea clippers had to be coaxed into having a portable greenhouse on deck; and even when the plants got safely to England they needed a charmed life to survive the rough and inappropriate treatment that they were likely to receive. (One such tree was planted on the wall of a heated peach-house, where it was ravaged by red spider. Replanted in a dark corner of the greenhouse, it got frozen solid three times during its first winter.)

But wisteria is tenacious, and by 1838 one plant sent home from China and planted in Kew Gardens was already 11 feet high, 90 feet in one direction, and 70 feet in another. I like to think that it is from such indestructible stock as this that our Manhattan wisterias descend. Certainly they have not lost that disposition to take over everything in sight, which makes us think of wisteria in winter as nature's vermin and in early summer—ah, in early summer!—as nature's metropolitan masterpiece.

Vine.

# VIII.

# A WORLD ELSEWHERE

In 1974, A. M. Rosenthal, then the executive editor of *The New York Times,* found out that I had never been to India. "That has to be put right," he said, and in no time at all it *was* put right, with characteristic speed and generosity.

I hope that this piece conveys something of the joyous disorientation and total freedom from everyday cares that came our way in India. And instead of the "têtes-à-têtes with chosen persons" that I found in Lytton Strachey and tried to emulate, we saw and heard, from the ramparts of Gwalior, a whole people in ebullition.

# India!

### The New York Times Magazine, 1985

When I went to India for the first time, not quite six months ago, I had in my hand the schedule of the Festival of India that was to be inaugurated in Washington by the Prime Minister of India, Rajiv Gandhi. It was a remarkable, nationwide roll call of events, in which seasoned professionals would do all that can be done to import an importable India.

In any other country, I should have knocked myself out getting ready for it. I should have gone to as many museums, as many churches, and as many houses and gardens, great and small, as could be fitted into the day. I should have gone to the theater, to the opera, to the ballet. I should have pestered eminent writers for their opinion on this question or that. I should have "taken the pulse of the country," the way people take the pulse of Italy by going to the horse race in Siena or of England by going to the Henley regatta.

I did none of those things. Three days into the journey, something showed me that, in India, art and life are one. Sometimes Indian art is in a museum, as it is elsewhere. Sometimes it is a great monument that has been preserved and guarded, and to which admittance may be procured for pennies. But most often it is just there, in the air, on the ground, all over the place, for the taking, and no name is attached to it.

That is what I learned—that art is everywhere in India, if we know how to look, and not only in famous places. It is in the costume (as spectacular as anything in Diaghilev's Russian ballets) of a woman working on the road. It is in the fragments of lapis-lazuli mosaic that lie on the ground beside a temple long left for dead. It is in the bracelets (canary yellow, it may be, or emerald green) that we see on the horns of white oxen by the roadside. It is in the

ferocious color of the spices in every small-town bazaar, and it is in the celestial spacing of one building after another in the abandoned city of Fatehpur Sikri, near Agra.

The epiphany that I have in mind occurred at midday, somewhere in nowhere, on one of the long straight roads that were built by the engineers of the Indian Civil Service in the nineteenth century. We had pulled off the road. Sitting on finespun blankets in the shade of a king-size acacia tree, we counted the twenty-three green parakeets that had flown out of its branches to take a look at us. From a whole battery of cardboard boxes there appeared Indian vegetarian dishes, each more delicious than the last. With them came long draughts of fresh lime and soda.

There were fields of mustard to give us a new notion of yellow, and in the distance the pink hills of Rajasthan. Indian talk went on all around us, and as the locals walked past us on their way home to lunch, they moved like gods, but un-self-consciously. From the other side of the hedge, a solitary flutist blew a cool spiral of sound into the clear pale air. The road was lightly trafficked, and we could not fail to notice that every truck that passed had been painted— front, sides, and back—in ways that were fanciful, euphoric, and wildly superstitious.

When we were all through with lunch, two dancing bears got down from a passing truck and began to limber up for the evening's performances. A twelve-year-old shepherdess came by with her sheep and said, "Good morning! How do you do?" in limpid, unaccented English. And as the late December sun warmed our Western bones, we agreed that from the moment we had stepped off the plane at 3 o'clock in the morning at New Delhi airport, everything had gone right—but right in a specifically Indian way that was not like the way of anywhere else.

We remembered, for instance, the ways of Indian luggage. If I speak of "Indian luggage," it is because everything in India is peculiar to itself. Boredom in India is Indian boredom, and unlike boredom elsewhere. Tantrums in India are Indian tantrums, and unique. Conversation in India is Indian conversation, carried on face to face, sitting or half-lying down, open-endedly and untouched by the tyranny of the wristwatch.

So it is with Indian luggage. When it comes down the carousel, it is unlike any other. Whereas American luggage lies flat and minds its own business, Indian luggage comes roped and bundled, with stenciled messages ("Good Luck!" or "Safe Journey!") in big letters on its sides. Not only that, but it rocks itself continually, frantically, forward and backward, as if a living creature were trussed up inside it and calling for help.

And right there, in what seems a quiet provincial airport, within sight of the first charcoal fires in the street, the visitor gets an immediate lesson in the interpenetration of Indian art and Indian life. For in the unwieldy animation of Indian luggage there is mirrored the unwieldy animation of Ganesa, the elephant-headed and hugely fat Indian deity, fundamental to Hindu belief, who functions as destroyer of obstacles and dispenser of wealth and wisdom. We shall remember that animation, that convulsive rocking and rolling, long after we have forgotten much else that happens to us.

But we shall also remember it when we see the sculptures of Ganesa that

are among the prime pleasures of Indian art. It is Ganesa's role to make things run smoothly, and with his Falstaffian gait, his irrepressible craving for candy, his colossal belly, and his wide, flapping, cabbage-leaf ears, he is an unmistakable figure, everywhere recognized and (unlike some other divinities) everywhere welcome.

Indians do not view their divinities, any more than they view the art in their museums, with the kind of detachment that is regarded as good form in the West. Nor do Indian museums see themselves as a department of show business. In this, they are closer to the village churches of France and Italy, where until lately it was taken for granted that anyone who wanted to come to see their treasures would come, and that everyone else (thieves and vandals included) would stay away.

Nor do Indian museums foster, or envy, the frenetic social activity that Americans expect of their museums. The work is there. The museum is open from time to time. What more can anyone want? If catalogues, reproductions, and postcards are defective by Western standards, nobody grieves. If there are no scarves, no pieces of simulated jewelry, and no neckties, that's perfectly all right with Indian visitors.

As against that, Indian visitors identify with Indian works of art with an intensity that is almost unknown in the West. To them, they are not works of art at all, in our sense, but objects of worship that happen to be in a museum and not in a temple. To see them lay gifts and offerings at the feet of a figure of dancing Siva is an experience that has nothing to do with "art appreciation" or with the nice distinctions in quality that we in the West like to find between one Crucifixion and another. Siva for the Hindu is right there, in person, dancing the universe into being, sustaining it with his perfected rhythms, and finally dancing it out of existence. We cannot wonder that what the worshipers have to bring, they bring.

Attention of a millenary, endlessly repeated, directly physical kind has been lavished upon many thousands of Indian sculptures. Where those sculptures have a specific anatomical attraction, the areas in question are likely to have been worn shiny by centuries of smoothing and caressing. (A flat-chested woman has no cachet in India, by the way.) Indians like to get in close, in this as in many other departments of life.

In India, the art of the past is always relevant. It will tell you how to distinguish the good people from the bad people among the divinities with whom you will become more familiar every day. It will tell you what goes on in those tiny, many-storied town houses where everyone knows everyone else's business. It will tell you about gardening, and about hunting, and about how to deal with people great and small.

It will tell you about the untroubled sexuality that is an immemorial feature of Indian life. Above all, it will give you a whole new set of references by which to judge human motives, human character, human beauty, and the interaction between human beings and nature. It will do all this with economy, with subtlety, and with wit. You will be lucky to have Indian art as your guide, and its guidance will not fail you when you come home, no matter where "home" may be.

"Art" in this sense can include the printed word. If you want to know India

and Indians, look out for the memoirs of the Emperor Babur (1483–1530) and note the freshness and the modernity with which he sets down every quirk of character that amused him. (Of one great warrior, he wrote: "His courage was unimpeached, but he was rather deficient in understanding.... He was madly fond of chess. If someone else played chess with one hand, he played it with two hands. He played without art, just as his fancy suggested.")

Observations of this sort and quality run throughout the great years of Mogul painting, which can be dated roughly from 1555 to 1857. During the three centuries of Mogul rule in India, paintings made in watercolor or gouache and small enough to be put into albums or held in the hand had an immense popularity at court. Beginning with Akbar, who took the throne in 1556 at age fourteen, the Mogul emperors not only did all they could to encourage the art of painting, but the Mogul nobility and the minor provincial rulers were delighted to follow the imperial example. Throughout north India and the Deccan, painting flourished and was protected, with results that can be enjoyed not only in India itself but in many a great museum in the West.

Mogul painting was concerned with portraiture, with demeanor and with differentiation. No two people were alike, and it was their differences, not their likenesses, that should be brought out. Mogul art was attentive to every detail of gardening, and it shows us how wretchedly the great Mogul gardens have been allowed to go to rot, and how easily, and at how small an expense they could be brought back to life. At this moment, looking at them is like looking at a broken phonograph, and just about as much fun.

Mogul painting was also minutely attentive to the strange and beautiful animals that came to India from time to time. (Once well described as "the first and ultimate connoisseur," the Emperor Jehangir could not believe, when he saw a zebra, that the delicate black line around the zebra's eye was not owed to cosmetics. Convinced of his mistake, he annotated a portrait of the zebra to that effect.) Mogul painters missed nothing—neither the purposeful tumult of a building site, the transports of secret lovers, the concentration of the calligrapher as he pored over a page of poetry, or the brief definitive savagery of battle. Missing nothing, they put everything down, but with a finesse that is still a sure guide to Indian mores.

Mogul painting is also unbeatable if we want to decipher the life of the labyrinthine town houses to which we may one day be introduced. Mounting the stairs that line the inner courtyard, we see into room after room. If there are doors, they are rarely shut. (Ventilation, sociability, and a determination to be in the know combine to keep them open.) We see cushions, divans, parted curtains. Here and there we see a dark and penetrating gaze or a beautiful nose turned away in affectation. We hear laughter and the swift movement of silks. If there are echoes of harem or whorehouse, they are misleading. This is just Indian life, going on as usual, with a mix of what is, what might be, and what ought to be. But to decode those looks, those squeaks, those mirages of coffee and sweetmeats, we need Mogul painting, and Mogul painting will not let us down.

What we remember most vividly from an Indian journey may not, in the end, be the great set pieces that people cross the world to see. They are just as likely to be a matter of chance, whim, patience, private affinity, and luck.

Sometimes a gifted photographer may sift them from the experience of every day, but most often we have to go to India ourselves to see them. Once we have been there, our India turns into a private India, a confidential India, and an alternative India.

People don't always want to hear about it. They prefer the big standard remarks about the big standard sights, and of course it is true that many of the monuments for which India is best known are on a colossal scale. The thirty and more cave chambers of Ajanta, the huge temples cut out of the living rock at Ellora, the northern medieval temples at Khajraho, the temple of the sun god Surya at Konarak, the enormous granite relief called "The Descent of the Ganges" on the natural rock wall of the reservoir at Mahabalipuram—all these and many another are as impossible to ignore as they would be to move. They will always be places of pilgrimage, just as was once the case with Persepolis and Angkor Wat. They are a part of everyone's imaginary India.

It is also true, as everyone knows, that India is a very large country indeed, has a population of more than 750 million and a climatic range that runs from the perpetual snows of the Himalayas to the sweet, damp, low-lying south. Nor is it unknown that at least one Indian city—Calcutta—has grown beyond reason, beyond endurance, and beyond the imagination of our great-great-grandfathers, who prized its large and uncongested spaces, its distinguished early nineteenth-century architecture, and its uncrowded and ever-more seductive department stores.

It is important in this context to remember that Indian art is not just painting or sculpture. Talk, costume, food, and drink are a part of Indian art and a part of Indian life, also. Indian art penetrates into every crevice of Indian life. The decorative arts, in their relation to Indian architecture, do not function either as fillers or as mere ornaments. The Taj Mahal is not simply a matter of noble forms and mother-of-pearl tonalities that change from moment to moment. It is spiced, prickled, and, in a strange way, put to the test by the linear decoration—much of it invisible in photographs and omitted altogether in the hideous reproductions that people buy by the hundreds of thousands—that adds color, tone, and nuance to surface after surface.

Anyone who goes to the largely unvisited museum that lies not one hundred yards from the Taj Mahal can see for himself the great variety of materials that were put to use in these partly abstract and partly botanical ideograms. The materials in question came from Baghdad, from Russia, from Afghanistan, from China, from Tibet, and from Sri Lanka as well as from India itself, and their names are sometimes familiar (jade, malachite, coral, carnelian, turquoise, lapis) and sometimes anything but (pankhuni, sang-musa, summog, khattu, hira, and surkh, among others). In any other country, all this could have turned to mere elaboration. In India, it turns to nuance.

Anyone, equally, who looks into the interior of the Taj Mahal, or stands at the knee-high balustrades that overlook the indolent river Jumna, will see that the profile of the great and justly famous building is no more than the equal partner of many another element in the general ensemble. To understand the Taj Mahal, it is indispensable to take it by surprise, difficult as that may be. On the far side of the Jumna, with the loud railroad trains crashing to and from and the water from the river pumped up to feed the archetypal Mogul gardens,

we see the Taj quite differently—with a train conductor's eye, a gardener's eye, even a water buffalo's eye. It is worth the trouble.

No less important than the role of the decorative arts is the parity enjoyed by dance and music. Dance and music in India are a part of life in ways that have no parallel in other countries. A lot of Americans enjoy the ballet, for instance, and can't wait to discuss the season's seventeenth change of cast in *Nutcracker*. But it would not occur to them to say, as was said in India more than one thousand years ago, that without a close knowledge of the art of dancing no painter could possibly arrive at a full and truthful expression of human feeling.

Equally well, not even those who go to concerts every night of the week would argue that music in America has the many-centuries-old, minutely calibrated function that it has in Indian life. Long before the Indian raga had its current popularity in this country, an English musicologist in India was moved to say that "in India, the nature of the music is that of the language (Sanskrit), of the architecture, of the painting, of the dancing—of the whole man." In fact, music was, as A.H. Fox-Strangways saw it, the universal element, the binder and combiner that could cause an educated audience "to sway, and tremble, and shed tears." "If ever music spoke the soul of a people," he concluded, "this music does."

Among the many attractions of the Festival of India are performances of the Kathakali dance dramas that are the apotheosis of the interaction between dance, music, and art. Anyone who knows Indian sculpture and goes to see a Kathakali performance will see at once that the body language is the same in the one as in the other. Indian sculpture without Indian dance would be much impoverished. Indian dance without sculpture would lack the brevet of authenticity that is given by sculptures that have existed for a thousand years or more.

Singing and drumming likewise have their part to play in the Kathakali dance dramas. Indian singing has within it an element of heightened speech— of speech, that is to say, in which something especially important is being said. The word as sound is fundamental to Indian culture and has been so ever since the Indian who knew how to read was a rarity. As for drumming, it is an activity that may take a lifetime to master, so complex is the role of the fingers, whether singly or jointly, of the thumb, of the knuckles, of the palm of the hand, and of all these in partnership. (When the drums used in Kathakali dramas come into play, the fingers of the right hand are taped—so *Grove's Dictionary of Music* tells us—with "cloth finger stalls made rock hard by a plaster of rice paste and lime.")

Indian painting of the Mogul period is to this day, as I have said, our best guide to Indian mores, even if the gardens have gone, the palaces are no longer inhabited, and the stylized manners of two or three hundred years ago have fallen into disuse. To go into an Indian movie house is to see entertainments that make "The Jewel in the Crown" look like Aeschylus or Racine.

Portly heroes and no-less-portly heroines act their heads off in archetypal soaps. Second-rate film stock gives them magenta complexions, and third-rate dialogue forces upon them a style of acting that Hollywood would have rejected even before the coming of the talking picture. But let us make no

mistake: These movies are to the Indian miniature what Judith Krantz is to Jane Austen. There is in them something atavistic, something immutable, something that inspires instantaneous recognition.

As must by now be clear, mine is an intimate India. What is true of Indian Mogul painting of the great period is also true of Indian life—that nowhere is a glance more eloquent, a whisper more compelling, or a touch of the fingers more poignant. That glance, that whisper, and that touch are everywhere.

They are as basic to Indian art as they are to human exchange, as basic to the Mogul garden as to the wayside shrine, as fundamental to drum and sitar as to the multitudinous rock-cut figures of the temples at Ellora, and as basic to the empty space as to the crowded one.

India can make a big noise, on occasion, and Indian processions, whether religious or political, set up an undisciplined racket that, once heard, is never forgotten. But it is in the sound of the sitar, the solo flute, and the implausibly versatile drum that India speaks to us in its own voice.

It has not, of course, escaped me, even at a distance of more than two thousand years, that Indians in general are paradoxical and contradictory people. Entirely at home in the life of the spirit and prehensile in their power of adaptation to its complexities, they are born, dedicated, full-time politicians. They are volatile, much given to banding and disbanding in short-lived and ferocious alliances, capable of great feats of energy and perseverance and yet happy at other times to sit the long day through, doing nothing much of anything. All this, and more, is set out in Indian art.

The very word "thug" is of Indian derivation, and never did men live up to it more thoroughly than those who practiced thuggee in its original form, strangling the visitor from out of town when he least expected it. (One archetypal thug said in a matter-of-fact way that he had strangled seven hundred travelers to date and only wished that it had been a great many more.) Acts of criminal ferocity can be found in that same canon of painting that excels in the portrayal of acts of love and learning.

Indians have been known to build themselves stupendous monuments, as happened with the Emperor Akbar at Fatehpur Sikri, only to abandon them and move on. Nor have they any feeling for that prime instrument of happiness in Western Europe and North America—the covetable country house, prettily arranged and lovingly maintained.

As for the look of India itself, as distinct from the look of India in Indian painting, in the prints and watercolors of English travelers, and in nineteenth-century photographs, it will immediately strike the visitor that only quite lately have Indians had any sense of conservation. Buildings that were not in current use had no meaning for them. Had it not been for the all but anonymous English Army officers and civil servants who saved one monument after another, and for Lord Curzon, who, during his years as viceroy, set in hand a nationwide program of rehabilitation and paid for much of it out of his own pocket, most of India's great monuments would have fallen into a definitive decay.

As E.M. Forster discovered in 1912, the Indian concept both of time and of history is completely different from our own. We delight in differentiation and vie with one another in the search for arcane scraps of knowledge about style

and dating, species and place of origin. Forster found that, on the contrary, Indians were content with general statements. Trees were trees, birds were birds, buildings were buildings, ruins were ruins. That there should be, in such matters, a hierarchy of curiosity seemed to them a needless complication.

But then talking, not looking, is the prime activity of the Indian. Language is, of course, the great instrument of confidentiality, and Indians are prodigious, irrepressible, never-tiring talkers. Many of them today have no great fluency in English. I do not have, and now shall never have, so much as a word of Urdu, Sanskrit or Hindi. But it takes only a short morning in the bazaars for a visitor to judge that there is something quite special about the uninterrupted clicketyclack of Indian speech.

I would, in fact, lay money that the English Jesuit, the Rev. Thomas Stephens, knew what he was talking about when he wrote in 1579 that "like a jewel among pebbles, like a sapphire among jewels, is the excellence of the Marathi tongue. Like the jasmine among blossoms, the musk among perfumes, the peacock among birds, the zodiac among stars, is the Marathi language."

Language works, among Indians, on a one-to-one or one-to-two-or-three basis, but it also works on an altogether vaster scale. In this context, I have a last image to offer. One of the great experiences of Indian travel is to climb to the top of one or another of the historic forts that overhang town after town in central India. You climb until your knees give way. You cross courtyard after courtyard. Monkeys scatter at your approach, spitting and squawking. Vultures veer up and away, scenting that you are still in passable health. And then, eventually, you reach a belvedere—often sexagonal or octagonal—from which you look down on the town.

Below you are blue doors by the thousand, white roofs as far as you can see, and alleys, terraces, and open shopfronts by—as it seems—the tens of thousands. And as you look down, picking out a turban here, a pale gray bullock there, a chromatic explosion of saris, and stall after stall of what E.M. Forster called "sweets like greasy tennis balls," you become aware of the most extraordinary, all-permeating noise that you have ever heard in your life. And what is it? It is the sound of India, talking.

Perhaps a hundred thousand people are down there beneath you, and every one of them is talking. They never fall silent. Other noises there may be—transistor radios of appalling quality, indiscriminate beatings and bangings of unknown origin, automobile horns worn to the point of no return—but fundamentally what you hear is Indians, talking. An Indian city rides on talk, the way a full-rigged sailing ship rides on the sea. Art and life are one, in that experience. It has in it something of speech, and something of song, together with echoes of music and intimations of dance. It is the Indian moment, par excellence and in excelsis, and—let me tell you—it is worth crossing the world to be there.

# INDEX